Situated Narratives and Sacred Dance

SITUATED NARRATIVES AND SACRED DANCE

Performing the Entangled Histories of Cuba and West Africa

Jill Flanders Crosby and JT Torres

University of Florida Press

Gainesville

26 25 24 23 22 21 6 5 4 3 2 1

Library of Congress Cataloging-in-Publication Data

Names: Flanders Crosby, Jill, author. | Torres, JT, author.
Title: Situated narratives and sacred dance : performing the entangled
 histories of Cuba and West Africa / Jill Flanders Crosby and JT Torres.
Description: Gainesville : University of Florida Press, [2021] | Includes
 bibliographical references and index.
Identifiers: LCCN 2020045485 (print) | LCCN 2020045486 (ebook) | ISBN
 9781683402060 (hardback) | ISBN 9781683402404 (pdf)
Subjects: LCSH: Anlo (African people)—Cuba—Social conditions. | Ewe
 (African people)—Cuba—Social conditions. | Anlo (African
 people)—Cuba—Rites and ceremonies. | Ewe (African people)—Cuba—Rites
 and ceremonies. | Dance—Cuba—Religious aspects. | Slave trade—Africa,
 West—History. | Slave trade—Cuba—History. | Dance—Ghana—Religious
 aspects. | Ethnology—Cuba.
Classification: LCC DT510.43.A58 F53 2021 (print) | LCC DT510.43.A58
 (ebook) | DDC 305.896/3374—dc23
LC record available at https://lccn.loc.gov/2020045485
LC ebook record available at https://lccn.loc.gov/2020045486

UF PRESS

UNIVERSITY
OF FLORIDA

University of Florida Press
2046 NE Waldo Road
Suite 2100
Gainesville, FL 32609
http://upress.ufl.edu

Cover: *Hilda la Obbini Omo Eleggua*. Acrylic on Canvas 67" x 54", 2008. By permission of Susan Matthews. Hilda Zulueta was an important spiritual leader in Perico, Cuba. She told us many stories and guided us through Perico's oral history. One day, she took us to the sugarcane fields of central España where her enslaved ancestors had worked. Here, we photographed Hilda. She died less than a year later. From that photograph, Susan Matthews created this painting in honor of Hilda.

The painting shows her in the cane field wearing black and red, the colors of Eleggua, her patron saint (*oricha*). She releases white butterflies from an African gourd, symbolizing the release of the spirits of her ancestors. At her foot is a depiction of Eleggua, owner of the crossroads.

In memory of Roberto Pedroso García and Bernard "Solar" Kwashie

Roberto

Melba Núñez Isalbe

April 13, 2016, brought unexpected news. Our dear friend, collaborator, and colleague Roberto Pedroso García had passed away. This book would not have been possible without his many interpretations and observations. His religious knowledge and presence opened many paths and doors, not just for our research trajectory but also for our own personal lives. Roberto was not just a research co-collaborator in Cuba, he was also a guide into a spiritual reality we never imagined for ourselves. He is and will always be missed and deeply loved.

JT Torres

During my first trip to Cuba in 2014, I had the pleasure of meeting Roberto. This trip was a soul-shattering introduction to religious performance in Cuba. I attended my first ceremony, witnessed my first trance, viewed sacred altars I had only read about. As the walls of reality fell, one by one, Roberto stood in as a new support. I remember him always being by my side, explaining every gesture, every arrangement. He took great care to ensure my stability and safety. His presence felt like a warm fire on an otherwise cold and dark night. Even now, despite his passing, I can meditate on his presence and still feel that comforting warmth.

Jill Flanders Crosby

Roberto was the calm in the swirl. As one of my two Cuban research assistants and co-collaborators, he was a gateway and grounding voice as we navigated the sea of religious information and elder stories. I counted on him always to be nothing other than professional, dedicated, and instantly

willing to help, no matter what the problem or need. He became our religious guide, and his knowledge was critical. His contributions to this project are immeasurable in more ways than one. It is true that without him, this project would not be what it has become. We lost our heart when Roberto passed away.

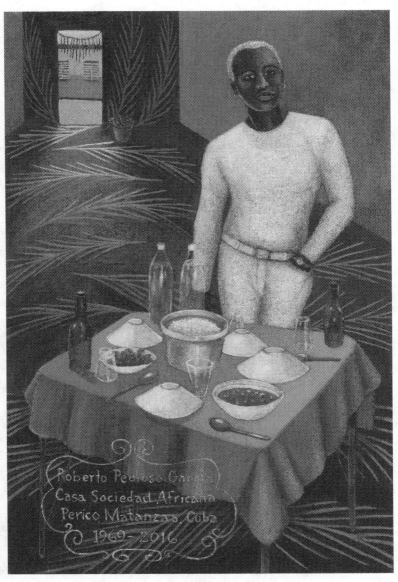

Roberto Pedroso García at Sociedad Africana (2016). Acrylic on canvas, 36" x 24". By permission of Susan Matthews.

Bernard "Solar" Kwashie

Jill Flanders Crosby

I was stunned to receive the news that Solar had passed away May 2, 2018, in Accra, Ghana. I had spoken with him on the phone a mere five days earlier. It did not seem possible, but it was true that a sudden illness had cut his life short.

Solar and I grew to be fast friends. The first time he accompanied me into the field, he was concerned that it would be an uneasy experience. But we both soon discovered that we could roll easily with whatever came our way. He was always professional and dedicated, as was Roberto. He would have loved meeting Roberto as much as Roberto would have loved meeting him. I was lucky to have known them both.

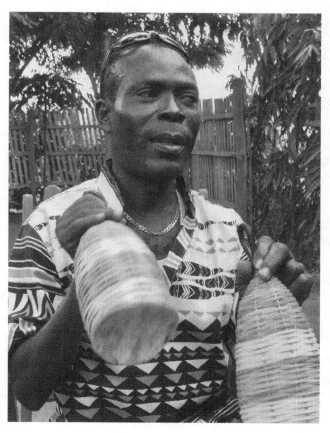

Bernard "Solar" Kwashie. Photo by Brian Jeffery.

Contents

Figures

Note on Spellings

Several words in this text refer to Spanish versions of Lucumí (Santería) terms. Since Lucumí emerged as a religion, it has been orally lived, enacted, and transmitted. Most of the West Africans who were enslaved in Cuba did not learn to speak Spanish, and most of the Creoles born to those Africans could not write or speak the Lucumí (or Yoruba) language. The result was a mixture of adopted Lucumí words with Spanish markers and orthography.

For the majority of these terms, especially those belonging mainly to Lucumí, we have decided to follow the orthography used by Natalia Bolívar Aróstegui in *Los Orishas en Cuba* (1994). For the Arará deities and terms, we have preserved many that appear in Guillermo Andreu Alonso's *The Arará in Cuba: Florentina, a Princess from Dahomey* (1997). But we have also followed several of our interlocutors' spelling preferences. These are noted when referenced. Often, our interlocutors told us that it was not important how a name is spelled. Rather, the main concern is how the religion is practiced.

When in reference to the work in Dzodze, Ghana, and Adjodogou, Togo, we follow the English spelling of Ewe terms, names, and locations. We have also chosen to follow spellings indicated in key scholarly sources and identify alternate spellings when appropriate. There remain several spellings of the same word, location, deity, and religious object(s) across the scholarly literature. Across all fieldsites, we frequently asked our interlocutors how they would spell the names of deities and religious objects. We follow those spellings unless otherwise indicated.

Note on Authorship

Unless each chapter has a specific individual credited with its authorship, the chapters are otherwise cowritten by the lead authors, Flanders Crosby and Torres.

Preface

Serendipity: Dancing with Scholarship

Ghana was serendipity. My (Flanders Crosby's) first experience there generated the roots of a decades-long arts-based ethnographic project. The first rendition of this project included an art installation titled *Secrets Under the Skin* that included performance, films, photographs, and visual art. The final step in this project now includes this book. The narrative below will briefly render this journey. The timelines, while mostly chronological, are imperfectly layered over each other, as is typical of time.

I (Flanders Crosby) danced my way through graduate school. Dance became not just a subject of study but also an instrument of navigation. My graduate research examined jazz dance, a form I practiced as a performing dancer and one historically rooted in improvisation. In 1991, the unpredictable steps of jazz dance led me to Ghana to study the West African roots of the genre.[1] A Ghanaian master drummer who had visited and performed at the university where I worked crafted a rhythm of events that connected me with dance anthropologist Judith Lynne Hanna. She in turn put me in contact with Ghanaian ethnomusicologist Dr. Daniel Avorgbedor, who at the time was based in New York. He choreographed even more connections, particularly with the University of Ghana. Upon my arrival in Ghana, one of Dr. Avorgbedor's research assistants, Shabaash Kemeh, introduced me to his brother, and master drummer, Johnson Kemeh. Johnson became my primary Ghanaian research collaborator and guided me to his Anlo-Ewe hometown of Dzodze, where I studied how to dance and participate in ritual ceremonies and festivals.

As a young performing dance artist and emerging dance scholar, I found it was not easy to reconcile what I initially believed to be two opposing selves: that of an artist and that of a researcher. I was concurrently a fac-

ulty member in the Department of Theatre and Dance at the University of Alaska Anchorage and a doctoral student at Teachers College, Columbia University from 1989–1995. My Alaska peers frequently reminded me that there is performance, understood as creative activity, and *then* there is serious research.[2] I also received comments from peer faculty questioning my worth as an academic, since I was "just a dancer." Meanwhile, several artist friends questioned whether I could still be a performing artist if I were pursuing a doctoral degree. It seemed as if becoming an academic threatened to diminish the efficacy of my artistic voice, while being an artist diminished the integrity of my academic voice.

It did not take long for me to resist this false binary. As I kept searching for my dance researcher voice in conversation with my performing artist-dancer voice, I gravitated toward ethnographic methodology, as it inherently made sense for my initial year-long Ghanaian study. Ethnography involves process in the same way that I understand process through years of dance training, choreographic practice, and performance. My ethnographic process in Ghana developed as fluid and in the moment, involving a multisensory, embodied engagement deeply attuned to detail and alternate possibilities. I continually navigated how to merge my artist and researcher voices. What borders could I cross? When, how, what, and where was the interface between these two *seemingly* different voices? How could this interface become more conversational? Could I push the current boundaries of ethnography and scholarly writing in an innovative and performative manner? I also asked myself how the concept of embodiment as a research lens could be mobilized. After all, as a performing dancer, and now emerging dance scholar, I found that embodiment was my central way of knowing and engaging with the world.

These interfaces that I encountered and questioned were, of course, not new (see Porcello et al. 2010; Vidali 2016, 395). Critical to my process was noted anthropologist and religious studies scholar Dr. Birgit Meyer. We met in Ghana and remain close friends. Importantly, at the time of my research, we both shared an interest in innovative ethnography, the evolving discussions of embodiment, and later, of sensational form—a concept deeply explored and theorized by Meyer (2008, 2010a, 2010b, 2011).

Meyer opened new doors, introducing me to spaces where artistic performance and ethnography did not conflict, but rather, illuminated each other. I began reading *Etnofoor,* a journal for which Meyer served as an edi-

tor, explored innovative platforms such as *Ethnographic Terminalia* (http://ethnographicterminalia.org), and published my own work in journals and on websites like *Material Religion* and *Centre for Imaginative Ethnography* (https://imaginative-ethnography.com). Meyer and I shared many discussions identifying and debating research that both directly and indirectly constituted performance as a method of ethnographic research grounded in the concept of embodiment (see Chernoff 1979; Clifford and Marcus 1986; Feld 1982; Geertz 1973; Ness 1992; Novack 1990; and Sklar 1991).

The year after my first year in Ghana, and while still in the doctoral process, I did an additional year of fieldwork in New York City to look closely at jazz dance while simultaneously taking West African and "Afro-Cuban" dance classes. My "Afro-Cuban" classes included Arará religious dances. I immediately recognized movement similarities between the danced religious forms I learned in Dzodze, Ghana, and the Cuban Arará forms I was now learning.

Ritual ceremonies in Dzodze always struck me as an aesthetically charged experience because of the central role played by dance and music-making. Each deity honored in ritual ceremony usually identifies with a particular drum rhythm and set of movements that invite the deity to "come down" and "dwell for a limited duration" in practitioners' bodies (Venkatachalam 2015, 21). Practitioners in possession (sometimes referred to as in trance) often continue dancing, and their dancing becomes visually striking in its power and execution.

Of course, possession was not a facet of "Afro-Cuban" dance classes in New York, but I knew it was involved in actual Cuban religious ceremony in the same process and for the same reasons as in Ghana. Curious to explore the relationship between the religious dance forms on both sides of the Atlantic, I sought explanations in the scholarship cited throughout this book for the possible links between the Ewe and Fon people of West Africa with the Arará communities of Cuba. I also kept intermittently returning to Ghana, in particular to Dzodze, to keep dancing at ceremony and ask questions.

In 1998, after completing my EdD, I turned my focus specifically to this study of connections. Beginning first in Ghana and then going on to Cuba in 1999, my project eventually took me to Togo (and briefly into Benin), West Africa. It evolved into an arts-based research project exploring the connections of the Ewe and Fon peoples of West Africa with their descen-

dants, who were brought to work in the sugarcane fields of central Cuba as a result of the transatlantic slave trade (Brandon 1997 [1993], 56; Brown 2003, 28, 74). In Cuba, the label Arará came to designate the cultural traditions and ritual practices that emerged from this history. Thus, the project emphasizes traditional religious dance, music, ritual, and shared artistic roots along with religious objects, sacred spaces, and oral histories across four field-site communities: Dzodze, Ghana; Adjodogou, Togo; and Perico and Agramonte, Matanzas Province, Cuba.

My seminal experiences in Ghana played a pivotal role in mobilizing art-making and theory in practice and writing. This new investigation of the connections among the Ewe, Fon, and Arará helped me further unpack the complexities of art-making, arts-based scholarship, performance as ethnographic method, sensational form, and art-as-ethnography. I viewed the world of religious ceremony through the lens of performance in order fully to understand, embrace, and eventually evoke in the ethnographic document the lived experiences and the histories of those who gave me their trust during fieldwork. Not only did this project and my research process continue to inspire performance as a critical lens for my work as a scholar and as a dancer, it also inspired performance as a critical component of the actual ethnographic document, whether it be as an art installation or as a book.

Along the way, I was privileged to collaborate with a group of core-searchers who are also artists. While I remain the lead researcher who spent decades in the field, without them—and without the inspiration of our collaborative process—none of this would be possible. While it is true that I and several of my collaborators identify primarily as artists, it is not accurate to assume that artists may not be trained in social science methodology as well as arts-based methodology. In arts-based doctoral programs, and even MFA programs, social science is frequently a critical component, and demanded as part of coursework. The belief that artists cannot be scientists, and vice-versa, reinforces the binary that I have spent years resisting. This book emerges from the desire to open up new ways of understanding the religious expressions we engaged with and researched. In order to accomplish this desire, we have all played with(in) the spaces between art and ethnography. We are artists performing fieldwork-inspired research. We are researchers creating art.

What began as a curious exploration of Ewe and Arará relationships in

religious dance structure blossomed into a complex historiography under-pinned by a plethora of oral histories across four field-site communities.[3] This historiography began by dancing beside and with elders and practi-tioners. Stories became vivid and embodied in the dance space, entwin-ing around each other and the dancing bodies. Along the way, elders kept telling more stories with the expectation that we would continue the per-formance. They trusted I would *do something* with their narratives, their histories. And so this book is dedicated to them and all those moments when stories danced alive.

Acknowledgments

There are always more people to thank when finishing a book than it is possible to mention. Without the many fluid conversations across the boundaries of disciplines, scholarship, friendship, and mentorship, knowledge is just not possible. Collectively, we thank Kerry Feldman, Michael Atwood Mason, and Sela Kodjo Adjei for reading sections of this book and offering suggestions for revision and investigation. Caught in the time warp of COVID-19, we especially thank Birgit Meyer and Stephan Palmié for the same. Their collective knowledge and years of scholarship that preceded ours were invaluable.

Thanks also to Meera Venkatachalam and David Brown for their long conversations with Flanders Crosby concerning West African and Cuban ritual practice. We both thank Stephanye Hunter at the University of Florida Press for believing in the book and guiding us throughout the process with calm reassurance. We thank Ray Bulson and Colin Tyler Bogucki for assisting us with preparing the many photographs for print.

In addition to all the artists, scholars, and interlocutors involved in this project, Flanders Crosby would like to thank Dr. Daniel Kodzo Avorgbedor, her first entry point into Ghana. He attended and graduated from University of Ghana, completed his PhD in ethnomusicology at Indiana University, served as faculty at the School of Music and Department of African American and African Studies at Ohio State University, and, upon retirement, returned to the University of Ghana Institute of African Studies and Department of Music. His significance in Flanders Crosby's scholarly life and his significance to this project cannot be stated enough. He closely followed Flanders Crosby's scholarly career, offered advice, and read and commented upon her research. He challenged her ideas in ways that pushed her to search and question deeply all aspects of scholarship. He not only encouraged Flanders Crosby to follow her research directions con-

cerning Ghana, Cuba, and performative ethnography, but he also encouraged the *Secrets Under the Skin* contemporary art installation.

Flanders Crosby also thanks Johnson Kwadzo Kemeh, her key Ghanaian collaborator in Dzodze-Ablorme and nearby communities from 1991 to 2013. Their working relationship remained active up to 2018. A master drummer from Dzodze-Ablorme, Ghana, Kemeh taught drumming in the Department of Music at the School of Performing Arts, University of Ghana from 1976 to 2014, serving for thirty-eight years as a Senior Principal Drumming Instructor. Kemeh's major duty at the Department of Music included teaching different African traditional drum and dance forms to Ghanaian and foreign students from across the world. Flanders Crosby also thanks Bernard "Solar" Kwashie, who was invaluable as a research collaborator in Togo, with equal thanks to Roberto Pedroso García, research collaborator in Cuba.

She extends thanks as well to Brooks Robinson, Douglas Causey, Robin Figueroa, Judith Burton, Mattijs van de Port, Wilfredo Benítez, Helmo Hernández, John Mouracade, Bernadine Jennings, Richard González, Dan Anteau, and Francisco Miranda, either for their belief in and support of this project in particular or for their early mentorship and conversations that helped build bridges across the sometimes seemingly empty spaces. She thanks David Essilfie Acheampong Quaye for further research help in Ghana during the writing of this book. In particular, she thanks Andrea Ramírez Álvarez in Colón, and Darlin Aguilar, Hortensia Alvarado, Alex Galeano Portilla, and Sandra Montero Suarez in La Habana[4] for their hospitality. She thanks Larry Corwin for his hospitality and transportation in La Habana, along with his ear and advice. He was a key grounding voice in the swirl of complicated Cuban dynamics.

Torres thanks his grandmother, Coraida Badía, who was the bridge to Cuba. Her stories, memories, and spirit planted the seeds of inquiry that would sprout years later, when Torres met Flanders Crosby in Alaska. Of course, for the cultivation of those seeds, Flanders Crosby deserves thanks. As one of the newest members of the project, Torres will remain deeply grateful for the open arms of everyone in both Cuba and Alaska. He also thanks Beauty Bragg and David de Posada for their mentorship when Torres first began nurturing a creative approach to research in Cuba. Without the guidance from those two generous souls, Torres would have never had the chops to accept Flanders Crosby's invitation to Cuba. Additionally,

Torres thanks those in particular who supported him during the intense period of simultaneously developing this book and completing a separate PhD program: Susan Finley, John Lupinacci, Olusola Adesope, Ashley Boyd, Zoe Higheagle Strong, Chad Gotch, Lisa Johnson Shull, Xyan Neider, Rachel Sanchez, Leticia Burbano de Lara, Emma McMain, Amy Kurzweil, and Nicole Ferry.

We emphasize the role played by Melba Núñez Isalbe. Acting as a "lead-on-the-ground" researcher, she not only transcribed and translated all Cuban interviews, but she also engaged in fundamental historical background research concerning the Cuban communities, sugar mills, and the complexities of "Afro-Cuban" religions. Her voice truly infuses all the Cuban story chapters of this book. Her subsequent analysis of each interview, along with her careful review, commentary, contributions, and corrections on all Cuban chapters, were critical. She performed background research and provided the Cuban family tree and city map data illustrated by Matthews. As well, she contributed to the writing of chapter 4.

Finally, parts of chapters 14, 15, and 16 were originally published as a single paper titled, "Secrets Under the Skin: Blurred Boundaries, Shifting Enactments, and Repositioning in Research-Based Dance in Ghana and Cuba" by Jill Flanders Crosby, Brian Jeffery, Marianne Kim, and Susan Matthews in *Congress on Research in Dance Conference Proceedings*, Volume 2014/Fall 2014, pp 59–69, DOI: http://dx.doi.org/10.1017/cor.2014.10. Published online September 23, 2014.

As always, we the authors are responsible for any errors in this book. As elder stories and narratives are malleable and shifting, as religious construction is fluid and changing, and as dance and storytelling are always emerging and responding, no doubt there are already new and alternate conversations emerging that may shift the results of the research that went into this book. That is the nature of knowledge. But it is the many conversations started and negotiated that allow for new ideas and alternate possibilities to have voice.

Notes

1. The West African root of jazz dance is well-documented in *Jazz Dance: A History of the Roots and Branches* (2014), edited by Lindsay Guarino and Wendy Oliver.

2. This dis-connect between performance and research was not necessarily evident

in my program at Teachers College—that of Arts in Education—spearheaded by Dr. Judith Burton.

3. Between Perico and Agramonte, 60 formal oral histories were recorded, with another 18 informally collected through notes between the years 2005 and 2018. All of Flanders Crosby's interviews may be found in the archives at Fundación Fernando Ortiz in La Habana, and at the Cuban Heritage Collection, University of Miami Libraries, Coral Gables, Florida. Recorded interviews in Ghana and Togo were more difficult due to the deeply secretive nature of religious expression there. Between the years 1995 and 2013, about 12 were recorded, but well over 40 conversations involved handwritten notes recorded in field journals.

4. We the authors have chosen to use the Spanish spelling La Habana for Havana throughout this book.

Introduction

Unfolding Layers

One of my (Torres) first Arará ritual ceremonies in Cuba took place in Agramonte, at Mario José's house. The air pulsed to the intense rhythm of drums. The earth kept the beat of the dancers' feet. The musicians, singers, and dancers performed in a harmony that seemed possible only with frequent rehearsal. And yet neighbors would arrive at different times and join with seamless transition. Everyone seemed to share a common focus, to "call down" a spirit.

I remember the first possession[1] I witnessed. That night at Mario José's, the young man, suddenly in trance, cried out. Several people helped him into a room, where he was dressed in purple and burlap, favorites of San Lázaro, the deity being celebrated, and the one who "came down." When the *montado* (possessed person) emerged from the room, eyes glazed over and lit cigar in his mouth, he danced, purified others, and then spoke with great fervor about the state of the community.

Prophecy was shared with those in attendance. If the news had not been favorable, or if a possession had not occurred, then those present would have likely become critical of one another as they wondered who among them was not upholding their religious devotion. During any ritual ceremony, not only is identity as a performative construct at stake, but also identity as a mode of membership and recognition.[2]

Ceremonies largely reveal a complex web of memory and identity—cultural memory as manifested through rituals, oral history narratives, and everyday sociality. These performances entail rich sensorial and embodied experiences that keep history alive for those who did not directly witness original events (Kirk and Thatcher 2005; Assmann and Czaplicka 1995). Through performance, a rich collective identity occurs as an aesthetic expres-

sion—the playing of drums, the dancing of bodies, the telling of stories—that mobilizes people to inhabit the past within the present. Additionally, the performances create a foundation for the communities that inform religious life and ceremony, what might be called Arará social memory.

As so many scholars, from Vygotsky (1980) to Hall (1990), remind us, identities, both individual and collective, are the names we give to the projects and practices that position us within social groups during particular moments of history. These scholars (see also Olick and Robbins 1998, 122–123) are quick to point out that identities are not permanent properties, but socially situated narratives that we both perform and are performed by.

Performance, in its many contexts, is how stories are kept alive, how authorship of situated narratives is negotiated, how ancestors are remembered, and how religious practice bends and shifts. For us as artists and researchers, performance was also how we interacted with the communities, even though the "real" agency in creating these important effects rests largely within those with whom we worked. What would later become one of our most robust sources of data were indeed the oral history narratives shared with us by elders at all four fieldsites. Soon we were swimming in layers of stories: the sacred, the political, the historical, and the personal.

People, Places, and Processes Involved

Members of the communities of Dzodze, Adjodogou, Perico, and Agramonte are all key and integral voices in and for this project. Due to the Ewe-Fon and Arará connections, the methodology included initiating a dialogue between the West African and Cuban communities during the research. Photographs, images, messages, and recordings of dance, music, and ritual were carried back and forth for comment and reflection. Religious practitioners were asked what they saw to get their responses to potential shared attributes of religious forms, dance steps, and drum rhythms. Cuban elders and religious practitioners sent questions for Flanders Crosby to ask of the Ghanaian and Togolese practitioners. Flanders Crosby would film those sessions, have them translated, and then carry those conversations back over to Cuba for further reflection. This process served as the critical method for cross-cultural knowledge generation across the fieldsites.

In Ghana and Togo, Flanders Crosby spent significant time in religious

shrines and at multiple ceremonies. In Cuba, respected elders began to invite key members of the collaborative American and Cuban-based research team into their homes to see religious objects: those present in everyday view, but also those that were located in private spaces or otherwise shrouded.

In Cuba in particular, we were taken to sacred sites, spaces that carry strong religious significance throughout the communities. These sites included a *laguna* (lagoon) at an abandoned *central* (sugar mill) where the enslaved were forced to work, a different site in the sugarcane field near that mill, and the threshold of a small and difficult-to-reach cave-like indentation near a different laguna. Here we lit a candle for the ancestors, purifying the space with cigar smoke and rum. Time was spent listening to and recording oral histories from individuals identified by the respective community as elders. Digging into these histories one layer at a time, we uncovered new questions to ask during the next round of interviews in order to excavate the entangled indigenous historiography encoded in them. Members of the research team danced beside community members during religious ceremonies and participated in accompanying rituals that preceded and/or followed the dance- and music-infused events. These experiences became critical reference points as we began situating and analyzing our fieldwork and oral history narratives within the complex history of scholarship on, in, and about "Afro-Cuban" ritual traditions. "Afro-Cuban" ritual traditions refer to practices that evolved in Cuba from the influence of enslaved Africans who arrived via the transatlantic slave trade.

Perico oral histories were largely narrated by elders who have since passed away. Hilda Zulueta and Reinaldo Robinson were the two most prolific voices. Members of this research team spent hours in both their homes listening to their stories; while we were at Hilda's, she also sang Arará chants. Hilda's cousin, Iraida "Guyito" Zulueta Zulueta,[3] lived down the road in the community of Tinguaro (between Perico and Colón) and also served as a critical voice. Often, when we asked questions, the answer was, "ask Guyito, she will know." We also spent time with Valentín Santos Carrera, an important *santero* (a priest or practitioner of the more popular religious expression Regla de Ocha, otherwise known as Lucumí or Santería). His historical knowledge of ceremonies and elders important to Arará history in Perico was invaluable, as were his insights into the community itself. After all, and as we heard over and over, all things religious belong together.

In Agramonte, we also spent time with elders in their living rooms and on their porches. We spent time with the great-granddaughters of Ma Gose, who started the first religious *cabildo* (sacred house) in 1912; Margarita Fernández Campos; Onelia Fernández Campos; and Onelia's husband Israel. In addition, we spoke with Hilario "Melao" Fernández Sosa, Fermina "Minita" Baró Quevedo, and Mario José Abreu Díaz. In both Perico and Agramonte, we also spoke with many others whose names continue to unfold through the chapters to follow.

Negotiating Local Voices with Global Scholarship

Arará as a label seems to signify one of the most apparent conflicts of our research: between the scholarly desire for clear categories and the fluidity of layered meanings proffered by interlocutors that we must accept. In other words, while we sought a usable definition of Arará, those with whom we spoke in Perico and Agramonte often suggested the fruitlessness of such a search. The same could be said about the oft-used term "Afro-Cuban" ritual traditions which is also a rabbit hole for researchers chasing African retentions in Cuba. These notions, and others, are interrogated within emerging scholarship to reconsider whether potential fieldwork agendas in Cuba may have influenced evidence of African retentions and subsequent scholarship (Palmié 2005, 281–283).

We constantly return to Stephan Palmié's argument that the term "Afro-Cuban" ritual traditions and, in particular, African retentions are seemingly self-evident but in fact highly complex concepts that may be created by ethnographers and scholars who approached the field authoring their own data (hence Palmié's suggestion that each word, "Afro"-"Cuban," should be inside individual quotation marks. E-mail to authors, April 22, 2020).[4] Palmié argues that students often followed the examples of scholars Pierre Verger and Roger Bastide, who conducted research in Brazil aiming to produce, rather than merely document, transatlantic similarities and to present these as evidence of common origins. Both Verger and Bastide also made their way to Cuba, and in fact Verger worked beside Lydia Cabrera at la laguna sagrada de San Joaquín de Ibañéz, located not far from Perico and Agramonte. The story these early researchers wanted to tell was about authenticated connections between "Afro-Cuban" ritual traditions and West Africa. This agenda was also deployed, if in a somewhat different sense, by

Melville J. Herskovits in the 1930s, and subsequently by his student William Bascom in the 1950s (Palmié 2005, 283).

Researchers in the mid-to-late 1980s (Palmié included) approached their initial research in or about Cuba under that still-prevailing agenda, but soon questioned such "givens" (Palmié 2005, 282–283). Flanders Crosby began her work later than this generation of questioning scholars, but not by much. She approached initial fieldwork operating in just such a scenario. Guided by scholars before her, she began determined to find those connected-across-continents religious dance and musical structures that certainly "must" be there. The longer she researched, the more she realized just how fraught such an enterprise was. Furthermore, the connections that she assumed she would readily find between religious practices were more subtle than expected.

Instead, the world of the Cuban oral histories and the lived religious life that included dance and music fascinated her far more than finding "connections." That said, it was the Cubans themselves who led us back to West Africa, not so much geographically but rather as an ideological source of legitimacy. During many of our conversations, they raised Africa without prompting. It is possible they were mobilizing their African connections based on national scholarship that pointed to these retentions and that was widely read in Cuba. Several interlocutors would reference books such as those by Vinueza (1988 [1986]), Andreu Alonso (1997), and many by Ortiz. However, from all of our interviews, it was clear that they were recounting not necessarily national scholarship but what their ancestors shared of their West African roots.

Importantly, from our interviews, language emerged that captured not so much the idea of shared West African roots, but the emotional, spiritual, and personal impact that has lasted throughout generations. Ripped from their homeland as enslaved people, carried to a new world in the brutality of the Middle Passage, and landing under the weight of slavery, would they not have wanted to hang onto their home as much as they could, and particularly their religious practices, to help them survive? In a Deleuzian sense, would not the loss of identity be the phenomenological equivalent to the loss of life (Deleuze and Guattari 1988)? The purpose of this book is to bring those questions and their connected stories alive, to approach fieldwork as artists, inspired by Vidali's (2016) claim: "Multisensorial anthropology is not just where the creatives are. It is where the humans are" (396).

About This Book

Part 1, "Situated Narratives, Embodied Memories: Living Oral Histories" brings alive fieldwork experiences, in particular the histories of religious life (mostly Arará) in Perico and Agramonte, through the performative retelling of stories. Chapter 1 provides a framework for approaching fieldwork using true fiction, choreographed narrative, and performance theory. Chapter 2 examines the complexity of "Afro-Cuban" scholarship by analyzing Arará's interrelationship with Lucumí, a name first applied to the various enslaved Yoruba-speaking peoples transported to Cuba whose collective identity coalesced under that term. It also addresses the various Arará classifications that have been advanced by scholars such as Brice Sogbossi (1998), Guanche (1996, 2005), Fernández Martínez (2005), Ortiz (1987 [1916]), Vinueza (1988 [1986]), Mason (2011c), and Brown (2003). Also in chapter 2, we consider the deity widely known as San Lázaro, regarded as one of the most important Arará deities in both Cuban Arará and Lucumí communities, and we build upon the work of Palmié (2005, 2013).

Importantly, part 1 lays down the key stories from Perico and Agramonte (chapters 3–9) that emerged during the decades of research. The stories acknowledge the multiple truths of oral histories, including the reasons behind their manifestations, signaling what Michael Atwood Mason (November 17, 2017) calls "interpretive multiplicities" (interview). This concept is probably most evident in the discussion of Armando Zulueta, whose complex relationship with San Lázaro has been contested across regional, economic, and political spaces (Brown 2003, 138–139). We offer a new look at the contestations surrounding Armando's San Lázaro as well as a more nuanced look at the argument about "Afro-Cuban" retentions as advanced by Palmié. While there is existing literature on the histories of Perico and Agramonte, we provide a complex historiography of each location's rich legacy, including the important characters who made such a legacy possible.

Chapters 10 and 11 offer deeper windows into West African Anlo-Ewe ritual traditions, and lead the reader back to the dialogues among all fieldsites across the oceans, using bridges engineered by our work. Chapter 12 begins with Flanders Crosby's relationship with Natalia Bolívar Aróstegui and then reflects on the ways scholars play a role in the ethnographic interface as it relates to social memory research and metaculture.

Part 2, "*Secrets Under the Skin:* Sensing the Moment at the Intersection

of Art and Research," unpacks the process of creating the *Secrets Under the Skin* contemporary art installation. The contributions made by artists Susan Matthews, Brian Jeffery, Marianne M. Kim, and Melba Núñez Isalbe provide an in-depth look at the collaborative process upon which this book, and the installation before it, so depended. In total, part 2 details the intersecting voices that together formed our approach to ethnographic work using methods from various art media.

As the stories in part 1 unfold across many people with many familial relationships, appendix A contains detailed family trees illustrated by Matthews along with a cast of characters important to the communities, but not necessarily detailed in the stories of part 1. Important to researchers who intend to replicate our processes, maps of religious houses in Perico and Agramonte are included in appendix B.

Finally, appendix C contains select transcriptions (as per her request) of Arará chants as currently sung by Lazarita Angarica Santuiste in Perico. We started transcribing these chants in 1999. Her re-corrections of our phonetic spellings have been ongoing, the last transcription having occurred January 2018. It was not necessarily that we transcribed them wrong; rather, her pronunciation kept shifting over the years. This only points out the difficulty of capturing, in writing, words that are imperfectly heard and without formal written documentation.

For pragmatic as well as aesthetic reasons, this book is very much a response to Stoller's (2018) call for social research "to be more playful, to take more representational risks, to construct narratives that sensuously combine head and heart" (110–111). In response to Stoller, this book continues the tradition of the art-installation by relying on literary styles of writing that employ fiction and memoir alongside academic analysis. The following chapters document stories and oral histories rarely shared outside their respective communities in ways that evoke the sensuous experience of being in the moment.

Conclusion

During a 2007 interview with Hilda Zulueta, she requested that we not be like another scholar who came for interviews, but never did anything with the information received to get it publicly disseminated. Her request became a resounding echo driving the *Secrets Under the Skin* installation, and the writing

of this book. To this day, it is the chorus of our project, signaling the imperative for our work to be applied, and to reach new audiences. Rather than reducing our inquiry to the singular analysis of the content of shared stories, we pay special attention to *how* stories are shared, and *how* individuals live by them.

The veracity of the stories we encountered dates back to stories from interlocutors' parents, who heard or witnessed the stories from their parents, and so on. These stories were often told to us as we sat in sacred spaces where the old *fundamentos* (material forms imbued with deities) from the "first" Africans were still lovingly cared for and "fed" each year.[5] Because of the generational transmission of these stories, space and materiality become critical reference points for collective memory. Halbwachs (1980) claims that "a religious group, more than any other, needs the support of some object, of some enduring part of reality, because it claims to be unchanging while every other institution and custom is being modified, when ideas and experiences are being transformed" (154). In other words, material objects are not seen as separate from their immaterial significance. Collective memory enacted through ritual often blurs the boundaries between representation and represented. Additionally, Halbwachs is helpful when interrogating the seemingly paradoxical practice of innovation within religious practices that seek to preserve tradition.

The African connections remain vivid and important in Perico and Agramonte. It was not only Cubans who pointed out connections to West Africa. At times, West Africans also pointed out and led us to the "connections." The term "Afro-Cuban" ritual traditions and the concept of African retentions are truly slippery.

For the artists involved in this project, interpretive multiplicities required multiple interpretations, through diverse media and artistic forms. Amid the academic debate over art, and whether it counts as knowledge the way systematic research counts, we artists take a clear stance. Like Flanders Crosby's first trip to Ghana, new opportunities beyond the recognizable became illuminated through the art we upheld. Therefore, the folds of multiple layers that we attempt to unravel in this book do not just form an argument that art is dialogically entwined with scholarship. The folds also juxtapose life experiences that are immeasurable by traditional science with stories of artists merging scholarship with artistic processes. These stories are about getting lost in one world and finding oneself in another, performing a history unbound by time and space.

Notes

1. Other verbs and phrases describing possession include: mounted (esta montado), dancing over one's head (bailaba sobre su cabeza), caught (lo cogió el santo), under (esta subido), and in trance (en trance). Roberto more often than not used en trance. Torres finds it ironic that if one puts the two Spanish words together, in English, it becomes entrance.

2. The authors are aware that the phenomenon of faked possession does occur at ceremony.

3. In Cuba, it is often standard to use two surnames. The first surname is from one's father, while the second is from one's mother. When enslaved peoples were brought to Cuba and forced to work under "owners," they were usually given their owners' surnames. Thus, for example, many people in Perico have Zulueta as one or both surnames, since Julián de Zulueta y Amondo was the then-owner of the sugar mill where the enslaved who later resettled in Perico worked. In our book, we often will provide both surnames, especially if the person we interviewed stressed both names as part of his or her identity. Other times, we may only use one surname.

4. In encasing these terms in quotes, we follow Palmié's advice not to take for granted what exactly is "African" or "Cuban" about the practices and traditions that we talk about in this book. Thus we choose to put quotation marks around the entire phrase. This is not to deny the origins of such practices among enslaved Africans in Cuba. Like him, we simply want to defer the authority on which to base judgements on the "Africanity" or "Cuban-ness" of these practices to our interlocutors themselves, rather than arrogate the authority to make such judgments to ourselves.

5. To feed a deity or fundamento means to offer it the blood of an animal (chickens, goat, etc.) and/or other items such as different types of alcohol, cigar smoke, palm oil, honey, and various types of food as religiously required across Ghana, Togo, and Cuba as observed through the authors' fieldwork.

PART 1

Situated Narratives, Embodied Memories

Living Oral Histories

1

Theories and Methods of Artists Performing Fieldwork

To this day, the Cartesian splitting of mind and body, of rational science and sensuous forms of knowledge, persists in social science. Privileging rigorously controlled observation, rationalists ask, What truth might there be in dancing? How does a walk to a lagoon offer empirical insight? Of course, researchers have no way of directly witnessing, and thus positively interpreting, the events being referenced in this book. Time has forever severed us from when enslaved West Africans arrived in the mills of Central Cuba and came to be known as the Arará. The stories, though, survive. Often, these stories are told in vivid detail, through the senses of the moment as experienced by a storyteller who does not just recount events but performs the moment.

For example, stories, accompanied by photographs or other artifacts, sometimes sent an interlocutor into trance, as was the case with Clarisa Emilia García, the wife of Perico resident Orlando Francisco Quijano Tortoló.[1] Other times, as was common with Hilda Zulueta, stories involved song and dance. At a more structural level, the telling was itself an oratory performance, full of the sensuous embodiments that remain elusive to rationalist research agendas.

In order to open up possibilities of other ways of knowing—the imaginative, the sensuous, the aesthetic—we rely on particular performances of writing (true fiction and choreographed narrative). This chapter presupposes that writing is both a method of research *and* a method of performance.

Performance

Following Marion (personal conversation 2016) who cites Schechner (2011), it is possible to analyze "something" that is a formal performance (such as a dance concert). However, it is also possible to analyze everyday cultural

enactments (for example, feeding a deity) as performance. By recognizing cultural enactments as performance, we argue for the shift from seeing and analyzing disembodied subjects to seeing and analyzing the processes that give meaning to everyday life. These processes take place as sensuous embodied events that are understood in and through the senses rather than through a static rationalism that analyzes a subject's meaning.

We could not avoid being actors in the performance even as we sustained analytical distance. The struggle resembles the one faced by van de Port during the initial stages of his research in Candomblé. He found himself incapable of transcribing the "sensation" of "being in Brazil." The music thumped in the sizzling air. Ecstatic undercurrents charged from body to body during ceremony. What did these sensations have to do with science? How could they answer something as banal as a "research question" when the wind stirred aesthetic electricity?

Van de Port soon realized the inextricable relationship between the senses and knowledge, a sensuous scholarship (Stoller 1997). He reminded himself to "insist on the thought that this is what *it* is all about" (emphasis ours). The "it": encounters that evade language as "the revelations that come to you, engulf you, unsolicited, unpredictable, as an immediate, full embodied knowing" (van de Port 2011, 11–12).

The archiving of cultural memory in embodied performance is a simultaneous act of remembrance and creation. Memory becomes a dialogical conversation open to continual invention and imagination. Memories performed as stories are a strategic way of enduring and remaining relevant. Ritual can be thought of as a story routinely performed, whether through narrative, dance, music, or gesture. Each ritual presents some unique aspect that simultaneously preserves history and extends its meaning to meet contemporary needs (Gee 1992; Mullen 1994; Richardson 1990).

Phelan (1993) warns that because performance lives only in the moment of itself, experiences like oral history narratives, ritual dances at ceremony, even staged recordings of music cannot be directly documented in nonperformative ways. Doing so would constitute an "economy of reproduction [that] betrays and lessens the promise of its own ontology" (146). In order to perform in ways that do "resignify" important meanings, we turn to Butler (1997), who reminds us that "we do things with language, produce effects with language, and we do things to language, but language is also the thing that we do" (8). In specific terms, storytelling creates particu-

lar effects like archiving cultural memory or recognizing a social identity. Elders act with stories, and stories become acts on others in what Fabian (1990) calls "sociality," which is "the result of a multitude of actors working together to give form to experiences, ideas, feelings, projects" (13). Through sociality, knowledge emerges not as information to be collected, but as a performance shaped by increasingly complex social interactions, such as fieldwork, art-making, and writing.

True Fiction

The writing of ethnographic stories in this book is deeply informed by Clifford and Marcus's (1986) description of "ethnography as art" (6). In many ways, the work of an ethnographer is to interpret a culture. Bound by language, researchers must perform acts of interpretation by relying on "useful cultural artifacts," such as local discourses, aesthetics, material objects, etc. Clifford and Marcus (1986) remind us that "literary processes—metaphor, figuration, narrative—affect the ways cultural phenomena are registered, from the first jotted "observations," to the completed book, to the ways these configurations "make sense" in determined acts of reading" (4). The result is what Clifford respectfully calls "true fiction" (6), which directly relates to how I (Torres) use the term. It references storytelling that is neither completely factual nor completely invented. Nonfiction and fiction, in this case, interact with each other in a dialectical manner so that meaning depends on both (Torres 2016, 113).

Patricia Leavy (2013) is among the scholars who challenge the clear divide between fiction and nonfiction. Her book *Fiction as Research Practice: Short Stories, Novellas, and Novels* calls for researchers to think of fiction as a means of inquiry in that it "grants us an imaginary entry into what is otherwise inaccessible" (20). The stories told in this book encourage readers to "imaginatively put ourselves in the shoes of others [so] that we are able to develop compassion and empathy" (28). Stories, regardless of their classification as fiction or nonfiction, involve readers by drawing on emotional power.

"True" or "untrue," stories build connections between audiences and authors, researchers and interlocutors, always with the goal Ricoeur (2007) had in mind: "To say that you think as I do, that, like me, you experience pleasure and pain, is to be able to imagine what I would think and experi-

ence if I were in your place" (180). This kind of knowledge is profoundly personalized. It focuses on the researcher as an author of experience who is also a character in a narrative of knowledge. Behar (1996) describes how intimate this process can be, defining anthropology as "loss, mourning, the longing for memory, the desire to enter into the world around you and having no idea how to do it, the fear of observing too coldly or too distractedly or too raggedly, the rage of cowardice, the insight that is always arriving late, as defiant hindsight, a sense of the utter uselessness of writing anything and yet the burning desire to write something" (3). What researchers do is tell the stories of experience that are unique to a specific moment in time. In so doing, the writing is usually organized as a narrative that places readers "close-in-contact with far-out lives" (Geertz 1988, 6). Just as the reader of scientific realist research experiences the distance of indifferent observation, readers of this book, by virtue of empathy, become a character in the narrative. Once readers feel an emotional connection with the characters in a story, they might be more open to the experiences under consideration. In Behar's (1996) words, readers must see themselves "in the observer who is serving as their guide" (16).

Chapters that employ true fiction will reference interviews in the endnotes to anchor any leaps in fiction in the fieldwork data. Flanders Crosby's strategy, choreographed narrative, chooses to weave literary leaps and fieldwork data within the text. Her choice presents a writing approach based on the performance of storytelling, either through dance, ritual, or oral history.

Choreographed Narrative

Choreographed narrative signifies a dance of voices, from storytellers, musicians, artists, and scholars. The intention is to continue what Richardson (1993) felt when experimenting with poetic texts, a method that "displayed the deep, unchallenged constructedness of sociological truth claims, and a method for opening the discipline to other speakers and ways of speaking" (697). Writing itself, argues Elliot (2017), is performative in nature as an "embodied, sensorial experience" (33). Such writing, Richardson (1993) adds, can "capture the messy sensorial experience of life," (25) and does not preclude "ethnographic rigor and historical accuracy" (28). Artistic forms confront the sensorial messiness and the many

simultaneous truths inherent in the fieldwork, allowing for a non-linear layering of stories.

As a method, choreographed narrative arranges the oral history narratives shared with us, similar to how one might choreograph a dance and driven by the sensation of movement. For me (Flanders Crosby), the task required choreographing the various versions of stories. While translating shared narratives into text, I first had to untangle multiple interviews and recast them in a way that honored the differences inherent in each telling. My sense of movement required staging; information paired with other information might shift understandings. In these cases, a single-story aspect might be moved and placed in proximity to other aspects from a different performance, creating a mise-en-scène that illuminates what might have otherwise been shadowed. For those stories that were shared by or known from only one or two interlocutors, other contextual factors had to be considered to understand those stories as a single performance, still staged in a particular frame. The purpose of choreographed narrative, ultimately, is to understand how stories become performances in relation to other performances, and how believed-in truth becomes a construction of an ensemble with particular dynamics that emerge only when the ensemble interacts in new and unsuspecting ways.

While choreographed narrative as a writing method is about the performance of words and stories, it also goes a step further. My writing style is also driven by the sensation of movement—in particular, those that I prefer as a dancer and choreographer. While movements-as-expressions are not easily translated into language—for how can one describe the colors, temperature, and flows that wash over and ebb through the body when dancing?—probably the best description I can find for my movement preferences as a dancer is a cascading lyricism of weighted flow. Specific to my perceptions, choreographed narrative is a sense of floating through time while simultaneously feeling deeply weighted and grounded, resonant and full, moving seamlessly and continuously even during suspended-movement phrases. When navigating the simultaneous truths and multiplicities into text, I work to find that cascading lyricism of shared stories. In contrast with Torres's true fiction, which fills in gaps with imaginative leaps, I seek to fill those gaps by arranging stories in ways that do not disrupt the current of perceived understandings over the riverbed of the book's text.

A Methodology for Composing Data as Stories

Vladimir Propp's (1968) terms *fabula* (the chronological order of events as they occurred) and *syuzhet* (the storyteller's arrangement of the fabula in the telling) help illustrate the methods used in this book to render elders' oral histories as written stories. Consider the hypothetical situation in which two people observe a car accident (fabula). One person reports: "The black car came out of nowhere and slammed into the red car." The other testifies: "Both cars collided when the red car crossed the intersection." Both witnesses have arranged the fabula into narratives (syuzhet). The first report indicates the black car is at fault by syntax alone. The black car, as the sentence's subject, slams into the red car, which, by virtue of its placement as the sentence's direct object, is framed as the victim. In the second testimony, the sentence implies shared guilt between both cars, but does shift the attention to the red car, which has become the acting subject.

As is apparent from this very simple example, grammatical features inherent in the syuzhet alone can communicate particular meanings, which suggest that nonfiction as a pure, unadulterated form of storytelling that is an exact transmission of the facts is not possible. Always at play is some level of invention (the etymological root of the word "fiction" is "fingere," which translates to "invention"). If there is always more than one side to any story, then good research is a collage of all the sides we can currently know. In true fiction stories, some elements, like dialogue, have been invented in order to transform the data into concrete scenes. To avoid any risk of deception or falsehood, the dialogue does not directly provide new information that would contradict any of the stories shared with the researchers.

Analysis pays close attention to the storytelling act, especially the performance of the storyteller. We compared stories across tellers as well as across locations for similarities and differences. Emerging differences were interrogated to understand how such differences emerged from a situated performance. In these cases, we asked what the differences meant in the staging of the story. As a result, the politics of whose stories get told, what versions of stories get highlighted, and what meanings or interpretations become emphasized remained central to our process.

Situating a storytelling act presents the most difficult obstacle for analysis. Due to its reliance on communicative memory, storytelling often con-

tains slippages, historical inaccuracies, and selective details. Because of its reliance on the rhetorical situation, storytelling is typically delivered with creative expression, coming dangerously close to fabrication. The fact that the stories comprising this book have changed across interlocutors does not necessarily disqualify them, but instead offers deeper truths about how conflicts based in class, race, and social status have shaped the identities of religious practitioners and Arará elders. Thus, because humans tend to arrange life experiences as narratives, analysis of stories should pay attention not just to *what* the story is but also to *how* it is being told.

Most interlocutors in Cuba had more than one version of the various stories captured in social memory based on particular group identities often tied to particular regions (such as Matanzas Province). Each offered differing degrees of knowledge that we needed to consider. Some stories were better-known and more widely shared than other stories. Of those widely shared, the variations may have differed in only one aspect, but that one aspect of difference could prove monumental. Other differences were not as consequential, but our awareness of the breadth of social memory at least gave multiple points for checking, rechecking, and cross-checking. Those stories shared by or known from only one or two interlocutors might have made for an easier retell, but they lacked the benefit of cross-referencing the story's details, or even its "truth." Even in Dzodze and Adjodogou, social memory and religious practice revolved around multiple narratives and differing stories. The most challenging task was weaving together the various versions of stories. While translating shared narratives into text, we had to untangle multiple interviews and recast them in a way that honored the differences inherent in each telling.

During these instances, we situated the narrative by clarifying who the storyteller was and how that storyteller related to the community. Finally, because researchers cannot directly witness the actual events being referred to by interlocutors, our research pays increased attention to elders' arrangements. Based on elders' relationships with us as researchers, information may or may not have been shared. And even if the information was shared to the best of an elder's memory, an elder's intentions might evade us.

The research is as much about the elders' stories as it is about those who are the storytellers. In a final layer, our own contributions to performance as researchers/authors/artists are reflexively analyzed. Not only did we feel the need to honor the storytelling tradition of the communities we engaged,

but we also needed to acknowledge that so much of what we learned and how we learned about the communities was through the sharing of stories. Indeed, stories are the "organizing principle in human existence" (Journet, Boehm, and Britt 2012, 4). What we believe to be true is dependent upon the narratives we find ourselves telling.

Conclusion

Extensive fieldwork requires a depth of understanding that might elude participant-observation. In order to reach such depths, the researchers, similar to a method actor preparing for a role, might become so immersed in the culture under study that distinctions between current and previous worldviews require critical reflexivity.

Karen McCarthy Brown (2001), who was initiated into Vodou[2] during her research, discussed the effect of losing cultural distinctions. In her introduction to *Mama Lola,* she remains clear that "the stories I tell about these experiences have authority only in the territory between cultures" (11). Torres also needs to remain equally clear. This research, important as it is to his own personal journey to Cuba, calls into question his cultural distinctions.

My (Torres) grandparents left Cuba, along with many others, during the revolution. I was raised at my grandmother's knee, hearing stories of an island to which she would never return, learning a history that made less and less sense to her. I remember uncles fighting with cousins about Cuban politics, which I did not understand. I remember my grandmother crying when she remembered friends who had stayed in Cuba, friends she would never see again.

When my grandmother was a child, a practitioner of Santería looked after her. This woman challenged my grandmother's Roman Catholic upbringing by encouraging her to see the importance of accepting all religions. My grandmother shared these sentiments with me and passed down many stories born from the convergence of different traditions. For years, Cuba existed in my imagination as an island that hid some deep family secret. Despite this curiosity, I was often told that "Cuba was not my history." Once, my mother, who will never admit she speaks fluent Spanish, even said, "Stop asking about it. There's nothing there for you to reclaim."

Literary writing allows me to interrogate the space between my own

fantasies and dreams of Cuba and interlocutors' fantasies and dreams of Africa. Like Brown, the stories I tell are only valid as bridges that cross the tenuous chasm dividing the personal from the cultural. Another author might tell these stories differently, based on that researcher's experiences. Observation is not a passive act; witnessing is not neutral. The telling is as important a consideration as the story. Rather than deny the inherent subjectivity of observation, I continue the recent tradition of telling not just the story of the observed, but also the story of the observation. It is only "when the lines long drawn in anthropology between participant-observer and informant break down," Brown (2001) writes, that truth is created in between; and it is only then that "anthropology becomes something closer to a social art form, open to both aesthetic and moral judgment" (12).

My mother was right. There was nothing for me to reclaim, because reclamation has never been the goal. The goal has been, from the start, to experience a history I can only imagine.

Notes

1. Orlando Francisco Quijano Tortoló is associated with a religiously significant house.

2. The spelling of Vodou varies across locations. Vodou is the spelling used by scholars of Haitian religion. Karen McCarthy Brown worked in Haiti, and in the Haitian community of New York City. In Ghana, among scholars of the Anlo-Ewe religion, the word is spelled Vodu or Vodun.

2

The Trouble with Arará,
or
All Things Religious Belong Together

When Flanders Crosby began research, she chose to focus on Arará, rather than the more popular Lucumí.[1] However, the boundaries between these two "Afro-Cuban" ritual traditions cannot be easily drawn. In this chapter, we examine the historic contexts of "Afro-Cuban" ritual traditions. We also explore claims about the importance of San Lázaro in Arará, a process that often felt like herding cats. Primarily, this chapter explores the following questions: What is Arará today? How is it practiced, remembered, and kept alive? How is Arará entangled with other "Afro-Cuban" ritual traditions practiced today?

Arará Classifications

The term *Arará* has a complex history. In general, "national descriptors" dependent on geographical locations in West Africa were applied to Africans in Cuba by slave traders and owners as if they were proper ethnonyms (Brandon 1997 [1993], 56). Thus, the broad name Arará was given to the enslaved Ewe and Fon people who arrived in Cuba from West Africa as late as the 1860s from an area known as Alladah in former Dahomey (present day Benin and parts of Togo). Arará became a subversion of the name Alladah. The label has no historical usage in West Africa. Rather, it was created in Cuba, with Fernando Ortiz (1987 [1916]) first discussing the classification and opening up deeper classifications from scholars who followed.

Many of these deeper classifications became based on further regional and ethnic differences (Brice Sogbossi 1998, 41–58, 82–83; Vinueza 1988 [1986], 22–27, 37–50). These classifications are Arará Dahomey (or Dajomé), Arará Sabalú (or Savalú), and Arará Magino. In *Santería Enthroned*

(2003), Brown carefully discusses these classifications of Arará in Cuba, particularly in relationship to the city of Matanzas and La Habana (74, 77, 138–141). Ethnographer Michael Atwood Mason, who spent time in Perico, writes that Aurora Zulueta, the niece and goddaughter of the well-known Armando Zulueta, told him that Perico is Arará Dajomé (as spelled on his blog, 2011c).

In our interviews, only three people ever used these classifications: Minita Baró Quevedo and Mario José Abreu Díaz, both from Agramonte, and Reinaldo Robinson of Perico. Minita broke down her classifications in reference to locations in West Africa important to an understanding of San Lázaro's West African legends and history. These locations (Dahomey land, Magino land, Mina land, and Tacua land) were all different places with different rites, chants, and ways to resolve various situations in life. Minita insisted that Perico is actually Magino land and Agramonte is true Dahomeyan land, a place Minita visited only in her dreams (interview, December 31, 2007). However, for the most part, when these categories were mentioned during interviews, interlocutors often did not view them as necessary to Arará history. In both Perico and Agramonte, what seemed most important to those we spoke with was honoring the elders, histories, stories, and rituals that made up the social memory of each respective place. Ultimately, what the literature provided as important Arará markers was not necessarily consistent with the conversations we had.

This is not to say that the above categories do not apply to either Perico or Agramonte or that the categories cannot be traced. Minita does differentiate Agramonte from Perico using these categories in a way similar to Mason's (2011c) insistence that Arará in Perico is Arará Dajomé. It was Aurora, he writes, who always "knew they were Arará-Dajomé" because the Arará had their own language and Aurora had learned to say "sofalú" (also heard as sifalú in Perico) rather than "mo juba" when invoking the ancestors.

All Things Religious Belong Together

Lucumí and Arará share many of the same deities, but differ in the naming of their deities and in their ritual practice. However, interlocutors frequently used the equivalent Lucumí names when calling Arará deities (and often used the associated Catholic saints' names [in Spanish], as evidenced by the name San Lázaro). This interchange of names was

always interesting to us. When we asked Marcos Hernández Borrego why Lucumí names are often called for Arará deities, he commented that it is because people see the entities "as one" ("como uno solo," interview, December 18, 2008). When we approached this same topic with Hilda Zulueta, she acknowledged that it is easier to call Arará deities by their equivalent Lucumí names. Once during a conversation about her Aunt Jacinta, Hilda mentioned that her aunt had an "African Oyá"[2] in order to indicate its Arará essence as an Arará deity. In many ways, legitimacy is inherently understood in terms of cultural proximity to "Africa" (interview, December 18, 2005).

Margarita Fernández Campos of Agramonte claims that her great-grandmother Ma Gose knew how to enact religious work with Arará and Lucumí together. Arará, Margarita notes, came first because it "came with them" from Africa, whereas Lucumí "came from" La Habana. According to Margarita, Ma Gose applied the same principle with all her *fundamentos*, Lucumí or Arará. In Arará, fundamentos are often made using old stones or fists of coral. To elevate each to the sacred, Ma Gose first went to the sea and made an Arará oath. Once when we were trying to decide whether a deity on Ma Gose's altar was Arará or Lucumí, Margarita, despite calling it by a Lucumí name, commented that she did not know. But it did not matter to Margarita because the deity answered her when she called out (interview, December 17, 2008).

David Brown refers to this form of code-switching as loan translation, a term from linguistic and creolization theory. One can say something better in someone else's language than one's own (interview, November 10, 2017). Even in an Arará ceremony, a *muerto* (spirit of a dead person) or Lucumí deity can come down, something the research team witnessed on more than one occasion. Yet Marcos commented that, despite the interchange with Lucumí names when speaking of Arará, the actual religions will never get mixed up because "Arará is Arará and Lucumí is Lucumí" (interview, January 2, 2016).

Marcos's affirmation needs to be interrogated a bit. Brown (2003) suggests that Arará may be a collapsing religion because of a loss of Arará knowledge. The reluctance of now-deceased elders to teach their religious knowledge to the young in Perico, Agramonte, and nearby Jovellanos (all communities with significant Arará heritage) means that the knowledge has literally gone to the grave (Brown 2003, 321n47). This loss of knowledge

came up often during our Cuban interviews. Comments from interlocutors are plentiful.

"You know, those elders said nothing," Alberto "Kikito" Morales Iglesias lamented.

"Elders did not give much information," Mario José said.

Minita, meanwhile, expressed concern over Agramonte's San Lázaro being the only Arará deity still locally received because all others were gone.

Midialis Angarica Galarraga of Perico commented that those who knew how to initiate in Arará are no longer alive and everything has been re-adapted. Lucumí, many interlocutors said, is more popular than Arará.

Lucumí may be popular out of necessity. Olivia King Canter, a *santera* with knowledge of Jovellanos and Perico, argues that for many years, people made a choice not to be initiated into Arará, including those whose roots were Arará. This, she claims, was due to the perception that Arará is a shrinking and limiting religion. If one needs to perform ceremonies in Arará and four or five people with knowledge in how to help are needed but not available, then the ceremony cannot be realized (interview, November 9, 2017).

Núñez Isalbe has remarked that Lucumí's popularity is probably due to its practical application in helping people solve everyday problems. They know what to do, how to make *santo,* the ceremony by which one is consecrated to a deity, while Arará has since become removed from daily life. Several of our interlocutors agreed that Lucumí is the living religion that is practiced every day and thus relevant to daily-life encounters. Midialis sees Arará more as a spiritual religion devoted to spiritual beings rather than deities. Despite wanting to become initiated into Arará, Midialis instead initiated into Lucumí. If she chose otherwise, she told us, she would never have access to particular sacred knowledge (interview, May 21, 2017).

However, the future of Arará is nuanced and may be assuming new identities and functions. Mason argues that Lucumí and Arará might be a false binary. For him, Arará is important even for primarily Lucumí practitioners, specifically because the Arará San Lázaro addresses health concerns (e-mail to authors, December 27, 2017). Importantly however, Arará *is* held onto tightly among the individual families in these communities that lovingly maintain old ritual objects, some that once belonged to the "first" Africans and their immediate descendants. These revered objects were

carried to various homes and *cabildos*[3] in Perico and Agramonte. Keeping Arará alive through veneration of objects, place, performance, stories and remembrance of elders, according to several we interviewed, keeps the house and everyone in it safe.

This, of course, *can* be seen as an everyday need. During a December 2015 trip to Perico, Víctor "Prieto" Angarica Diago, currently in charge of the first religious cabildo in Perico known as Sociedad Africana (African Society House), was very sick and confined to his bed. The family knew they had to go "feed" every Arará fundamento in that house for Prieto to recover. Ten days later, Prieto grew well enough to travel the one hour's distance to the city of Matanzas.

Furthermore, Arará deities stay with the house and the family for as long as the family will care for them; in Lucumí, the material representations imbued with a person's Lucumí deities are often dismissed with death.[4] "You do not say goodbye to an African santo, you pass it from one hand to another" ("El santo africano no se despide, es un cambio de una mano por otra," Hilda Zulueta, interview, December 18, 2005). Reinaldo Robinson is adamant that nothing religious (such as fundamentos and drums) should ever be removed from a religious house or else "you lose the customs of the roots of the house" ("se pierdan las costumbres de las raíces de la casa," interview, December 16, 2006).

In May 2017, we finally found the house where an old fundamento called Hevioso, the Arará name for the Lucumí Changó,[5] still rests. Hevioso (also spelled Hebioso or Jebioso) is similar to the name Xebieso (also spelled Hevieso or Hebieso) given to the thunder deity among the Southern-Ewe speaking people of Ghana and Togo and the Fon people, found largely in Togo and Benin. Few in Perico remember this house, since Hevioso's public ceremonies have long since ceased. But Teresa, the current resident of the house, continues to honor Hevioso on the day of her birthday, even though she is several generational and genealogical steps removed from the person who originally owned the fundamento.

Collapsing can mean breaking, falling apart, disintegrating, shattering, weakening and so on. Without a doubt, certain Arará practices did just that. Deities, fundamentos, and ways of giving them have been lost. Elders guarded their secrets closely, often at the expense of the education of the young. But collapsing can also mean giving way, bending and folding—and, what we find most important, *enfolding*. Lucumí might have become

Figure 2.1. The Arará fundamento imbued with Hevioso. This fundamento once belonged to Fabiana Zulueta, sister to Fidela Zulueta. Photo by Miguel A. Parera.

the religion of the everyday, while Arará may at times seem to be collapsing and getting lost. But the collapse is not entirely negative.

We envision Arará collapsing in generative ways; not folding but rather enfolding, evolving into new shapes and practices. Some innovations are accepted, some are contested, some are negotiated, and some are forgotten. This idea is well-theorized by Brown (2003, 115–162, 294–296). Additionally, according to Brown, Arará practice, as he knows it from the countryside, is actually more deeply "syncretized" along the axis of Lucumí and Arará than the axis of Catholicism (Lucumí is often argued as "syncretized" with Catholicism, although this is under debate) (Interview, November 10, 2017).

The boundaries of old shape-shift, eliminating others that are no longer useful. As Brown (2003) writes, from the "migrating, lost, invented and re-covered deities and the historical ebb and flow of local pantheons, arises the simpler question of significant variation within local systems themselves" (141). Of course, this enfolding and evolving differs from La Habana down through the city of Matanzas and the Matanzas Province. Each location has a different reality (Brandon 1997 [1993], 61; University of Chicago 2013). This book, however, tells the local stories of Perico and Agramonte.

The cultural syncretism that blends boundaries is not exclusively a Cuban phenomenon. Scholars of West African religious studies have written that these same processes were long ongoing in West Africa itself inside both the Dahomeyan and Yoruba lands and clearly at the moving edges of their shifting borders. Thus, the existence of "pure" African forms is challenging (Brandon 1997 [1993], 9–31; University of Chicago, 2013). Brandon (1997 [1993]) writes that the African religious source traditions are embedded in "continuing processes of accumulation, renewal, discarding, modification, and borrowing [all of which] form a part of [a] religious history about which we know little [regarding] the ongoing manifestation of a basic attitude toward life which is expressed in a variety of ways and a variety of contexts" (11). West Africans of several nations slept beside each other in the *barracones* (slave quarters), worked collectively in the sugarcane fields, and together strove to make sense of what was happening to them. They formed new social identities as they worked out how best to continue their religious beliefs, some with no knowledge of how to give or receive deities, others possessing such knowledge. At a critical historical moment, one filled with as many ruptures as connections, these regional variations and deities came into contact under new and extraordinarily difficult times.

San Lázaro: Herding Cats

It always seemed that the moment clarity around San Lázaro emerged, a new conversation added a new wrinkle. San Lázaro, as most of our interlocutors commented, is the most important deity in today's Arará ceremonies and rituals.[6] San Lázaro is, in fact, one of the few remembered and still-active deities in the Arará pantheon in Perico and Agramonte. According to Brown (2003), a pantheon in Lucumí is a "hierarchical extended family of archetypal spiritual beings" (114). However, as illustrated below, San Lázaro goes by many names.

Babalú Ayé is a Lucumí name for San Lázaro; he is considered the deity of all skin diseases. Bolívar Aróstegui (1994) states that in the New World Babalú Ayé inherited some of the characteristics given to Chopono or Chakpatá, the African deity of smallpox (256). Babalú Ayé dresses in violet and red and is identified with the Catholic parable of San Lázaro. Asojano is an Arará name for San Lázaro, and he shares the same traits as Babalú Ayé. But even here, according to Mason (2020), the names are used fluidly in Lucumí and Arará, although the Arará tend to employ Asojano more often than not. This, he comments, "fits in with a very old tradition that it is dangerous to speak the deity's real name as it calls down pestilence" (e-mail to authors, February 24, 2020).

The name San Lázaro is commonly used as a collective name, despite the many different names or roads (manifestations) of San Lázaro. San Lázaro, who is celebrated on December 17, has many roads dependent upon community practice, his characteristics, or new characteristics added to that road. Some of those roads have distinctly "African" names. For example, Alua is a road of San Lázaro, and this San Lázaro dresses in black and has no feet. Alua belongs to Perico's Sociedad Africana and to Mario José of Agramonte. For each different road, when that deity possesses, the person possessed is dressed and handed objects according to the road of that San Lázaro.

Some African names for San Lázaro have disappeared from active use and are found only in written accounts like Cabrera's *La Laguna Sagrada de San Joaquín* (1993 [1973]). Flanders Crosby has not yet found written documents to support some of the names and roads for San Lázaro that she heard in both Perico and Agramonte. When she asked other "Afro-Cuban" scholars about some of the roads for San Lázaro identified by elders in both fieldsites, they were perplexed.

San Lázaro's pantheon can vary depending upon memory, and local, regional, or specific cabildo. Both Brown and Mason claim that in one pantheon, for example, the deity known as Naná Burukú[7] is the grandmother of San Lázaro (interviews, respectively, November 10, 2017, and October 13, 2017). Meanwhile, in Perico, many claim Naná Burukú is the sister of San Lázaro. Other interviews, with Margarita Fernández Campos (December 17, 2008) and Valentín Santos Carrera (December 18, 2007), identify Naná Burukú as the mother of San Lázaro.

Brown (2003) himself mostly uses the term San Lázaro as a collective for all the potential San Lázaro names in either Lucumí or Arará.[8] Following Brown, we also use San Lázaro as a collective term while embracing the multiplicities using specific names, pantheons, and roads of San Lázaro when given to us by our interlocutors.

Brown's detailed research (2003) focuses on Lucumí. But he also writes about San Lázaro in the city of Matanzas and in La Habana, briefly discussing San Lázaro in Perico by raising local and regional contestations. According to several of Brown's interlocutors, there is a San Lázaro that was created by Perico's Armando Zulueta that he claimed as an Arará San Lázaro. These interlocutors insist that Armando's San Lázaro is not Arará at all, but rather is Lucumí. Furthermore, it is an illegitimate invention, they argue, meant to confer the ability to give and receive San Lázaro for "practical and commercial motives" (Brown 2003, 138). The legitimate Arará San Lázaro, according to several of Brown's interlocutors, descends only from the Cabildo Espíritu Santo Arará Sabalú of the city of Matanzas (Brown 2003, 138–139). For us, sorting out Armando's San Lázaro was a significant challenge. We devote an entire chapter of this book to Armando, but first we discuss him briefly here.

There are differing stories about Armando's San Lázaro. But it is commonly accepted that Armando first received San Lázaro from religious elder Octavia Zulueta of Perico who is remembered as an enslaved African. Community narratives thus identify Armando's San Lázaro from Octavia as Arará due to her probable African origin. Later, however, Armando was consecrated to Lucumí. And here, stories begin to diverge. Several interlocutors in Perico and Agramonte insist that he received a second, but now clearly Lucumí, San Lázaro from his Lucumí godmother, Adela. However, there are other interlocutors who argue that the second San Lázaro in Armando's house, alongside that received from Octavia, belongs to one of

Armando's goddaughters (meaning Armando consecrated her into the worship of a deity). This story is also known to Mason, who interviewed Armando's niece Aurora. Regardless, after his Lucumí consecration, Armando modified the giving of San Lázaro to new initiates. As a result, while Armando claimed his San Lázaros were Arará, others argue the deity is a new Lucumí San Lázaro.

Furthermore, both Armando's San Lázaro fundamento from Octavia as well as Octavia's own are in an open *cazuela* (a specific container for many fundamentos, often with a bottom and a lid; for San Lázaro, this is known as *yarara*). What this means is that since the form of San Lázaro has two pieces, one serving as a lid to the other, the lid may be easily lifted to see what it contains inside. The contested cazuela that he received from Adela (or that belongs to one of his goddaughters) is open and contains seven stones. (Octavia's contains only five.) The modified San Lázaro he gave to new initiates was also open and contained seven stones. But he always gave a new San Lázaro with Octavia's Arará San Lázaro present. Thus, he argued, his San Lázaro was Arará. The argument from the Cabildo Espíritu Santo Arará Sabalú that Armando's San Lázaro is Lucumí rests on the fact that the "legitimate" Arará San Lázaro, they claim, imbues a sealed cazuela from which the lid cannot be lifted (Brown 2003, 138–139). An open San Lázaro, Mason informed Flanders Crosby, particularly one that has seven stones inside, means that the form is Lucumí (interview, October 13, 2017).[9]

Mason's point, he argues, brings up the argument of form versus origin (interview, October 13, 2017). If one accepts the argument of Cabildo Espíritu Santo Arará Sabalú, then the form of Armando's San Lázaro indicates that it is Lucumí. But the origin story with Octavia indicates at least that his San Lázaro from her is Arará. Interestingly, Hilda Zulueta is adamant that the San Lázaro in Perico is the "original" because theirs are not sealed; "because Africans brought it like that" ("porque los africanos los trajeron así," interview, December 20, 2007). At the time Armando was initiated into Lucumí, there were emerging regional contestations, as Lucumí was going through significant changes in practice and modernization, and various houses sought to claim authority for their religious efficacy (Brown 2003, 138–139). As Armando was situated inside these regional power plays and the interface between tradition and modernity, it is not surprising contestations arose.

Folds within the Interface

As stated in the book's introduction, even the general term "Afro-Cuban" ritual traditions can be considered a construction of scholars who chased down and "evidenced" African "retentions" (Palmié 2005, 2013). In Cuba, distinct expressions arose, including Arará, Lucumí/Santería, Palo Monte, and Abakuá. In early scholarship, it was commonly understood that among these practices, Lucumí has a syncretistic relationship with Catholicism. Syncretic narratives, however, bleed across these "Afro-Cuban" ritual traditions.

Particularly relevant in Palmié's work is the term "ethnographic interface" (2013, 262), relating specifically to the unique relationship that developed between ethnographers and "Afro-Cuban" ritual practitioners. This interface is presented as a porous membrane resulting in "ethnographic scholarship [that] gets inscribed on religious practice" while at the same time practitioners inscribe back on ethnographic scholarship. This is particularly relevant as ethnographers are initiated into Lucumí, and as practitioners become ethnographic scholars, thus blurring the line between practitioner and ethnographer. This produces a dialogic and circulatory pattern that is ultimately "cooked by history" (University of Chicago 2013).

Palmié argues that syncretism is an artifact that scholars have brought into the world via this ethnographic interface (University of Chicago 2013). Other scholars weigh in on the term syncretism and offer further possibilities for a replacement term: fusion, concentration, reconstitution, reorganization, reworking, joining, and creolization (Brandon 1997 [1993], 2, 9; Brown 2003, 115; Dodson 2004). Mason likes the term "African-inspired" (e-mail to authors, December 28, 2017). Given the above discussion of Arará concerning collapsing, folding, and enfolding, all these terms are particularly relevant to what we have heard throughout our many interviews. But there is no doubt that we often encountered West Africa in Cuba. That left us to navigate the permeability and historical construction of the ethnographic interface in the field. Were we authoring our own data and inscribing it on Arará religious practice in Perico and Agramonte?

Conclusion

Those in Perico and Agramonte are the ones who offered stories that frequently included Africa. Captured in their memory and narrative my-

thology, Africa remains relevant and emergent. They want to keep "their" traditions alive; they want others outside of their communities to know their stories, and they do not seem concerned by arguments of African retentions, the term "Afro-Cuban" religion, or even whether Armando's San Lázaro is Arará or Lucumí. They perform their history with passion, and perhaps that is the point in telling their stories beside those of Africa.

In the West African communities where Flanders Crosby conducted fieldwork, Sakpata, also known as Togbui Anyigbato, appears "to walk the same road" as San Lázaro. To state it plainly if a bit reductively, it is through Sakpata, Togbui Anyigbato, and San Lázaro that resemblances were found and conversations were initiated by and between the Cuban and West African interlocutors. In her West African fieldsites, Flanders Crosby did not encounter the types of controversies discussed above— but then, the package was different in so many ways. Those currently in West Africa were not the ones ripped away from their homeland. Their lineage from their elders and religious practices, while of course constantly in flux, did not suffer the same degree of rupture. They did not have to rebuild the way the enslaved West Africans in Cuba had to rebuild. This is not to say that colonialism and inter-ethnic or neighboring wars did not cause loss and rupture, and thus affect memories, stories, and religious practice in West Africa. Rather, the ruptures she can still sense in Cuba (through artifacts, stories, and sacred locations) appear to be more violent.

West Africans were stolen from their homes, suffered unimaginable ill treatment, and witnessed others' deaths. Arriving in a foreign land, they were sold into forced labor and stripped of their very identities. In the barracones, they were crammed next to strangers, some with different languages or different dialects of common languages, and different ways of worshiping, trying to make sense of it all by finding some road back to the very deities that promised protection. Histories and identities became entangled in complex collective memories that survived through creativity and preservation. As Halbwachs (1980) explains, "[T]he reason members of a group remain united, even after scattering and finding nothing in their new physical surroundings to recall the home they have left, is that they think of the old home and its layout" (128). As Brown states, "the 'Afro-Cuban' religions today owe their existence to a history of gains from hard-won struggles, not passive 'survivals,' where their resiliency is owed

as much to innovative transformations wrought on New World Soil as to their maintenance or preservation of 'pure' African traditions" (5–6).

Despite the physical differences of the new region, the displaced tell stories of the old home as a means of surviving in the new one. Considering this existential imperative of storytelling, we keep in mind the questions Palmié put to us: "Are they good stories? And even more importantly, what's the point in sharing them?" (e-mail message to authors, October 8, 2017).

Notes

1. According to Brandon (1997 [1993]) it is not clear whether the slave traders borrowed this term from the enslaved or the slave traders began to use it in the same way the Yorubans were starting to refer to themselves (56). Cuban scholar Jesús Guanche (1996) states the term may have derived during the slave trade from an old coastal factory named Ulkami or Ulkumi (51). Lucumí is a term applied when referring to the Yoruba religion practiced in Cuba, which is also known as Santería.

2. Yoruba deity who owns thunderbolts and winds. She guards the gate of the cemetery and carries all colors but black. In Matanzas, Oyá is identified with Santa Teresa de Jesús, who is celebrated on October 15. According to Midialis Angarica Galarraga, Allegue is the name given to the Arará Oyá, while Andreu Alonso (1997) writes, "Dañé is to the Arará the lady of lightning bolts, winds and storms. She is the Oyá Yansá of the Yoruba" (38).

3. Cabildos acted as mutual-aid societies dedicated to important entities that kept alive various religious traditions. This term has been applied to heterogenous African and creole organizations, from informal social clubs to the cabildos de nación (López Valdés as cited in Brown 2003, 63). Cabildos de nación were registered organizations of slave membership linked to a church as official cofradías (brotherhoods) under a saint's patronage. Many of these associations still existed in the 20th century and, according to López Valdés (in Brown 2003, 63), they constituted the starting point for some modern Lucumí religious institutions.

4. In an e-mail message to the authors (December 27, 2017), Michael Atwood Mason told us that some deities are buried with their owners while many are dispatched to a river.

5. Changó is the Yoruba name of the deity of thunderbolts, music, and virility. He was the fourth Alafin (king) of Oyó. In the Arará tradition he is known as Hevioso and shares the traits of his Yoruba counterpart. His colors are red and white, and he is associated with Santa Bárbara, who is celebrated on December 4. Brice Sogbossi (1998) argues Hevioso is a deity incorporated into the Fon temple. Hevioso came from Yoruba land bearing the name of Changó (42).

6. Midialis Angarica Galarraga would object. For her, Malé is more important than San Lázaro. In Perico, Malé represents the Arará rainbow serpent, the husband of Juerdase. Andreu Alonso (1997) compares him to the Oddúa, Odudúa, or Odduwa of the Yo-

ruba (first king of Oyó and founder of the dynasty of Benin and Oyó), and adds that he is a force of the underworld identified with the Catholic santo San Manuel (Immanuel, the sacred name of Jesus, celebrated on January 1). Midialis cites as a source for this information Oscar Rodríguez, the former president of the Matanzas Yoruba Association in the city of Matanzas. He was in charge of all the casa-templos (religious houses) in Matanzas Province. Midialis did not tell us why Rodríguez made that claim.

7. Naná Burukú is a complex deity. It can be Lucumí or Arará. Generally, Nana Burukú is seen as a *majá* (snake), is female, and is a relative of San Lázaro, from grandmother to sister. Bolívar Aróstegui (1994, 252) states that for the Arará, Naná is either considered the mother of Babalú Ayé or one of his paths. Among the Yoruba she is considered the mother of god and grandmother of all Obatalás. She may be male or female. Naná's colors are white, red, and blue. She is associated with the Catholic Santa Ana, the mother of the Virgin Mary, who is celebrated on July 26. Andreu Alonso (1997, 49) argues Naná is a riverine deity, sister of San Lázaro, and he identifies her with Santa Marta.

8. The many San Lázaro names we have heard are: Asumayayá, Adosumayayá, Acrojonú, Danagosi, Nanú, Ananú, Afimaye Camaye, Adasoyi, Alepretre, Asojuano, Obarara, Dai, Edogueño, Daidawedo—all as spelled by Núñez Isalbe from our oral history interviews.

9. It is noteworthy that in Agramonte, Arará San Lázaros are also open rather than sealed. However, they are sealed in nearby Jovellanos.

3

Perico and Agramonte

Sensorial Stories

JILL FLANDERS CROSBY

Macusa's Story

I remember turning my head for an instant while winding down my recording of an arranged music and dance event one afternoon at Prieto Angarica Diago's house (Sociedad Africana). It was 1999, my first year of coming to know the Perico community. By the time I turned back, someone was possessed and crawling on the floor out to the ceiba tree behind Prieto's house. Ceiba trees, considered sacred, were chosen above other trees by the Ararás because it reminded them of the cotton tree of Benin (Brice Sogbossi 1998, 43). *Orichas* (deities) live inside ceibas (Loko in Fon), along with *egguns* (dead spirits) and the spirits of different ancestors.

At the base of the tree in Prieto's yard was a Palo (Monte) *prenda* belonging to Prieto's father. Palo's associated prendas are typically made from iron cauldrons and are imbued with supernatural forces.[1] This particular prenda behind Prieto's house was for Siete Rayos, a Palo *muerto* and the Palo equivalent of the Lucumí Changó and the Arará Hevioso.

I would learn years later that the person in trance was Hilda "Macusa" Zulueta Dueñas (hereafter Macusa), and that she simply arrived from off the street at Prieto's already in trance with Siete Rayos at the tail end of my staged recording.

A little more than ten years later, at a ceremony at Reinaldo Robinson's house, once again, in will come Macusa already in trance with Siete Rayos. It was then that I realized that only I saw her peculiar entrances as unusual.

The community, unlike myself, was well aware that Macusa had received an unusual "remembrance" from Cheo Changó years ago when she was a young girl. I had heard vague rumblings about this story, but I remained unaware of its significance. This night, I finally clued in that there was more to know. I began to track Macusa's story deeply through interviews with Macusa herself, and with her sister Guyito Zulueta Zulueta.

According to Guyito, *babalawos* in La Habana foretold Macusa's "remembrance" before it actually happened. Babalawos, initiated members of the Lucumí Ifá system whose guardian deity is the divination god Orula or Orunmila, use the *tablero de Ifá* (Ifá board), ikines or ekines (palm nuts), or the ékuele, a chain with eight pieces of dried coconut or turtle shell, to divine. During this particular gathering, both Macusa and her grandfather, Justo Zulueta, were mentioned. Typically, these types of babalawo gatherings consist of evaluating the well-being, status, and role of community members. Macusa, they said, had a tendency to be a partygoer rather than taking religion seriously. The babalawos then mentioned a "remembrance" that would manifest itself in Macusa when Justo passed away.

Some years later, Cheo Changó (formally known as José Gerardo de las Mercedes Cabrera y Zayas) was in Perico when his good friend Justo was on his deathbed. Cheo also had a Palo muerto Siete Rayos, specifically known as Siete Rayos Punto Firme. Once Cheo arrived at Justo's, he fell into trance with his Siete Rayos and sent for Macusa and her mother. According to Macusa's sister Guyito, when they "arrived at my grandfather's, that was something worth seeing . . . it was a confirmation of the message [the babalawos] sent" ("y desde que entró por aquella la puerta aquello fue grande, grande, grande hasta el momento . . . se confirmó lo que dijeron, el mensaje," Guyito Zulueta Zulueta, interview, December 28, 2015).

Macusa remembers that it seemed as if Justo had been waiting for something or someone. Cheo first spoke to Justo and then he spoke with Macusa's mother. As Macusa tells it, Cheo said to her mother, "I'll leave you a small piece, but big enough for as long as you live. I'll leave you with a huge remembrance" ("yo a ti te voy a dejar un gajito, pero muy grande para mientras que tú vivas. Te voy a dejar un recuerdo muy grande, muy grande"). And according to Macusa, at the moment when Justo died, she fell into trance with Siete Rayos. And thus, "y bueno . . . gran recuerdo" ("and well . . . what a remembrance," interview, December 18, 2007).

Ever since then, Siete Rayos will "catch" her ("él me coge") at any moment,

even while doing ordinary activities. Macusa may show up during ceremonies, at events, or in locations around town in trance even though, as Macusa put it, she is not consecrated to anything. "Yo no tengo hecho nada."

One time, Siete Rayos "caught" Macusa and she crawled from one street corner to her cousin Hilda Zulueta's house. "Parece que él estaba limpiando la calle," Macusa said. "It was as if Siete Rayos was cleaning the street."

After Macusa's possession that first night at Prieto's in 1999, a spontaneous ceremony erupted. The rhythms of the sacred drums of Sociedad Africana could not be silenced. Soon we were at least twenty inside a small, cramped room, standing shoulder to shoulder and collectively singing and dancing. Rhythms came from everywhere: from palms beating on dresser drawers, on bodies, or from clapping while songs rang out with immediacy. Cigar smoke permeated the room and Cuban rum was poured in discreet amounts but shared freely. I remember dancing with abandon beside my friend Olivia until I suddenly realized that she was going into trance. I stepped back to watch. The rest of the room also sensed the imminent mounting, and they paid Olivia special attention by singing louder and dancing with more emphasis in her direction, encouraging the possession. The room was electric.

At approximately two in the morning, after the impromptu religious drumming evolved into a social rumba, the evening came to a close. My companions and I climbed into the little Lada that would carry us two-plus hours up the lonely stretch of the *autopista* back to La Habana. The autopista, a six-lane highway (three in each direction), fell into a state of neglect after the revolution. It is not lit; it is filled with potholes; and much of the surface consists of ruined sections of concrete. The majority of the autopista has few to no services along the way to La Habana, and few cars travel it after dark.

Two people that night needed a ride to their house up the local road just outside of Perico. Four of us would sit in the tiny backseat—barely big enough for three—for about ten minutes. Right before squeezing into the back myself, I looked up at the sky and distinctly remember seeing stars that were so bright and so close, they kissed my face.

Sensorial Threads, African Connections

This was the moment when Perico shifted from merely a place to gather data to a living, breathing, and performative space imbued with evoca-

tive history. What began as a journey to research Arará dance and music in Perico evolved in a new direction: a focus on oral histories. From all these stories in both Perico and, later, nearby Agramonte emerged the insistence that not only is Arará in each individual community the "original" or "first" Arará, but that Africa is proudly its source. Elders in both communities who are great-grandchildren of former enslaved Africans speak with determination and love of the stories of their African elders who were tricked into climbing onto a slave ship, or speak proudly of relatives who brought their drums, deities, and/or *collares* (sacred necklaces)[2] of their deities "directly" from Africa. Their West African roots are foundational to their identities as Cubans in their communities, where the Arará danced ritual practice is still remembered and enacted.

Significantly, these African elders contributed sacred objects, altars, corresponding *fundamentos* and rituals that are maintained by their relatives and the community. As well, old photographs of these African elders and their immediate descendants are lovingly maintained, hang in prominent positions on walls, and are sometimes embedded in the altars themselves. These pictures spoke words and brought to life elders who passed on a deep sense of roots from Africa to the generations that followed. These early elders started religious *cabildos, casas de santo, casas de fundamento,* or *casa-templos* (all religious-based houses of varying levels, depending upon historical timeline, function, or official registration in the city of Matanzas) where old fundamentos are still housed.[3] Time has dealt different fates to these casas. For some, religious significance has slipped into distant memory, while others remain robust. Regardless, all remain embedded in the fabric of Arará history in each community.

Centrales and Lagunas

In Perico and Agramonte, common histories include nearby and mostly abandoned sugar *centrales* where the African ancestors were enslaved.[4] The centrales are associated with nearby sacred *lagunas,* sometimes known as *ojos de agua,* which are "natural ponds that gather and hold rainwater during the wet season and slowly evaporate" (Mason 2011b). These lagunas are imbued with their own repository of stories, and ritual ceremonies took place at their watery edges.

Associated with Perico is central España Republicana (its name since

Figure 3.1. At the ojo de agua at España Republicana. Luis Doubuchet purifies the space with cigar smoke. Photo by Brian Jeffery.

1960) and its nearby laguna, both about five kilometers outside Perico on the road to Cárdenas. España's laguna is within view of the skeletal remains of the mill; the batey (community) surrounding the former central is also called España Republicana. After emancipation, however, many of the once-enslaved Africans relocated from España to Perico.

In the shadow of central España is an abandoned and covered well where, according to Hilda Zulueta, ceremonies once took place and the well was "fed" with the blood of a sacrificed animal every year before the sugar harvest. Justo, along with "los santeros viejos africanos," were all in charge of feeding the well. Not only were drums played during feeding, but in that well lived a huge serpent. In later years, laments Hilda, the well was sealed and forgotten about.

One year, a plane that came to check one of the mill pumps "fell" ("se cayó un avion ahí") because the sacred being that once lived in the well ("lo sagrado que había allí") was no longer being fed.[5] This sealed well is the reason, Hilda argues, why so many strange things started happening in

Figure 3.2. *Hilda Victoria Zulueta. Ahi Vive Aggidday* (2010). Illuminated manuscript by Susan Matthews. Sumi ink, metal leaf, and watercolor on paper, 17" x 22". By permission of Susan Matthews.

España. As with many things, not participating in regular acts of remembrance can lead to havoc.

Agramonte is located about a twenty-five-minute drive from Perico, and its central, Unión-Fernández,[6] is located three kilometers NW of town. Its surrounding batey is known as Unión de Fernández, but, unlike central España, very little can be seen of the original central. It is largely in ruins and overrun by weeds, and its associated laguna, Ramona, is a greater distance away from the central than España's. Like España, there are dramatic stories about Unión-Fernández and laguna Ramona. Here, enslaved people would run away to hide in caves tucked into a rock face, and many important ritual ceremonies were held. "There is such a strong history that no one wants to go there" ("Hay una historia muy fuerte allí de que nadie quiere ir," Mario José Abreu Díaz, interview, December 31, 2007).

Once, elders recount, a middle-aged man went to the ojo de agua, threw himself in, and disappeared. Religious leaders went to la laguna with drums, to sing and chant prayers at its edge. As the singing continued, the water began to part, and suddenly, the man surfaced. Elders told him that he could not reveal what he had seen in the depths of the ojo. It seems that one must always keep silent about what is seen in the underworld. Revealing what is seen could lead to the deities keeping you there.

Related to Agramonte (and closely associated with the nearby community of Jovellanos) is the still-functioning mill once known as Santa Rita Baró, now known as René Fraga, located eleven kilometers east of Agramonte. During our visit to René Fraga in May 2017, several workers (and a nearby resident of its batey) told us that during the past year Fraga's administrator had not honored the formerly unbroken tradition of walking a goat around the interior of the mill before offering it as a sacrifice for a successful sugar harvest. Thus, that year, once again in apparent consequence of not participating in acts of remembrance, the harvest yielded next to nothing.

Laguna Sagrada

Located outside the town of Pedro Betancourt, a forty-five-minute drive from Agramonte, la laguna sagrada de San Joaquín de Ibáñez (the sacred lagoon of San Joaquín of Ibáñez) plays a part in some stories to follow. Fieldwork did not focus on this laguna and Pedro Betancourt's abandoned sugar mill, once known as central Cuba but renamed Cuba Libre in 1960.

Figure 3.3. Josefina Tarafa. Image from Lydia Cabrera Papers, Cuban Heritage Collection, University of Miami Libraries, Coral Gables, Florida.

As of 2018, it had been dismantled. Still, Cuba Libre retains a close connection to Justo Zulueta through the former administrator and eventual owner (along with her brothers), Josefina Tarafa de Armas. Josefina's family also owned central España. Not only did Josefina spend a great deal of time with Justo, but she contributed an important sacred object to his altar.

Josefina worked alongside Lydia Cabrera investigating "Afro-Cuban" religions in and close to the places where I (Flanders Crosby) spent time. According to Ramón Adair "Pupy" González Díaz, Josefina accompanied Lydia as a photographer in the winter of 1956 when Lydia made her historic recordings of religious music at la laguna sagrada de San Joaquín de Ibáñez near Pedro Betancourt. Pupy still lives in the shadow of Cuba Libre, around the corner from the ruins of Josefina's house. He liked to describe the magnificent trees Josefina planted.

I once asked Pupy why he held on so strongly to Josefina and her memory. He immediately grabbed me by the hand and led me forcefully behind him outside of his house and down the sidewalk, where he insisted I gaze on what was left of Josefina's trees, which she had collected from around the world. Now, only two trees remain, both from Madagascar. His conviction regarding her contributions to the well-being of the area around Cuba Libre and her dedication to knowing more about local religions was clearly evident in his determined body language and the passion in his voice.

In May 2017, myself, Torres, Susan Matthews, Melba Núñez Isalbe, Melba's husband Miguel A. Parera (our driver), and two of my students from the University of Alaska Anchorage walked to la laguna sagrada de San Joaquín de Ibáñez. Just one year prior, ceremonies had been revived after a gap of fifty-plus years, and we were on our way to observe one. While not a deeply religious event, it was an interesting collage of sensorial information. Here we were in a rented Audi, followed by horse-drawn carriages and people on foot. There were obvious class differences among those joining together on this tree-lined walk. We were expecting to brush up against the sacred, the magic, the authentically spiritual, as were the Cuban organizers of the event, one of whom was Pupy. But others had quite different expectations. People began selling alcohol. Others danced as if they were at a nightclub and not a ceremony. The spring was dry. A sacred ritual, which had seemed so close at the entrance to la laguna just moments ago, became a distant memory.

What does it mean for history to return to its spaces? So much effort and hope had been put into returning to this sacred spot, the site of an important story, but the actual return was a radical contrast with the history. Whose experience is authentic? The researcher's disappointment—in this case, both local Cuban and foreign researchers—the beer seller's profit, the foreign students' awe, the teenager's fun, the practitioner's compromise? All of these different meanings come from the relationship with this space. The point was to interact with la laguna so as to evoke its cultural memory. The spring, while dry, still became a source of life—just not in ways that can be easily recognized.

Something sacred did happen, depending on what one calls "sacred." We walked in Josefina's footsteps. Josefina, Justo, and their collective histories were deeply felt that day. However, despite the sensorial experience of a community reviving a sacred past, Josefina remains an elusive figure.

Although she has a strong connection to Justo, and her family were the last owners of central España before the revolution,[7] few we talked to in Perico other than Reinaldo knew much about her.

Conclusion

About halfway through this research project, an image developed to explain my insistence that the research team record as much as we could about the Arará religious histories in Perico and Agramonte and that we be sure to "do something with it." Justo was behind me, with his hand firmly on my back, pushing me through a door held open by Hilda, who, like Macusa and Guyito, is one of Justo's granddaughters. On the other side of that door was an ambiguous white space, a shaft of sunlight that beamed out emergent possibilities.

If I dared to step through the door, I would enter a gleaming portal radiating the histories of those who had created a new life filled with resilience,

Figure 3.4. Felipa's Afrás. The fundamento imbued with Sowebi (white ceramic) is front left, back left (with water) is the fundamento imbued with Cuvi, and back right (with water) is the fundamento imbued with Afrá. Photo by Miguel A. Parera.

embodied performance, and the tenacity to hang on to "African" roots. This image is especially relevant to Hilda. As a daughter of Eleggua, Hilda was consecrated in her Aunt Felipa's house, at the feet of Felipa's Arará fundamentos for Eleggua: Cuvi (also called Cuvijerganza or Cuvijergán),[8] Afrá (also called Tocuo Yeyino Babajureco), and Sowebi.

Eleggua, a Yoruba deity, whose colors are black and red, keeps and owns all roads and paths. Eleggua is the first of the four *Guerreros* (warriors), together with Oggún, Ochosi, and Osún. He is usually linked to Echu, who represents the unrestrained or "negative" side of a figure called Echu-Eleggua. This is why every Eleggua and Echu carries a special compound name. Eleggua, the restrained and tamed side, lives inside the house and keeps everything in order, while Echu lives in the street and can never enter the house due to his untamed and unrestrained nature (Mason 2016, 12–13).

Just like his Yoruba counterpart, Afrá must be appeased first and treated with utmost respect; his colors are also black and red.[9] Sowebi is Afrá's wife. The Arará or Lucumí "Eleggua" is known for the ability to open doors and make all things possible. The door has also become a symbol for the responsibility to tell the stories.

"Are they good stories?"

I think so.

Notes

1. Palo Monte came to Cuba from the basin of the Congo River in Africa. Divided into three main branches, Mayombe, Briyumba, and the Regla Kimbisa del Santo Cristo del Buen Viaje, its practitioners believe Nsambi (also Nzambi, Zambia, or Nsambia) is the substance or universal spirit that governs the world. This force or spirit has the quality of taking any form, be it human, animal, or mineral. A prenda constitutes the material representation imbued with these forces (Fernández Martínez 2005, 60–61).

2. Collares, largely used in Lucumí, are made from strung glass beads usually called *matipós*. Classified into three types, the first is the single-string necklace with beads in specific shapes and colors, with a mandatory number related to the different deities. This is used as a daily accessory. The second type, seldom used daily, is a double string made out of two parallel strings divided into sections by a larger bead called *gloria* (glory). The third type, used in ceremonies, is the bunch necklace, clusters of bead strands joined into sections by glorias, or special beads. Older collares were sometimes made from objects like seeds, beads, and cowries, as evidenced in those of Ma Gose of Agramonte (Domínguez 2016, 31).

3. A cabildo may be called a casa-templo when it is specifically registered as such in the city of Matanzas. Often, if a house is not officially registered, it might still be called

a casa-templo, casa de santo, or casa de fundamento. These names are sometimes used interchangeably. What is most important, however, is the community's recognition.

4. The *barracones* can still be found at many of these existing or abandoned mill sites. Some are abandoned; some have tenants, but have had little work done to modernize them. Others have been modernized for current living conditions, as is the case in España Republicana.

5. At this same well, Hilda further commented, one could see a statue of Christ, but since the revolution, Christ is no longer there. Exactly what she meant by this comment remains unclear, because the statue of Christ can still be found inside the church grounds located close to the abandoned central España. This is depicted in Matthews's illuminated manuscript in this chapter.

6. Perret Ballester (2008 [2007], 190) names this central as Unión-Fernández, with a hyphen, whereas several interlocutors call the central Unión de Fernández. We have chosen to adhere to Perret Ballester's rendering.

7. In addition to the mills España Republicana and Cuba, the Tarafas also owned Santo Domingo, Flora, and Saratoga. See Perret Ballester 2008 (2007).

8. To "receive" a deity "at the feet" of an elder's deity or fundamento means to receive the deity in the home of an elder where an Arará fundamento still lives. Felipa's Arará Eleggua was the last Arará Eleggua in Perico (Hilda Zulueta, interview, December 20, 2007). According to Macusa Zulueta Dueñas, Cuvijergán is the name of one of the Afrás that lives in the small shed outside her house. Her house once belonged to Felipa Zulueta, who was sister to Justo Zulueta.

9. Most Afrás encountered in Perico live outside the house, and at least one of the two that are always together eats raw food. Brice Sogbossi (1998) adds this may be due to the fact that Afrá is the equivalent of the Yoruba Echu, an untamed nature of Jurajó, the Arará Eleggua (36). According to Bolívar Aróstegui (1994, 34) and Rivero Glean (2011, 61), Afrá and Eleggua are associated with various Catholic santos: San Antonio de Padua, San Martín de Porres, El niño de Atocha (Antioquía), and San Pedro. In Matanzas, Afrá is mostly identified with San Pedro, who is celebrated on June 29; but in Perico he is associated with San Antonio de Padua, who is celebrated on June 13.

4

Perico

JILL FLANDERS CROSBY AND MELBA NÚÑEZ ISALBE

At the northern edge of Perico, sugarcane fields that once belonged to central España meet the ends of streets. But there is a place where the cane fields swallow a street servicing the last homes on that block as it transitions into a dirt road that disappears into tall sugarcane, headed towards España and the sacred location known as Ducaqué. Legend recounts that Ducaqué still receives the annual *awán* basket (a religiously significant basket for a San Lázaro cleansing) every December 18. From this edge of Perico, the twin chimney towers of central España rise impossibly high in the sky, reminding the town of its history.

At Ducaqué, we took our last photo of Hilda Zulueta before she passed away on August 12, 2008. Hilda, often our eager companion, guided us to homes and locations important to Perico's history, including España. Over the ten years we spent in Perico before she died, our relationship with Hilda as a daughter of Eleggua came to embody the entire research process. She opened the doors, clearing the way for us to enter unthinkable worlds.[1]

Perico, located in Matanzas Province, Perico municipality, was founded through a process beginning in 1845. Wanting to connect important regional sugar areas with the nearby town of Cárdenas, the Empresa de Ferrocarriles de Cárdenas (Railroad Company of Cárdenas) built critical spurs extending westward from its main line (Ágara Sánchez 2017, 5). When the company acquired a plot of land in the Perico area, it commenced construction on a railroad station (Gutiérrez Machín and Calderín Kindelán n.d.).

According to Andreu Alonso (1997, 13) and many people we interviewed, the majority of those enslaved at España arrived from West Africa and the

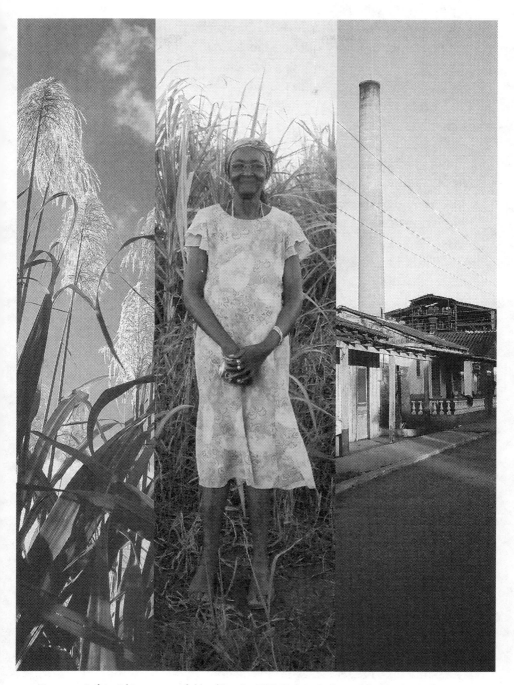

Figure 4.1. *Left to right*: sugarcane fields of España, Hilda Zulueta in front of the location in the sugarcane fields known as Ducaqué, and España Republicana in 2006. Photos by Jill Flanders Crosby.

former "Kingdom of Dahomey." (This same belief is true in Agramonte.) The first Arará settlement in the immediate area was registered in 1861 (Gutiérrez Machín and Calderín Kindelán n.d.); Andreu Alonso, however, gives 1863 as the date of the first Arará settlement (16), while Perret Ballester (2008 [2007]) gives 1863 as the date when central España was founded by Julián de Zulueta y Amondo. It is likely that the first Arará arrived enslaved and began working the fields in 1861, before España was officially registered upon production of its first sugar harvest in 1863. After emancipation in 1886, the Zulueta y Amondo family began to construct homes on the current site of Perico for formerly enslaved Africans and their families (Reinaldo Robinson, interview, January 15, 2006).

Scattered across the Perico township, several religious casas remain active and well-known, each with old and important fundamentos and altars. Two casas in particular are officially registered as casa-templos in the city of Matanzas, the provincial capital of Matanzas Province. These two casa-templos are Sociedad Africana, founded by Ma Florentina, and Justo Zulueta's Sociedad Virgen de las Mercedes. These sites are important to Perico's Arará religious history, and are illuminated in the choreographed narratives that follow.

Ma Florentina—Princesa Dahomeyana

As well-known as Ma Florentina is—along with her *cabildo,* eventually known as Sociedad Africana—information about both remains cloudy. We do not know for sure whether any type of a *sociedad* was started in España before the formerly enslaved relocated to Perico. But it would seem likely that if a sociedad had not yet been fully formed, key religious leaders were already emerging. According to Andreu Alonso (1997, 21), la Sociedad Africana was headed by Ma Florentina, while Vinueza (1988 [1986]) adds the name of Ta Facundo[2] as one of the founders based on her 1981 interview with Victoria Zulueta, who was raised by Ma Florentina (45). Midialis Angarica Galarraga, great-granddaughter of Victoria, says that Ta Facundo was merely Ma Florentina's support. Reinaldo Robinson always included a woman named María Virginia as a cofounder of la Sociedad Africana with Ma Florentina, but few other than Reinaldo and Valentín Santos Carrera ever mentioned her.

Because cabildos were required to be formed under the "protection" of a

Catholic saint after emancipation (Ortiz 1984 [1921], 22), Sociedad Africana was first established under the protection of Our Lady of Mercy (Nuestra Señora de las Mercedes) in 1887 (Andreu Alonso 1997, 21). However, Vinueza (1988 [1986]) states that she could not find any official documents attesting to this date (44). Thus, Vinueza conducted interviews with Victoria, who set the date only as in the 20th century (1988 [1986], 44). It was not until 1959 that its name changed to Sociedad Africana Santa Bárbara (Midialis Angarica Galarraga, interview, January 3, 2018). Midialis learned from Victoria that Ma Florentina did not acquire her formal property paperwork until 1918. However, Midialis states that Ma Florentina was living there much earlier, and when she passed away in 1923, her Perico property went to Victoria.

According to an interview with Victoria by Vinueza (1988 [1986]), Ma Florentina was born in West Africa, in Lucumí land, and later went to live in Dahomeyan land (35). A former Dahomeyan princess called Tolo-Ño (in Lucumí territory) and Na-Tegué (in Dahomeyan territory), she was captured and brought to central España to work under Don Julián de Zulueta y Amondo around the 1860s (Andreu Alonso 1997, 14–17). An official document known as the Baptismal Act from the Catholic church of Perico San Miguel Arcángel, now located in Perico's Municipal Museum (Museo Municipal de Perico Constantino Barredo Guerra), gives Ma Florentina's age as 17 years old when she was baptized in 1863 in Cuba. This suggests that this was the same year she arrived enslaved. However, Andreu Alonso (1997) writes that she was branded at age 15 in Africa before she began her journey across the sea (15). It is also possible she arrived as early as 1861 but was not baptized until 1863. Because enslaved Africans received the last name of their owners, she was called Florentina Zulueta (Andreu Alonso 1997, 17). Interestingly, Andreu Alonso states that Ma Florentina died in 1933 at 105 years old (1997, 43). That would actually make her birthdate 1828, placing her at age 17 in 1845 rather than 1861 or 1863. Midialis suggests that her real age was not known when she arrived in the Perico area in either 1861 or 1863, for Ma Florentina could not speak Spanish. "How would anyone know?" Midialis asked us. She is adamant that Ma Florentina died in 1933 at age 105. Thus, the mystery of her true age and arrival in Cuba produce altering stories.

According to elders, la Sociedad Africana was the heart and soul of Arará in Perico, functioning as a collective aid society and as a center for religious

activities. Oral history narrates how early members literally lived together and collectively housed their individual fundamentos under la Sociedad Africana's roof. Oral history also recounts that it was Ma Florentina (and some add María Virginia) who "gave" the fundamentos to those housed in la Sociedad Africana.[3] When each member eventually moved to a house of his or her own, some took their fundamentos with them. Fundamentos that were left behind with Ma Florentina were eventually distributed after her death by Victoria. Ma Florentina's own fundamentos of San Lázaro and an Arará Hevioso remain in her house today, along with those that belonged to deceased godchildren of the house, other members of the family, or religious practitioners outside of, but important to, the family.

Prominently placed outside the house at the front of Ma Florentina's side yard are her two Afrá fundamentos, along with a third fundamento known as Chacho Cuacutorio, which includes a combination of Jundajó (Eleggua) and Aggidai. According to Midialis (interview, May 21, 2017), Cuacutorio represents the Guerreros (warriors) of Lucumí. Furthermore, Aggidai is considered a messenger from Dasoyi (San Lázaro), who is related to Ochosi, the archer and hunter and one of the four Guerreros.[4]

Figure 4.2. Ma Florentina's fundamento imbued with San Lázaro. Photo by Miguel A. Parera.

Figure 4.3. Ma Florentina's fundamento imbued with Hevioso. Photo by Miguel A. Parera.

However, according to Andreu Alonso (1997, 20), Aggidai is actually one of Dasoyi's avatars. It is interesting to note that the spelling of Dasoyi bears a resemblance to that of Da, which in Ewe means snake or serpent, and is also a Vodu deity. Frequently in Perico it was suggested that San Lázaro and a *majá* (snake or serpent) have a close relationship with each other; sometimes they are even one and the same, as some roads of San Lázaro are that

of a majá. According to Mason's blog entry (2013), Dasoyi is considered the father of Babalú Ayé.

Oral history legend recounts that these three fundamentos are "from Africa." Exactly what that means is fluid. Some think it is literally true that the objects came from Africa. Since Ma Florentina was a princess, they argue, she was therefore allowed to bring her objects with her. Others understand that it was the memory of African objects that guided Ma Florentina to make new ones.

Oral history legend also recounts that Ma Florentina's drums came from Africa, with the same reasoning. This widely held belief is partially based on a story Prieto Angarica Diago told us about carpenters who came to Perico from La Habana's Conjunto Folklórico Nacional de Cuba (the National Folkloric Company of Cuba) and who could not determine the wood used to make the drums.

"No se hicieron aquí en Cuba," Prieto, Victoria's grandson, told us. They were not made in Cuba. After telling us this same story for several years, he finally declared that the drums were made in Cárdenas.

There is yet another story that the drums belonged to a man named

Figure 4.4. Ma Florentina's fundamentos imbued with Afrá. When fed, the Afrá in back takes raw meat, the one in front takes blood and honey. Photo by Miguel A. Parera.

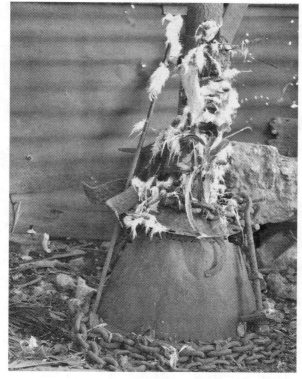

Figure 4.5. Ma Florentina's fundamento imbued with Chacho Cuacutorio. Photo by Miguel A. Parera.

Figure 4.6. Ma Florentina's drums in 2010. Photo by Brian Jeffery.

Cabo Cruz. Whether any of the above is true or not, according to Midialis, the drums of Sociedad Africana were first played in 1887 at Perico's train station. In 2017, the drums celebrated 130 years of playing.

Victoria Zulueta

Victoria Zulueta[5] was born in a *solar* (family house) located behind Justo Zulueta's house December 23, 1902, to Digna Zulueta. Digna, daughter of Africans, could not take care of Victoria; thus, Victoria became Ma Florentina's goddaughter. It was upon Ma Florentina's death, on January 6, 1933, that Victoria became responsible for la Sociedad Africana (Prieto Angarica Diago and Midialis Angarica Galarraga, interview, January 3, 2018).

While famous in her own right, stories about Victoria are few. She often worked closely with Cheo Changó while she continued important ceremonies at la Sociedad Africana. She even lived for a while in the city of Matanzas under Cheo's roof with other religious practitioners. Cheo's image and religious authority, according to our interlocutors, are legendary, so it made sense that Victoria would spend time with him in Matanzas. Victoria's son Cuito, and her two grandchildren, Prieto and his brother Ñuco, became important drummers of Arará rhythms. Victoria used to lock la Sociedad Africana's door when elders were conducting their ceremonies. Still, Prieto recounted, he always managed to break into the house through any window in order to see what was happening. He knew that someday he would carry forth the legacy of the house.

Together with Perico resident Miriam Bravo, once a dancer with Grupo de Artistas Aficionados (Group of Amateur Artists), Victoria formed Perico's Dahomey Arará Folkloric Group in 1978. Hilda Zulueta spoke proudly of this group's importance. When we found Miriam Bravo (or rather, when she found us, sitting in the old Hevioso house), she was proudly carrying her unpublished and slowly disintegrating thesis with pictures of the group in order to share this important document of Perico's history.[6]

Hilda Zulueta

During our first Perico visits, time and time again, we took note of Hilda. Clearly, she was deeply respected, evident in the deference paid to her and how she presided over the ceremonies we witnessed. Elders often describe

Hilda as one of the last "Africans," since she was consecrated at the feet of her Aunt Felipa's "African" Arará (Afrá) fundamentos. Hilda carried a deep sense of responsibility to her community. She felt it her duty to attend ceremonies, since her Eleggua had been "born" in Felipa's fundamento house, and Eleggua will always arrive to verify, through possession (having mounted Hilda), that things are being done properly (interview, December 20, 2007).

There are stories of Hilda's Eleggua standing guard at the door of the house where a ceremony was being held and refusing to let anyone depart, particularly if they wanted to leave before they, too, fell into trance. Usually when Eleggua blocked the door, two or three other attendees would almost immediately fall into trance—especially the ones trying to leave.

Sometimes Hilda would avoid attending ceremony to prevent possession, but that did not always work. One time, upset with a woman named China who was holding a *tambor* (ceremony), she stayed home while her daughters went out for the evening. But Eleggua had other intentions. Hilda was ironing clothes, and because it was nighttime, she was wearing a worn-out dressing gown. The next thing she remembered, she was sitting in the house she had sworn not to go to that night. Those who had attended China's ceremony later told Hilda that China, in trance with Changó, was dancing at the door and calling out for Eleggua (Hilda) to arrive. Her daughters told her that they were coming home when they saw someone resembling their mother running like crazy in the street. One went after her while the other ran home—to find the clothes that Hilda had been ironing were on fire. As Hilda recounted to us, her Eleggua "danced and cried out and from that moment on, my body does not go to bed dirty, with worn out clothes, or naked" ("bailaba y gritaba y partir de ahí este cuerpo que está aquí no se acuesta ni sucio, ni ripiado, ni sin ropa," interview, January 8, 2006). This is not unheard of in Perico. Hilda described how her Aunt Jacinta could be woken up after falling asleep by her deity, the "African Oyá." Kikito Morales Iglesias, a Perico drummer, told us that even if one avoids a tambor, the deities can get you out of your kitchen or bathroom and bring you to the tambor ("si el santo quiere, te saca de la cocina, te saca del baño, y te trae hasta el tambor," interview, January 8, 2006).

While several in Perico know Hilda's Eleggua as Lucumí, Hilda argues that her Eleggua is actually a mixture of Lucumí and Arará because of her consecration in front of Felipa's "Arará Eleggua" (Afrá) by Armando Zulu-

eta. Hilda would also receive Eleggua vocero (Eleggua as a warrior) from Cheo Changó. Hilda was often described as the godmother of Ma Florentina's drums, even though Ma Florentina's drums actually belong to Malé, a deity who represents the Arará rainbow serpent in Perico. This is simply because Hilda's Eleggua, as she told us, liked to pretend the drums were his (Hilda Zulueta, interviews, December 18, 2006, and December 20, 2007).

Cheo Changó

Cheo Changó, a renowned religious personality of Matanzas Province, is still mentioned, remembered, and revered in most Perico religious houses and intricately woven into Perico's religious history. He spent long periods

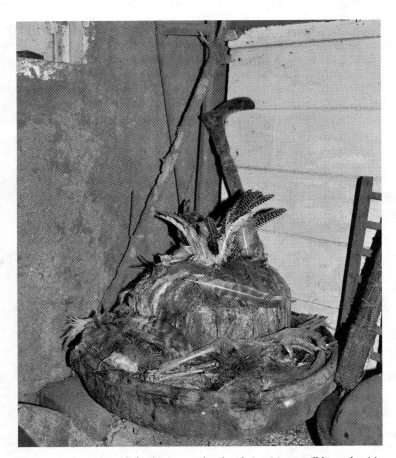

Figure 4.7. Cheo Chango's fundamento imbued with San Lázaro still housed at Ma Florentina's Sociedad Africana. Photo by Miguel A. Parera.

in Perico, especially in la Sociedad Africana, seldom missing a celebration. According to legend, Cheo was a very striking and confident figure. In la Sociedad Africana is a picture of him with a wide grin, and his San Lázaro remains in the *casita* (small house) along with Ma Florentina's. He consecrated Prieto and Ñuco, besides giving Hilda her Eleggua vocero.

According to Graciella "Tita" Tabío Robinson, Cheo died old and blind because he never listened to the messages of Siete Rayos. Cheo always told his godchildren they must listen, follow, and do what Siete Rayos said. However, he himself never followed his own advice, commenting that he was in command of his life and not Siete Rayos. Siete Rayos might say what he wanted, but Cheo would do as he pleased.

Once, Siete Rayos came down and warned Cheo's godchildren that "my horse[7] will be invited to a house and will be offered a bountiful table with delicious food. He [Cheo Changó] must not eat anything from the table or he will suffer the consequences."

Cheo went to the house and ate from the table. Almost immediately, Siete Rayos came down to alleviate the weight of the sentence. Cheo could have died if Siete Rayos had not come down. Cheo did not die, but his sight started failing until he lost it completely (Graciella "Tita" Tabío Robinson, interview, January 4, 2018).

But Cheo will always be remembered for the "remembrance" he left Macusa Zulueta Dueñas and for his friendship with Justo. How he came to become Justo's friend belongs to a story about Reinaldo, who was Justo's son.

Reinaldo Robinson

Reinaldo does not carry Justo's surname because Justo and Reinaldo's mother were not legally married. Justo was married to another woman at the time, and she did not allow Justo to pass his surname on to Reinaldo. Reinaldo attested that being the son of such an important religious elder carried tremendous significance. Justo was born in 1882, and his house was built in 1905, when he was 23 years old. Reinaldo would be born 22 years later, in 1927, and, over the course of his life, he would be a part of, visit, and attend all religious ceremonies celebrated in Justo's house. When Justo's house passed to Reinaldo, he kept taking care of his father's fundamentos—or, as he would say, the fundamentos took care of him. He also determinedly kept Justo's ceremonies alive.

Through an interview with Reinaldo's great-grandson Armando Omar Pérez Méndez, we learned one of the most interesting stories of Reinaldo's relationship to Cheo Changó. A celebration was being held at la Sociedad Africana and Reinaldo decided to attend out of respect for Victoria Zulueta. Reinaldo liked to dress smartly, and he caught the attention of one of Cheo's religious goddaughters. Reinaldo, who was not interested, paid no attention. Regardless, she chased him around the room until, feeling rejected, she made a false claim that "he touched my buns." Being Cheo's goddaughter, her call was not ignored. Reinaldo addressed her politely, say-

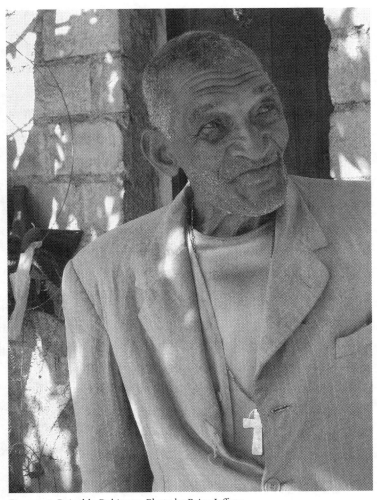

Figure 4.8. Reinaldo Robinson. Photo by Brian Jeffery.

ing she was mistaken, but most of Cheo's godchildren and Cheo himself were already turning on Reinaldo. Reinaldo turned to Cheo and said his goddaughter was confused. Cheo's reply was authoritative: "You have no right to speak to me like that."

If Victoria had not interceded, the argument might have ended differently. Victoria vouched for Reinaldo and acknowledged him as a son of an important religious house and incapable of behaving so badly.

Upset, Reinaldo decided to leave. But, as he stepped outside, Cheo became possessed by Changó. He immediately lifted Reinaldo up and started to spin him around, crying, "This is my son and he cannot leave." Once he put Reinaldo down, Reinaldo left. Later on, Cheo asked Victoria about the father of such an unusual boy. Victoria replied, "He is son to Justo Zulueta." Cheo investigated Reinaldo and Justo further; with time, he became Reinaldo's religious godfather and Justo's best friend (Armando Omar Pérez Méndez, interview, May 21, 2017).

Josefina Tarafa

Reinaldo spoke often about Josefina Tarafa. Her gift of a leopard skin to Justo's altar around 1948, according to Reinaldo, is legendary. Josefina was deeply curious about the religious life of the formerly enslaved and their descendants.[8] She spent hours with Justo, and once told him that something was missing from his house. One day, she returned with a leopard skin from Africa that still hangs from the ceiling next to his altar.

Legend has it that the leopard's tail has special powers. According to legend, it rewards anyone who touches its tail with a wish. When our research team was with Reinaldo in Justo's house, it was not unusual for people to stop by, stand underneath the leopard skin, and touch its tail. The tail has been pulled so often such that it broke at one point, and Reinaldo repaired it with a white leather patch.

Josefina accompanied noted ethnomusicologists Alfred Métraux, Pierre Verger, and Lydia Cabrera (along with Teresa "Titina" de Rojas, Lydia's romantic partner and colleague) to la laguna sagrada de San Joaquín de Ibáñez (Cabrera 1993 [1973], 9) near Pedro Betancourt. They conducted fieldwork and made the recordings that form the basis of Cabrera's book *La Laguna Sagrada de San Joaquín* (1993 [1973]). One can only imagine what it was like to conduct fieldwork during those years. Cabrera, Tarafa, de Rojas,

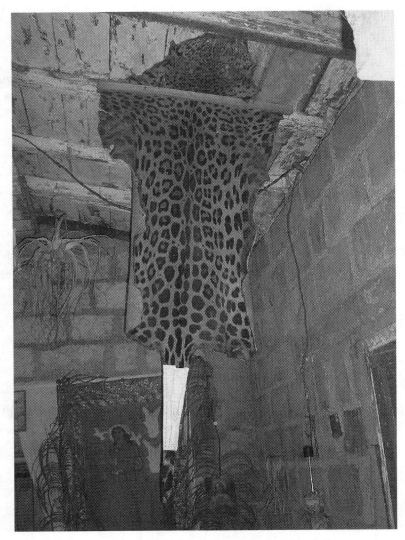

Figure 4.9. The leopard skin in Justo's house. Photo by Melba Núñez Isalbe.

Verger, and Métraux were all equals, and they must have all understood and contemplated the significance of their work. Beyond the Smithsonian Folkways recordings (2003) that resulted from that 1956 fieldwork, their legacy has been a guiding light to the scholarship that has followed. Meanwhile, Josefina's passion for inquiry and respect for "Afro-Cuban" religion remains on view via the leopard skin hanging close to Justo's altar.

Notes

1. The photo we took of her that day inspired the first painting created by Susan Matthews for the *Secrets Under the Skin* installation featured on the cover of this book.

2. There were no official papers, but according to Prieto Angarica Diago, Ta Facundo was Ma Florentina's husband.

3. Today, these fundamentos are known as being received as "santo parado." This concept evolved and appeared as Lucumí practice became codified and standardized, even though Lucumí religious ceremonies were growing into new ideas and concepts as early as 1850 (Brown 2003, 141–142).

4. Rivero Glean (2011, 110) states that the colors for Aggidai (also written Agidai) are combinations of royal or Prussian blue, amber, red or coral, black, and gold. Rivero adds that this deity is also known as Aché in Matanzas and Agé and Wewé in Jovellanos, and is associated with San Norberto, who is celebrated on June 6.

5. According to a personal conversation with Midialis, Victoria was born Victoria Ruiz, but changed her name to Zulueta.

6. Her thesis, "Origen y Desarrollo en Cuba de la Danza del Grupo 'Dahomey Arará,'" was jointly authored with Consuelo García. Rogelio Martínez Furé was her advisor.

7. This is how those in Lucumí, Arará, and Palo are often described when they fall into trance. They are "horses" (caballos) for the deity to "mount."

8. According to Perret Ballester (2008 [2007], 53), José Miguel Tarafa de Armas bought España Republicana in 1950. It is worth noting that he bought central Cuba in 1909. Central Cuba (later known as Cuba Libre after the revolution), located in Pedro Betancourt, is where his daughter, Josefina Tarafa de Armas, served as administrator for several of her father's mills and had her main residence, according to historian Ramón Adair González.

5

The Rememberer

JT TORRES

Meeting Ramona

We arrive at Ramona's house late in the morning, before the heat of the day really picks up. The house is various shades of yellow. The steel shutters are open and so are the double front doors. A young girl, who introduces herself as a live-in nurse, meets us at the door.

The nurse, who appears to be no older than fourteen, tells us to wait in the front room, a space barely big enough for the five of us. There are just enough seats, but no other furniture. She enters another room through a sheet hanging from an arch and returns with Ramona, a large woman in a sleeveless nightgown who can barely walk without the nurse's assistance. Ramona coughs as she sits in one of the chairs in the front room. Her lids seem heavy over her eyes, which sink in pools of skin. Ramona holds her chest for a moment. She coughs; pain shows on her tired face, and then she asks the nurse for a cigarette.

Smoke pours out of Ramona's lips and forms an aura around her. Ramona's illness grounds me in reality, but fills me with an intense sorrow. I shift my attention to the water-damaged walls, their deep stains giving them the texture of mud, as if this house grew out of the earth. In many ways, it did.

Sometime in the late nineteenth century, Ma Teresa came from the Dahomey region of Africa to Cuba as an enslaved woman. In Cuba, she acquired the name Zulueta from the infamous owner of four mills, including España. Eventually, she was able to earn her freedom and save money, which allowed her to buy her sons' freedom and, finally, the house in Perico on Ramón Illa street.

Ma Teresa's granddaughter was María Luisa Elizalde, Ramona's mother. While María Luisa Elizalde raised Ramona, they often shared the house with many family members and distant relatives, including Catalina Frequete, María Luisa Elizalde's aunt, who owned the sacred *fundamento*. The fundamento is dedicated to Afrequete, sometimes referred to as Frequete in Perico—both are Arará names for the Lucumí Yemayá. This is why Catalina Zulueta, who was the original owner of the fundamento, is called Catalina Frequete.

The fundamento is cradled by a massive mamey tree that seems always to cast a cool shade on the house. The house itself is of historical importance. The altar at the base of the mamey tree is a symbol of the inclusive nature of the Elizaldes' home. Travelers were regularly welcomed and often

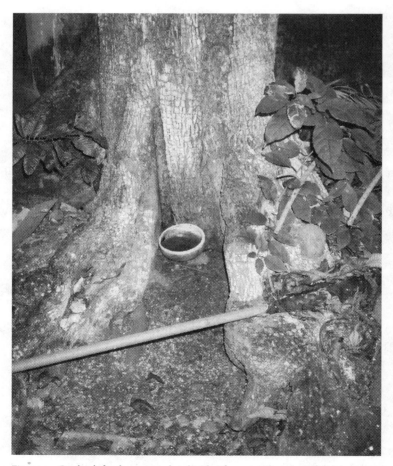

Figure 5.1. Catalina's fundamento imbued with Afrequete. Photo by Miguel A. Parera.

stayed with the family. One traveler, María Rivero, a daughter of Changó,[1] brought with her from Pinar del Río a Lucumí fundamento, and for many years María Rivero's fundamento shared space with Afrequete.

Ramona invites us to see the backyard. Outside, the mamey tree is like a guardian tower. Its bark is glazed auburn by the sunlight drizzling through the umbrella of outstretched branches and vernal leaves. At the base of the mamey tree is the jícara that is imbued with Afrequete. The jícara contains water, signifying it is an Arará fundamento. It is the same color as the soil, making it easy to miss. The jar for María Rivero's fundamento is gone, but no one knows where.

We go back inside the house, where Ramona's nurse serves coffee. She offers each of us an espresso cup on a dish. A few strands of hair slip loose from her bun and hang down in her face. Someone walks down the road, passing the open doors. He shouts that he's selling pastries. His voice is urgent, as if it's vital that someone purchase at least one.

Ramona coughs, holds her chest, and lights another cigarette. After she exhales a cloud of gray, she tells us a story.

This chapter presents a true fiction performance. True fiction, the writing of fieldwork data using literary techniques, transforms an interview that occurred among Melba Núñez Isalbe, Roberto Pedroso García, Susan Matthews, Jill Flanders Crosby, Hilda Zulueta, and Ramona Casanova Elizalde on December 21, 2007, and a follow-up informal conversation among Roberto, Melba, Jill, and myself on December 15, 2014. The fiction elements mostly pertain to arrangement of data into dialogue, plot organization, and scene construction. Ethnographic information, such as names, descriptions, and relationships, have not been altered.

The Rememberer

At five, Ramona had picked up two habits: talking back to adults and falling ill. Her mother insisted these two things were related, that Ramona had a mischievous spirit.[2]

"Don't say such things about our beautiful princess," Catalina, her mother's aunt, said from the front door. She was sweeping the puddle of water that formed there every time it rained.

"She's going to do great things for our community," Catalina continued. Despite living past 100, her voice remained as strong as the wind. Catalina

was by now short, thin, and gray all over, like ash settled on her skin and couldn't be dusted off. She swept the last of the water, her broom swooshing against the dirt floor, and then stood behind Ramona, who was busying herself trying to peel papaya. Catalina rested her hand on Ramona's shoulder. Her touch felt light, airy, like it came from the wing of a small bird.

"It's good to be independent," Catalina said.

"Independence breeds disrespect," Ramona's mother retorted.

"One thing is not related to the other at all," Catalina said in a voice so sharp she sounded decades younger. "I used to go to church in La Habana to be with Ana María Delo. I've been to several churches, Catholic, Protestant, whatever. But I also speak with Justo Zulueta in African language every day.[3] I keep the fundamento for Frequete behind this house. I can do many things because I'm independent."[4]

"But you can't get your own medicine," Ramona's mother said, and stood to collect the dishes from her and Ramona's lunch.

Once a week, Ramona accompanied her mother to the pharmacy, a fluorescent-lit store on the main street. There, the attendant would immediately ask how Catalina was. "She'll live forever with this medicine," her mother would say.

Ramona had come to think it was true. She had never heard of Catalina being sick or having any malady. She only grayed further with each passing month, like her body was slowly and peacefully entering its own personal winter.

As Ramona's mother carried the dishes to the kitchen, she grumbled that people who aren't told where to look soon become blind.

"Let her see things for herself," Catalina said. She collected the discarded peel and seeds and smiled at the juicy mess on Ramona's face.

On the day of Ramona's medio asiento, the elders made a list of materials Ramona's mother would need in order to create an Eleggua for Ramona. Once they finished, they warned Ramona that Malé, a powerful deity who takes the form of a *majá*, prides Himself on scaring those who are naughty, those who live without respect for tradition.[5]

"You will be visited by snakes," one of the elders said.

For the first time that day, excitement flashed in Ramona's eyes.

To complete the medio asiento, a ceremony was held at Ramona's house.

Hilda, a friend of Ramona's, was there. She was in a powder-blue dress and patterned scarf. Her thin body moved gracefully among people as she approached Ramona and hugged her.

"Do you have a santo now?" Hilda asked.

Ramona didn't know how to answer. She avoided looking at Hilda, who seemed so composed, so perfect.

At the front door, she noticed a puddle of water forming, and thought about fetching the broom to sweep it for Catalina. But as soon as the drums started, Catalina found her. She took her arms and swung her around, dancing. Catalina was barefoot, her knotted feet stepping in rhythm with the drums.[6] Because the house did not have concrete floors, Catalina's feet seemed to come directly from the earth. Everyone crammed into the living room, the only room besides the kitchen that then had electricity.

"Listen to the drum," Catalina said, as she danced with her body bent over so low she almost reached the floor. "Close your eyes."

Ramona did so and felt the tension in her legs vanish. It was like she was becoming weightless. She could feel the music as it channeled down her shoulders and directed her feet.

"Ramona," she heard her mother say. Her voice was so far away, like it came from another country entirely.

"Fly away," Catalina said in a voice that was much closer.

"Look at her! How adorable!" someone else said in the distance. Angélica? Mimi? María Rivero, in her wide white skirt and turban?

Ramona kept her eyes closed and continued dancing. The air swirled around her and it felt like she was being lifted by it. She could no longer feel the ground, just the drums' rhythms, a rush of energy from some unknown place.

Ramona spent the next few weeks exploring the backyard. She stepped over shrubs, brushed past chickens, and dodged the clothes hanging from the line in her search for a snake. Any snake. She wanted to find Malé before He found her. If she was in fact naughty, as the elders had said, then Malé would come to frighten her. Ramona, however, would not be afraid.

One day, while Catalina took clothes from the line, she laughed at Ramona.

"Child," she said, "you are trying too hard."

Ramona reminded her what the elders had said.

"Come help me with these clothes," Catalina said. "They must be off the line by three."

"Why?"

"It's just something that the elders prefer. There shouldn't be any clothes hanging by four."

"I don't understand." And Ramona really didn't. What was the point of doing something for no reason other than someone else's preference?

She resumed crawling through the foliage, her nose inches from the earth.

Catalina finished removing the clothes and folding them. Then she took her broom and began sweeping the backyard, making a path for Ramona to follow. Ramona scanned the earth Catalina revealed by dusting the roots of the orange trees, cleaning around the chirimoya, anón, mango, and avocado trees. Catalina stopped sweeping when they reached the statues.

The stone statues had always been there, but Ramona had never really paid attention to them. One was of San Lázaro and another was of Las Mercedes. The grass had started to grow up and around the statues' feet, like the earth was claiming them as its own.

"These belonged to your uncle, Gerardo de las Mercedes Elizalde, Chicho," Catalina said. She leaned on the broom and gazed at the statues like she was seeing them for the first time. Her eyes became glazed over with a dreamy film. "He was the son of Las Mercedes."[7]

Then Catalina cleared a path that led Ramona to the growing mamey tree. It was already the largest tree in the backyard. Its canopy covered almost the entire house. At the base were the two jars, their clay color almost a perfect match for the soil.

"In Arará," Catalina said, "Yemayá also takes the form of a majá."[8]

Ramona searched around the fundamentos, looking behind the tree and up at its branches, and pouted. Her frustration showed on her face; she puffed up her cheeks and frowned.

This made Catalina laugh. "You are missing the point." Catalina sat on a wooden bench. She was breathing heavily, like it hurt. "Religion for its own sake is fruitless. But religion that sprouts from the deep roots of family grows into a powerful tree."

Ramona didn't understand. She was now more worried about Catalina than curious about snakes. She sat next to Catalina and hugged her. She thought she would hold her until her breathing returned to normal. Ramona could feel Catalina's faint heart, like a distant star casting the last of its light.

"Do not fear what is to come," Catalina said. "Many will live and die in this house, and their spirits will only strengthen the walls."

"Do you need your Coramine?"

Catalina laughed, but it sounded like air being squeezed out of a balloon. "Nothing helps arteriosclerosis."

It was a word too big for Ramona to repeat. It sounded foreign, like it came from another world. She didn't want to know what it meant. She would much prefer never to have to hear it again.

Catalina's breathing finally relaxed and she used the broom to prop herself up on her feet. "I still need to sweep the water in front of the house."

"Just leave it," Ramona said.

Catalina touched Ramona's head and smiled. "Things have to get done."

Ramona offered to sweep the puddle for her, but Catalina insisted.

Soon came the morning when Catalina did not wake up.[9] Ramona's mother sent for Doctor Rodríguez while she and some of Ramona's uncles prepared the house for Catalina's mourning. Ramona wanted nothing to do with it. She carried a glass of water up and down the street in front of the house. The dense clouds turned the morning sun into a kind of haze. The steamy light falling on the wooden house[10] made it appear like an old photograph. The entry and windows were dark as night, like the house contained some sinister mystery.

Ramona turned to walk back up the street, but stopped and gasped. There! In front of her! A black snake slowly slithered into the grass just inches from her feet. In a single panic-struck motion, Ramona tossed the water from her glass onto the snake and ran back inside the house.

As the day progressed and relatives arrived, Ramona could think only about the snake. Was it Malé? Yemayá? Why had she run? She wasn't supposed to be scared. She spent all day thinking about the snake's long form, how the hazy morning light glistened on its sleek body, how its scales were like millions of little stars.

Just before sunset, Ramona went back outside and turned to walk up the street. The snake was still there, still slowly slithering into the grass. "I'm not afraid," she said. She closed her eyes and repeated that to herself until she could hear music starting in her house.

The house was full of people. Someone had fallen into trance. People passed

around a jícara and sang the chants of each deity. The earthen floor vibrated with the drums' beat. Ramona didn't feel like dancing; her legs felt too heavy, grounded like the roots of a tree swollen with water. Still, as she squeezed past everyone in the living room and walked down the dark hallway past all the bedrooms until she finally reached Catalina's, she realized she had been in exact step with the rhythm.

Ramona peeked inside Catalina's room. The room felt so full of some inexplicable emptiness that Ramona didn't know if she'd fit. A single lantern on the nightstand was lit, giving the room a dreamy golden aura. That was the only source of light—the sun had vanished behind the horizon and the light of the single bulb in the living room did not reach down the hall. The rooms without electricity always felt cooler, more distant, lonelier.

Catalina's room was probably the biggest in the house. Ramona approached the bed and touched it. There remained a slight feeling of warmth. The bedclothes were beautiful. They were of a fine white linen that seemed too clean ever to have been slept on. The sheets and pillowcases were crocheted. Many years later, Ramona would embroider her own pillowcases the same way.[11]

She stood in Catalina's room and became lost in thought. Her mind seemed to travel to distant pasts, where she saw Catalina as a child in La Habana, and to far off futures, where Ramona saw herself as an old woman, sweeping the puddle of water in front of the house just as Catalina had.

Her thoughts were interrupted by the pleasant smell of cooked rice. Ramona turned and found her mother standing at the room's entrance with a plate full of food. Her mother appeared younger in the lantern's glow. She looked softer, gentler.

"Take this and offer it to Catalina's fundamento," she said.

Without question, Ramona took the plate. It contained *tapi tapi,* round balls of saltless rice. The tapi tapi was accompanied by popcorn, fritters of *carita* beans, and rice cooked with milk.

Outside, Ramona placed the plate in front of the jícara for Afrequete. She sat down and it felt like she wasn't alone, like Catalina or her mom or someone was there watching her. It wasn't an eerie feeling, more like a protective one. It made Ramona feel safe.

Ramona began spending her days in the backyard. She kept the area around Catalina's fundamento clear of twigs, leaves, and fruit that had fallen from

the trees. Neighbors who passed and saw her said it was wonderful that she had taken up Catalina's tradition, but Ramona didn't understand. All she was doing was sweeping the backyard.

Sometimes she would fall asleep out there, under the cool shade of the mamey tree. One of those times, she had a dream that the backyard was crawling with snakes. No earth could be seen, only the tight black bodies of majás all entangled with one another. Ramona couldn't move without stepping on one of them. She stood there, her legs locked in fear. Suddenly, she heard Catalina say, "Remember the secrets."

Ramona looked toward the fundamento and saw Catalina standing in a skirt that billowed in the soft breeze. Her feet disappeared among the snakes, but she wasn't concerned about them.

"The elders," she said. "We take the knowledge of the traditions with us when we die. It shouldn't be so."

Catalina seemed sad—rueful, even. Ramona felt a heaviness in her heart and wondered if that was what Catalina had felt, why she needed Cora-mine.

"Promise me," Catalina said. She held her hands in front of her chest, as if praying. "Promise me you will always sweep the puddle of water in front of the house."

Before Ramona could answer, she was awake, lying in the backyard, a lizard scurrying across her leg.

As Ramona got older and began taking care of the laundry, she began following the customs of her elders. For one, she always had the clothes off the line by three in the afternoon. Habits like those strengthened her relationship with the elders, who began sharing important stories with her, stories Ramona would always remember.

"They never told me why it's important [to have the laundry down by three p.m.]," she tells us and laughs. "But they trusted me after that. I learned about other, more important things."

Before long, Ramona's responsibilities included caring for dying elders. She tended to those who died in her house, like her uncle Chicho, María Rivero, and her parents, as well as those who passed in their own homes, like her uncle Justo. She prepared each one for the passing and also helped organize the related ceremony.

"There's no one else," she says. "I don't have children. I have to remember."

The sun began its descent, pulling a cloak of humidity over the world. Ramona's eyelids appeared heavy, each blink lasting a moment longer. Out of respect, we decided to leave. Ramona walked us out, refusing help from her nurse. As we pulled away in the rental car, I looked back to find her sweeping the puddle of water at the entry to her house, keeping her promise to Catalina.

Notes

1. Ramona: Si, hija de Changó que es una tinaja de esas pertenecía a ella. No era familia nuestra, pero bueno antes se usaba que las personas emigraban de un lugar hacia otro dentro del mismo país y esa persona era de Pinar del Río, pero vino para acá y vivió aquí hasta que aquí mismo falleció como parte de la familia nuestra. Yo era muy niña, pero bueno la recuerdo perfectamente.

Ramona: Yes, she was daughter to Changó. She owned one of the earthenware jars. She wasn't family, but in those times, it was common to receive people who came from different places within the country. She [María Rivero] was from Pinar del Río, but she came here and lived here until she passed away as a member of the family. I was very little, but I remember her perfectly.

2. Ramona: A los 5 años me hicieron medio asiento porque entre las enfermedades y las majaderías era una loquita.

Ramona: When I was five they made me medio asiento because I was always sick and was really mischievous.

3. Ramona: Ella pertenecía o por lo menos su asociación más cercana era con el abuelo de Hilda, Justo Zulueta.

Ramona: Her (Catalina's) closest acquaintance was Hilda's grandfather Justo Zulueta.

4. Ramona: No tiene nada que ver una cosa con la otra, en lo absoluto porque mi familia toda es católica y mi tía Catalina iba a la iglesia. Ah esa es la otra parte, ella viajaba mucho a La Habana porque tenía relación de algunas amistades que tenían familiares ahí en Máximo Gómez que antes le decían Recreo. Y yo estoy por pensar que son familia de esa gente porque la amiga de mi tía se llamaba Ana María Delo, a la otra le decían Cuca, pero no me acuerdo del nombre. Ella viajaba mucho a La Habana y entonces siempre iba a la iglesias, igual que aquí era católica. No tiene nada que ver una cosa con la otra, se complementan.

Ramona: [Because] one thing is not related to the other at all. All my family is Catholic and my aunt Catalina went to church. She used to go to Havana a lot because she had some friends who had relatives in Máximo Gómez, formerly Recreo. I am beginning to think they are related to those people because the name of a friend of my aunt was Ana María Delo and there was another woman whose nickname was Cuca, but I don't remember her given name. She [Catalina] traveled a lot to Havana and there she was always attending different churches, just like here. She was Catholic. One thing doesn't oppose to the other; on the contrary, they complement each other.

5. Ramona: Y en cuanto a la serpiente yo la respeto, pero yo no le tengo miedo, yo no, ellos dicen que yo era más mala que no se que cosa.

Ramona: Regarding serpents, I respect them, but I am not afraid of them. My elders said I was very naughty.

Ramona: Por eso yo digo que le sale a la gente majadera que dicen que no creen en nada, a esos es a los que le sale porque a mí nunca me ha salido.

Ramona: That's why I say they emerge in the presence of naughty people. Those are the ones to whom it reveals itself, because it's never come for me. I've never been afraid of him.

6. Ramona: Antes el baile era casi llegando al piso y sin zapatos porque mi tía Catalina bailaba sin zapatos.

Ramona: When they (elders) were dancing they bent over, almost reaching the floor, and [were] barefoot. My aunt Catalina danced barefoot.

7. Ramona: Esas eran de un tío mío. Gerardo de las Mercedes Elizalde, mi tío Chicho, que él siempre estaba, a mi me parece que él era hijo de las Mercedes, porque siempre estaba hablando de Somaddonu.

Ramona: They belonged to an uncle of mine. Gerardo de las Mercedes Elizalde, my uncle Chicho. He was always . . . I believe he was son to our Holy Lady of Mercy (Las Mercedes) because he was always talking about Somaddonu, the male path of Las Mercedes.

8. Hilda: Las Yemayás del Arará todas tienen la misma trascendencia.

Hilda: All Yemayás in Arará have the same form.

Melba: La forma de serpiente.

Melba: The form of a snake.

9. Ramona: Mi tía moriría en el 1955 ó 1956.

Ramona: My aunt died in 1955 or 1956.

10. Ramona: Exactamente, pero bueno era así de esa forma. Cuando mi tía falleció, bueno ahora se hace otro tipo de ritual, pero en aquel entonces a mí no se me olvida, era otra casa, la casa de madera, era uno, dos, tres, cuatro cuartos corridos, la cocinita, el piso de tierra y ahí se hizo ese velorio y empezaron a cantar y el toque era con los pies y así salía el baile y todo perfectamente. También yo recuerdo que ella le ponía a su santo, era algo que se hacía con arroz sin sal, ponía rositas de maíz, frituritas de frijol carita. Hacía arroz con leche también, pero lo que más recuerdo así, ¿Hilda como se llama una cosa que se hace con arroz blanco?

Ramona: Exactly, it was like that. When my aunt died, well at present they do a different ritual, but I can't forget what I saw that time. The house was different, it was a wooden house with an earthen floor and one, two, three, four rooms in a row, a small kitchen. The wake took place there. They (elders) started to sing and they danced and marked the beat of the drums with the feet. I also remember she (Catalina) cooked a special meal for her fundamento, it was something made out of rice without salt. She also offered popcorn, fritters of *carita* beans, rice cooked with milk, but what I remember the most was . . . Hilda, what was the name of that meal made out of white rice? (Answer: tapi tapi).

11. Ramona: Era una casa de madera que estaba en muy malas condiciones porque además a ellos no les preocupaba hacer una casa del otro mundo, era un cuarto amplio para ella sola y ella se sentía muy bien allí. Sin embargo, a pesar de todo eso la ropa de cama era muy fina, de hilo blanca, con puntas las sábanas, las fundas bordadas. Hay

cosas que se le quedan a uno en la mente y yo hace cuestión de unos años fue que yo pude lograr hacerme una funda con la punta tejida porque ya te digo yo voy arrastrando esas cosas. La ropa era muy fina y yo no estoy segura, pero a mí me parece que ella viajó.

Ramona: This was a wooden house in really bad shape because they [the elders] were not concerned with building a luxurious house. She [Catalina] had a big room to herself and she felt very good in there. However, the bedclothes were really beautiful. They were really fine, made out of white linen. The sheets had nice lace edges and the pillowcases were embroidered. Some things stay with you forever. Just a few years ago I was able to make a pillowcase with crocheted edgings because I'm dragging all those memories with me. The bedclothes were kind of fancy and I am not sure, but I think she [Catalina] traveled someplace.

6

Agramonte

JILL FLANDERS CROSBY

It has already been said repeatedly that stories do not fit into a singular image, and that divergent memories form a messy tangle. Agramonte is a puzzle, particularly when it comes to the stories of Ma Gose. Our information about her came through interviews conducted over several years. In that span of time, elders passed away or their minds slipped into dementia. When we encountered contradictory information, we could not necessarily return to a previous interviewee to ask new questions for clarification. At such moments, choreographed narratives became useful. Choreographed narrative, a style of writing that arranges analysis of data as a dance of multiple voices, helped stage the layers of mystery surrounding Agramonte.

Agramonte and Mario José

Cuevitas became Agramonte in honor of Ignacio Agramonte Loynaz, one of the leaders of the Cuban War of Independence against Spain, on August 15, 1900. Melba, Roberto, and I made our way to Agramonte after I witnessed Mario José Abreu Díaz, an important Agramontean ritual practitioner, dancing in trance at the *awán* ceremony at Armando Zulueta's house in Perico.

Mario José's dancing was unlike anything I had seen so far. In the most intimate way imaginable and resplendent in the San Lázaro clothing he had brought with him in case he became possessed,[1] his body enfolded in conversation with the drums. The way he danced, the respect he gave that evening—they were reason enough for me to want to meet and talk with Mario José and extend my research into Agramonte.

One day about a year later, all three of us arrived unannounced at his house. Roberto disappeared inside. After about 10 minutes, he beckoned Melba and me to a *casita* behind the house. It turned out to be Mario José's casita for his Palo *prendas*. Inside, he was on the floor, working with a young man in what appeared to be a healing ritual, an activity not unusual for an important ritual practitioner. It was only when I whispered something to Melba and Mario José whipped his head around, eyes squinting in my direction, that I realized he was mounted with his *muerto*, Juan Felipe. A high-pitched voice emerged from his lips as he began asking questions.

Of course, the voice was Juan Felipe's. He told us many things about one of the Arará/Lucumí deities that day. We received information about Naná Burukú—that she often manifests as a snake, and lives in a well or at the base of a tree. We had never recorded information this way before. This put me in mind of the work of Meera Venkatachalam (2015), who, during her Ghanaian research in the Volta region at Anlo-Afiadenyigba, received critical data from the spirits that inhabited her interlocutors, and new doors opened. The spirits addressed other attendees present at ceremony, and Venkatachalam herself. They literally became her informants and critics. She writes that Anlo "hosts" assign a powerful agency to the spirits and that they "are active agents in the making of history, especially religious history" (22).

Soon thereafter, Mario José became a close friend. Every time we arrived at his house, the laugh in his eyes became infectious. He opened doors, leading us into the homes of elders who provided information on former and current Agramontean Arará elders and practitioners. He led us to critical sites: the abandoned sugar central Unión-Fernández, the still-working central René Fraga, and laguna Ramona. Below are the stories of those elders and these sites. Woven together as unfolding and cascading vignettes, central themes nevertheless run through them all: *majás* and miraculous healing. Elders we interviewed consistently referred to the cast of characters that follows as critical to understanding Agramonte's religious history.

Ma Gose

Manuela Fernández (Ma Gose) is identified in present-day Agramonte as having started Agramonte's first religious *cabildo*, much like Ma Florentina did with Perico's Sociedad Africana. She brought several of her *fundamentos* to Agramonte from nearby former sugar central Unión-Fernández.

According to her great-granddaughters Onelia Fernández Campos and Margarita Fernández Campos, Ma Gose was tricked onto a slave ship in West Africa when she heard drumming and singing on board (interviews, December 31, 2007, and December 17, 2008). She was first taken to the Apodaca central in West Amarillas, fifty-one kilometers from Agramonte. Later, Ma Gose was taken to nearby Unión-Fernández, where she worked alongside Ta Andrés, known as "Coso Coso." Ma Gose and Ta Andrés had both been singers in their respective West African communities. Once in Cuba, they became close, singing together in Unión-Fernández.

Unlike Ma Florentina's Sociedad Africana, it appears that no other formerly enslaved persons who eventually resettled in Agramonte from Unión-Fernandez or their individual fundamentos were housed, even temporarily, at Ma Gose's sociedad. According to Minita Baró Quevedo, some elders from Unión-Fernández went to Jovellanos rather than Agramonte with their fundamentos. But since then, religious practitioners have come from Jovellanos to Agramonte, such as Florentino "Papa Tusa" Madan.

There are accounts that an active "great society" called Pueblo Nuevo existed in one side of a former Unión-Fernández barracón with many altars, where Ma Gose was "la reina" (Vinueza 1988 [1986], 37).[2] Ma Gose moved to Agramonte around 1912. Her cabildo, known first as Sociedad Africana San Lázaro (Vinueza 1988 [1986], 46), was once a rustic wooden house with earthen floors before being modernized with concrete.[3] There, she and Ta Andrés became the *gallos* (singers) for all of Agramonte's religious casas (Hilario "Melao" Fernández Sosa and Minita Baró Quevedo, interviews, December 31, 2007). Today, Ma Gose's fundamentos are still housed in what is now called Templo de San Manuel, where she danced Arará (Minita Baró Quevedo, Israel Baró Oruña, and Melao Fernández Sosa, interviews, December 31, 2007).

Our interlocutors who spoke of Ma Gose ranged from their mid-40s to their 90s, and included her great-grandchildren, great-great grandchildren, and other Agramontean elders. According to her closest living family at the time of our first interviews, several of her objects came from West Africa, in particular, her *collares*. Mario José, who attended one of these first interviews, offered that in Dahomey, "they had those secrets under the skin and once they got here they got them out" ("y ya tenían las cosas dentro de la piel, debajo de, y lo que hacían era que la sacaban," December 31, 2007). Whether these stories are true or not is not relevant to her story. They are

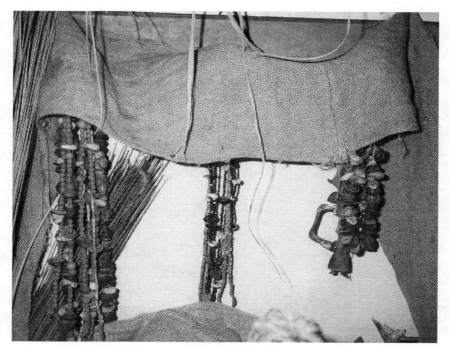

Figure 6.1. Ma Gose's collares. Photo by Jill Flanders Crosby.

proudly and firmly held beliefs, and thus form an important oral history connection back to West Africa. They also form a tangible connection through physical objects that help anchor oral history to material history.

Making Water Fall

Ma Gose is described as wearing a wide apron. She gave candies to children, she parted her hair with a knife, and on San Lázaro's celebration days she wore a tartan skirt with 17 bells hanging from the hem (Israel Baró Oruña and Onelia Fernández Campos, interview, December 31, 2007; Margarita Fernández Campos, interview, April 11, 2008). During the dry season, Ma Gose threw water upwards, spoke in the Dahomeyan language, and rain began to fall on her property. That is why on January 1, during a ceremony still occasionally held at Ma Gose's casa-templo by her great-great grand-children in order to continue tradition, people still throw buckets of water—so much, in fact, that the water reaches the railroad located about one

kilometer away (Mario José Abreu Díaz, interview, December 31, 2007, and April 9, 2008).

One time, Mario José recounts, the police arrived during a celebration at her house. Because they thought she did not have the official permission required for that celebration, they took Ma Gose, in trance, to jail. Every time the guard fell asleep, he would suddenly awaken to find Ma Gose outside her cell, sitting by his side.

"Oh, I left the cell unlocked?" the guard asked.

"Son," Ma Gose said, "take me to my house, for the celebration can't continue until I return."

The guard ignored her, taking her back to her cell and making sure it was locked.

Eventually, Lieutenant School arrived and asked why Ma Gose was in jail. The police took her back to her house, and "when they got here, the two officers were possessed . . . [they] had to put away their guns and uniforms" ("dicen que cuando llegaron aquí, se subieron los guardias aquí . . . los dos guardias hubo que guardarle el fusil y guardale la ropa," Mario José Abreu Díaz, interview, December 31, 2007).

Melquíades Leopoldo Fernández recounts Ma Gose's legendary generosity. She once helped a penniless woman pay for an initiation ceremony to San Lázaro. Ma Gose's godchildren brought this woman a blanket to sit on and the required headscarf for the ceremony. As some others did, she "paid with roasted kernels of corn" ("y tú sabes con que pagaron con granos de maíz tostados," interview, April 9, 2008). When mice ate those kernels of corn, the initiated woman continued to pour more roasted corn into containers (corn is an important attribute of San Lázaro). That was her way of paying her santo and Ma Gose.

Agosifi, San Manuel, and Naná Burukú

Now wrinkles are introduced into the stories. According to Israel and Onelia, Ma Gose came to Agramonte from Unión-Fernández as Agosifi (interview, December 31, 2007). Several other informal interviews with Melquíades, Minita, Margarita, and Ma Gose's great-great granddaughter Alicer Baró Fernández suggest differing reasons for the name Agosifi. Agosifi was Ma Gose's African name, or it was due to the African dialect, or it is the name of her birth deity, or possibly even her consecration name.

When people are initiated to the worship of their birth deities, they are given "consecration" names to add to their given family names. In Spanish, the birth deity is the *santo de nacimiento* or guardian angel. One receives this birth deity when initiated into the religion (Arará or Lucumí), and from that day forward, that initiation day is celebrated every year. Alicer's neighbor, Luciano Hernández Juara, whose father was close friends with Ma Gose's grandson Atilano, told us that Atilano always gave the name of Ma Gose's casa-templo as Agosi Sumayayá (Sumayayá or Asumayayá is the name of one of her San Lázaros). But it is likely that Agosi is a phonetic abbreviation of the name Agosifi.

When Ma Gose arrived in Agramonte, according to Israel and Onelia, she carried all her fundamentos with her, but most importantly, she came with San Manuel ("principalmente uno que le dicen San Manuel"), who is celebrated on December 31—January 1 (interview, December 31, 2007). In Cuba, San Manuel is celebrated December 31 (with some ceremonies on January 1) because according to the Arará practitioners, December 31 is the day one pays homage to the king of Dahomey (Vinueza 1988 [1986], 48–49). Israel and Onelia did not know an Arará name for San Manuel, but during their interview, Mario José (also present) clarified that Ma Gose's house, which he says also has Naná Burukú, celebrates San Manuel on January 1, the same day that Naná Burukú was born. Both Melao Fernández (in a separate interview) and Mario José contend that Naná is a serpent and lives in wells that are near ceiba trees. But when pressed about the names of Ma Gose's San Lázaros, also regarded as foundational to Ma Gose's casa-templo, Mario José responded that syncretism (sincretización) blurs boundaries of names (interview, December 31, 2007).

During Margarita and Onelia's interview in December 2008, Margarita commented on Agosifi's celebration taking place on January 1. San Manuel, Margarita argues, is a line of that "deity" and its form is "como una serpiente" (like a snake). When I asked Margarita about that deity's Arará name, Margarita replied, "Danagosi." Margarita was our only interlocutor who ever referenced the name Danagosi. However, Ma Gose, Margarita commented, did not become possessed with Danagosi, but she did fall into trance with her San Lázaro. San Manuel's path, Margarita continued, is that of a snake, and is related to the rainbow.

But Danagosi is not the only word used for a deity as a serpent or snake. During an interview, Melao called out the name Malé as equivalent to

Adayi "lord snake" ("Adayi don majá") and commented that people call him Osain but he is San Manuel, a "21" (a serpent),[4] and he crawls all over town (interview, December 31, 2007). The question for us was always whether Ma Gose's San Lázaro thus became blurred with San Manuel (with the path of a majá), or the two simply had a "relationship" with each other, as is often quietly suggested in Perico between San Lázaro and a majá. Ma Gose is mentioned as having San Lázaros that were strong and relevant to the community, but her important day of celebration is San Manuel's day rather than San Lázaro's day on December 17.

Minita, also an important religious elder in Agramonte, referred to Ma Gose's casa-templo in this way: "Well it was not San Lázaro's, it was of Dayiemejuddo and he is celebrated on January 1, San Manuel . . . which is related to San Lázaro" ("Bueno, en si no era de San Lázaro, en si era de Dayiemejuddo que es el del día 1, que es San Manuel . . . es una rama de San Lázaro," interview, December 31, 2007). In a 2008 interview (April 9), when she called the name Dayiemejuddo, she added the attribute "the divine doctor," and Roberto Pedroso García immediately chimed in, "San Manuel." Interestingly, the name Dayiemejuddo is similar to the name Dan Ayido Huedo (also seen as Hwedo), the rainbow serpent, commonly understood as ruling over and protecting the Dahomeyan kingdom (Brown, interview, November 10, 2017; Mason, interview, October 13, 2017).[5] It is also similar to Da, meaning "snake" in Ewe and a vodu deity.

Asumayayá and Nanú

But what about Ma Gose's San Lázaros? During Onelia and Israel's interview with Mario José present, he offered that Ma Gose had the San Lázaros known as Asumayayá and Ananú (often shortened to Sumayayá and Nanú), and that they are the strongest of her casa-templo. Margarita also tells us Ma Gose had Asumayayá. But according to Margarita, Ma Gose only fell in trance with Nanú, a path of San Lázaro, and she claims that Nanú is also a "21." Nanú, she recalls, is male and female and a father and mother to all the troops of San Lázaros (interview, December 17, 2008). In an earlier interview with Margarita, she had recounted that Ma Gose actually made her fundamentos with Asumayayá, the male San Lázaro, alongside the female San Lázaro, Nanú (interview, April 11, 2008).

While Minita refers to Ma Gose's casa-templo as that of Dayiemejuddo, she does know that Ma Gose brought Asumayayá, an important San Lázaro, with her from Unión-Fernández. She says that he (Asumayayá) leads the troops because he is an elder (interview, April 11, 2008). Everything at Ma Gose's house was from Africa, she adds. Yet Minita argues that her serpent belonged to something different ("la serpiente era de otra cosa") and that it is not a path of San Lázaro.

Finally, Melquíades also acknowledges that Ma Gose came to Agramonte with the most important San Lázaro from Unión-Fernández. However, he called her house the house of Nanú, and assumed she was Lucumí, not Arará. Since Onelia, Israel, and Margarita all refer to Ma Gose as having both Arará and Lucumí deities, perhaps this is why Melquíades believes she was Lucumí. Melquíades recounts that, when Nanú possessed Ma Gose, she took her two crutches,[6] and then two more deities would come down— Ochofire with a flag in front of her, and Asumayayá in the rear, with Ma Gose (Nanú) in the middle. Her Nanú, he said, beat the drum in a very peculiar way, different from the other drummers. But Melquíades also says Ma Gose had Acrojonú. Lázara Graciela, born in Unión-Fernández on December 17, 1915 (San Lázaro's celebration day), called Ma Gose's deity Cuarayajibó and said that San Lázaro always has a basket of food (interview, April 9, 2008). Melquíades and Lázara were the only two elders who ever mentioned either one of these names.

Untangling Ma Gose

Clearly, Ma Gose had several of the "troops of San Lázaro." From all of the stories we heard, we believe that her consecration name was indeed Agosifi (perhaps from an African dialect), perhaps Danagosi; her birth deity day is that of Dayi/Dayiemejuddo/San Manuel/Danagosi; she celebrated on January 1, San Manuel's day; but she also had strong San Lázaros known as Nanú, Asumayayá, and perhaps Acrojonú and Cuarayajibó. While there is a well in Ma Gose's backyard with a ceiba tree at its edge, there is some confusion over the name of who lives in the well. Even if it is indeed Naná Burukú, the lines of her serpents seem to have blurred together. The deities on her altar that have been identified by a combination of her relatives (primarily Margarita) and the house's current neighbor, Luciano, are San Manuel, Danagosi, Asumayayá, Nanú, and Nana Burukú.

Figure 6.2. Ma Gose's fundamentos. *From back left*, San Manuel imbues the smaller white sopera and Danagosi imbues the right sopera. *Front center*, Asumayayá imbues the left cazuela and Nanú imbues the right cazuela. Naná Burukú is just to the right and behind Nanú with the white bowl on a saucer, and with a saucer for a lid. Photo by Melba Núñez Isalbe.

Alicer relied on Luciano to give us more accurate information about Ma Gose's altar than Alicer herself had. We have also heard that Ma Gose initiated an elder named Florentino Madan (Papa Tusa) to the worship of San Lázaro and that Ma Gose gave San Lázaro's celebration day to Florentino's casa-templo while she chose to retain her consecration day for Danagosi/San Manuel. Florentino's son, Nemesio Lázaro "Madan" Baró, currently keeps December 17, the celebration day for San Lázaro, strong.

Ta Andrés, "Coso Coso"

While in West Africa, Ta Andrés heard chants from somewhere in the distance. He recognized the chants, despite the fact that they were being sung incorrectly. Ta Andrés followed the source of the singing until he noticed a ship, on which Ma Gose had already or was about to become enslaved.

As social memory recounts, Ta Andrés was also tricked into boarding that same day (Minita Baró Quevedo, interview, December 31, 2007, and January 1, 2018).

Minita, Ta Andrés's great-granddaughter, claims he was someone whom the owner of Unión-Fernández counted on for everything. Everyone in the mill, even the doctors, called for Ta Andrés when someone was sick. Ta Andrés was treated as an equal and was "more in command than the real owner of the mill" ("Él era ahí uno más, que más bien mandaba él que el rey del ingenio, que el dueño del ingenio," interview, December 31, 2007).

According to Minita, Ta Andrés and Ma Gose were both equally the heads of Ma Gose's Sociedad Africana San Lázaro. But when Ta Andrés was about to die, he went to Ma Gose's to find Sisto, her son, who was now in charge rather than Ma Gose. Ta Andrés told Sisto that he did not want to be here anymore, he did not like what was to come, and he was not going to keep on living in this world. Ta Andrés then went home and told his son Desiderio not to go to Unión-Fernández that day because when Desiderio returned, Ta Andrés would no longer be alive. Discounting the story, Desiderio left for Unión-Fernández on his horse. On the way, he reached a ceiba tree that grows at the intersection of four roads, when an immense whirlwind would not let him take the road to Unión-Fernández. As Minita says, "[He] said to himself, 'ah, my father.' He thought about his father and came back. But by the time he got here, my great-grandfather was already dead" ("y dice, 'ah mi papá.' Y le dio la idea y cogió y le metió al caballo y cuando llegó aquí, mi bisabuelo se había muerto," interview, December 31, 2007). And so, says Minita, Sisto was now in charge. Ta Andrés died in 1904, thirteen years before Ma Gose.

Ta Andrés's powers of healing are legendary. Once, in Unión-Fernández, a young boy named Quintín drowned while bathing in a pond (*la lagunita*). All the "Congos" (practitioners of Palo) went to la lagunita dressed in white and began to sing "in Lucumí, in Iyesá, in many tongues" ("en Lucumí, en Iyesá en no sé qué, en una pila de lenguas," Minita Baró Quevedo, interview, April 9, 2008). By four in the afternoon, Ta Andrés and an elder named Mamá la Vida began singing Dahomeyan chants. Suddenly, Quintín, who had been in la lagunita since eight in the morning, emerged from the water, completely dry.

Those gathered asked Quintín where he had been. According to Minita's recollection, Quintín said, "I cannot tell anyone what I saw, not even my

mother. If I say it, I will die. And since I do not want to die, I will not tell anyone anything" ("No lo que yo vi, no se lo puedo decir a nadie, ni a mi mamá. Si yo lo digo me muero y como yo no quiero morirme, yo no le voy a decir nada a nadie," Minita Baró Quevedo, interview, April 9, 2008).

Minita also described how Ta Andrés once brought his son Desiderio back to life. Desiderio apparently had an argument with an old man when they were both working with oxen. Desiderio got angry and hurt the elder with a goad ("una cosa de esas con que se pincha a los bueyes"). This elder put a curse on Desiderio ("una cosa de esa de brujería"), and later, a wagon ran over Desiderio, killing him.

Desiderio was taken to the infirmary, where candles were lit and flowers set around while Ta Andrés was summoned. However, Ta Andrés, who knew everything in advance, went to the infirmary and ordered that all the candles and flowers be taken away, and that Desiderio be taken to his own bedroom. He locked himself and his son in the bedroom, and when the door opened,

> my grandfather [Desiderio] went out running really fast. Everyone began to cry "dead man walking dead man walking" because we didn't know what he did inside there. He brought his son back to life and went to sit on the *taburete* [a wooden chair with goat skin] in front of the house.
>
> Cuando se abrió la puerta, lo que salió fue un mil quince de allá adentro que era mi abuelo corriendo por todo el batey. Y la gente y los viejos, "un muerto ya viví, muerto ya viví" porque no sabemos lo que hizó alla adentro. Pero lo vivió y entonces fue para allá y se sentó en el taburete delante de su casa. (Minita Baró Quevedo, interview, December 31, 2007)

Elders with Serpents

According to Minita, all the enslaved Africans at Unión-Fernández had serpents, and they were not taken away because the slave owners feared snakes (interview, April 9, 2008). Perhaps enslaved Africans sensed something of agency that came in the form of a serpent, that which persists and instills fear in their captors. Ma Eduarda was Ta Andrés's sister and, according to Minita, arrived on the same boat with Ma Gose and Ta Andrés (interview, January 4, 2018). Ma Eduarda had serpents. But her legend goes further.

At her house in Agramonte she kept a stone that gave birth to a new stone every year. This reproduction began the year that Ta Andrés came to Agramonte. Stories of stones that live and reproduce are not uncommon. Bascom's 1948 fieldnotes from Jovellanos reveal similar stories (Palmié 2018, 789–791). That fecund stone, says Minita, is used for religious purposes.

Once, Minita's cousin Bocachula fell down a well at Ma Eduarda's old house, where Bocachula's mother was then living. Those present at the house did not know which chant they had to sing to get him out safely. But Minita was able to help thanks to her father's teachings. Minita stood on the opposite side of the street so that she would not only not see what she did not "have to see" ("no tenía que ver"), but because she wanted to stay out of the spotlight and did not want to be seen, as fame was not important to her. Minita began to sing the proper chant for Naná Burukú (born on the same day as San Manuel), spoken in the proper tongue, and suddenly, Bocachula appeared. Witnesses called it a miracle. Minita, of course, did not tell anyone what she had done (interview, April 9, 2008).

Minita laments that the well is now merely a sewer. Those who now live in Ma Eduarda's old house will never be happy, she comments. For not only is the former well not respected anymore, but neither were Ma Eduarda's deities. They were removed from the house and taken elsewhere. They should have been left there, she says—perhaps dusty, but inside "their" house. Memories of deities and their associated sacred forms clearly crossed the ocean. But it seems that once a stone or a fundamento is in Cuba, elders contend that it does not like to be moved.

Then there is María de la Cruz, who, says Minita, lived all by herself with her serpents.[7] Melao recounts that he was born prematurely, and was dying. María de la Cruz left her place and came to the house where he had been born.

> I remember she had two serpents inside an earthenware jar. I was immersed in that jar and with that she made me medio santo and here I am . . . her name was María de la Cruz Baró and she was Atilano's mother. (Atilano was the son of Sisto and María de la Cruz.)
> me acuerdo que en una tinaja tenia dos majases y llegó me metió ahí y me hizo medio santo con eso y mírame . . . ella se llamaba María de la Cruz Baró que era la madre de Atilano. (interview, December 31, 2007)

As we traced stories of serpents, majás, snakes, Ma Gose, and San Manuel, we spoke to Margarita on December 17, 2008, about Danagosi and San Manuel/San Lázaro as paths of snakes. Suddenly, we got swept into the world of Perico. As Margarita called out the name of Danagosi, we mentioned Malé, the Perico name of a similar deity (whose celebration day is January 1). Margarita immediately responded with the name of Fidela Zulueta of Perico, who was consecrated to Malé.[8]

"Eso de Malé se quedó in Perico," Margarita said of Malé remaining in Perico. But Margarita continued her story by stating that Fidela's family was like family to Margarita's. They loved each other deeply and Fidela loved Margarita's father dearly. Whenever her father went to Perico he always stayed at her place.

"Justo Zulueta era como un padre para mí," Margarita said, remembering Justo, who was also once Fidela's lover, as a father to her. "Muy buena gente, familia."

Embodied Dancing

The day Núñez Isalbe, Pedroso García, Matthews, and I all accompanied Mario José to Agramonte's associated la laguna Ramona for the first time, the visit was deeply felt and we would talk about it for days. We felt something tangible there, even in its intangibility. What we felt there in the quiet space of la laguna were the past lives and histories that belonged to the sacredness of Ramona. As we stood beside Mario José, he narrated stories that helped weave la laguna's magical spell. The following night, we accompanied Mario José to a ceremony in the nearby community of Jovellanos for San Manuel on January 1, also known as Dan in Jovellanos.

In Jovellanos, the ceremony began, and almost immediately Miguelina, the matriarch of the Jovellanos Baró family, became possessed. The energy was high. A bell hung in the middle of the ceiling with a rope attached to it that ran to the wall. The rope was frequently pulled so that the bell joined in with the rhythms of the drums, heightening the intensity of the ceremony. Mario José's dancing became deeply evocative, even before he fell into trance, as he enfolded and unfolded into and out of the creases of his body, seemingly reaching into a deeper well of meaning and pulling forth the histories, stories, and contexts of Arará in Agramonte. Watching Mario José dance, one could smell laguna Ramona and see the ceremonies, hear

Figure 6.3. Laguna Ramona. Photo by Brian Jeffery.

the sounds at Unión-Fernández and glimpse Ma Gose speaking her Da-homeyan language, throwing her bucket of water, with rain falling around her. It was the histories, stories, and contexts that infused his dance with such passion. It is the histories, stories, and contexts embodied in Arará music and dance that continue to give it power and life.

During one of the last ceremonies I attended at Ma Gose's on the eve of December 31, 2015 (when San Manuel's celebrations often begin), Onelia, now with advanced dementia, was gently led into the main room to a chair in front of Ma Gose's altar by Alicer. She sat quietly, seemingly unaware of much around her—until the drums began. Her body began to dance first through her hand, as if beating the drum, then more of her body moved until finally she was standing. Although her body could no longer move as it once had, the memories and histories of how and why seemingly pen-etrated the fog. She became immersed in memories, history, Ma Gose, and all things Arará.

Notes

1. When one falls into trance, one receives clothing or articles of the colors and attributes of the deity who comes down—in the case of Mario José, those of the road of his San Lázaro Alua. Often, a person will travel to a ceremony with special clothing should he or she fall into trance.

2. Early societies and cabildos had kings (los reyes) and queens (las reinas). Later, they had presidents (Vinueza 1988 [1986], 42).

3. According to Israel Baró Oruña, concrete floors were formerly not admissible in a religious house.

4. In Cuba, a lottery has been in place since before the revolution in which the number 21 is represented by a snake. Thus people commonly use the word 21 to refer to a snake. "It's a 21."

5. An internet search of the name Dayi Ayido Huedo (Hwedo) turns up multiple and common entries also attesting to this fact.

6. Some San Lázaros are considered advanced in age when they arrive and mount a person. Thus, the person mounted is given crutches with which to walk.

7. Perhaps Minita was describing María de la Cruz, who was married to Sisto, in her later years when she said that María lived by herself.

8. Michael Atwood Mason surmises that Oshumaré (the oricha of the rainbow and the serpent) has evolved to become Ocha (a common contraction of oricha) Malé (e-mail to author January 5, 2021).

7

Becoming History

The Many Lives of Justo Zulueta

Of all Justo Zulueta's curious characteristics, what might be the most peculiar was his refusal to tell anyone his real age. Not only did Guyito mention Justo's refusal to share his age, but Macusa also said Justo preferred she call him "uncle" rather than "grandpa." Here was a man with powerful deities, a man himself almost deified, and yet he seemed to be painfully aware of his own mortality. Part of me (Flanders Crosby) wonders if the two qualities—deification and mortality—are actually in opposition; rather, stories of Justo suggest they co-create one another. Justo and his deities protected Perico for many years, and yet he feared the banal: being caught in the nude, not looking fashionable, and sharing his age.

In order to approach the vastly complex figure of Justo, Flanders Crosby and Torres combine their writing methods, choreographed narrative and true fiction, to explore the curious relationship Flanders Crosby has had with this towering figure. True fiction pertains to the ways information about Justo was organized into the following story. Elements like dialogue, scene construction, and plot organization rely on literary strategies. What remain true are the details, descriptions, and events. Employing choreographed narrative, multiple voices are brought together in a singular performance to compose this chapter. The "I" in this text will refer to Flanders Crosby.

Justo was born in 1882, four years before slavery was abolished in Cuba (1886). Because of the Moret Law, which stated that all children of enslaved people born after 1870 would be "free" (Scott 2001, 97), Justo was not born into slavery. In a variation on Justo's origin story, Vladimir Osvaldo Fernández Tabío, Justo's great-nephew, told us that Justo's mother, Dolores

Campos, arrived from Africa pregnant, and Justo's freedom was "bought" by other enslaved Africans who recognized his spirit in his mother's womb. Reinaldo named Pastor Zulueta as Justo's father. After tracking down official paperwork, Vladimir told us that Justo's father was called Dionisio Zulueta, but he could not clarify whether Pastor was Dionisio's nickname or vice versa, whether Dionisio was Justo's biological or adoptive father, and why Dolores's last name is Campos and not Zulueta if she arrived enslaved. These matters will remain a mystery.

Mystery invites mythology. Many elders associate Justo with pop culture. Guyito referred to Justo as a "liberato criollo," a reference to a Cuban soap-opera that aired during the 1980s. The main character, Liberato Criollo, lived in a sugar mill, but was free. The similarities are important to the cultural memory of Justo, as Guyito gushed at the resemblances between the show's star, Idelfonso Tamayo, and Justo. Other elders, and descendants frame Justo as prophetic. Vladimir recounts the common story of an ancestor in Africa of whom Justo reminded the elders. According to Justo's great-grandson Armando Omar Pérez Méndez, that ancestor was a beloved prince who had the same santo as Justo. During a ceremony long ago, while in trance with a deity, the prince warned his people of dark times ahead in which they would be enslaved and taken to a faraway land and face unthinkable hardships. This prince promised his people that, even far away in space and time, they would be protected.

He foretold of a man who would be born in this faraway land, and this man's birth would signal the end of their hardships. In return, the man was to be consecrated and confirmed exactly as the prince was consecrated and confirmed.[1]

Ma Florentina, the African princess, became something of a spiritual mother to Justo. She introduced Justo to María Virginia, with whom Ma Florentina established Sociedad Africana. And María Virginia would eventually become Justo's godmother, the one who gave Justo his Obatalá/Oddu Aremu.

Oddu Aremu is not an easy name to trace. According to Moore and Sayre (2006) the name Odu (single d) Aremu appears in a Lucumí canto (chant) and may be a reference to Oduduá, an *oricha* that is associated with a walk of Obatalá (131–134). In personal conversations I had with both Brown and Mason about the name Oddu Aremu, both immediately raise the name Oduduá or Oduá in association with Obatalá. Brown further

adds that he also knows the name Oddu Aremu in a Lucumí canto sung by Lázaro Ross,[2] while Mason mentions Odu as a very powerful road of Obatalá (David Brown, interview, November 10, 2017; Michael Atwood Mason, interview, November 11, 2017).

Bolívar Aróstegui's book *Los Orishas en Cuba* (1994) does not specifically cite the name Oddu (or Odu) Aremu, but she does describe the Lucumí path of Obatalá Ogán where Obatalá comes from the city of Oduaremú (106). A document titled *Falsas Deidades dentro la Supuesta Familia de Obbatala* (*False Deities within the Alleged Family of Obbatala*), forwarded to me by Mason (via David Brown, who found it on internet), declares that Odua Aremu (as spelled in the document) is a scam and should by no means be received.

For Justo to receive Oddu, he had to walk barefoot on the hot ground to the ojo de agua of the España lagoon. Once he arrived, elders threw Justo in the water, even though he did not know how to swim. The elders then placed white sheets on the ground for Justo to walk back to España. To complete the ceremony, they sang to the deities. For over half an hour, quiet sun-tipped ripples were all that could be seen. Miraculously, as if guided by the songs, Justo emerged from the lagoon, his body dripping wet and reflecting the sun's harsh glare. At first, it was difficult to look at him, all that radiant light like the burning glow of an eclipse. As he got closer, though, it became difficult *not* to look at him. He could have been a spring bloom, a grapefruit sunset, a loved one seen for the first time. He carried in his mouth the precise herb for Oddu Aremu.[3]

From that moment on, the elders established a *fundamento* at el ojo de agua for Oddu Aremu.[4]

Midialis Angarica Galarraga tells us that Oddu Aremu is Lucumí. Estela "Estelita" de los Ángeles Santuiste knows Oddu as Lucumí and Somaddonu,[5] a name not many in Perico know, as Arará. When we talk to interlocutors who know of Somaddonu, it is in reference to a deity understood to be Oddu Aremu's twin, brother, or companion. According to Andreu Alonso (1997, 28) Somaddonu can be the Arará Obatalá. He continues on to say the Dahomeyan cult of Erzili or Erzulie is also identified with this deity. Fernández Martínez (2005, 83) claims that the cult of Zomadonú (as she spells it) must have been introduced by a member of Dahomeyan royalty since only members of the royal house of Abomey worshiped this deity. Rivero Glean (2011, 144) writes that Zomadonu (no accent) was one

Figure 7.1. Justo's fundamentos underneath Justo's altar. Somaddonu imbues the smaller white sopera on the back left, while Oddu Aremu imbues the larger sopera on the front right. Ochún imbues the container with the ceramic hen lid. Photo by Melba Núñez Isalbe.

of the most powerful spirits of the royal family in Abomey and adds he is a six-eyed monster who was born with teeth, hair, and beard. Brice Sogbossi (1998, 38) adds Zomadonou (no accent) is the main deity of the Nesuxwe pantheon, which refers to the monsters of the royal family of Abomey.

During a 2007 interview with Perico drummer Kikito Morales Iglesias, he identifies Oddu and Somaddonu as brothers—indeed, twins. One, he says, lives in the sacred well behind Justo's house while the other lives inside. Reinaldo always insisted that Oddu Aremu and Somaddonu are the same except that they have different paths. He would physically point out Oddu and Somaddonu, both of them in their individual white *soperas,* living side by side underneath Justo's altar.

According to Andreu Alonso (1997), Somaddonu lived with Ma Florentina (28). When Florentina died, her goddaughter Victoria gave Somaddonu to Justo. Andreu Alonso spells Oddu as Ordu-Aremó (49) to identify a male Obatalá, while Aremó signifies a prince or heir to the throne (49). Somaddonu, he adds, is identified with Las Mercedes (Our Lady of Mercy), the Catholic collective term for the Lucumí deity Obatalá, the owner of

all heads, whiteness, and purity (Obatalá may also be represented by the Catholic image of Las Mercedes [Bolívar Aróstegui 1994, 117]). As such, Somaddonu is the Arará Obatalá (28). Additionally, Andreu Alonso refers to Somaddonu as a she (44).

Armando insists that Oddu Aremu is most likely Lucumí. Marcos Hernández Borrego believes that Justo's Oddu is Arará, but he does not know anything of Somaddonu. Adela de las Mercedes "Mamaíta" Corbea also identifies Justo's "Mercedes" as Arará. In an interview with Valentín Santos Carrera, he argues that María Virginia, who many in Perico agree is the one who gave Justo his Obatalá (Oddu Aremu), received her Obatalá[6] from Africans and did not consecrate to any Lucumí santo.[7] This information is supported by Andreu Alonso (1997): "Justo received from his godmother, Virginia Zulueta, an Arará by birth, the deities still extant there . . . that passed on to his descendants when he died" (25).

This suggests that Justo received an Arará, and not a Lucumí, Obatalá. Both Midialis and Armando argue that Oddu Aremu was actually Justo's consecration name. In Mason's fieldnotes from his interview with Aurora Zulueta in 2000, she told him clearly that Justo had made Obatalá and that "his name in santo was Odu Aremu" (e-mail message to authors, November 29, 2017). An Agramontean interlocutor also mentioned this, but more clearly pronounced the name to fit with the spelling given by Andreu Alonso (1997) as Ordu Aremó (49).

After Justo's consecration, María Virginia said to him, "You are now part of its history."

"We all are," I imagine Justo saying.

"Like the branches of a sacred tree, reaching out across the land, reminding all who see its leaves that their roots are still alive."

It was January 2, 2018, when we were able to dig down deep into local contradictions about Oddu Aremu with Vladimir, now in charge of Justo's house following Reinaldo's passing. Vladimir insists on the validity of his knowledge because of the significant time he spent with his uncle Reinaldo discussing Justo's legacy, and the fact that, in turn, Reinaldo spent significant time with Justo, learning as much as possible. Reinaldo, Vladimir told us, deeply upheld the religious history of Justo's house, and was responsible for getting his house officially registered as a casa-templo. Oddu Aremu is definitely Arará, Vladimir argues. He acknowledges that there is a path of the Lucumí Obatalá known as Oddu, but because Justo's Oddu is male,

it is Arará. Not only that, there is no other Oddu Aremu like Justo's in Cuba—but there is in Africa. This information came from Reinaldo, who had heard it from Justo. Justo, in turn, was told this information by the elders who consecrated Justo. Furthermore, says Vladimir, María Virginia and Ma Florentina not only gave Justo Oddu Aremu, but they also gave him San Lázaro with Afrá, an Arará Hevioso, an Arará Ochún, and Somaddonu, who is older than Oddu. This reveals a slippage in Andreu Alonso's narrative (1997, 28), which claimed that Somaddonnu was passed on to Justo after Ma Florentina died.

According to many of our interlocutors and Brown (2003, 128–143), as Lucumí religious life encountered significant change, reform, and innovation during these years, its popularity surged. However, Vladimir argues that, as Lucumí became more popular, Justo did not want anything to do with religious things "a lo moderno" (modern). Finally, Vladimir insisted that Oddu Aremu is not only Justo's deity, but it is simultaneously Justo's consecration name.

Midialis adamantly interprets Oddu Aremu as Justo's consecration name, which means heir or prince (Midialis Angarica Galarraga, interview, December 31, 2015). Whether Oddu Aremu is Lucumí or Arará will remain a discrepancy among differing memories, the oral history legends of Perico, and scholarly Arará and Lucumí work. It is Justo, himself, however, who is the story worth sharing.

I have, obviously, only seen Justo in photographs. One photograph in particular, now a part of Justo's altar, came alive beyond the verbal mention of his name the first time I saw it. In it, Justo stands between two horses, one of his hands on each of their individual bridles. The horses appear completely under his command, as if the mere flick of his wrist could charge them into a gallop or call them to an instant halt. Justo stands tall, head slightly cocked to the right. He is cleanly dressed in a white button-up shirt and white trousers held up by a belt from which his horse crop hangs. There's a sense of purity about the photo. Justo's expression is confident, yet calm, the expression one might expect on someone accepting an exceptional destiny. The photo does not suggest pride, but a powerful resolution at being the "foreman that he was," as he was described by Macusa.

This photo once sat in Justo's favorite chair, the one he always used, particularly on the day of his big celebration for Oddu Aremu. Some years after

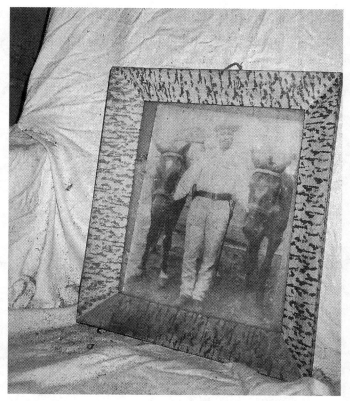

Figure 7.2. Justo's picture in Justo's chair. Photo by Jill Flanders Crosby.

Justo died, Reinaldo made Justo's chair a part of the altar, draping it with a white cloth and a sign that says "No sentarse" (Do not sit here). Susan Matthews painted a picture of the chair as part of the *Secrets Under the Skin* installation, albeit without Justo's picture in the chair. I take it to mean Justo himself is sitting there rather than his photograph. Now, Vladimir's *muñeca* (doll), representing his *muerto,* called Francisco, sits in this chair.

Some time around the turn of the twentieth century, the España mill began downsizing, displacing several workers who had once been enslaved. In Perico, an administrator for España named Sánchez[8] had rows of small houses built. Justo, Ma Florentina, and María Virginia each moved into one of these houses.

On an economic level, displacement required nothing more than a couple of signatures from wealthy landowners; on a religious level, it required

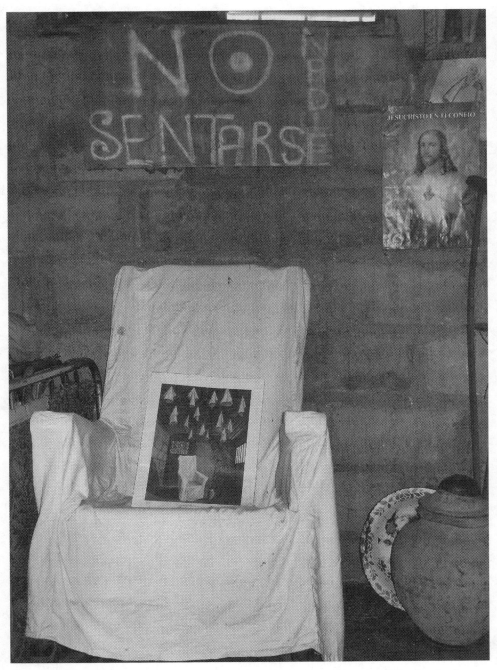

Figure 7.3. A print of *Justo's Chair* (2010) by Susan Matthews in Justo's chair. Photo by Jill Flanders Crosby.

a serious ceremony. In general, fundamentos do not like moving, especially after finding a home, which they had done in España. Oddu Aremu had a strong connection with el ojo de agua of the España lagoon, where Justo had seemingly disappeared in the water. The water was like a portal to Africa. No matter where in the world He was, He could reside in it and instantly feel the familiar soil of a land known as home. To convince a fundamento to move, an important ceremony must be held.

The elders organized a *rogación grande,* an important set of prayers, for the deity. They spent the day gathering Oddu's favorite herbs and praying, asking Oddu to consider a new home in Perico. After Oddu agreed, Justo began gathering all the necessary food, drums, clothing, tobacco, and rum. In the meantime, Vladimir told us, Justo had to ask all the other santos for permission. One by one, he made small offerings in their favor, until Oddu's day finally arrived on September 24. Eventually, after moving to Perico, Justo would keep three bodegas (storage rooms or "warehouses") for Oddu's day each year.[9]

At first, it seemed as though Oddu would find a home suitable for the deity in Perico. In Justo's home, built in 1905, was the altar for Oddu: multiple old and new statues of Las Mercedes of varying sizes, photographs and layers of popular culture and mass-produced objects and images. Featured prominently on Justo's altar is a huge statue of Las Mercedes. It came from a man called Mario Regoyard, whose daughter Mercedita is named after Las Mercedes, said Hilda. Mario came to Justo's house to stand before Justo's altar and asked for his wife to be blessed with a child. After his wife got pregnant and his daughter was born, he gave Justo the statue as a gift to place on the altar

Justo's casa-templo is known by multiple names: the house of Oddu Aremu and Somaddonu, the house of Obatalá, and also as the house of Las Mercedes. These names are also all interchangeable for Justo's deity. Of the four names, Oddu Aremu is most frequently called by our interlocutors. When Oddu Aremu is called, it is usually in reference to Justo's actual deity itself.

For years, it seemed the prophecy Vladimir and Armando remember had been fulfilled. Stories of Justo and Oddu's divine protection are many. Once, when a hurricane was headed straight for Perico, Oddu had Justo place a malanga leaf and a bottle of water behind the door of his house. The hur-

Figure 7.4. Justo's altar. Photos by Brian Jeffery (*top and middle*) and Melba Núñez Isalbe (*bottom*).

ricane turned away before reaching the city. When storms threatened the annual *tambor* for Oddu every September 24th, Justo stood in the middle of the street, possessed by Oddu, and redirected the winds. Rain would fall on the entire town except Justo's house, where the ceremony occurred.[10]

As the years passed, Justo's roots spread deep into the history of Perico. It is said that he had at least 44 children, including Reinaldo, whom I first

met on a brief tour of religiously significant houses in Perico when my research first began. His genuine generosity, trust, and friendship led to many subsequent afternoons spent deep in discussion over several years. Justo's love for Reinaldo and the wonders of Oddu Aremu are apparent in one of Reinaldo's stories. Once, when Reinaldo was only 5 years old, he spilled boiling milk all over himself. He screamed and instantly Justo appeared at the door. Everything in Justo's hands fell to the floor, including his walking stick. His eyes went white. Oddu had possessed him, and when he lifted Reinaldo the burning instantly stopped. He then carried his son to Andrés, their doctor.[11]

Justo's most interesting romantic relationship of which I know might have been with Fidela Zulueta, also known as Chichí. She was the last African relocated from España to Perico. From the descriptions I've been able to gather, Fidela was a strong woman who always looked at people with a stern expression, as if she expected everyone to do something wrong. The wind stirred seconds before she appeared. She also had a *bastón*, which she would use on anyone who irritated her.

The two of them spent many years together. She would sit in the rocking chair across the room from Justo's favorite chair, the one he used during all his celebrations.[12] While Justo had many lovers, his relationship with Fidela, whether as friend or lover, might have been the longest. Fidela grew hard of hearing and began having difficulty walking. But according to Hilda, when the "saints came into her head" ("los santos venían en la cabeza") she danced beautifully, like she was transformed into a young woman.

"You really had to see it" ("Había que verlo"), Hilda said. "Lindo, Lindo, Lindo, Lindo." Beautiful.

Despite the relative peace Justo experienced, despite his roots becoming entangled with Perico's, Oddu would grow restless.

Vladimir recounts a story about Oddu becoming upset with Justo without a clear reason. Oddu stated He would no longer possess Justo. With the elders' help, a ceremony had to be performed in which Justo tied several sashes of various colors around his waist, making a skirt. Twin brothers were placed at Justo's either side, possibly referencing Oddu Aremu and Somaddonu. For hours the drummers' hands danced on the taut skin of the sacred instruments, calling for Oddu's forgiveness in a steady rhythm. Finally, Justo became possessed, and everyone was grateful.

But Oddu was not appeased. Not long after, He possessed Justo and decided once and for all He would return to el ojo de agua,[13] that sacred portal connected with Africa, a place that existed in memory, at home in history.

Of course, I can't speak for a deity, but I wonder about the themes in these stories. Perico was becoming something new, something distinctly Cuban, and Oddu wanted to return to el ojo de agua, and ultimately to Africa. How can I not think about conflicts of history and diaspora, of the hope for retention and the necessity of invention? Was Oddu conscious of those traditions that are invariably lost in the creation of new ones? Did Oddu fear getting lost in the same wrinkles, layers, and folds of multiple truths inherent in the passing of time that we as researchers fear?

Only Fidela, in trance with her deity Malé, could stop Oddu. And how she did it will always be remembered.

Like the story of Fidela, the most intriguing stories of Justo are told differently, depending on who is doing the telling. At first, it seemed that each story was one and the same, with slight variations made by elders, each one having a uniquely shaped memory of the same event. Guyito confirms that all versions, while some slippage still exists, are indeed true. "Well, I am Justo's granddaughter, and that happened when many elders like him were alive" ("Bueno, soy nieta de él, según cuando existían grupos de más coterráneos de él sucedió eso"). These slippages at first frustrated me. Which story was "right?" With time, however, I grew to embrace the slippages, for they offered multiple points of view into a complex oral history about Justo, Oddu, and the lagoon. Few left in Perico, if any, know for certain "what really happened." As is frequently the case with cultural memory research, the fixed "figures of memory" become recontextualized through contemporary and localized perspectives (Assmann and Czaplicka 1995, 130). Crystallized stories, each with their own refractions, remain.

Even the story of Las Mercedes on Oddu's altar has variations. Reinaldo has a slightly different story from Hilda's. One year, during a possession at a ceremony, "the deity" ("el santo," meaning Oddu Aremu/Las Mercedes) made signs for all present to say hello to all of the existing Las Mercedes plaster statues on Justo's altar. But the sign, muses Reinaldo, was as if the deity was saying, "You need a bigger statue." The following year, someone brought the large statue of Las Mercedes that dominates the altar, and not even Justo at first knew why it was there. "She was baptized upon arrival.

It was really something," ("Cuando vino la bautizaron, no aquello fue un fenómeno"). Neither right nor wrong, slippages helped me piece together plausible possibilities. The community of Perico forms a rich tapestry of legend that animates religious life. The approach now is not to seek that absolute truth, but to offer possibilities of what might be by trusting the slippages, even when they don't trust themselves.

Fidela's deity, Malé, is commonly believed to manifest as a *majá* (snake). Hilda and Marcos both tell me that Malé's wife is Juerdase, the Arará name for the Lucumí Ochún in Perico, the deity of sweet water and femininity. Fidela and her fundamentos imbued with Malé and Juerdase lived for a while on Camilo Cienfüegos street. They shared the house with her sister Fabiana, who had the old Arará Hevioso. Later, Fidela moved to Malé's present house on José Márquez. Inside the house is the altar for Malé and

Figure 7.5. Fidela's fundamentos imbued with Malé (*left*) and imbued with Juerdase (*right on plate*). Back left is a second fundamento imbued with Malé, while Fidela's San Lázaro imbues the back right cazuela. Photo by Miguel A. Parera.

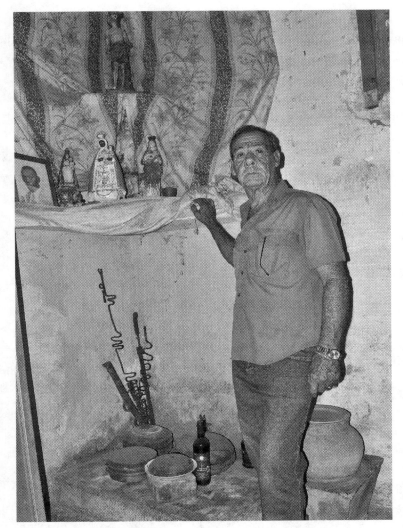

Figure 7.6. Fidela's fundamento imbued with Osain stands in the left corner. Marcos Hernández Borrego stands on the right. Photo by Miguel A. Parera.

Juerdase. Malé imbues a *cazuela,* and Juerdase imbues the form of a white ceramic plate covered with a single cazuela top. In a corner, accompanying Malé and Juerdase, sits Fidela's Arará Osain. According to Kikito, Malé wanders all around (Alberto "Kikito" Enrique Morales Iglesias, interview, December 20, 2007).

Indeed, Malé has been known to use the now-sealed well behind the house to travel throughout Perico. Malé apparently is quite a traveler,

since He first lived at Fabiana's Hevioso house and continued to travel from Fidela's new house to Fabiana's and from well to well. Traveling between wells and communication across wells in the Perico community is not unusual. According to Hilda, Malé also travels from the cemetery where Fidela is now buried to visit Hilda's house. Malé also lives in a hole in the cross at Fidela's gravesite and no one knows why or how that hole was made. Even with this freedom of mobility, however, Malé prefers His house, and especially the avocado tree in the backyard. When she was much older, Fidela would call her grandson Nicolás and his friend Kikito to climb up the tree in her backyard and knock down the avocados. She explicitly gave them two warnings: "Throw the first avocado on the ground so that it breaks. And don't look down. Do that and everything will be good." This, she assured them, would keep Malé pleased. A similar process is followed at Justo's house with his avocado tree: the first avocado goes to the well behind his house, and somewhere in his yard lives a snake.

On January 1 Fidela would roast two whole hens for Juerdase. January 1 and December 31 are important dates shared by many deities identified with San Manuel, the Catholic santo celebrated on this day (it just so happens on this same day, Justo celebrates for his Palo muertos María Vence Guerra, who is related to the Lucumí Oyá, and Mayimbe Cunga). Fidela would also have new clothes from head to toe and prepare a mat to sit on with striped towels that carried all the colors of the rainbow (although of course Juerdase's, according to Hilda, are never as vivid as Malé's). The towels would be accompanied by two bottles of sweet wine, a new washbowl, and the roasted hens. Hilda tells us that as a daughter of Eleggua, a male deity, Hilda could never get close to her grandmother on that day, since Juerdase only has one husband.[14]

It was some time around the end of September when Oddu made His final decision to return to Africa. Fidela was across the street, but as soon as Oddu made His decision, she fell into trance with Malé. She danced brilliantly, her body like a pulsing star.[15] When Oddu stepped outside, Malé stopped Him.

"We will grow old in Cuba," Oddu said.

"There is no place greater than time," Malé replied.

As they argued, two rainbows formed above Justo's house. One of the

rainbows faded in the darkening clouds while the other rainbow was so radiant it silenced the sun. The sky went dark as rain drummed the earth.[16]

"History is a measure of death." Oddu had tears in his eyes, even as he continued his dance with Malé.

"And it is the story of life."

Oddu lowered his head. The light that had radiated from Him His entire life softened, becoming the subtle shade of dusk, until only Justo could be seen, gray as evening rain, leaning on his bastón. He went to Fidela and they embraced. From a distance, they looked like the entangled banyan roots of a timeless tree.[17]

Years later, Justo would pass away close to midnight. His family did not inform Fidela; she was elderly, and she had her own things to worry about. Hilda recounts that at the cemetery, where they played Arará, Fidela approached. Hilda says, "Malé was the one who arrived . . . he [Malé] got her out of bed."[18] According to Marcos, no family member of Hilda's can ever live in Fidela's old house on José Márquez. Before passing away, for whatever reason, Fidela announced that it would be better to have the house burned than have a family member live there.[19] Ultimately, a woman named Adelina "Melo" Ferrín was chosen by Nicomedes Zulueta, Hilda's mother, to live there instead. Before Melo could move in, however, the coconut was thrown for Malé, who agreed to let Melo move into the house.

Melo was a rather quiet lady, and, while the research team spent a few afternoons with her, she really did not like to talk about Malé or the house, nor would she let us interview her. I was fortunate to be able to see and photograph the fundamentos imbued with Malé and Juerdase in 1998. Little had changed when I returned in 2017 and could finally see Malé's altar once again.

On May 18, 2018, I finally saw a picture of Fidela. Melba and I found her great-granddaughter Ismari Caridad Diago González, who was a daughter to Mercedes, in nearby Cárdenas. Mercedes was a second daughter to Nicomedes and a sister to Hilda. Fidela was described to me as rather plain, with a sharp nose, mostly by several male interlocutors. In the photo, she stood in the middle of her family, her hand resting on Hilda's shoulder. Hilda had her first son in her arms. Also next to Fidela were Nicomedes, Fabiana, and Mercedes. It was a stunning family photograph capturing three generations of strikingly beautiful women who were all very well-dressed. Fidela in particular demonstrated a fierceness in both her stance and her gaze at the

Figure 7.7. Fidela's family. *Back row, standing, left to right*: Nicomedes Zulueta, Fidela Zulueta, and Mercedes Zulueta. *Front row, sitting, left to right*: Fabiana Zulueta, and Hilda Zulueta holding her first son. Photo by Miguel A. Parera.

camera, as if she stared directly into history, challenging its authority. "Just try to define me," she seemed to say.

No wonder she and Justo were each other's equals.

Today, Fidela's house is, for the most part, religiously "inactive." She seems to be remembered primarily by Hilda, Reinaldo, and Marcos, despite the significance of her relationship with Justo and her deity Malé. While Justo sired 44 children by many women, he only had one child with Fidela: a daughter. Nicomedes Zulueta. "My grandmother's saint is quite mysterious," says Hilda. Uncertainty is the skin of history. As historiographers, what we know can only be told with caution. Nothing, not even a deity, is free from the reach of time.

Notes

1. Reinaldo Robinson: Fíjense que ellos, con todas las cosas que ellos trajeron, lo pusieron a él allá porque era lo mismo, aquél era el mayor de allí en dar la consagración, era igualito, esa es la historia que yo he oído.

Reinaldo Robinson: When they [elders] brought everything here, my father like that [previous] ancestor [who remained in Africa] became an important figure inside religion. They said dad was exactly like him, that's the story I've heard (Reinaldo Robinson, interview, January 21, 2006).

Armando: Tengo otra historia de Justo que dice que allá había un príncipe que tenía las mismas raíces que adquirió aquí por medio de los africanos. El dijo, "Van a ir para una tierra lejana que le van a hacer la consagración y la confirmación a un hombre que va a ser igualita a la mía cuando ustedes se vayan."

Armando: There's another story that talks about an African prince who had the same roots and characteristics Justo acquired in this land through those Africans [elders]. The prince said, "You will go to a faraway land and once there, there will be a man whose consecration and confirmation will equal mine" (Armando Omar Pérez Méndez, interview, May 21, 2017).

2. Lázaro Ross was an important practitioner who helped found Conjunto Folklórico Nacional de Cuba. He was an eminent *apkwón* (singer) in Lucumí and Arará.

3. Reinaldo Robinson: Dicen que estuvo allá abajo media hora ó 45 minutos sin saber nadar y salió. Dicen que salió con la yerba que llevaba en la boca. Ese cuento me lo hizo él a mí y entonces la consagración fue desde el central España hasta la laguna ésa una calle de sábanas blancas por arriba de las sábanas blancas, sin zapatos.

Reinaldo Robinson: It is said he was down there [in the lagoon] around half an hour or 45 minutes. He didn't know how to swim but he got out of the lagoon carrying in his mouth the precise herb [needed for Oddu]. And during his consecration, he walked from España, the mill, to the lagoon. They placed white sheets on the ground and he walked over them barefoot (Reinaldo Robinson, interview, April 11, 2008).

4. Guyito Zulueta: Y entonces queda origen de fundamento que se llama el ojo de agua del central España que ahí estuvo Oddu Aremu.

Guyito Zulueta: then the origin of the "fundamento" is at the ojo de agua of central España, Oddu Aremu was there (Iraida Zulueta Zulueta, interview, December 18, 2008).

5. We spell Oddu Aremu following Vladimir's spelling preference as learned from Reinaldo.

6. According to Andreu Alonso (1997, 49n25), María Virginia's fodú was Saborissá (also known as Aggayú, father of Hevioso). However, we have not found any other reference to this deity during our interviews.

7. Valentín: Bueno María Virginia en aquella época a ella le hicieron la ceremonia ellos los africanos para Obatalá, ella lo único que tenía era Obatalá no tenía más nada. Su sopera con su Obatalá adentro, era lo único que ella tenía.

Valentín: in those times Africans made her a ceremony for Obatalá. She only had Obatalá, her soup-tureen with her Obatalá inside. That was the only santo she had (Valentín Santos Carrera, interview, December 18, 2007).

8. In many stories, Reinaldo references an "administrator" named Sánchez who organized the relocation to Perico. We have not been able to verify this interpretation.

9. Hilda "Macusa" Zulueta Dueñas: era mucho porque él vivía ahí tenía tres bodegas para esa día.

Hilda "Macusa" Zulueta Dueñas: it was a lot because he lived there and had three

bodegas (storage) for [Oddu's day] (Iraida "Guyito" Zulueta Zulueta and Hilda "Macusa" Zulueta Dueñas, interview, December 18, 2008).

10. Hilda Zulueta: de las hojas de malanga. Oddu cuando había ciclón mandaba poner una hoja de malanga detrás de la puerta y una botella de agua y quien te dice que con eso se alejaba el ciclón, quien te dice a ti que con eso se alejaba el ciclón, esa es una. Estaba lloviendo como ha llovido los días de las Mercedes que la gente casi no ha podido ir al tambor.

Hilda Zulueta: a ceremony with malanga leaves. When a hurricane was approaching Oddu would say we had to place a malanga leaf and a bottle of water behind the door. Those two things made the hurricane go away. Sometimes it would rain a lot near the celebration day of Las Mercedes and people couldn't attend the tambor (Hilda Zulueta, interview, December 20, 2007).

Hilda Zulueta: Entonces se paraba en el medio de la calle con el sosi, haciendo sus ceremonias, lo que decía no sabemos, pero sabemos que hacía sus ceremonias y llovía en una parte del pueblo y para acá para el tambor no llovía.

Hilda Zulueta: Then he would stand in the middle of the street holding the sosi and making his ceremonies. We didn't know what he said, but we did know that he made his ceremonies and it only rained in one area of town. The area where we were having the tambor remained dry (Hilda Zulueta, interview, December 20, 2007).

11. Reinaldo Robinson: Ahí le vino el santo a la cabeza y él fue el que me cargó y me llevó a donde estaba Andrés.

Reinaldo Robinson: Oddu came to his head, he lifted me and took me to Andrés (the doctor) (Reinaldo Robinson, interview, April 11, 2008).

12. Vladimir told us this information about Fidela in her chair opposite Justo during an informal conversation in May 2018.

13. The tragic irony of el ojo de agua is that while some believe the ojo to be a spring, it is in actuality a natural recession that had filled with rainwater. If our musings are accurate, and Oddu represents the longing for the source of tradition, a home in history, then el ojo de agua is the symbol of diaspora, a door that has been shut. Stephan Palmié might also find this symbol amusing in the context of "Afro-Cuban" scholars seeking a similar source.

14. Hilda Zulueta: Una señora de un solo marido.

Hilda Zulueta: [Juerdase] is a woman meant to have only one husband (Hilda Zulueta, interview, January 21, 2006).

15. While Guyito confirmed this story, she could not verify a return to Africa. It was Hilda who stressed the return to Africa.

16. Hilda Zulueta: Mis mayores decían que el arco iris, uno era de Malé el de los colores vivos y el del color más clarito era Juerdase que es la mujer de Malé y cuando salen, que a veces va a llover empieza a bombear está bombeando el agua.

Hilda Zulueta: My elders used to say there were two rainbows, one with striking colors for Malé and one with faded colors for Juerdase, Malé's wife. When they appear in the sky and it's about to rain, water begins to spill (Hilda Zulueta, interview, January 8, 2006).

17. Reinaldo Robinson: El santo de Fidela (Malé) lo haló.

Reinaldo Robinson: Fidela's santo (Malé) pulled him back (Reinaldo Robinson, interview, April 11, 2008).

18. Hilda Zulueta: Que era que Malé era el que llegaba . . . la levantó de la cama.

Hilda Zulueta: when she arrived, Malé was already on her head . . . yes, he (Malé) got her out of bed (Hilda Zulueta, interview, January 21, 2006).

19. Marcos Hernández Borrego: Lo dijo antes de morirse que antes de que la familia viniera a vivir ahí que la casa cogiera candela.

Marcos Hernández Borrego: She (Fidela) said it before passing away that she'd rather set her house on fire than allow her family live there (Marcos Hernández Borrego, interview, January 2, 2016).

8

The Notebooks

JT TORRES

Musicians in Cuba

One of the reasons music has such spiritual qualities in Cuba is because of its relation to daily life and to the sacrosanct. Arará, which has roots in West Africa, shares much of what Paul Stoller and Cheryl Olkes (1987) describe during Stoller's experiences in Niger:

> The sound of the *godji* penetrates and makes us feel the presence of the ancestors, the ancients. We hear the sound and know that we are on the path of the ancestors. The sound is irresistible. We cannot be unaffected by it and neither can the spirits, for when they hear it "cry," it penetrates them. They then become excited and swoop down to take the body of the medium. (174)

Within the context of religious ceremony, music contributes to what Judith Becker (2004) calls a "habitus of listening" (71). Of course, she borrows the term from Bourdieu, but uses it to understand the relationship between music and lived experience. This concept can be situated within an Arará *tambor.*

Extending Becker (2004), the habitus of listening in the context of Arará is one in which the rhythm of the drums, the African-influenced lyrics of the chants, and the dance movements all guide the individual's attention to a particular focus and shape *how* those individuals listen (71). In other words, the drums are not just listened to or appreciated; they direct the mind, body, and soul to perform in a particular way (Nodal 1983, 163). For

this reason, music is as sacred to those who descended from the Arará as a temple might be to someone who was raised in Judaism. In the shadow of Carpentier's (2001) *Music in Cuba*—and what an impressive shadow it is—this chapter, through a true fiction interpretation of a series of interviews, dramatizes the tensions of keeping sacred the musicality of Arará religious expression.

The Perico and Agramonte interviews that inform the true fiction here primarily include a December 28, 2015, interview among Jill Flanders Crosby, Melba Núñez Isalbe, Roberto Pedroso García, Susan Matthews, and Jesús Alberto Morales Varona (Jesusito); a May 21, 2017, follow-up interview among Jesusito, Jill Flanders Crosby, Melba Núñez Isalbe, and JT Torres; and a December 18, 2005, focus group interview in Perico with several musicians and elders, including Hilda Zulueta.

The Notebooks

The sky opened up just as Hilda and María approached casa de Quito. The rain fell in sheets that quickly flooded the uneven streets. Carriages pulled by horses splashed by and children played in the pools of rainwater. The scarf on Hilda's head became heavy with water. She and María huddled as close to the entrance of the house as possible without entering. The door was open, but no one could be seen.

"*Buenas,*" Hilda said, and her voice echoed in the empty house.

Finally, a young woman with her hair pulled back appeared. She had a suspicious look, like she was hiding something.

Hilda began to explain the reason for their visit—that they needed to look through the notebooks Quito had left behind. Despite the rain dripping into her eyes, her feet drowning in lukewarm puddles, Hilda wore a pleasant smile. She spoke warmly, like she was talking to a close relative. This, however, was only the second or third time she'd seen this woman.

"María's granddaughter is attending a ceremony in Varadero," Hilda explained, in a tone as sweet and light as meringue. "Time has had its way with our memory and we cannot remember the chant for when San Lázaro is recovered from being buried."[1]

The woman's expression didn't change. She was pretty, with the wet light of rain reflecting in her eyes and loose threads of silky hair that rested perfectly on her cheeks. "I can't help you," was all she said.

"But the notebooks?" María said, fast and sharp, the complete opposite of Hilda's approach.

"The notebooks weren't meant to be seen by anyone."

"Then why create them?"

Hilda placed her hand on María's shoulder, a signal for her to calm down. As quickly as it started, the rain began to let up. The returning sun turned the air sticky and hot.

"They were for my uncle. Each rooster sings in his own henhouse."

"That's what Eleggua says," Hilda said, excitedly, as if that were a point of relation among the three women.

The woman nodded without the slightest change of expression. "I don't follow religion."

Hilda tried to hold onto her smile, like it was water in her hands.

"Look," the woman said, her face finally softening into a show of empathy. "I don't understand all of this. But Quito was a good uncle. It was his wish. I'm sorry."

Hilda nodded and kissed the woman on her cheek. She and María headed back home, avoiding stepping into the deeper parts of the flooded streets.

Quito was the *gallo*, the lead singer, for Sociedad Africana. As a gallo, he was responsible for preserving songs and directing their performance. While alive, he kept three notebooks that contained Arará chants used in ritual ceremonies. These were chants sung to specific deities and at certain times. The sacred music of Arará, its drums, its dances, its relationship with the spirits (sometimes referred to as *muertos* or *egguns* and deities) relied on the chants. Without them, they couldn't be sure the deities would answer their calls. In song form, these chants told of a long, complicated history that spanned Cuba and Africa, enslavement and freedom, and the ocean of possibilities between. Quito carried the notebooks around in a small briefcase, which he would bring to *tambors*. He used the notebooks to remember chants, perform them, and as a guide for those who came after him. Before he passed, he told his niece not to let anyone see them, and said that if she didn't want them, she should bury them. His niece has since kept her word, not sharing the notebooks with anyone.[2]

There are, however, still some who remember them, such as Lazarita

(Angarica Santuiste). She is daughter of Ñuco, Prieto Angarica Diago's brother. As the current gallo, she belongs to the family that is keeping alive Ma Florentina's Sociedad Africana. She attended tambors with Quito and always stood beside him, reading the words to each chant off his notebook. If she pronounced something incorrectly or began a chant out of order, Quito would correct her. Sometimes, rare as it was, he would hand a notebook to Lazarita so she could study a chant, but she was never allowed to take one of them home with her.

Eventually, however, Lazarita began keeping her own notebook, writing down everything she could glean from the glimpses of Quito's notebook during tambors.[3] For many years, Lazarita's recording has served as the most commonly accepted order of chants.

When Quito stopped going to tambors and Lazarita began leading the chants, she followed the notes she had kept. Once, however, Hilda leaned close to her and whispered that she was singing out of order, that the chant she had just started did not follow the previous one.[4] Lazarita paused, letting the others continue to sing without her lead. Instantly, she wished she could ask Quito why he had changed the order, why he hadn't followed the notes that were so precious to him. By that time, however, she was not able to ask Quito any such question.

Lazarita was practicing her singing when Hilda and María arrived, their clothes still damp from the day's earlier rainfall. Lazarita had aged gracefully. Her skin retained its glow, and her voice had matured, so she sang with the depth of a sacred well. She invited Hilda and María into her home and sat with them on the wooden chairs in her living room. María asked Lazarita what chant she had been singing.

"Abobobo aguerese illara boguae, abobobo aguerese illara boguae, illara boguae, illara yagüe, illara boguae, illara yagüe aquerese, aquerese iyara yagüe." Lazarita paused, cleared her throat. She seemed to be as light as the air when she sang, like a majestic bird calling to the sky. "It's for Juerdase, Malé's wife."[5]

They told her about Quito's niece, about the impossibility of ever seeing the notebooks. María asked Lazarita if she had ever recorded the chant for when San Lázaro is recovered from being buried.

"Not that one. Quito was very protective."

Hilda sighed. "The elders take all the knowledge with them to the grave.

Then they complain that the younger generations don't care enough, don't learn the right way. But how can they?"

If indignation could be seen, it would look like this: Hilda's rain-soaked body steaming in the late afternoon heat.

It's possible Quito wasn't religiously motivated. He had told his niece that if she didn't want the notebooks, she should bury them in their yard. It is also said that at Quito's wake, his family forbade an Arará ceremony. Anyone wanting to honor *el difunto* (the deceased) gallo would have to hold the tambor at their own house.

While Quito's family mourned at the *funeraria,* Aurora, Armando Zulueta's niece, appeared, possessed by San Lázaro. There was nothing Quito's family could say in the presence of such a powerful deity. With their hearts changed, Arará music was played while they carried Quito to the cemetery.[6]

The deities find a way.

Besides Lazarita, possibly the youngest person to have seen the notebooks was Jesusito, María's son and a drum prodigy from Perico. Hilda and María found him at his house on a refreshing Sunday morning, the breeze carrying cooler air from the sea. Jesusito, a man with soft, round muscles and a look of deep curiosity, was arguing with a group of people. Jesusito, shirtless despite the cooler weather, fiddled with his gold necklace.

"Why not play many styles," one of the others said. "Then anyone who attends a *toque* [a playing of the drums at a religious ceremony] can relate to the music regardless of their religion."

"Yes," said another. "We must continue to evolve with the times. Things aren't so traditional anymore."

"It's not right," Jesusito said. His face lit up when he saw Hilda and María, as if they were the validation he needed. He walked over to them and kissed each on the cheek. He turned back to his guests and said, "Arará is Arará and Lucumí is Lucumí."[7]

He walked Hilda and María to the couch and offered them seats. After they were seated comfortably, Jesusito gave María a look of expectation, as if he needed her to support his argument.

"It's like the chant for Obatalá," Hilda finally said. "Eunde llama lo dia, eunde llama lo de—"

"That's for San Lázaro," one of Jesusito's guests said.

Hilda shook her head. "Exactly my point. Mixing the styles leads to confusion."[8]

The others politely stood, as if sensing the futility of arguing any further. They waved to Hilda and María as they left.

Jesusito sat in a wooden chair across from the couch and sighed. "Nothing is sacred to them. They only hear the music, not the meaning within it. I can't stand seeing the Arará drums disrespected. Most ceremonies, I'm there without really being there."

Hilda and María nodded in agreement, as hard as it was to hear of Jesusito's disillusionment. This was a drummer, after all, who had earned the respect of multiple communities in Matanzas Province. He played in Perico, Agramonte, and Jovellanos. He was fluent in many languages of the drums and could perform any variation in musical style, including Lucumí, Arará, Bembé, Güiro, and Cajón. María, his proud mother, deeply loved Jesusito, who had been, in her eyes, hope for future generations. Jesusito learned how to play the *caja* from Cuito, a legendary drummer from Perico. The resemblances were clear signs of fate: both Cuito and Jesusito had the Lucumí Ochún, both were left-handed, and both had begun playing the drums at seven. Even when Jesusito was very young, people recognized Cuito's gift in him, so much so that when Cuito died, Perico simultaneously felt the grief of a tragic loss and the elation of hope for the future.[9] Since his late teens, Jesusito had been the one to take the glass and call down the egguns during a ceremony. He was the one who communicated with the spirits.[10]

María told Jesusito the reason for their visit and asked if he remembered the chant for San Lázaro. He did not.

"It's impossible to see Quito's notebooks," María said.

Jesusito laughed.

"What's funny?"

He waved off the question like it was lingering cigar smoke, but he couldn't swallow his smile.

Hilda had to know what had made him laugh. Jesusito knew all too well about those notebooks, for Cuito wasn't his only teacher. It was true that Cuito had passed down his gift for playing the caja, but from Quito Jesusito had learned the *meaning* behind playing the drums, the significance of each rhythm, the history of each lyric.[11]

When he was no older than eleven, Jesusito would cross the street from his

family's house and enter the shoe repair shop owned by Quito.[12] The shop was one of the only concrete houses on the street. There, people would visit Quito with their damaged boots or torn loafers for him to stitch, glue, or shine. If Quito was working, Jesusito would drum on discarded, hollowed-out shoe boxes, arranged as if they were the real thing, a *cachimbo* and *mula* with the caja in the middle. Sometimes, Quito would stop what he was doing to correct Jesusito's playing. When he wasn't busy, Quito would answer Jesusito's questions about Arará.

"Why can't I play at a tambor yet?"

"You're too young."

"Why can't my sister play?"

"Only men can play."

"What is that you are making?"

"It's an amulet."

"Can I have it?"

"Yes."

Other times, Quito would reverse their roles and ask Jesusito questions. One day, after feeding the drums the food and herbs preferred by their associated deities, Quito asked Jesusito if he knew where the drums came from.

"From Africa," Jesusito quickly said, proud that he knew.

They stood outside Sociedad Africana, the sun beaming down.

"Did Africa give them directly to you?"

"No."

"You must know where things come from. Yes, Ma Florentina brought the drums from Africa. In Perico, the drums belonged to Malé's house, but there were no men to play them there. The silence made Malé sad. The drums should be played! So He found a way to call attention to Sociedad Africana. The drums were moved and Cuito could finally play them."[13]

Jesusito nodded. When Quito spoke, Jesusito stared at him with eyes open so wide it was like he was trying to see all of the earth in one glimpse.

"The drums in Agramonte are similar," Quito continued. "They are made exactly as in Africa. Hemp and skins. No string. No rope. It was this way with Ma Gose's wedge drums. Things must be done as they always have been."[14]

Quito was, besides Hilda, the only person who freely shared information with Jesusito and taught him many of the secrets he wouldn't fully under-

stand until he was much older. It was Hilda who told him that the real name for drums is *jun*.[15] Aside from those two, Jesusito would have to wait until elders were possessed to ask them questions. Hilda said it was because the deities saw how pure his desire to know was, and that that was something ordinary people could not yet see.[16]

"It's so much information," Jesusito said, but he wasn't complaining. Sometimes it just felt like he had to plug his ears with his hands to keep the knowledge from spilling out like water.

"You must remember it all," Quito said.

As Jesusito grew older and began playing at ceremonies, Quito practiced with him, using his notebooks. There in his shoe repair shop Quito would explain the meaning behind everything related to the drums, such as how the drummers guided the runner during the *awán*. He told Jesusito a story about how Luis, who ran the *canasta* (basket) from the ceremony to its burial spot, took an unusually long time.[17] It's the drummers' responsibility to guide the runner without fail. And should he get lost, the caja would let everyone know. When Luis finally returned, Hilda scolded him, and said that he had "almost killed the drummers."[18]

During one tambor, Quito opened his notebook and turned to a particular chant. He instructed Jesusito to play while he sang. Jesusito noticed that Quito sang differently from the words in the notebook. Afterwards, Jesusito said to Quito, "You sang it wrong." It sounded more like a question.

Quito laughed. "How so?"

"The notebook says, 'agama, agama isa ocure cure dagoro sú' . . . You said something else."

"Yes. A chant for the Arará Obatalá. He likes this version."

Jesusito scratched his head. He didn't think much about "being wrong" when playing the drums. The music filled him with an energy that directed his hands, that guided him. It was like the drums played him, not the other way around. But with the chants, it was different. He didn't understand why Quito would sing the words differently from how they were written.

"Every performance must be a new experience," Quito said. "Don't get so stuck on a single word that you miss the song."

"Then why have the notebook at all?"

Again, Quito laughed. He sat down and placed his hand on Jesusito's shoulder. "Let's say you go to the beach just as the sun begins to set on the horizon. You see the sun splitting the ocean with a long gold river of light.

You want to record such an experience, so you draw it. Years later, your children show you the picture and ask you to describe that experience. You do so, and they argue, 'But that's not right. That's not how it is in the picture.' Did you remember it wrong?"

Jesusito had been tapping the tips of his fingers on the taut skin of his drum along to Quito's explanation. He could not answer the question.

Quito slapped his thigh and stood. "These notebooks are the most meaningless part of it all. They are a reference, but not the performance. Just like with the picture."[19]

The story comforted Hilda and María, who had listened with such concentration that as soon as Jesusito finished speaking, it felt like they were waking from sleep. Their minds had to readjust to consciousness, to the sting of daylight.

"*Claro*," was all María said, trying hard not to gush at her son's wisdom. Jesusito could counsel her, just as she did him when he was a child.

After a few minutes of silence, listening only to the gentle breeze scratch the tin roof of the house, Hilda and María stood and kissed Jesusito on the cheek. They began to accept that they would most likely never see the notebooks again. In place of despair, however, Hilda tried holding on to the hope Jesusito inspired in her. While walking home, Hilda sang, "Aggidai nasaoro efe enado do mido efe enado mido nasaco do mi do e."

To which María responded with the chant sung to Aggidai at the close of a tambor, giving thanks to the deity: "Aggidai nasaoro efe ena domido."

Notes

1. Hilda: y hace falta porque es un San Lázaro que va a hacer una ahijada de María en Varadero.

Hilda: And we need it [chant] because one of María's goddaughters will consecrate San Lázaro [to someone else] (Hilda Victoria Zulueta Zulueta, interview, December 18, 2006).

2. Hilda: Si él se las dejó antes de morirse. Le dijo, "Tú me las recoges y no se las des a nadie, si tú no las quieres, las entierras en el cementerio."

Hilda: Yes, [Quito] left [the notebooks] to [his niece] before passing away. He said to her, "You keep them and do not give them to anyone. If you do not want them, bury them in the graveyard" (Hilda Victoria Zulueta Zulueta, interview, December 18, 2006).

3. Lazarita: Si porque en mi libreta está puesto como Malé, ¿por qué?, porque no sé si me hago entender que hace muy poco conozco esos santos con ese nombre, no tengo dominio de cómo es el verdadero nombre de cada santo en esta rama, entonces para mí se me hace fácil decirlo así porque no tengo dominio.

Lazarita: In my notebook this appears under the name of Malé, why? Because I need you to understand those santos are all new to me and I do not know the name of each santo in Arará, so it's easier for me to use Yoruba (Lucumí) names (Lazarita Angarica Santuiste, interview, January 21, 2006).

4. Hilda: Fíjate que él [Quito] estaba últimamente que lo llamaban para [el] tambor y no quería ir y a Lazarita se le pegó bastante porque ella lo sentía cantar y escribía y ella andaba con una libretica y tú la veías siempre escribiendo algún canto. A veces él trastocaba el canto y ella entonces lo escribía y yo le decía "Mira, tal canto que él cantó ahora no va ahí. . . ."

Hilda: Lately he [Quito] did not even want to attend any tambor. They [those of the community] called him and he would not go. Lazarita learned a lot because she listened to him and wrote down the chants. She was always writing the chants in a notebook she carried with her. Sometimes he changed the order and I would tell her, "That chant he just sang does not follow this other" (Hilda Victoria Zulueta Zulueta, interview, December 18, 2006).

5. Hilda: Juerdase lo bailaba con un plato de miel.

Hilda: Juerdase dances [that chant] with a saucer full of honey (Hilda Victoria Zulueta Zulueta, interview, December 18, 2005).

6. Lazarita: la familia no le quería tocar, nosotros sí queríamos tocarle porque era un integrante más de nosotros, entonces se estaba velando en la funeraria y ese mismo día había toque aquí en casa del difunto Raúl en casa de Yolanda y el San Lázaro de la difunta Aurora salió de aquí y fue directo para la funeraria y sacó el muerto de aquí y lo llevó para allá y vino a buscarnos a nosotros aquí.

Lazarita: His family [Quito's] did not want us to play Arará and we did want to play for him because he belonged to our tradition. The very same day he was lying in the funeral home, we were having two tambors in town, one at Yolanda's and one at Raúl's. Aurora [niece to Armando Zulueta] in trance with San Lázaro went directly to the funeral home, took Quito['s corpse] out and came here looking for us (Lazarita Angarica Santuiste, interview, January 21, 2006).

7. Jesusito: En los toques por ejemplo que ahora hay una mezcla de Arará con el Lucumí y que yo no estoy de acuerdo en eso porque una cosa es una cosa y la otra es la otra. Los muchachos que están tocando ahora están mezclando todo eso, mezclan el Arará con el Lucumí, mezclan el Arará con el Gangá, mezclan el Arará con no sé qué, mezclan el Arará con la rumba, mezclan el Arará con el guaguancó y eso no está bien. Entonces los mayores que quedan, como Ñuco, como Prieto, como mi papá—pero mi papá no—ellos dos Ñuco y Prieto no le dan un pare a eso. Si ellos son los que mandan y son los dueños de eso ahí y no le dan un pare a eso ¿se lo voy a dar yo? Yo ya voy muy poco a eso por esa situación porque no me gusta que mezclen una cosa con la otra.

Jesusito: people are mixing Arará with Lucumí and I don't agree with that. Arará is Arará and Lucumí is Lucumí. The young generations of musicians are mixing Arará with everything—with Lucumí, with Gangá, with rumba, with guaguancó, with I don't know what, and that ain't right. The elders that remain, Ñuco, Prieto, and my father [Kikito]—not my father—Ñuco and Prieto do not do anything regarding that. If they are in charge [of the Arará drums] and do nothing about it, what can I do? I seldom attend any [Arará] toque because I don't like that mixture (Jesús Alberto Morales Varona, interview, December 28, 2015).

8. Hilda: La juventud de ahora te ponen cantos de Changó como si fuera de Obatalá, cantos de Eleggua como si fueran de Changó, y no es posible. Cada santo tiene su canto y su significado.

Hilda: Nowadays the young generations are mistaking the chants. For them Changó's are Obatalá's and Eleggua's are Changó's, and that is not correct. Each santo has a chant and each chant has a meaning (Hilda Victoria Zulueta Zulueta, interview, January 21, 2006).

9. Kikito: El difunto [Cuito] tenía hecho Ochún y era zurdo y él nunca pensó, porque era uno de los cajeros más grande que había en el Arará, por lo menos en esta provincia de Matanzas. Él nunca pensó que él se fuera a morir y que dejara un relevo para ese tambor, un tambor de fundamento, de mucho respeto.

Kikito: The deceased [Cuito] was consecrated to Ochún and was left-handed and he never thought, being one of the greatest caja players of Arará in Matanzas Province, he was going to die and leave a follower of this highly respected tambor, a *tambor de fundamento* (Alberto "Kikito" Enrique Morales Iglesias, interview, January 26, 2006).

10. Hilda: Fíjate que cuando se va a iniciar el Arará, Jesusito siempre coge el vaso, no sé si tú te fijaste, y moyugba a todos los antecesores del Arará, dondequiera que nosotros vamos es Jesusito el que moyugba, por eso hay que moyugbar antes que nada los muertos. Primero todos los muertos de la Sociedad Africana, los mayores de este pueblo, y después moyugbar los muertos míos y él los de él que es el que está moyugbando también.

Hilda: When Arará is about to begin, Jesusito is the one who takes the glass, I don't know if you noticed, and calls all the Arará ancestors. Wherever we go he [Jesusito] is the one who calls the ancestors. First we must call all the muertos of the Sociedad Africana, the elders of this town, and then all the muertos of my family and of his family as he is the one who's making the call (Hilda Victoria Zulueta Zulueta, December 18, 2005).

11. Jesusito: Quito también que él explicaba, que para mí Hilda y Quito eran los únicos que explicaban.

Jesusito: Quito also explained many things to us. Hilda and Quito were the only ones who gave us much information (Jesús Alberto Morales Varona, interview, December 28, 2015).

12. Jesusito: Ahí lo que había era una zapatería porque él era zapatero. Yo siempre estaba ahí.

Jesusito: He was a shoemaker and there was his shoe repair shop. I was always there with him (Jesús Alberto Morales Varona, December 28, 2015).

13. Jesusito: Ese tambor es de allí, de Malé Ta fodu Malé, lo que pasa es que el tambor era de allí, pero allí no había hombres para tocar el tambor. . . . Entonces los que tocaban el tambor eran la gente de la Sociedad. Hoy yo te presto el teléfono y mañana te vuelvo a prestar el teléfono hasta que el teléfono se queda contigo, eso fue lo que pasó.

Jesusito: The drum belonged to Malé's house Ta fodu Malé, the drum belonged to that house [Malé's], but since there were no men to play it. . . . Those who played it were the members of Sociedad Africana. Today I lend you my phone and tomorrow I'll lend you my phone again until the phone remains with you and that's [how the drums ended up at Sociedad Africana] (Jesús Alberto Morales Varona, May 21, 2017).

14. Israel: Este sistema es africano, aquí los tambores nuestros no eran con esas estacas y esos cáñamos porque tiene que ser cáñamo, no puede ser otro tipo de cosa, no puede ser una soga, no puede ser un cordel, tiene que ser cáñamo. Eso es netamente africano, nuestro sistema era de llave, unas llavecitas o este sistema clavado. Aquello si es netamente africano.

Israel: They were built following the African system. Our drums did not have wedges and hemp because you have to use hemp, you cannot use strings or ropes. That system is African, ours had keys or nails. Those drums were purely African (Onelia Fernández Campos and Israel Baró Oruña, interview, December 31, 2007).

15. Hilda: Nosotros decimos el Arará pero ese es [el] *jun*. Por eso cuando el santo viene, que el santo baja de verdad el santo dice, "El jun este es mío porque es de fulano, de esperancejo."

Hilda: We say the Arará drums, but their real name is *jun*. That's why when santos really come down they say, "This jun is mine because it belongs to so-and-so" (Hilda Victoria Zulueta Zulueta, interview, January 21, 2006).

16. Roberto: Claro, porque con el yo en sí no te decían cosas pero en trance preguntas y el santo ve el interés que tenía la persona y entonces le decían las cosas.

Roberto: Of course, when they [elders] were not in trance they wouldn't give you much information but once in trance you would ask questions and the santo would see your interest [and] then [he/she] would give you much information (Roberto Pedroso García in conversation with Jesús Alberto Morales Varona, interview, December 28, 2015).

17. The place that was traditionally used as the burial spot for the canasta is known as Ducaqué, located just outside of the central España. It is not known whether Luis Doubuchet still carries the canasta all the way to Ducaqué, for this is a held secret.

18. Hilda: Entonces cuando él [el mandadero] vino yo le pregunté y se echó a reír. Yo le dije, "Si yo sé que tengo que mandar un awán [la canasta] contigo no lo mando porque vas a matar al tamborero."

Hilda: When he [runner/messenger] arrived, I questioned him and he began to laugh. I told him, "Never again will I send an awán [the basket] with you because you will kill the drummer" (Hilda Victoria Zulueta Zulueta, interview, January 8, 2006).

19. Jesusito: Él escribía de una forma y cantaba de otra. Yo tuve la libreta en la mano y lo que él cantaba no era lo que estaba escrito.

Jesusito: Quito wrote one way and sang differently. I had one of the notebooks in my hands and what he sang was not exactly what was written there (Jesús Alberto Morales Varona, interview, December 28, 2015).

9

French Gods and the Awán

Narrating Armando Zulueta

JILL FLANDERS CROSBY

On the warm evening of December 15, 2015, Melba, Miguel, Roberto, and I were standing outside on a veranda during ceremony, talking with Marcos Hernández Borrego. Upon hearing that the four of us would return to Perico December 26, María Eugenia Suset Zulueta announced that she wanted to feed the "French Gods" when we returned, something that hadn't been done in eight years.

We all looked at each other and said, "Why not?" We had helped facilitate this ceremony back in 2007, when María Eugenia had enacted this tradition for the first time since Armando Zulueta, María Eugenia's uncle, passed away (María Eugenia Suset Zulueta, interview, January 1, 2018). The feeding had indeed occurred then, but we had to return to La Habana early that day, so we were not able to witness its process. Eight years later, on December 26, 2015, we did.

The French Gods, two small, carved, wooden twin figures (*ibeyis*), had belonged to Armando's mother Teresa de Laí (spelled La I by Andreu Alonso 1997, 36; but spelled Laí as suggested by Michael Atwood Mason in a personal conversation). Apparently, said María Eugenia, Teresa had a twin sister, which explained the set of twin carvings in the family. When Teresa passed away on December 27, 1972, at the age of 98, Armando inherited them, along with Teresa's house. He continued to honor his mother's memory through yearly ceremonies every December 26 for her French Gods, much as Teresa had done, until he himself died.

Oral history recounts that Teresa arrived in Cuba from Haiti as a young

woman. She not only brought her ibeyis with her, but she also brought four *fundamentos*—Malé, Juerdase, and two Afrás (Afrá and Cuvi). Once in Cuba, where she later met Armando's father, she acquired a drum to play for her deities. Belonging to Changó, this sacred drum (minus its drumhead) is now revered as a fundamento.

Andreu Alonso (1997) throws a wrinkle into Teresa's origin story. He writes that the Julián de Zulueta y Amondo family purchased a group of French-speaking slaves in Santiago de Cuba and brought them to España. Some of their deities, he says, are still worshipped in a house on San Juan Street (48n22). Andreu Alonso does not give the last name of the owners of this house. But this is indeed Armando's (Teresa's) house, even though the street on which Armando's house is located is now usually called Pedro Arrieta. However, we have not been able to find any evidence for the claim about the French-speaking slaves, nor have we heard any narrative about this story. Teresa de Laí's arrival in Cuba remains a mystery.

Unlike Fidela's Malé and Juerdase, whose celebration day is January 1, Teresa's Malé and Juerdase are included in the feeding of the French Gods on December 26. This poses an interesting question: Why that date? January 1 is considered the traditional day of feeding for Fidela's Malé and Juerdase. The evening of December 31 into January 1 are the traditional days for other similar deities represented in the form of a snake (and their associated rainbows), such as Danagosi in Agramonte, and for the deity simultaneously known as Odan, Dan, or the syncretized San Manuel in nearby Jovellanos.[1] Whether Teresa may have originally made her celebrations for Malé and Juerdase on January 1 is unknown. December 27 is the date she passed away. It is possible Armando shifted this date to the day before the anniversary of her passing to honor her memory (although Valentín Santos Carrera once told us the celebration date was always December 26).

We also wondered whether María Eugenia had collapsed the identities of Malé and Juerdase into those of the "French Gods" alongside the twins, simply because they belonged to Teresa. Did Teresa actually receive the fundamentos in Perico, since Juerdase is a name we have not heard outside of Perico? Alternatively, since many enslaved in Haiti also had Dahomeyan influences via the transatlantic slave trade, it is entirely possible that Teresa brought the memories of her deities with her from Haiti and found resemblances to Malé and Juerdase in Perico, and subsequently her Haitian deities took on attributes based on Malé and Juerdase.

But here may be an example of the collapsing of many names into one, or, as Mason (2017) suggests, a theology of multiplicities or "interpretive multiplicities" (following Robert Farris Thompson 1993, 215). Mason suggests understanding interpretive multiplicities as "the various and simultaneous meanings or uses of symbols and actions," embracing "the fundamental multivocality of symbols and symbolic action." In a 2017 interview, Mason suggested the name Juerdase could have sprung from the collapse of the various names (and spellings) of the vodu rainbow serpent that ruled over and protected the Dahomeyan kingdom, Damballah Huedo/Dan Ayido Huedo (Hwedo, Wedo). Mason's blog (2011a) identifies the united Danda-Güeró or Jueró (male side) and Aidá-Güeró (female side) as the rainbow serpent in Arará.

There are other possibilities that could account for Juerdase. Jueró could be collapsed with the Arará name for Ochún, that of Mase, to create Juerdase. Juerdase, according to Hilda Zulueta and Marcos, is indeed the Arará equivalent of Ochún (see Andreu Alonso 1997, 48n21), and she exhibits characteristics of Ochún/Mase through her preference for the color yellow and sweet things. Jueró, Güeró, Huedo, Hwedo, and Wedo all share phonetic pronunciation and spelling similarities with the beginning of Juerdase's name. Stretching this out, Fernández Martínez (2005, 82) states that in Perico, Malé is assimilated into San Manuel. Brice Sogbossi (1998, 42) argues that San Manuel is syncretized with Dan Ayido Hwedo in Jovellanos, although he does not specifically mention this as known in Perico.

Regardless, María Eugenia was adamant that all of Teresa's deities, including Malé and Juerdase, came with Teresa from Haiti. To support her argument, she told us that the music and dancing for Teresa's celebrations on December 26 differed from what was normally seen in Perico, indicating to her that Teresa's deities were not from Perico. People danced in couples, she told us. In addition, Teresa's brother Imbasó was one of the few who knew how to play the proper rhythms on Teresa's drum for her deities (interview, January 1, 2018).

Malé, Juerdase, and the twins all live together in and on top of a small wooden cabinet with open shelves behind the door to the *cuarto de los santos* (a room dedicated to the use of the fundamentos). Propped on top of the cabinet, a small papier mâché horse perched on top of an even smaller wooden house accompanies the twins. A Catholic image of San Manuel rests behind them. Underneath are the forms imbued with Juerdase and

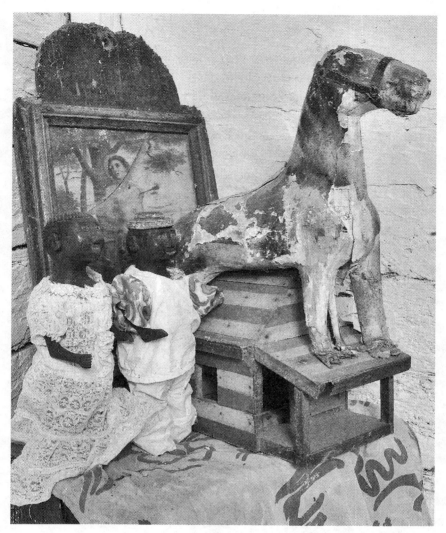

Figure 9.1. *From left to right*: the twins (ibeyis), and the horse on the house. San Manuel's Catholic image is in back. Photo by Miguel A. Parera.

Malé on their individual shelves. Juerdase imbues a yellow plate covered by a *cazuela* lid. Below Juerdase, Malé imbues a complete cazuela. The drum lives in the opposite corner of the room.

On December 26, the twins, Malé, and Juerdase were each placed and fed one by one at the foot of Changó's drum, all on banana-tree leaves, while the two Afrás were fed outside where the fundamentos live permanently. That night, the ceremony began with a *moyugba* (a ceremony to call

the deceased) at the patio behind the house that is reserved for *los muertos*. Marcos led the ceremony, assisted by Roberto. María Eugenia called out the names of the deceased who belonged to the house. Marcos and Roberto answered "Ibaye" (Lucumí) or "Sifalú" (Arará) after each name, depending upon each person's primary religious affiliation.

Next, we went to the front gate, where we fed Teresa's Afrá and Cuvi, calling the names of the deceased before throwing four pieces of coconut and asking for their blessing. Eko (ground corn boiled and wrapped in a banana leaf) and the blood of four white chickens was offered. The chant

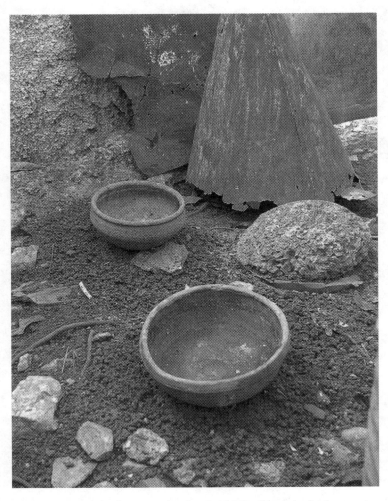

Figure 9.2. Teresa's fundamento imbued with Afrá (*back*) and the fundamento imbued with Cuvi (*front*). Photo by Miguel A. Parera.

"Enicho, enicho eleguano gananube, enicho, enicho afrá conuwe"[2] was sung. We made cleansing motions on our own bodies as one by one we went forward to pull feathers from the chickens, cleansed our own bodies again, and sang a second chant: "Eracucu nasawe asoquere mayoquere." Honey was given to the fundamentos.

We moved to the cuarto de los santos and did much the same for the twins, followed by each fundamento, although each received its own special

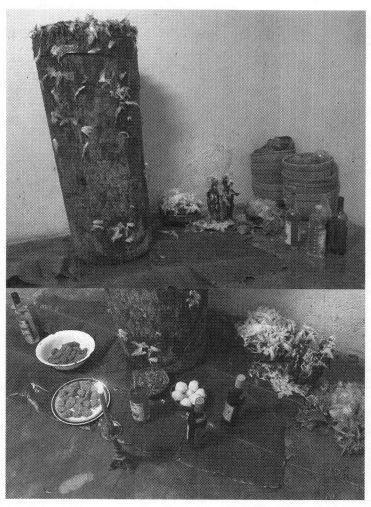

Figure 9.3. *Top photo, left to right*: Teresa's drum, Malé, the twins, and Juerdase. *Bottom photo, left to right*: sacred foods for Malé and Juerdase—bollitos de frijol carita, bollitos de chícharo, okra, and tapi-tapi. Malé, the twins, and a partial view of Juerdase on the right. Photos by Miguel A. Parera.

offerings. At one point, neither María Eugenia nor Marcos could remember the actual name of "Señora de Malé."

"Ask Melba. She has it written down," María Eugenia says.

Indeed, the actual name was located in our 2007 interview with Valentín (we had the interviews with us). He last officiated at the ceremony in 2007, and acted as a companion beside Armando during Armando's many religious celebrations. We confirm that the name of "Señora de Malé" is Juerdase. She receives two yellow hens, honey, and *vino dulce* (sweet wine).

Witnessing this important lineage illuminates the enduring legend of Armando and his well-known *awán*. Critical to his character from stories we gathered was that Armando had enduring respect for history and tradition. Whatever one may want to say about his nieces who followed in his footsteps, they also carried and continue to carry his rich legacy.

Armando and the Awán

Armando's legendary reputation reaches beyond Perico, across Matanzas Province and beyond, stretching from La Habana to the United States.[3] He is famous for his San Lázaro, for the amazing things he did with his San Lázaro, and for saving many through his own healing powers and through the awán, dedicated to San Lázaro, held at his house. Agramonte's Mario José Abreu Díaz credits Armando with saving his life when he was seriously ill. Armando showed up at Mario José's house and performed a special healing ritual. Then Armando buried "something" in Mario José's yard before planting two trees in the same spot. One grew stronger, as did Mario José; the second died. Mason (2011c) captures Armando's aura perfectly: "They say he could read your past like a book. They say he could tell the future. They say he could heal almost anyone."

Armando received his San Lázaro from Octavia Zulueta. While no clear recollection regarding her status as a formerly enslaved African seems to exist, Perico's collective memory points to her being freed from central España. If that is true, timelines suggest she may have arrived at España at a young age and closer to the year of emancipation in Cuba. Collective memory also frames Octavia's San Lázaro as Arará and "from" Africa.[4] If she was enslaved, she may have "brought" her San Lázaro with her from either her life in Africa or her memory of Africa. We could find no official record of either her birth or death, nor much information about her. But

her legend in Perico is fierce. Octavia's history not only helps validate the San Lázaro she gave Armando as powerful, but it also validates the San Lázaro as Arará.

According to María Eugenia, Octavia and Armando's mother Teresa deeply respected each other. One night, Armando went to a *tambor* at Octavia's house when he was only seven years old and became possessed with San Lázaro. Octavia had to walk Armando home.

According to Marcos and María Eugenia, Octavia gave Armando his Arará San Lázaro when he was young. Mason tells me from his 2000 interview with Aurora Zulueta, Armando's niece, that Armando was only nine years old when he received his San Lázaro from Octavia (e-mail to author, April 24, 2018). When he turned 30, Armando left Perico. He lived largely in Sancti Spíritus with his partner and lover Armando Valdivia, and he worked as a cook in El Hotel Colonial. During this time, he made santo in 1948 in the city of Matanzas, entering the Lucumí tradition and, according to María Eugenia, Valentín, and Marcos, he began giving San Lázaro to numerous godchildren. But he would come to Perico when sent for and, of course, always returned for the awán held at his house every December.

The awán is a yearly ceremony held on December 18, a day after the traditional celebration day for San Lázaro on December 17. It is a ritual of cleansing and health. Arará rhythms and songs are played and sung during Armando's awán.[5] Armando actually began celebrations for San Lázaro on December 16 and 17. Traditionally, in the days leading up to December 16, the house is cleaned, and several Catholic statues perched on small platforms attached to one of the interior walls of the house are dressed in new capes. The night of the sixteenth (actually in the early hours of the seventeenth), a moyugba for the ancestors takes place. Over the rest of the night/morning and into the next night, practitioners feed all the fundamentos and continue ritual preparations, culminating in a Lucumí ceremony with *batá* drums on December 17. But according to Valentín, the awán on the following night remained the ceremony closest to Armando's heart.

During the evening of the awán itself, twenty-one plates of special food are prepared and carefully placed in a circle around a large *canasta* (basket). Attendees, wearing a strand of cundiamor (a type of vine) around their necks, walk one by one around the plates, pick up handfuls of the food from each one, and make cleansing motions over their bodies to wash away illness before throwing the food in the canasta.

After dropping small coins in the canasta, they then pass by four religiously significant participants, one with a speckled rooster, one with a guinea fowl, one with a hen, and one with a *já* (a sacred broom for San Lázaro made from cogollo, the stiff part of a palm leaf) for final cleansing. Finally, the strands of cundiamor are thrown in the canasta, and the lead person "receiving" the awán's special blessings goes through further ritual enactments before tossing in the clothes he or she was wearing when the night commenced.

The head of the goat offered to San Lázaro tops the canasta, which is then wrapped and carried in procession by all Lazarinos (those who have San Lázaro) to the front gate to be carried on top of the head of a "runner" or "messenger," supposedly to Ducaqué. Until the runner returns with the empty canasta, the *gallo* of the Arará musicians sings "gua, gua, gua," while attendees respond with the same words, without stopping, until the runner returns. At the same time, *santeros* and *santeras* lightly dance while singing, moving counterclockwise in a circle. When the runner returns, the dancing fully commences, and the Arará rhythms and songs continue for hours.

Figure 9.4. The awán basket and food. Photo by Brian Jeffery.

But Octavia also had her own ceremony that became somewhat linked with Armando's celebrations. On December 16, Armando would wash his santos in the morning, but he would leave everything else untouched until after Octavia's own ceremony that evening. He would offer her help with the animals and frequently play drums himself, as, according to Marcos, Armando could play drums and sing Arará and Lucumí chants from memory. At midnight or shortly thereafter, he and many others would walk to his house from Octavia's house (usually with more than one person in trance) to start the moyugba and the feeding of Armando's Arará fundamentos.

Armando often relied on Aurora. According to María Eugenia, at eleven years old Aurora received her San Lázaro from Armando, thus becoming his goddaughter (interview, January 1, 2018). After Armando passed away in 1990 at sixty-seven years old, Aurora continued the awán until she died on January 2, 2002, at sixty-two years old. The tradition of the awán continues thanks to María Eugenia and, on occasion, Armando's third niece Aquilina Suset Zulueta, and his great-great niece, Janerquis "Jeny" Santana Unzueta.

Attending the awán is moving. Many in the community come together for several days to help with the preparations, and have the dedication to stay up all night after the moyugba of December 16/17 to help feed the fundamentos and cook food. There is the feeling of solemnity as all pass around the canasta, and the joy when dancing begins—dancing that clearly is deeply felt while people wait for the deities to arrive and inform the community of new actions required in the coming year to continue the community's well-being. Until she passed away, Hilda Zulueta's presence at the awán was commanding. Those present waited in particular for Hilda's Eleggua to arrive.

I was told on more than one occasion that during Armando's time, the awán's glory and power radiated across the island. At least a hundred people from all over the surrounding area including La Habana filled the house. Since Armando's death, and even over the time I have been in Perico, the awán, unfortunately, has become quieter, with fewer and fewer attendees. Armando's legacy still lives, but its radiance glows in a different light.

Untangling Armando's Narrative

Armando remains a complicated figure. According to Valentín, Marcos, and María Eugenia, everyone loved Armando. He never argued with any-

one, and gave back selflessly. People would knock on his door and Armando was there to help and to give San Lázaro to those who asked (Valentín Santos Carrera, interview, December 18, 2007).

Yet the legitimacy of his San Lázaro, as he began giving it to new godchildren, remains contested. Is Armando's San Lázaro Lucumí or is it Arará? Is it an invention for commercial purposes, or is it something else rooted in Octavia's traditions? Here the narratives enter multiple slippages, with some narratives more stable than others. Narratives also frame and implicate social, historical, economic, and political issues, while revealing regional contradictions, arguments, and claims of authority.

It is a stable narrative that Octavia was likely enslaved at España and that Armando received his San Lázaro from Octavia; according to María Eugenia, it was called Afimaye Camaye. Armando's and Octavia's San Lázaros are similar in form in that they are in open cazuelas and they both contain multiple stones. Currently there are five in Armando's and seven in Octavia's. Later, he made *Yemayá con oro para Inle* (Yemayá with oro for Inle)[6] through his Lucumí godmother Adela Alfonso on April 29, 1948 (Mason 2011c; Michael Atwood Mason, interview, October 13, 2017). Here, the narratives start to slip.

According to María Eugenia, when Armando made (that is, was consecrated into the worship of) Yemayá con oro para Inle, he received a new Lucumí San Lázaro from Adela. She would point out this second San Lázaro to us on multiple occasions when we were photographing the cazuelas. This new San Lázaro is also open and contains seven stones. María Eugenia keeps it next to the one Armando received from Octavia, giving it almost equal status, both being important San Lázaros belonging to Armando. The only difference is that the one he received from Octavia is kept on a slightly higher pedestal.

Some Perico interlocutors dispute this. Marcos thinks this second San Lázaro belonged to one of Armando's godchildren. Aurora, according to Mason, also understood that this second one belonged to one of Armando's godchildren and was left behind at Armando's house. When someone who has a San Lázaro dies, the fundamento is asked through divination whether it wants to stay in its original location or go elsewhere. Cheo Changó's San Lázaro, for example, chose to go to la Sociedad Africana. So it would not be unusual that a San Lázaro belonging to one of Armando's godchildren chose to go to Armando's.

Valentín put it this way. When Armando was consecrated to the Lucumí religion, his godmother Adela offered to "fix" (*arreglar*) his San Lázaro. But Armando refused. He asked that it be left the way Octavia had given it, with three old stones, but agreed that when he consecrated others, he would give San Lázaro the way Adela gave it (Valentín Santos Carrera, interview, December 18, 2007). And here, María Eugenia and Valentín both agree. He kept his San Lázaro from Octavia intact as he received it—open, although now it contains five stones, a *secreto* (secret), and cowrie shells, and has seven holes in its lid. The Lucumí San Lázaro from Adela, or belonging to one of his godchildren, is also open, but inside there are seven stones along with a secreto and cowrie shells, and seven holes in its lid.

After Armando was consecrated to Yemayá he modified the tradition of giving San Lázaro as it was then practiced, whether Lucumí or Arará. During his ceremonies for his new godchildren, the open Arará San Lázaro that Octavia gave him was present. He gave or crowned his new godchildren with an open San Lázaro, with seven stones, a secreto, and cowrie shells, as Arará. Valentín has a slight twist to this story. He understands it as a mixture—indeed, something new. Perhaps a Lucumí santo, but received with Arará songs and ceremonies (interview, December 18, 2007). However, Armando never set aside or disrespected the Arará San Lázaro from Octavia (Valentín Santos Carrera interview, December 18, 2007; Marcos Hernández Borrego, interview, January 2, 2016, and December 31, 2017; María Eugenia Suset Zulueta, interview, December 19, 2007, and January 1, 2018).

And thus, a second instability to Armando's narrative is whether the San Lázaros he gave to his godchildren are Arará or Lucumí. Vladimir Osvaldo Fernández Tabío, Justo Zulueta's great-nephew, says they are Lucumí, as does José "Chinito" Francisco Ung Villanueva, an important santero in La Habana whose San Lázaro is from Armando's lineage. Chinito also indicated that some practitioners call Armando's San Lázaros Araluco, meaning a mixture of Arará and Lucumí. Others, such as María Eugenia and Marcos, are adamant they are Arará.

Practitioners who belong to the Cabildo Espíritu Santo Arará Sabalú of the city of Matanzas believe that the only legitimate Arará San Lázaro descends from their *cabildo* (Brown 2003, 138–139). Armando's, those from the Sabalú cabildo argue, is an invention. But Valentín argues the opposite—that any sealed San Lázaro was created in La Habana. "It has nothing to do with ours" ("que no tiene que ver nada con el de nosotros"). And

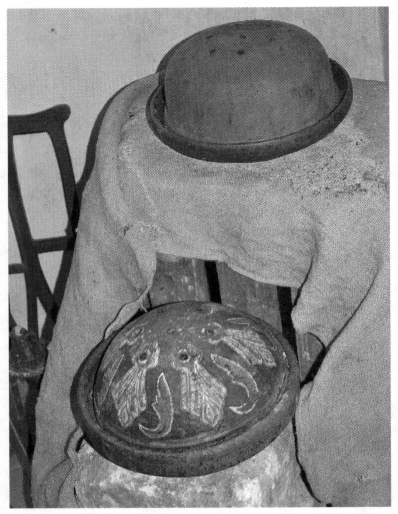

Figure 9.5. Armando's fundamento imbued with San Lázaro from Octavia (*top right*), and the fundamento imbued with San Lázaro (*bottom left*) is either from Adela or it belonged to one of Armando's goddaughters. Photo by Miguel A. Parera.

indeed, the Cabildo Espíritu would agree with this difference. But they then add that theirs is the only *true* Arará San Lázaro, precisely because their cazuela is sealed, a true sign that it is Arará (Brown 2003, 138–140). As we went around to several houses in January and May 2018 to ask further questions about Armando's San Lázaro, there was surprise among most that Armando's legitimacy was questioned, particularly that his San Lázaro was contested as possibly not being Arará.

Mason (interview, October 13, 2017) does not see anything about the form of the cazuela for San Lázaro that Armando received from Octavia that is Arará. Rather, its form suggests to him that it is Lucumí. But, he said, if one compares the form with its origin narrative, that of Octavia, then it is far more complicated. Her San Lázaro is revered as Arará. Everyone ascribes the label of Arará to the San Lázaro Armando received from Octavia, Mason argues, *because of* Octavia; that is their marker (including Chinito and Vladimir). And without a doubt, Octavia's influence with Armando was powerful. As an interesting side note, Mason points to the fact that anthropologist William Bascom's notes from his 1948 fieldwork in nearby Jovellanos describe visiting Armando's house. Bascom comments that there was an Arará altar in the back room of the house (interview, October 13, 2017).

As Mason argues, Armando had access to, by all accounts, this astounding San Lázaro that would come down and conduct amazing healing rituals. Additionally, he made Yemayá con oro para Inle, which is unusual in itself. Importantly, however, his sign in Yemayá was "Odí-Ojuani," a divination sign strongly associated with San Lázaro. This was proof to Aurora that he was a legitimate child of San Lázaro (interview, October 13, 2017). Thus, his efficacy and spiritual essence were powerful. Yet Armando's story, how he conducted his religious affairs once he was consecrated into the practice of Lucumí, suggests that he was compelled to try to balance his Arará line with his new Lucumí line. The question of why, argues Mason, is what is interesting (interview, October 13, 2017). David Brown echoes similar sentiments (telephone conversation, April 25, 2020). Rather than focus on binaries (Arará vs. Lucumí), he argues, it is more compelling to investigate the processes at play that compel others to legitimize binaries of opposition.

During the time that Armando made Yemayá, Lucumí religious life was undergoing a surge in popularity as well as significant change, reform, and innovation. I heard Perico interlocutors call this reform and innovation "lo moderno" (a modern style) when they discussed it and raised its historical impact. In the air was a new institutionalization of receiving deities in order to standardize practices of Lucumí initiation (Brown 2003, 128–143).

Important to this narrative is that when one receives a Lucumí San Lázaro during a consecration (*hacer santo*) to *another* Lucumi deity (for example, Yemayá con oro para Inle), the San Lázaro that happens to come along as well is actually considered "indirect" rather than "direct" (direct

is hacer santo). In brief, hacer santo (making santo) requires consecration (sitting or placing the *oricha* [santo] over the initiate's head). This is an elaborate series of rituals that supplanted the older system, which was known as *santo parado*. Santo parado, in particular, was commonly practiced in rural areas and among the "Africans" and their early descendants. The method of santo parado, which is the oldest (and the non-standardized) manner of practicing the African-based religions, did not require a complex and standardized consecration ceremony like the hacer santo that is held at present. Santos parados were passed on from one generation to the other through less-complex ceremonies, and, rather than the current practice of hacer santo, the initiate's head was washed with herbs (Reyes Herrera and Rodríguez Reyes 1993, 28–34). Santo parado was not that different from how the Arará fundamentos were passed on in Perico. But santo parado was dismissed as illegitimate during the period of innovation (Brown 2003, 142–143), thus further delegitimizing Armando's San Lázaro received from Octavia.

Mason (interview, October 13, 2017) suggests that it is clear from Bascom's notes that the arguments about santo parado vs. hacer santo were very much alive around the time Armando was making santo. Some even felt that santo parado, rather than hacer santo, was the "real thing." Regardless, religious models of legitimacy and authority were evolving and highly contested. Here Armando straddled these two worlds and these two systems, riding the wave of the popularity of hacer santo and "lo moderno," with his respect and roots in Arará, mixing, innovating, reinventing, and mobilizing. Melba suggests that this is where Armando's mastery lies. He realized he was in the middle of all these changes. Thus he decided to give his San Lázaros within the Lucumí traditional form, but imbued them with the charisma of the Arará through association and prayer. He was shifting and adapting to the new times while also giving legitimacy to his traditional roots and Octavia's San Lázaro (Mason, personal e-mail to author, April 1, 2020).

As Mason and I discussed at length, Armando does not fit easily into categories; he is straddling the bridge and crossing boundaries at every turn. It is not easy to slide Armando into a specific slot. Is he Lucumí? Is he Arará? Add to the list of fluid categories his sexual orientation. Armando respected certain boundaries, like Octavia's Arará lineage, and that also made him an interesting boundary-breaker (Michael Atwood Mason, interview, Oc-

tober 13, 2017). Armando was doing what was already in the air: innovating. Likely, he did not see binaries—he saw possibility. But perhaps he also became a "dangerous" person for breaking too many rules, especially since his reputation was powerful.

Octavia Zulueta, Marule, and Casa de Aggidai

Behind Armando's house is a small *casita*. This casita contains a half-buried secreto for San Lázaro. An upturned and bottomless pail, buried in the ground, protects the secreto. Every year during the awán, the secreto is fed with a mixture of blood, white wine, and rum. Few, including myself,

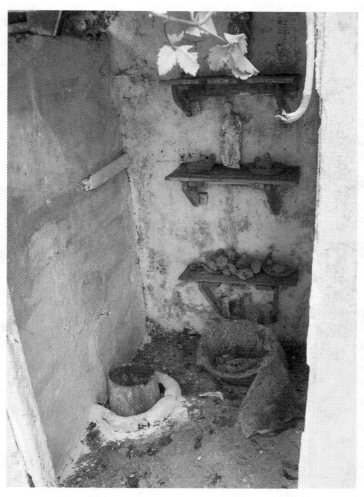

Figure 9.6. Armando's secreto, *lower far left*. Photo by Melba Núñez Isalbe.

have permission to see this, and so we must turn our backs. Aurora shared a story with Michael Atwood Mason in 2000: One day, Octavia appeared at Armando's house right before she passed away, installing the secreto in the ground. Later, the casita would be built around the secreto. Mason (interview, October 13, 2017) theorizes that this secreto is much like what is known as a *kiti* in Benin, a buried version of a fundamento, setting up an intimate relationship between the cazuela fundamento imbued with San Lázaro in the cuarto de los santos and the buried version in the casita. This is really Arará, Mason commented during a conversation we had February 7, 2018. Strikingly, when I showed him pictures of another fundamento at Octavia's old house called Aggidai, which he had not seen before, he immediately commented on the similarity of the secreto to that of Aggidai.

Aggidai presents another slippage, a story that is hard to trace. Aggidai lives outside in the backyard behind Octavia's old house inside a round metal circle that is sometimes referred to as the wheel (la rueda). Octavia had raised a young child known as Juana Ester "Marule" Zulueta Cárdenas

Figure 9.7. The fundamentos imbued with San Lázaro belonging to Octavia (*right*) and Marule (*left*). Photo by Miguel A. Parera.

in that house, who lived there after Octavia died. Now, Marule's son Pelli watches over the house, keeping Octavia's traditions alive. Marule told Pelli that Aggidai never actually belonged to Octavia. Rather, it belonged to a man only identified as El Zurdo. El Zurdo was younger than Octavia, but that is all that is known about him (and Aggidai). Marule always fed Aggidai, but Pelli had stopped feeding Aggidai until he was told in a *misa* (spiritual reading) that Aggidai was upset at never receiving anything when Pelli butchered swine in the backyard. Thereafter, he began feeding Aggidai with a rooster right after feeding Octavia's and Marule's San Lázaros (interviews, January 2, 2018, and May 18, 2017).

The exact identity of Aggidai remains a mystery. According to Hilda, Aggidai is a path of San Lázaro and is Arará (interview, December 18, 2006). Hilda loved to sing Aggidai chants to us during our interviews. Some of these chants are still sung today by Lazarita Santuiste during Arará ceremonies. Marcos understands that Aggidai is a San Lázaro. But Andreu Alonso (1997) states that "Dasoyi reveals himself in seventeen avatars; Aggidai, the messenger, is one of the most important" (20). Brice

Figure 9.8. The fundamento imbued with Aggidai. Photo by Melba Núñez Isalbe.

Sogbossi (1998) also mentions Dasoyi, commenting that in Perico, rather than calling the principal deity of smallpox Sakpata, they call it Dasoyi instead (37).

Conclusion

Narrating Armando reveals an oral history awash in multiple and simultaneous truths. Armando's story is also a poignant narrative that points back to the dialogic nature of the Cuban and West African fieldwork (as do all the Cuban narratives). As we transition into the final two chapters detailing fieldwork findings and stories from Dzodze, Ghana, and Adjodogou, Togo, this point is made more emphatically. The connections among the three countries illuminate the ways history exists as a performance that crosses geographical boundaries. Dasoyi has Da embedded in its name, and Da, known as the serpent deity in West Africa, imbues Dzodze and Adjodogou ritual life. Sakpata (also spelled Sagbata, and called Togbui Anyigbato in Dzodze), known in West Africa among the Ewe and Fon as the god of smallpox (Soumonni 2012, 35), is strongly associated with Dahomey, and Da "walks" with Sakpata/Togbui Anyigbato. A deity in West Africa called Da Zodji (phonetically pronounced as Dasoyi) has been identified as a Sakpata deity (Bay 1998, 157). San Lázaro in Cuba has attributes of Sakpata. This indicates a potential enfolding of San Lázaro in Cuba as a path of a snake, as so many of our interlocutors have suggested. According to María Eugenia, Armando's San Lázaro received from Adela (or belonging to one of his goddaughters) is called Adasoyi. María Eugenia believes Adasoyi has a relationship to a serpent, and claims that she found a hole in the floor under Armando's bed that has something to do with "the creature."

Jueró/Güeró, has attributes of a vodu deity called Anyidohuendo in Adjodogou. Anyidohuendo radiates the colors of a rainbow, with male and female identities that mirror the stories of Malé and Juerdase.[7] Armando's awán will have a sister story in Adjodogou. Oral history analysis requires the ability to be flexible enough to embrace understanding in lieu of the formal written word, as well as numerous pronunciation and spelling differences in (in this case) religious deities, objects, and practices with diverse but related stories. The dialogic conversations we carried back and forth across countries illuminate this idea. Indeed, the dialogic conversations constructed a bridge across the spaces of water, land, and history.

Notes

1. The three names from Jovellanos come from a personal conversation with Alessandra Basso Ortiz in 1997, who conducted research in Jovellanos, and a personal conversation with Olivia King Canter, a santera who has close connections to Jovellanos.

2. As sung by Marcos Hernández Borrego and written by Melba Núñez Isalbe. Marcos does not know the exact meaning of this chant, but basically it asks for blessing.

3. Miami's Church of the Lukumí (as spelled by Brown) Babalú Ayé has a Babalú Ayé fundamento descended from Armando Zulueta that in turn gave birth to the Babalú Ayé of the Yoruba Oyotunji village in Shelton, South Carolina (Brown 2003, 139).

4. Michael Atwood Mason tells me that Octavia had a nombre de santo which was Jundesi, but he has never heard that she made santo.

5. Núñez Isalbe witnessed an awán in Agramonte December 18, 2018, but it was done in the afternoon, while they play music at night. The awán is also a tradition known in the city of Matanzas.

6. Yemayá con oro para Inle is based on the four pillars and on changes that took place in the second half of the nineteenth century regarding Lucumí consecration. Inle is a deity that cannot go to one's head, and so one must "make" him through Yemayá, who is one of the four pillars. The Lucumí Ochún, Yemayá, Changó, and Obatalá are the four pillars.

7. Akyeampong identifies Aido Hwedo as "a snake in the sky pantheon who manifests himself as the rainbow" (2001, 109).

10

Dzodze

Dancing with Dashi

JILL FLANDERS CROSBY

The first time I met Dashi, I had been talking with Johnson Kemeh in the front room of his Dzodze house. Not only did I take drumming lessons from Johnson at the University of Ghana in Accra, but he also became my primary Ghanaian research colleague. Dashi, Johnson's sister and a priestess, walked in and our eyes immediately met. Instantly I knew that I would return many times. From 1991 to 1992, I interacted with Dashi during my first research project exploring a generalized understanding of West African dance structures. Little did I know then that years later my research would shift to a specific focus on the ritual dances and practices of the Anlo-Ewe that subsequently led me to the Arará of Cuba.

A few months later, while still on my first research project, I arranged for a dance event of Ewe ritual dance at Dashi's shrine compound with Johnson's help for film documentation, just like I would do years later at Prieto's in Perico. While this event was arranged, it still unfolded following religious protocols and procedures, and it included deities normally honored by Dashi as part of her religious practice.

This afternoon at Dashi's was my first experience with Ewe ritual dance. Just like in Perico, someone became possessed. But here, multiple attendees fell into trance. This was my first experience witnessing possession. I was fascinated by the intense bodily changes of the person in trance, as well as with other participants and observers. Right away, a palpable threshold was crossed. Dancing intensified dramatically as movements, and even everyday actions and gestures, grew in strength, intent, and immediacy. A dif-

ferent level of performance emerged. It is the instant when walls dividing particular individual identities seem to dissolve and the collective social community invests itself fully in the immediate moment enacted through expressive form. Of course, there will always be those who remain distanced and on the edges of the ceremonial space, but for others, fully present, the change is striking.

From that moment on, I was intrigued by dances that invite trance in and around Dzodze, and their associated ritual practices, historical and social narratives, and cultural memories—the very contexts within which the dances are situated. "Movement embodies socially constructed cultural knowledge," writes Sklar (1994, 12). From these contexts spring memories, "the very mechanisms for reproducing habitus" (Venkatachalam 2015, 15).[1] Without these contexts, the dancing body, even in trance, has no well or source from which to draw. Even daily life operates on some level of staged or hailed performativity, as Butler (1988) shows with acts of gender. Indeed, dance research must include the narratives and memories that give rise to movement. Critically, such an approach illuminates the agency of those who are dancing.

Ewe History

Dzodze is located 101 miles east of Accra, in the southeastern corner of Ghana's Volta Region, not far from the Togo border and in the Gulf of Guinea's Bight of Benin. Its residents consist largely of the Anlo-Ewe, a subgroup of the Ewe people. The Anlo-Ewe, however, are also spread across the southern half of Togo, extending into southwest Benin and southeast Nigeria (Venkatachalam 2015, 25). This geographical breadth illustrates a wave of migration that collective Ewe cultural memory understands as one that began further east in the Yoruba lands of what became Nigeria (Venkatachalam 2015, 26).

Ewe migration history is linked to the migration of the Adja (also spelled Aja) and Fon peoples. Historically, all three peoples have been collectively identified under several blanket terms—the Adja, the Adja-Ewe, and Gbe-speaking people (Laumann 2005, 15).[2] Their migrations occurred more or less at the same time, and narratives point to all three leaving from roughly the same areas. But the narratives fluctuate regarding what grouping of the Fon, Adja, and Ewe arrived at and founded certain settlements, and even

regarding when they first became identified as three distinct peoples from their collective identity and migration patterns.

All narratives, however, recognize the close relationship among the Adja, Ewe, and Fon. According to Laumann (2005), all three peoples share a common set of cultural beliefs and practices (16), while Amenumey (1986) argues that the Adja and the Ewe are essentially one people, as evidenced by their linguistic, cultural, and religious affinities (5). Venkatachalam (2015) points out that the southern Ewe maintain close cultural and trading links with the Fon (29), and that "their belief in an eastern homeland has led them to promote trade and ritual links with societies east of them, like the Aja, Fon, and Yoruba" (Venkatachalam 2015, 26).

According to known historical narratives, the series of migrations by the people eventually known separately as the Ewe, Fon, and Adja began from today's southwestern area of Nigeria (Laumann 2005, 15). The Ewe in particular originally left from the walled city known as Ketu, a Yoruba town located in the southeast of today's Republic of Benin, in part due to the westward expansion of the Yoruba sometime around the fifteenth century (Amenumey 1986, 5–6; Laumann 2005, 16; Venkatachalam 2015, 27). The westward migration of all three peoples continued into settlements located in today's north and central Togo. The Adja settled Tado and later founded Alladah. Along with the Fon, they also settled near each other throughout the Dahomeyan kingdom. Meanwhile, the Ewe went to Notsie (Amenumey 1986, 6; Laumann 2005, 16; Venkatachalam 2015, 25–28). Some nationalist accounts have the Ewe simultaneously migrating farther westward from Notsie into present-day Ghana to escape the cruelty of King Agorkoli, but these accounts may have been privileged by missionaries of the Norddeutsche Mission, which had been active in the area inhabited by the Ewe since the mid-nineteenth century (Birgit Meyer, personal e-mail to author March 19, 2020; Greene 2002, 1015–1027).[3] Amenumey (1986, 11) and Nugent (2005, 30), however, point to staggered and layered timelines of departure.

Regardless, as the Ewe continued moving west, many initially settled around the mouth of the Volta River in present-day Ghana while others subsequently followed the Volta river north and established other diverse settlements (Salm and Falola 2002, 7). An understanding of the slippery history of the Ewe as outlined above cannot be underestimated in considering the Arará in Cuba. Religious borders have always been, and remain, fluid.

During my first year of preliminary research in Dzodze, spanning 1991–1992, I received a history of Dzodze from Vincent Kofi Kodzo, Senior Executive Officer attached to the Ketu District Administrative office of nearby Denu. Kodzo lived in Dzodze Ablorme (a district of Dzodze), and at that time, Ahiadzro Adzofia V (Kodzo's son), from the lineage of the Adzofia Royal Stool family of Dzodze, was installed as Ablorme's chief. With Kodzo's carefully typewritten and informal four-page document, as well as information from Johnson, I paint a very brief sketch of Dzodze's specific history before discussing my later fieldwork largely conducted from 1998 to 2013, which helps illuminate Perico and Agramonte. All spellings are from Kodzo's document, and a few differ from those above.

Dzodze History

Togbui Adzofia migrated from Notsie with his war god, known as Dey (a swarm of bees), in order to escape the Notsie leadership of Fia Agorkorli (Agokoli). Adzofia and his people eventually made their way to and founded present-day Dzodze. The shrine for Dey was located in Dzodze's Ablorme district near what would become the Dzodze market. From roughly 1898 until his death in 1933, Togbui Ahiadzro Adzofia II granted lands for the present-day Dzodze market, the police station, and the Presbyterian church in Ablorme. Located along the road that connects the community of Denu to the south and that of Ho to the north, Dzodze gradually grew into a commercially important town.

Anlo-Ewe Ritual Traditions

Anlo-Ewe spiritual practice "acknowledges the co-presence of other entities, among them spirits that have names and specific needs" (Grossi 2020). The spiritual practices vary across the region and embrace diverse regional spaces (Brown 2003, 115–119). These spirits, also referred to as deities (Adjei 2019), range from ancestral to natural forces. They imbue material forms from trees to rocks to molded, carved, or sculpted forms, thus elevating them to the sacred.

Anlo-Ewe deities can be categorized as *vodu* or as *tro*. Rosenthal (2005) states that either term is an imperfect choice due to the fluidity of categorization across the diversity of Ewe communities (183). According to

Venkatachalam (2015), the word vodu is used by the Fon and Adja people, while the Ewe use tro (26; 52–54). Guerts, as cited in Venkatachalam (2015), argues that vodu is a system of knowledge, and *trowo* (plural of tro) are but one aspect of vodu (53). Meyer offers that usually the Northern Ewe use tro while the Southern Ewe use vodu (e-mail to author, March 19, 2020). Adjei (2019) largely uses vodu, taken from his fieldwork and from having been raised in the Anlo-Ewe area. Vodu, he says, "can 'mount' or possess an individual to serve it, it can be acquired (or found), it can also be inherited, manufactured or transferred" (222). Nukunya (1969) writes that "vodu should be distinguished from 'tro'" (5–6). Vodu, he argues, may be acquired and established by anyone with the financial resources, while tro chooses its initiate through possession (5–6).

Johnson tells me that both terms are used in Dzodze. Tro refers to those deities to whose worship one will initiate and which one will serve, while vodu refers to those that are acquired during initiation. Vodu supports tro and vice versa (telephone conversation, April 4, 2018). Regardless of local designations, whether vodu or tro, they both "protect and heal humans," and their ceremonies include drumming, dancing, and singing (Rosenthal 2005, 184). In this chapter, I use the designations and their indigenous names as they are employed by my interlocutors.

In Dzodze (and later in Adjodogou, Togo), what are known as *Legbawo* (plural form of *Legba*) greeted me on my daily walks. Legbawo are usually clay or cement figures with eyes defined by cowrie shells. Their cowrie shell eyes were always looking right back at me as I passed. They were around so many corners, tucked into entrances, guarding the boundary between one district and another, inside compounds, and/or at compound gates, depending on their designation—du-legba, akpeli or akpele legba, and agbonu legba being just three of many types (Gilbert 1982, 60 [Gilbert did not capitalize these legbawo in her article]).[4] There were Legbawo located at the entrance to and inside Dashi's compound. Some had already been present and were built before she moved into the house, while others were built after her first initiation. They contain power, as they are often constructed with powerful herbs embedded in them (Birgit Meyer, e-mail to author, March 19, 2020).

As a prankster (although also a guardian), the Legbawo became a powerful metaphor for the complexity of Ewe religion for researcher Venkatachalam (2015). For her, "West African religious experience does not

lend itself easily to description or analysis" due to its dynamic cultural processes (74). Alegba[5] the trickster (her spelling for Legba) "is always playing tricks in Anlo country [by] creating illusions, causing things to appear and disappear," in a sense sustaining a "state of chaos" (74). This "divine dance of Alegba" adds to the particular challenge that ethnographers encounter when they experience the constant change and flux of material reality within Anlo-Ewe religious culture (74). I respect this sentiment. For me, Anlo-Ewe religion did feel like a consistent swirl. But such perceptions are always in the eye of the beholder rather than existing as general or external chaos. I had to construct my own dance with Legba in order to unravel slowly what at times felt impossible to understand—as if the boundaries around religious knowledge were impenetrable. I navigated my way via dancing and via the concurrent cross-Atlantic dialogue I was fostering between the West African and Cuban communities. As time went on, and as I carried more conversations, photos, and films back and forth between Ghana and Cuba, the two sides of the Atlantic held up a mirror to each other, illuminating the paths of knowledge, helping me tease apart the seemingly impenetrable boundaries.

Dashi

Formally named Kpetushie Kemeh Nkegbe, Dashi is a well-known priestess in Dzodze, specifically in her district of Ablorme. Everyone calls her either Amegashie (the Ewe word identifying a priest or priestess) or by her nickname, Dashi. Her nickname arose from the name of one of her deities—that of Da, the Ewe word for snake, but also a vodu deity that manifests as a serpent or a snake. One day she found herself at a compound belonging to Iflenu Flanu-Nuafe, another priestess, arriving there in the middle of the night, as she described it, as if she were in a dream. Dashi apprenticed with her, and became initiated. According to Dashi, she began serving Ese. Everyone has Ese (also known as Se or destiny), but one can choose, as Johnson explained to me, whether or not to use it. Because of the unusual manner in which Dashi found herself at Iflenu Flanu-Nuafe's house, Dashi felt that her destiny was now decided. Once Dashi was initiated, a bowl or pot was prepared and placed in her room to give her power (Johnson Kemeh, telephone conversation, April 4, 2018). Ten months to one year went into this process. And so, at age 35, Dashi became a priestess.

According to Johnson and Dashi, not only does a deity choose new initiates, a deity also chooses the priest or priestess who will train and guide the initiate through the ritual process. If a deity is interested in a new initiate, the deity will let that individual know, either through sickness or through a downturn in day-to-day life events, such as economic loss or personal problems. Usually, there will be a divination reading that will confirm such a scenario (although, as Meyer pointed out, some may attend a Pentecostal church and try for deliverance; personal e-mail, March 19, 2020).[6] During my time in Ghana and Togo, this was a recurrent theme in conversations with priests, priestesses, and initiates. Suddenly one gets sick, suddenly there is a problem, suddenly one may find him- or herself at an important house as if in a dream.

Dashi has become initiated to, or acquired, several deities. She has Mami Wata, Trokosu (as spelled in Dzodze), and Krachi-Dente.[7] She is a member of the Afa divination group, and she became a half-member of the vodu Yewe group (the thunder deity pantheon).[8] But her main deity is Togbui (as she calls him), described to me as the landowner—an earth deity, and an old deity. Dashi herself asked to receive Togbui, as he is important in the area and he works with tro.[9]

Her shrine compound began modestly. When I first started going to Dashi's shrine in 1991, Togbui had imbued a clay-cement form embedded in the ground at the corner of her compound, close to her house. Modest in size, it had a spherical head on a short base. Togbui's spherical head had cowrie shells for eyes, indents for ears, and a hole for a mouth with a smoking pipe in it. He wore a small clay pot on top of his head. His ritual broom rested at his base, with strips of red and black cloth resting on the surrounding ground.

By 1999, Togbui had his own shrine room, which grew in stages. His new room was a round structure with a conical thatched roof, separate from Dashi's house, with a piece of cloth over his door in his colors. Togbui now imbued a form that consisted of an overturned clay pot with multiple holes on an earthen mound encircled with dried palm fronds. He was surrounded by empty gin and schnapps bottles (both requisite drinks when asking for something from Togbui), talcum powder containers, calabash dishes—either empty or filled with cowrie shells—his broom, and several walking sticks.

Within another six to seven years, his shrine grew to a much larger,

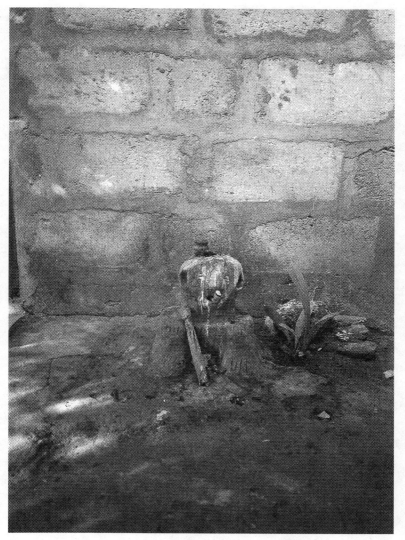

Figure 10.1. The form imbued with Togbui in its first stage. Photo by Jill Flanders Crosby.

square-shaped building that was an extension of the original round struc-
ture, but now with a sheet metal roof. This extension included a separate
storage room for Togbui's "things," as well as locked doors. Togbui now
imbued an elaborate earthen clay-and-cement form about three feet tall,
once again with a spherical head form with larger cowrie-filled indents for
eyes. His mouth consisted of a hole through which Dashi could pour drinks

Figure 10.2. The form imbued with Togbui in its second stage. Photo by Jill Flanders Crosby.

(especially a local gin known as *akpeteshie*) directly into Togbui, while he also had smaller holes on the top of his head.

It was not just the shrine room that had been added to and updated; Dashi's entire compound changed. The compound's exterior walls went from a modest weaving of palm branches for a boundary marker to concrete. Elaborate pictorial stories were painted on those exterior walls, as well as on the external walls of her house inside the compound, and included her own portrait. These pictures also appeared on Togbui's shrine. It was full of red and blue spots, the same spots that covered Togbui's new form.

The compound is comprised of Dashi's house, her Togbui shrine, and an outdoor activity space. This outdoor space now has a sheet metal roof covering most of its expanse to keep out glaring sun and rain. She has several rooms attached to her main living quarters, but they exist as separate, self-enclosed shrine rooms. There is a room for her Trokosu, a water deity, and one for Mami Wata, Trokosu's "spouse." Mami Wata is a water deity usually described (including by Dashi) as someone who lives in the sea.[10] A painted

Figure 10.3. The form imbued with Togbui in 2013. Photo by Brian Jeffery.

image on the wall next to her door depicts a mermaid with a mirror in her right hand, a hairbrush in her left, being embraced around her waist from behind by a man who has flippers for feet.

Other pictorial images across her shrine compound include a python, a three-headed snake, a drummer wearing a northern-style smock and playing a talking drum,[11] a serpent as a rainbow that arches over a crocodile, and, of course, her main deity, Togbui.

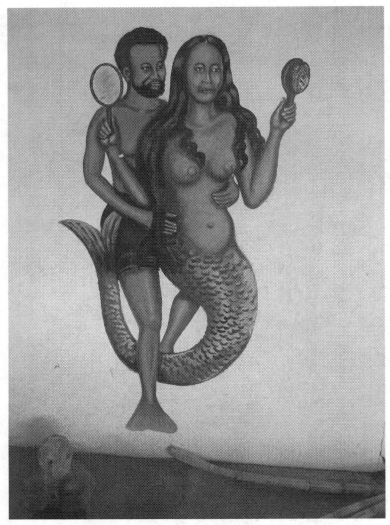

Figure 10.4. Mami Wata's illustration on the outside wall of her shrine room in Dashi's compound. Photo by Jill Flanders Crosby.

Moving with Dashi

During my time in Dzodze, Dashi was foundational to my research. We found ways to relate to one another despite my never mastering the Ewe language beyond basic conversation. Our communication often looked like a dance: glances, gestures, and poses. I never worried about being with her and not knowing what to do. If I needed to go somewhere, she moved me

along. If I needed to do something with an object, she handed it to me and I imitated her movements.

Dashi and I frequently traveled together, sometimes also with Johnson, to religious ceremonies in the area. I was especially keen to witness anything I could related to the secretive Yewe practices. If there was a ceremony that was not secret, such as a funeral for a Yewe adherent, where dancing was involved, Dashi was always willing to let me come along. I always danced, and because my experience as a dancer enabled me to learn movement patterns quickly, I danced at ceremony with a good degree of competence. Dashi never minded my presence.

I was sometimes called Dashi's daughter at these events. Since members of Yewe receive a Yewe name, my honorary Yewe name became Sotsimede, meaning one who is fast. My dancing demonstrated not only that I learned fast, but that I could dance well. Frequently, Dashi would pull me up to dance with her as if to show off the foreign researcher at her side who could truly dance. Being able to dance well, I believe, helped me become accepted at other ceremonies. Johnson often told me after we left a ceremony, while we were reflecting about what we had just witnessed, that he had heard many others commenting on my good dancing. I was always being pulled up to dance inside the ceremonial circle.

I also spent quite a bit of time at Dashi's own ceremonies at her compound, a one-minute walk from Johnson's. One time, in early 1999, I stayed up all night at Dashi's yearly ceremony to feed and cleanse all of her deities. Johnson had long since gone to bed, and I sat in a chair next to where Dashi sat. A new shrine room was constructed for Togbui for this event, the first new rendition for Togbui I witnessed—the round structure with a conical thatched roof and cloth at the door. This night, I primarily observed keenly, watching the events unfold, only dancing occasionally. It was the start of the ceremonial three-day event, a wake-keeping at which ceremony lasts until dawn breaks. One by one, the forms imbued with Dashi's deities came out of their individual shrine rooms into the center of her compound. It was an impressive collection of material culture forms. There were white human forms with slanted eyes, white human forms riding miniature scooters, and miniature Ghanaian-style stools, among other things. I walked around the assortment, observing the cleansing and feeding. Singing and moments of drumming and dancing were interspersed.

The night wore on. The attendees danced and sang, determined to last the

Figure 10.5. Dashi's deities. Photo by Jill Flanders Crosby.

night. Finally, light glimmered on the horizon and dawn was here. Everyone had made it through the night. The joy at first light was immediately felt in the crescendo of voices and the deepening of drumming and dancing. Fatigue slipped away and the energy level ramped up. We continued to dance, drum, and sing for about another hour. Finally, we ceased so we could all rest—but only until late afternoon, when another ceremony began.

Navigating the Boundaries

In reality, it was far from easy to cross boundaries that seemed to prevent access to religious knowledge. Significant information continued to be impermeable, a shell I could never quite crack. Layers of life stories remained beyond reach, protected by layers of skin. "Edges and boundaries," I often lamented in my journal. There were many social and etiquette

boundaries and status differences critical to social life and communication, facets that Chernoff (1979) identifies as something "Africans pay a great deal of attention to" (161), and that can feel like a giant roadblock to an outsider. There were strict rules and religious borders that could not be easily crossed by someone not inside the religion. This, of course, was also true in Cuba, but shrines and altars in Cuba can be found in everyday living spaces, unlike in Dzodze (and Adjodogou), where deities hide in their own shrine rooms, out of public view. Living space in Cuba did not necessarily allow for altars and *fundamentos* to have their own separate spaces. Furthermore, I enjoyed a different degree of access and trust in Cuba, as I was someone who had been to West Africa—perhaps the most important factor. Those in my Cuban fieldsites were thirsty for information from West Africa. The Ghanaians, unlike the Cubans, did not inherit a history of displacement due to the transatlantic slave trade. My work in Cuba was eventually interesting to them, but not in a way that initially gained me any capital.

I seldom gained entrance to the interior of most of Dashi's shrine rooms, with Togbui and Trokosu being the two exceptions, but even those were rare. I could occasionally get a peek into Mami Wata's[12] marvelous room every time Dashi went in and out of it if I were sitting at the right angle in her compound. Mami has a room of her own at Dashi's and is fond of fine and expensive things. The material culture found in Mami's shrine rooms, as depicted in pictorial representations, and in her/his narratives (for Mami can be both female and male), reflects these fine and expensive things. Every time I had a glance in Mami's room at Dashi's, the array of popular culture items—mirrors, perfumes, beads, lace cloth, colorful bottles, and so on—tantalized me. I had a sense of Mami from those furtive glances.

This minimal access to shrine rooms did not necessarily hold true at other shrines in the area. But in a number of places, the ways I got in were sometimes exceptions to the rules. One time, Johnson and I walked through the bush to the nearby small village of Dzogbefeme to witness a ceremony for a deity known as Agbosu.[13] The ceremony was in full swing when we arrived, and I was escorted to a house to change into the requisite cloth wrapped around my chest, and to remove my shoes and watch. At religious ceremonies in Ghana (and Togo), one does not wear a shirt or shoes, and watches are not usually permitted at most ceremonies. Females wrap a long piece of cloth around their chests, leaving their shoulders bare, while

men wrap a cloth around their waist and wear no shirt. Johnson remained outside, talking to an elder.

I emerged and headed toward Johnson. Before I reached him, a woman in trance tore out from the ceremonial space, saw me, and grabbed my arm. She yanked me toward and through a small doorway. I could feel her other hand on my back, pushing me to my knees. Looking in front of me as I knelt, I could see several embedded-in-the-earth religious forms with cowrie-shell eyes imbued with the deities staring right back at me with impatient skepticism, as if to say, "Who are you?"

I was in a shrine.

The attending priest sat in front of me. At least I recognized him as someone I had met and knew from Dzodze. After about two minutes, the possessed woman jerked me out through a different shrine door, now running me directly into the ceremonial circle. As she flew, another possessed woman was running into the shrine and collided with me. I could hear those in attendance in the ceremonial circle gasp, but I calmly followed and was led to a bench to sit and watch. Rather than being concerned, I was fascinated by what was happening, drinking in every sight and sound of the "performance" unfolding in front of my eyes, focusing on dance movements and interactions among practitioners. I knew Johnson would eventually find me, and indeed he soon did.

We settled in. Soon, a possessed man who was one of the priests present streaked toward me and pulled me up to dance. I was not familiar with these particular drum rhythms and dance movements, so I had no choice but to imitate. I followed every movement he executed, including the fervor of his dance, energized by his trance state. I received a roar of approval from the crowd, who had never seen me before. From then on, I was allowed to enter the Agbosu shrine whenever I visited Dzogbefeme and greet the deities with offerings.

Finding Togbui and Da: San Lázaro and Malé

Despite the fact that Togbui was Dashi's main deity, it was not easy to uncover Togbui's significance. It was a slow unfolding of information, as it took time to know what to ask, and why. For a while, all that I could get out of anyone was that Togbui is a landowner and an old god. The names Xholu (Xhorlu) and Anyigbato were also frequently mentioned with Tog-

bui. When I asked about Xholu, I was told that he was "a landowner and an old god." And Anyigbato[14] was also "a landowner and an old god." Could they all be landowners and old gods? Are there differences among them? As often as I asked, information was not readily forthcoming. Often, if I probed more deeply, Johnson would look at me and comment that he had already given me that information, or look at me as if I should not be told, since I was not initiated (nor had I initiated in Cuba).

Of course, to Johnson, this was all information that he had grown up with, and thus it was perfectly clear to him. To me, it was a chaotic swirl that I was struggling to deconstruct. I did know that when Togbui came down and possessed attendees, they were usually dressed in red, blue, and white (often displayed as vertical stripes on cloth). But there were also other color combinations of varying degrees of red, black, and white. Those in trance were often handed various objects, such as a walking stick of some kind, or they (while in trance) would go find a walking stick. But mostly they were handed a broom, the same brooms that surround Togbui's form wherever he is found. I was told that there are several types of Togbuiwo that could come down and that they could be identified by the fact that they were dressed in the different types of dress and with different objects. But I did not discern much else for some time.

I focused on what I could understand—the dancing body—and reminded myself to be patient. I had to trust that the more often I was present at ceremony, respected protocols, returned to Dzodze, asked questions, and brought back photographs and videos from earlier visits along with offerings to the shrines and deities, the better chance I would have of breaking down those seemingly impenetrable boundaries. Most of my visits to Ghana after my dissertation year, other than 1999 and 2006, stretched from a few weeks to one to two months at a time, usually with only weekends spent in Dzodze due to Johnson's teaching schedule in Accra, although I could sometimes sneak in five-to-seven-day visits. Whenever I *was* there, I would always be participating in Dashi's daily shrine activities, attending ceremonies, and conducting interviews.

As I simultaneously started and carried on research in Cuba, I often returned to Dzodze to describe what I saw and encountered there in order to set up a dialogue across the waters. The interest in Dzodze about those across the transatlantic space was muted in the beginning. But as I kept bringing back pictures from Cuba and my questions grew in new direc-

tions, interest gradually increased in Dzodze. Once, I showed Dashi a picture I had taken in Cuba around 2002 of one of Justo Zulueta's fundamentos (although I did not yet know the name of it). She looked at it for less than a minute and commented that it looked just like Togbui, who by now resided in his second form at Dashi's.

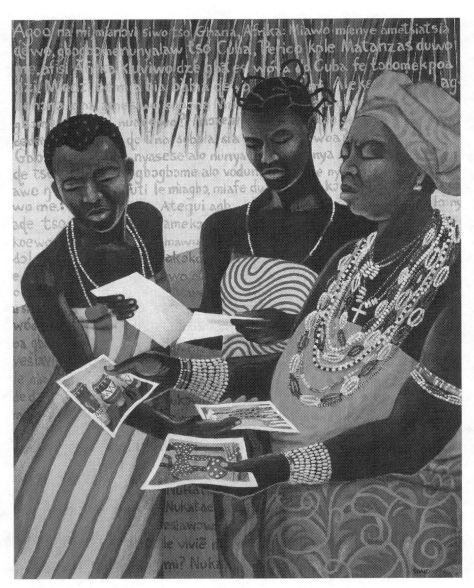

Figure 10.6. *Dzodze Women Viewing Photos of Perico* (2010). Acrylic on canvas, 67" x 54". By permission of Susan Matthews.

As I gained trust in Cuba, elders opened up to me with religious information and allowed me to take more pictures of their altars and fundamentos. Thus, every time I returned to Dzodze, I had new pictures to show, with expanded knowledge. Interest increased further. Susan Matthews painted a picture from a photograph I took of one of these picture-viewing events

Figure 10.7. *Robinson's Evidence* (2013). Acrylic on canvas, 67" x 54". By permission of Susan Matthews.

in Ghana, with Dashi and her devotees looking at pictures from Cuba, just as she painted one of Reinaldo Robinson in Cuba looking at pictures from Dzodze. Practitioners on each side of the Atlantic recognized similarities in religious forms.

At the same time, Johnson and I listened to recordings of the Arará rhythms and songs from Perico. He often commented that he recognized rhythms and melodies, seemingly knowing what patterns and melodies would come next, saying, "I know that song." It was not that he could necessarily sing the words even in his own language, but for him, it struck a very familiar cord. Something similar happened when in 2006, I showed a DVD of drumming and dancing I had earlier recorded in Perico to Patience Kwakwa, one of the dance faculty members at the University of Ghana. "It [the rhythms] sounds like Atsia," she commented. Atsia is an Anlo-Ewe dance and music form I had not yet witnessed. Although not Ewe, she knew Atsia because she was a dance scholar. In the meantime, when I went back to Cuba in 2007, knowing Dashi had found that Togbui resembled Justo's fundamento, I demonstrated a singular step and accompanying gesture I had seen in Togbui's suite of dances that mirrored a basic movement pattern of Arará dance. Hilda in particular nodded when I showed it to her, as did the then-owners of the "Oyá" house, Orlando and his wife Clarissa.

About a year later, I returned to Perico with a DVD recording I had made in Adjodogou of Atsia music and dance. That same step in Togbui's dance that mirrored a basic pattern of Arará dance also happens to be performed in Atsia. Now I had that step on video, along with the sound of its accompanying drum rhythms. The film format rendered the dance and drumming much more immediate than my attempts to show the step without the drums. Although that specific step was not immediately visible when I first began the video, those present in Perico immediately cried out, "You see, there it is." They began to dance that basic pattern, falling right in place with the drums even before they saw that specific step on the screen. The same foot pattern, the same gesture, the same shoulders. This was a striking moment. What I had long witnessed as an assumed connection had now been demonstrated through an embodied rhythm that spanned time and space.

Conclusion

One day, around 2008, Johnson and I were riding in a *tro-tro* (a local Ghanaian term for a mini-bus employed for public transportation) when up ahead, a big, fat snake was moving across the road (and was, unfortunately, immediately run over by our tro-tro). "Togbui," Johnson exclaimed. By now, I knew enough from Perico and Agramonte of the potential relationship between San Lázaro and Malé (and the rainbow that accompanies Malé). Pieces that had always been right in front of my face started to fall into place. Shortly thereafter, I mentioned to someone standing near me and Johnson that I had seen interesting shrines for a deity known as Sakpata in Adjodogou, Togo, and in Cotonou, Benin. By now, I also already knew of the relationship between Sakpata and San Lázaro. Johnson immediately quipped, "Yes—the same as Togbui," as if I should have known that all along. Pieces dropped suddenly into place. They should have dropped earlier, because I also now knew that Justo's fundamento that I had once shown to Dashi was San Lázaro—but it was one of those observations that needed an "aha" moment.

Shortly thereafter, I confirmed in an interview with Dashi that Sakpata[15] was indeed another name for Togbui (or, as my Togo research assistant Solar would say, Togbui is another name for Sakpata), and that Da likes to "walk" with Togbui. When one plays Togbui music (the drum rhythms), Da (and Yewe) music will automatically come in. One cannot do something for Togbui without doing something for Da.[16] This relationship between Togbui and Da helped me hypothesize why some in Perico and Agramonte claim there is a relationship between San Lázaro and a serpent even as other interlocutors and scholars are not so sure. Imperfect connections perhaps imperfectly analyzed, remembered, and passed down, but worth consideration and reflection.

Shortly thereafter, Dashi finally told me that Xholu and Anyigbato were also one and the same as Togbui, even though there were some differences. This did not make sense at first. They are the same, but they have differences? Then, around 2010, Dashi's portrait of Togbui on her shrine changed, and now his full name, Togbui Anyigbato, appeared. A new "aha" moment arrived. She had finally "given" me his full name. In Cuba, there exist many walks, roads, and types of San Lázaro. All are San Lázaros, but each with slight differences. When they come down at ceremony, each is dressed dif-

ferently. But it remains a fact that all are San Lázaros. And each San Lázaro has a distinct name, as evidenced by the names Nanú, Sumayayá, and Alua. So too are Xholu and Anyigbato, two in the family of many possible Togbuiwo/Sakpata. Considering that Togbui is often used as a title in front of a particular deity's name, this makes even more sense. Dashi, however, along with her shrine members, always referred to Togbui Anyigbato simply as Togbui, which led to my initial confusion.

Figure 10.8. Togbui Anyigbato's illustration on Togbui's exterior shrine wall. Dashi is on the left. Photo by Brian Jeffery.

It took me time to make all these connections: Dashi's Togbui Anyigbato with Sakpata; Togbui Anyigbato/Sakpata with Da; Togbui Anyigbato/Sakpata who "walks" with Da; and thus the connection between San Lázaro and Malé. This is not to suggest that Togbui Anyigbato is the same as San Lázaro and Da is the same as Malé. They changed as they traveled to Cuba. There is no way they crossed the Atlantic without altering, being reinvented and reimagined, especially under such difficult circumstances. But there are resemblances and shared attributes. And as evidenced in the next chapter, Togbui Anyigbato/Sakpata became the hinge upon which those in Cuba verified the African connections that they believed in and sought. They could see the resemblance and the similarities. This was proof for them.

It took me time to make these connections because, as Palmié critiqued, I went hunting with a specific agenda, and that agenda initially failed me. It revolved around Yewe and Xebieso. I knew that the Yewe thunder deity Xebieso was similar to the Arará thunder deity Hevioso. That blinded me. That is where I insisted on looking, rather than letting the data tell me where to go. What also blinded and failed me was assuming that I needed to turn to a formal and quantitative analysis of music and dance forms. Perhaps fortunately, I did not have the musical training to conduct such a musical structural analysis—that is, to notate and analyze drum rhythms. Instead, I slowly learned to let the field wash over me and inscribe its own data and methods.

The prolific oral stories, sacred spaces, dances, and ritual processes I encountered began to take center stage, and with that, I got out of my own way. Dashi led me there. "It looks like Togbui." Johnson led me there. "I know that song." The Cubans led me there. "You see, there it is." Sakpata, Togbui Anyigbato, and San Lázaro led me there. Perhaps I came to Legba in a different way than I realized. Or maybe it truly was Hilda opening my door and Justo pushing me through, while Legba helped me encounter some sense of clarity.

Notes

1. Bourdieu (1990) uses "habitus" to refer to the structures that condition the embodiment of cultural practice (55). In a literal performance, artists must be acutely aware of aspects like stage directions, musical cues, and audience interest. They embody these aspects as a staged performance. Similarly, cultural actors must embody that which constitutes the social moment, in this case the contexts embedded in religious practice.

2. Venkatachalam (2015) names the Gen/Mina and the Phla-Phera as other people falling under the Gbe-speaking subcommunities (25).

3. Meyer further offered that she thinks the missionaries privileged these stories, thus offering an account of a common origin, which then led to dispersal of the Ewe due to the cruel king Fia Agorkorli (Agokoli) and thus created the need to reunite the Ewe people, which was the project the mission set for itself.

4. The du-Legba tend to be larger and serve as Legbawo for sections of the town or all of the town, while Alegbawo are for individual households (Gilbert 1982, 60, 90n1). The categories of akpeli/akpele Legba and agbonu Legba were given to me by Bernard "Solar" Kwashie, my Togolese field work research assistant, as well as by Johnson Kemeh. In Adjodogou, du-Legbawo are for everyone in the community, akpeli Legbawo protect everyone in the house, and agbonu Legbawo, while also for the house, guard the gate or fence, whatever those boundaries may be. In Dzodze, du-Legbawo and akpeli Legbawo serve the same function as in Adjodogou, but there are also the kpornu Legbawo that guard the entrance, ashime Legbawo for the market, and mornu Legbawo for a smaller market. Akpeli Legbawo, Johnson tells me, require herbs for their power, and sometimes there are rocks buried underneath or nearby that are also charged with power (telephone conversation, April 4, 2018).

5. Alegba is known as Legba in Dzodze. In a telephone conversation on April 4, 2018, Johnson told me that the use of Alegba or Legba depends on the dialects of individual communities.

6. As Meyer also reminded me, it is important to understand that traditional Ewe religion has been and remains under attack by Christianity (e-mail to author, March 19, 2020).

7. Krachi-Dente is a fairly new deity that arrived in Anlo territory from northern Ghana. According to Venkatachalam (2015) Krachi-Dente (along with Fofie) is an umbrella term used to refer to "a corpus of practices dedicated to the veneration of the slave ancestors of some Anlo" (63).

8. According to Johnson, being a half-member means that one can participate in vodu Yewe ceremonies without fully belonging. If one becomes trusted enough, the person can also witness secret ceremonies usually reserved for full Yewe members only. This is extended in particular to those who have several tro deities, since tro and vodu support each other (telephone conversation, April 4, 2018).

9. Venkatachalam tells me that Togbui Anyigbato was not in her fieldsite of Anlo-Afiadenyigba, a community south of Dzodze, and that Togbui (or Sakpata) is vodu from the Fon and not generally found in Anlo-Ewe communities. However, I found Togbui Anyigbato in many communities surrounding Dzodze, and both Johnson Kemeh and Solar told me he was all over the area from Ghana into Togo.

10. Over my time in Ghana, I would hear fantastical stories about Mami Wata's fabulous cities under the sea. Here, one could find fine things or the latest technology.

11. The drummer on Dashi's compound wall represents a percussionist who plays Brekete rhythms from northern Ghana. These rhythms migrated down to Anlo-Ewe land.

12. Mami Wata is a water spirit believed to have overseas origins. She can bring good fortune in the form of money or other material culture goods, such as a fine new bracelet (Drewal 2008, 60–63).

13. Agbosu, while I had access to its shrine, remained a mystery. I do know it has a relationship with a crocodile-type creature, as evidenced by paintings on the shrine walls and through conversations. I also know the practice helped root out ill deeds and/or witchcraft, much like how I understood Krachi-Dente in Dzodze to work.

14. Meyer broke down the name Anyigbato for me. *Anyigba*—earth, the one of the—belonging to the—earth (e-mail to author, March 19, 2020).

15. Sakpata, associated with smallpox in Dahomey, "was a vodun of the country, of the bush" (Bay 1998, 158), and he is the "the earth itself" (Bay 1998, 156). Soumonni also identifies Sakpata as the god of smallpox (2012, 25). Bay further discusses the contentious literature and theories that argue that at one time in Dahomey, smallpox may have been used to direct and control political power. Regardless, Sakpata, argues Bay, has historical connections to issues of the power of royalty in the Dahomeyan kingdom. When I sent Michael Atwood Mason the picture of Dashi's latest rendition of her form imbued with Togbui Anyigbato (seen in this chapter), he commented in a personal communication (March 5, 2018) that "It seems to be where pock marks from infectious disease become the leopard spots of kingly authority. Awesome."

16. Johnson Kemeh, telephone conversation, April 4, 2018.

11

Adjodogou

In the Land of Vodu

JILL FLANDERS CROSBY

After spending a week with Bernard "Solar" Kwashie in Cotonou, Benin, June 2006, I accompanied him to his hometown of Adjodogou, Togo. Leaving Cotonou, we went west to Lomé, the capital city of Togo, before backtracking east in a bush taxi for about 45 minutes, snaking through the countryside toward Vogan, a larger community just north of Adjodogou where we would sleep that first night. Along the way, we passed inconspicuous and sometimes faded signboards, some set low in the ground and otherwise hidden in a sea of tall weeds and grass, with words and pictures advertising multiple vodu shrines with the names of deities that were both old and new to me. But the word *vodu* immediately caught my attention, elevating those artifacts from the inconspicuous to the very obvious. Other evidence, such as priests indicating the presence of their vodu shrines, was also abundant. On poles high above individual compounds dotted along the roads, flags displayed the colors of that compound's main deity as spatial markers conceptually announcing, "Here is a shrine."

Adjodogou provided a welcome respite from Cotonou. Nevertheless, Cotonou remained a vivid experience as we drove out of Benin and into Togo. In Cotonou, the week before, I had arranged for a ritual ceremony to film for research purposes, the ceremony being for a deity known as Koku. Multiple people fell into trance and ran up and down the suburban neighborhood street lined with immaculate middle- to upper-class homes as the ceremony spilled out of the ritual compound. Directly across the street from the shrine compound sat a brand-new car in a splendid magenta color. "I

wonder what the neighbors must think," I mused that afternoon, as another person in trance came flying out of the compound and ran up the street, turned around, ran back, and began vigorously dancing in front of the drummers who had by now followed the dancers out into the street.

It was an interesting study in contrasts. My mind kept spinning in circles at the thought of powerful vodu shrine compounds easily inhabiting middle- and upper-class Cotonou neighborhoods. While these vodu shrines were not exactly "modern," they certainly were not small. They contained several dwellings with multiple separate shrine rooms, with elaborately rendered forms imbued with the individual deities.

In one of those compounds, I saw for the first time a magnificent form for the deity Gu (or Egu). Gu, the deity of iron (which in some ways resembled Lucumí forms I had seen for the Cuban deity of iron, Oggún), imbued an impressive sculpture that seemed to exist purely by happenstance. At first glance, it seemed as though some upward force had collected heavy metal objects and scraps into a self-sustaining pile in the outside yard of the compound. Ensnared, entangled, and indistinguishable scraps of metal came together the way threads of individual narratives weave into the larger tapestry of history. It reminded me of Ma Florentina's Chacho Cuacutorio, hers a resplendent form of what seemed to be more intentionally assembled, but still seemingly random, metal parts from who knows where.

Here in Cotonou, I also saw what I thought was my first Sakpata shrine. Unlike with Dashi's Togbui Anyigbato shrine, I was not allowed to look into the Cotonou shrine to see the material form imbued with Sakpata, which would have allowed me to note any resemblance to Togbui Anyigbato. Like Dashi's shrine, it had red, white, and blue-black spots on the exterior wall, but I had not yet made the connection. This would take me another two years.

Adjodogou was its own study in contrasts. After arriving in Vogan and settling in, Solar and I waved down motorbikes in order to travel to Adjodogou and announce our arrival to Solar's family. We headed southwest for about a twenty-minute ride along the road connecting Vogan and Aného and arrived at Adjodogou in the late afternoon. We stayed until well after dark. With no electricity, Solar's senior brother Togbui Tafune lit a kerosene lamp and placed it on the ground right outside the door of his clay block house once it grew dark. He sat on his stoop as Solar and I relaxed in roughly framed lounge chairs with a simple cloth sling supporting our bod-

ies. The quiet cool of darkness enveloped us that first evening and offered a reprieve from the frenetic pace of Cotonou, its unrelenting heat and noise, its wind-stirred dust and sand. Stars once again entered the narrative of this fieldwork experience as I gazed up at a synesthetic night sky, dotted with singing celestial pearls. They seemed to radiate not just light but also sound, which muffled the voices of Solar and his elder brother in conversation. But Adjodogou, my additional research site for the next seven years, eventually proved to be anything but quiet.

Adjodogou

Adjodogou was founded by Solar's great-great grandfather Foli Gadjin, and the community remains largely in family hands to this day. Foli, before founding Adjodogou, would travel from his then-home of Aného on Togo's southwest coast of the Bight of Benin up to his favorite location to both farm and fish. After a time, he established a small village at his fishing and farming site where he could sleep, since it was easier than going back and forth to Aného. Others who had been coming to farm and fish also decided to stay. A small market was established at the junction of the main road between Aného and Vogan.

Early in the history of Adjodogou's market, it became a target of attacks by thieves. According to Solar, Foli was a strong man who fought off the pillagers. From him, the town earned its name—*adjo* meaning "attack" and *dogou* meaning "nobody can come." Foli became both the chief and a priest of the area, as he brought the first two deities to the community who called out to him as powerful stones. The first one was Sakpata, and Foli found him in a river. The second, Xebieso (Yewe), was found on a farm. This finding of Xebieso coincides with the findings of Nyamuame (2013), who writes that Yewe itself can be found in unusual or precious objects (115–116).

Xebieso's story, or that of the arrival of Yewe in Adjodogou, unfolded over years. Foli was walking on his farm when he found the stone. At first, as Solar narrates, he did not take it seriously, but then he got sick. Only through divination did he learn that the stone was Xebieso. Now knowing that he had to pay attention to Xebieso's needs, Foli would pour libations and do whatever he was told to do. But the actual landing of Yewe as a fully functioning religious practice in Adjodogou did not happen until Yewe finally "caught" someone. According to Solar, the first person Xebieso actu-

ally "caught" was Foli's grandson, Solar's father. Solar can no longer mention his father's birth name, since once his father was "caught" by Xebieso, his original name became null and void according to Yewe customs. After being caught, his father needed a new name, and thus he was called Soidezedo (as spelled by Solar), a name meaning "arrived" or "settled," indicating that the deity had settled there. Although everything for the shrine was prepared in Foli's time, it was Soidezedo who became Yewe's first member, the first one "caught." In order to take on this responsibility, Solar's father was kept inside the shrine for three years to learn religious protocol before being presented to the larger community.[1]

The discovery of Sakpata took a slightly different path. Solar's great-great grandfather found a small stone one day in his fishing net, but he threw it away. The next day, he cast the net and the same stone appeared. He threw it away again. But later he found that same stone in his room. He did not understand at first. But soon, his skin began to erupt in rashes, and he went for divination. Sakpata appeared, saying that Foli had to be his own priest. The rashes that appeared on Foli's skin signified Sakpata's relationship with sickness and smallpox. Sakpata had picked Foli.

Both stones that Foli found (Sakpata and Xebieso) were eventually placed in a small hole under the individual material forms constructed for each deity. Sakpata imbues a form inside his own roofed shrine room, while Xebieso imbues a form inside a larger, walled, open-air shrine space that is dedicated to the Yewe pantheon.[2]

The arrival of Da (the snake), or rather the formal establishment of Da's shrine, is a very different story. Apparently Da was already on Adjodogou land, imbuing a tree next to Sakpata's eventual shrine location. Da began to "capture" the women of Adjodogou from Foli Gadjin's time up to that of Solar's mother. It began with one of Solar's foremothers, several generations back, who was captured for some reason, most likely because Da had already been in her family before her. But soon, other women were being captured. As Solar tells the story, the women captured would not necessarily be dancing or attending any drumming event. They might simply be out farming and then suddenly they would find themselves on the ground by Da's tree (which was eventually called Mama Da). "So they are captured and say, 'Here I will stay, here I will stay forever, you see," Solar told me. "And so my mother just entered [where the Da tree grows] and she became vodu" (interview, June 2010, Accra, Ghana).

The Shrines of Adjodogou

In Adjodogou, I could freely enter Sakpata's and Da's shrines. The Yewe shrine was more complicated. Priests would throw the cowrie shells in front of Sakpata to see if Xebieso would grant me entry. I did not ask for permission often, as Yewe shrines are among the most difficult for non-members to enter. Despite all my years in Dzodze, I was never invited by the Yewe priests to throw the cowries to request permission to enter the shrine despite my keen (and well-known) interest in Yewe. In Adjodogou, I surmise that I was allowed into the Yewe shrine the first time I visited Adjodogou to film music and dance primarily because I offered a much-needed financial donation to the community, along with food and drink for the day. But Sakpata still had to give permission, even before I specified the amount of my donation.

Usually, when the cowries are thrown, Solar tells me that Sakpata initially declines whatever request is put before him. Something else must be offered—more money at the foot of the deity, a second bottle of gin, another fowl, perhaps more *akpeteshie*. During my first visit in 2006, I had to give more akpeteshie. In 2013, I was allowed in to the Yewe shrine a second time, along with two other members of the *Secrets Under the Skin* team the year we brought the show to Ghana.[3] We threw the cowries first to Sakpata to ask permission. But this time, unlike the first time I visited Adjodogou, Sakpata did not hesitate. Permission was granted the first throw. Incredulous, Solar's brothers threw the cowries a second time. Sakpata still did not hesitate. In this second throw, like the first throw, the cowries landed two up, two down (called *Wlin-meji*, as spelled by Solar), giving permission. We spent that afternoon first making music and dance in the space between the Sakpata and Da shrines while goat, fowl, and other food and beverage goods we had bought were cooked and fed to the community. Then we reassembled inside the Yewe shrine. It was quite a culmination of the Togo fieldwork. In front of Sakpata's shrine and in the Yewe shrine, it was lively and engaged. We laughed and danced, with spirits raining down upon us, possessing those who were caught by them. It was an afternoon of celebrating friendships built and trust granted. Susan Matthews would later create a painting of one of the many *Legbawo* she viewed in Adjodogou that day that would become a part of the *Secrets Under the Skin* installation as it continued to travel beyond Ghana.

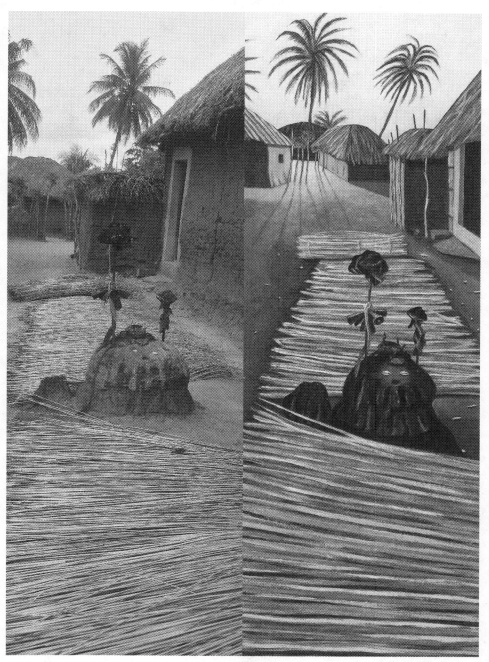

Figure 11.1. Afeli as a photo (*left*) and (*right*) as rendered by Susan Matthews; *Afeli* (2015). Acrylic on canvas, 72" x 53". By permission of Susan Matthews.

The Shrine Forms

The main Sakpata shrine room is located directly across from Da's separate open-air shrine enclosure. No ceremony for Sakpata that I ever attended, including the many times we made music in the area between the two shrines (usually, every time I visited Adjodogou), was exclusively for Sakpata. Da was always included. We poured libations for Sakpata, walked over to Da for libations, walked back across and poured more libations for Sakpata, walked back to Da and sang, danced, and drummed, and then continued drumming, dancing, and singing our way back to Sakpata. When possessions came down, the one in trance always visited both shrine rooms.

Sakpata's form in Adjodogou was unlike Dashi's first form for Togbui Anyigbato in Dzodze, somewhat like the second form she made for him, and very unlike the third form. Adjodogou's shrine enclosure was also unlike what I saw in either Dzodze or Cotonou. Most likely, financial resources and access to materials drive the construction of Sakpata's form and shrine-room enclosures. In Dzodze, over time, Dashi had access to finances and materials to construct and paint a concrete, walled structure. Eventually, she also remade Togbui Anyigbato into a remarkable form. Clearly, in Cotonou, shrine compounds in a city center have more access to resources as well, allowing shrine enclosures to be made of concrete and painted.

In Adjodogou, Sakpata's shrine walls are simply mud and clay. No spots could possibly be painted on those walls. Sakpata's form itself is a conical mound of mud and clay with various types of seashells embedded in it. Ritual brooms lean up against the form, while the requisite empty gin bottles and schnapps lie around its base. A handful of cowries lies on the ground, and there is a tip of palm frond (called *azan,* as spelled by Solar) draped on the wall behind Sakpata with an un-shucked corn cob hanging above the frond, in the middle of its span.

On top of Sakpata's mound sits an inverted clay pot containing several holes, of the sort that can be readily bought in the market and is specifically designed for religious purposes. Solar says that the number of holes in the pot, known as an *amagaze,* is irrelevant, as long as there is one central hole. It is through this central hole that blood and akpeteshie are poured into Sakpata's form in order to feed the sacred stone buried under the form's base. Dashi's new Togbui Anyigbato form also has a central hole on top and at its mouth to allow her to feed it. This is not unlike what happens with

the San Lázaro *fundamentos* in Perico and Agramonte, where offerings are poured through the holes in the lid of the *cazuela*.[4]

What is interesting is the resemblance between a feature of the Togolese Sakpata shrine and Armando Zulueta's *secreto*. Called *sinuze* (as spelled by Solar), it is a special pot, placed in front of Sakpata, and inside is a small calabash bowl. This bowl is used to mix herbs and water together to drink, or for therapeutic bathing. Unlike Armando's secreto, however, nothing is buried underneath. However, Solar tells me, when fowls are offered to Sakpata, the attending priest, while holding the fowl, will then touch the sinuze with that fowl as part of the offering.

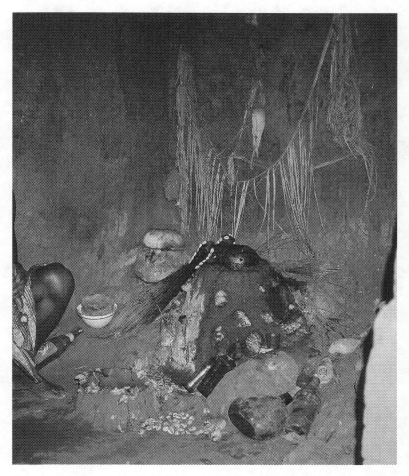

Figure 11.2. The form imbued with Sakpata in Adjodogou. The sinuze is in the ground to the left of the form. Photo by Jill Flanders Crosby.

Da imbues a large tree with roots that rise like mountains from the red earth. In the valley of the tree's roots, Da cradles offerings: talcum powder tins, perfume bottles, a candle, and a calabash bowl. In the right-hand section of Da's compound, just inside the entrance, is another tree imbued with a deity known as Logozago (as spelled by Solar). This tree has three strips of cloth (red, black, and white) tied around it with cowrie shells at

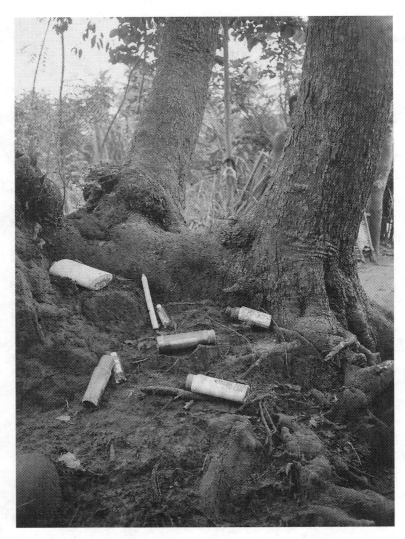

Figure 11.3. The tree imbued with Da in Adjodogou. The tree imbued with Logozago (with the strips of cloth tied around it) is visible in the near distance between the two sections of Da. Photo by Jill Flanders Crosby.

its base. While its deity is not directly related to Da, the tree grew inside the shrine and became recognized for its powers. People consult Logozago when making promises in exchange for the granting of particular wishes.[5]

Both Solar and his aunt, Sikasi Ede, an important priestess of Adjodogou, point out that Sakpata and Da walk together and, in a sense, are the same. They are like siblings who have differences, but they do the same work, a view echoed in Dzodze as well. Of course, Sakpata and Da manifest themselves differently. This relationship between Sakpata and Da has sister stories throughout Perico and Agramonte. Many paths of San Lázaro had something to do with a *majá* (snake). Then of course, Malé, in Perico and Agramonte, also seemed to bear a resemblance to Da. In Perico, Malé was seen at the top of Fidela's avocado tree. Justo's own avocado tree had some relationship with a serpent. In Perico, Malé was a traveler, moving around town and from well to well. So Da and Malé, the snake, always intrigued me.

Sakpata: The Land Owner

Priestess Sikasi Ede has her own Sakpata shrine room in her compound, along with many stories. Here, I was never granted access to her shrines, for she did not know me well. Regardless, Sikasi was very open with her information, and she willingly answered the questions sent from Cuba that I captured on film. As Sikasi told me, Sakpata is the most important among the deities. He is the owner of the earth on which one walks in every region, and the most important shrine is that of Sakpata, because when one wakes up, one steps on the earth. As Solar added, "He is there for the ground. He is the owner of the land, so he is strong for every African." As such, he is the leader of all deities (interviews, June 2010, Adjodogou, Togo, and Accra, Ghana).

Sikasi knew that she needed Sakpata when she started to break out in rashes. Later, despite having built her first shrine for Sakpata, her rashes returned. She thus had to build another Sakpata shrine, one she calls Tso Glikpodzi. This caught my attention, as did Sikasi telling me that she also has Dzagli, known as the soldier or bodyguard who guards Sakpata. Xholu (spelled as Xhorlu by Solar) and Anyigbato, the other names I always heard in Dzodze, are also attached to Sakpata in Adjodogou.[6] All of these names are reminiscent of Minita's story about seventeen San Lázaros among San

Lázaro's troops, and again point to the many walks or paths of San Lázaro in Cuba. They are all San Lázaros, but with differences and different distinguishing names: Nanú, Sumayayá, Alua; just like Anyigbato, Xholu, Dzagli, Tso Glikpodzi—all Sakpatas.

Sikasi further caught my attention when she told me that the most striking deity she served, known as Anyidohuendo (as spelled by Solar), radiated the splendor of a rainbow. There was a time when Sikasi could not sleep because she had nightmares. "I would see myself in the river or in the bush," she said. The only way to wake up from the nightmares, according to her, was to enter the rainbow beaming from the river or bush. Thus she had to initiate to Anyidohuendo.

In Adjodogou, Sikasi tells me that there are two rainbows, the male and the female, the male being brighter and more colorful. In Perico, this is the same story Hilda Zulueta narrated about Malé and Juerdase. Historically, the concept of the rainbow appeared to have been widespread across the area formerly known Dahomey and remains true to this day. So it is not at all surprising it would have made its way across the Atlantic through the transatlantic slave trade and be reinvented in a new place where peoples from multiple disparate communities were now living in the same *barracones* and forced to work in the same sugarcane fields. This concept also made it to Haiti through Aida-Wedo (female) and Damballah (male). Memories of a life left behind were reconfigured as a way to sustain social identity. New names and altered concepts sprang from a similar well.

Threading Connections and Closing Circles

It was in Adjodogou where I finally saw Atsia, the dance and music form on which professor Patience Kwakwa commented after viewing my Perico DVDs. Solar and I had returned to his village for a funeral one week after we finished my first Adjodogou visit.

Funerals are weekend-long affairs. There is usually a wake-keeping on Friday night that lasts until dawn, and then there is singing and dancing intermittently on Saturday, but featured on Sunday. This particular wake-keeping, held at Sikasi's compound, could not even begin, as torrential rain closed in shortly before we were to commence. We retreated inside to wait. The rain continued into the next day. Rivers flowed across the floor of Si-

kasi's compound and forked around the many Legbawo and other ritual sculptures embedded in the earth.

Sunday broke bright with sunshine. The drums appeared, and were cleaned and tuned. Benches were pulled out and arranged on three sides of the area where the drums would play. We placed thatch over the top of the drumming and dancing space so the sun would not be too strong on those dancing and drumming. Food was cooked, and drink was poured. Once the music and dancing began, I mainly watched and filmed entirely new (to me) dance forms. Everyone present sang, and most eventually danced, but it was primarily the younger family members who got up and danced the most. At one point, two of the dancers began moving around in a circle, falling into the Arará step I knew so well from Perico and Agramonte (and the step from Togbui Anyigbato in Dzodze). I had the same reaction my Perico interlocutors would later express after seeing this segment of the film: "You see, there it is." And in the actual moment for me, indeed, "there it is." The signature gesture, the double rise and drop of the shoulders, the same step.

"There it is."

Adjodogou also surprised me when I showed the community enlarged 12" × 16" photocopy prints from my pictures of the many fundamentos and religious objects from Perico and Agramonte in July 2011. On this particular trip, I also carried prints of Susan Matthews's paintings, and copies of my performance-based videos. The *Secrets* installation had already opened in Cuba, and I was back in West Africa to begin introducing the show to galleries in Accra and carry back evidence of the show to all my interlocutors in Dzodze and Adjodogou. The community of Adjodogou did not really know much about my Cuba work before this trip, despite my numerous visits. I showed them my performance-based videos created for the installation on my laptop in an outdoor space while Solar translated my careful narration about the artistic intent of the videos. Then I pulled out the photocopies and Susan's prints. I was careful with my words, letting the pictures (and images of the fundamentos) largely speak for themselves. And then those from Adjodogou led me back to Cuba. Their surprise, according to Solar's translation, came mostly from their realization that their religion had gone to places outside of their community. They could recognize their belief in other worlds.

I remember a year prior, the first time I showed Solar many of the same

Figure 11.4. Residents of Adjodogou view Flanders Crosby's videos. Solar sits on the right with his sunglasses on his forehead. Photo by Jill Flanders Crosby.

images and videos as part of my methodology to open a dialogue across my fieldsites. We talked extensively about Armando's *awán* at the same time. Solar began telling me about their own one-week celebration for Sakpata in the Adjodogou area. At the end of that celebration, he narrated, nobody can go out late at night because they do not want to meet Sakpata. One must head toward the house by six or seven p.m.

But then Solar began to describe the ceremonies for Sakpata that are similar to the awán. He described the process of taking a basket, everyone cleaning themselves, putting the "rubbish" in the basket, wearing a green herb around their necks that also goes in the basket, everyone being further cleansed with fowls, and finally throwing small coins in the basket before it is taken away to a crossroads. When I interviewed Solar and asked him what he thought after seeing my videos from Armando's awán and hearing my descriptions of that event, he said:

I was surprised. I could see so much similar and everything they did and everything I saw right now, you have been telling me plenty, so many things. It is similar, just slight difference because the thing is from here—so [the Cubans] took [it] over, so they are doing it. But the difference is [here, when in ceremony] nobody will put on a shirt or wear sandals. But I see [in your] video, the one who is possessed still has on a shirt. That is the only difference. But the ceremony with the basket [the awán], it is the same, the same, it is the same. So how they are doing it, I like. I know Sakpata travels to everywhere, I know Sakpata is around everywhere. So [the Cubans] must continue and do it. One day, one day maybe we will visit them, and maybe they too, and we will go shrine to shrine—we walk together, yes. (Interview, June 2011, Accra, Ghana)[7]

What Solar expresses is a recognition of the metaculture created by an ensemble of social actors. In other words, the contact of, say, the scholar's discourse with that of the elders opens up layers of meaning. As defined by Urban (2001), metaculture consists of narratives shared across communities about those communities, creating a "culture that is about culture" (3); in the case of our book, metaculture references reflections by artists, scholars, interlocutors, and others that provide commentary on location-specific social memory.

As an inevitable effect of the bridge-building between Cuba and West Africa, interpretations and recognitions like Solar's highlight the multiple layers of knowledge production. As Jones (2002) expressed, "Ethnographers do not present the culture but are conscious of how they act as interpreters of the culture" (9). And these interpretations impart "An accelerative force to culture. [They aid] culture in its motion through space and time. [They give] a boost to the culture that [they are] about, helping to propel it on its journey. The interpretation of culture that is intrinsic to metaculture, immaterial as it is, focuses attention on the cultural thing, helps to make it an object of interest, and, hence, facilitates its circulation" (Urban 2001, 4). Consistent with the aim of our overall research is that final notion—to facilitate the circulation of stories, practices, and communities in a performance that keeps these traditions alive. What is created in the wake of such interactions is an object of interest that all involved parties have a role in shaping.

Notes

1. The term for this is called "being outdoored."

2. The enclosed Yewe compound is known as *yewefe* or *yewekpo* (yewe house) (Nukunya 1969, 3). In Dzodze, the deities of the Yewe pantheon are known as Xebieso, Agbui, and Adayido (the last two names as spelled by Johnson). In Adjodogou, they are known as Xebieso, Agbui, and Avlekete. Ventakachalam (2015) names the Yewe gods as Hevieso (as she spells it—meaning thunder), Avleketi (sea), and Voduda (serpent) (108). Akyeampong (2001) names them Hebieso or Xevieso, Agbui *or* Avleketi, and Voduda or Da (108).

3. Brian Jeffery and Susan Matthews accompanied me to Adjodogou, along with Solar Kwashie.

4. There are also times in Cuba when the cazuela lid is lifted and offerings are poured directly onto the stones.

5. Sometimes people may name their child after Logozago, provided they value what Logozago has done for them. But should they fail to honor their promises, Logozago destroys them and makes them miserable (telephone conversation with Solar Kwashie, April 24, 2018).

6. Yet other names for Sakpata in Adjodogou include: Dasahorlu, Ahorlutotkpo, Torholu, and Azonwheanor (all as spelled by Solar).

7. I have edited Solar's English for readers not familiar with Ghanaian pidgin.

12

Acts of Storytelling

Natalia Bolívar Aróstegui cast a stern look in my direction (Flanders Crosby's). Núñez Isalbe and I spent several hours on December 22, 2015, at her house in La Habana, finding out more about Josefina Tarafa. I first became aware of the depth of Natalia's work at the seminal AfroCubanismo[1] workshops held at the Banff Centre in Banff, Alberta, Canada, in 1994. She was treated with significant reverence by all in attendance for her work and knowledge. She remains a major power broker in the world of "Afro-Cuban" religious scholarship, and a prolific writer.[2] Her expansive knowledge helped assemble pieces of Perico's oral history puzzle, particularly concerning Josefina and her connections with Justo Zulueta.

We rode the elevator that day to Natalia's airy fourth-floor apartment and stepped into a room that felt like a museum—plants occupied every corner, paintings and "Afro-Cuban" religious artwork decorated the walls, and surfaces of all kinds (floors, tables, etc.) displayed even more "Afro-Cuban" religious art and sacred objects. Natalia, her eyes probing ours deeply, wore her sacred *collares* and *iddés* (sacred bracelets).[3]

Natalia told me that day that if I were going to research and write about "Afro-Cuban" ritual traditions, and in particular about Perico, I must understand the work of all those before me, such as Andreu Alonso (1997), Vinueza (1988 [1986]), and others. She also stressed that I must understand and discuss the depth and complexity of "Afro-Cuban" ritual traditions. Most importantly, I must have knowledge of the work of Lydia Cabrera, who, of course, had had Josefina at her side in the field at la laguna sagrada de San Joaquín de Ibáñez. The names of author-researchers and their publications rolled off Natalia's tongue. She was humble enough not to mention her own impressive body of work of more than thirty years, which included writings on all possible aspects of "Afro-Cuban" religion.

Ghana and Togo cannot be left out of this conversation. Embedded in

the Cuban oral histories are layers of similarity that intersect with the Ghanaian and Togolese research, and that shoot through the threads of conversations that the research team carried between Cuba and Ghana. While the Ghanaian and Togolese stories Flanders Crosby heard during her years in West Africa are not as historically prolific or detailed as those of Cuba, they remain important to the overall historical fabric.

Of course, the stories presented in this book make no attempt to provide an all-inclusive "Afro-Cuban" religious history, a family tree of religious names, religious concepts such as *botánica* or *espiritismo,* or details of other religious practices such as Palo, Gangá,[4] and Lucumí. The research remains location-specific among four communities, two in Cuba and two in West Africa. This is but a bare slice of space across the diverse geographical breadth of "Afro-Cuban" Arará and Ewe and Fon danced ritual traditions. Natalia may well remain disappointed.

Clearly, evaluation of interlocutors was critical in telling these stories. People's memories were not always clear, and stories were likely reimagined. Oral history remains inherently fluid, mercurial, and performative in shifting layers of "coming to be." Some stories may have become deeply woven into community mythology because, in many ways, cultural identity depends on particular stories being (re)told (Richardson 1990; Mullen 1994; Olick and Robbins 1998; Journet, Boehm, and Britt 2012). Stories can often be dismissed by outsiders as false; but if they are believed within a community, then this research team treads carefully in the use of the word "false."

We also acknowledge that information may have been withheld from us. Thus, we ran particular stories past two respected scholars in "Afro-Cuban" ritual traditions, David Brown and Michael Atwood Mason. Both of them, initiated priests into the Lucumí religion, spent significant time in Matanzas Province.[5] Mason in particular practiced and researched in Perico. Regardless, our research ultimately depended on the performance of cultural memory. After all, Natalia did argue that in order truly to understand and write about "Afro-Cuban" ritual traditions, a scholar needs to merge the scientific research method of Fernando Ortiz with the oral-based methods of Lydia Cabrera (Morales Rodríguez 2015).

Both social and cultural memory are evocative and powerful vehicles in the communities of Dzodze, Adjodogou, Perico, and Agramonte. Our writing reveals the stories told to the research team in order to evoke a

sense of place from those who lived and still live there. The relationship between identity and memory is simultaneously a collective weaving of history and myth, construction, change, reimagining, and reweaving (Van Dyke 2009). Social memory is also a collection of individual identities dependent upon age, personality, acceptance into the circle of power brokers, elder reverence, and religious artifacts still in family possession (Olick and Robbins 1998). Social memory relies on the stories of youth and elders, moments of imagination at the telling of any particular story, that gives rise to recognized identities at the forefront of a community. Under such considerations, a story's fact/fiction binary becomes irrelevant.

Cultural memory consists of shared ideas of the past that are not easily evoked through the written word (Assmann and Czaplicka 1995). Its actual state of being is ongoing, performative, and shifting—existing inside a public sphere of interactions and recollections brought into agency by both simple as well as complex rituals. There are slippery edges around each story, as both history and myth are products of cultural formations, such as oral history narratives. Faced with such peculiar forms of "data," it seemed appropriate to share the stories in equally imaginative formats—the literary writing employed in this book and, before it, the art installation.

Notes

1. AfroCubanismo was a workshop held in Banff, Alberta, Canada. Flanders Crosby attended this workshop in 1994 and 1995.

2. Her books *Los Orishas en Cuba* (1994) and *Lydia Cabrera en su Laguna Sagrada* (2000) are two excellent examples that are widely read and consulted today.

3. Iddés are usually made of single or multiple strings of beads of different colors and patterns according to the various deities.

4. Gangá is an African-derived religion in Cuba practiced only in Perico. Basso Ortiz (2001) asserts the word Gangá may be derived from the river Gbangá in Sierra Leone or from Gbangbama, the area in which the river runs; therefore, Gangá refers more to the name of the area than to the name of the people (196).

5. In particular, see Brown's *Santería Enthroned* (2003), and Mason's blog *Baba Who? Babalu* (http://baba-who-babalu-santeria.blogspot.com).

PART 2

Secrets Under the Skin

Sensing the Moment at the Intersection of Art and Research

13

Narrating the *Secrets Under the Skin* Installation

JILL FLANDERS CROSBY

It is May 21, 2004. I am waiting at the Dzodze roadside for a tro-tro. With me is Johnson Kemeh, and we are headed to nearby Nogokpo to a large and important Yewe shrine. We hear the rumor that today there will be a major Yewe ceremony, a very unusual one that comes along only once every few years, usually when someone has been dealt a particular judgment by Xebieso, one of several deities possible for Yewe. In this particular area, Xebieso is sometimes called So, and two other deities in the Yewe pantheon are known as Adayido and Agbui. It turned out that Xebieso's judgment had been that the offender be struck dead by lightning. The offender had cheated someone out of a mere 1,000 Ghanaian *cedis,* the equivalent at that time of about fifty cents USD. Regardless, at that time, 1,000 cedis was still money lost.

When we arrive, we wander. We ask directions. Someone finally says, "Oh, you came for a look," and then escorts us toward the sound of drumming. We make our way to seats located at the inner edge of the dance circle, and close to the main Yewe shrine. The ceremonial circle itself is huge. Two drum ensembles are on either side, one near us, the other directly across, but far enough away from each other that they do not impede each other's sound.

Dancers are streaking across the circle from one side to the other in long strides. Groups of attendees from surrounding-area shrines arrive one after the other, singing and ringing bells to accompany their walk and call the deities. We faintly hear them in the distance, but their bells and singing grow ever louder until finally they break out of the bush and enter the circle in stunning regalia. Those in attendance, already dancing, singing, and

ringing bells themselves, increase their fervor. Women known as Avleshies, who have been consecrated to the deity Agbui, are allowed a special comic role and create improvisational skits that inject humor into the afternoon. One Avleshie has a toy calculator, adding up numbers and telling members, "So-and-so, go pay your dues to the drummers"; "So-and-so, go pay your dues to the shrine." Another Avleshie sports huge yellow-rimmed plastic sunglasses, and holds a toy phone. "Did you hear what happened?" she says mockingly into the phone. "All because so-and-so wanted to cheat someone else out of 1,000 cedis."

Suddenly, Yewe members collectively leave the ceremonial circle and disappear into a separate, smaller, and distant shrine room. When they return, as a singing and dancing processional, the large bones and skull of the deceased are held in one man's hands and arms for eventual placement in the larger shrine. The ceremony ratchets up as another group suddenly disappears into that main shrine. Then, just as suddenly, its members pour back out, run around the circle, run back into the shrine, exit again, run around the circle a second time, and go back into the shrine a third time. This time, they come bursting out with two Yewe members, each holding a long stick straight up, aiming at the brilliant blue sky. The striped cloths tied around the top of each stick leave bright trails of oranges and blues.

The colors are those of two of the Yewe deities, their imbued material forms hidden underneath a cloth carried by the two men, who are in a sort of trance. Johnson tells me that Yewe does not "possess," yet the Yewe deities will, in a sense, imbue the body of the person who is carrying them. Inside the shrine, the deities had chosen these two to carry them outside. The third deity, though, chose not to be exposed to the public today (neither Johnson nor I knows which deities came outside and which one stayed inside). The men carrying the participating deities begin streaking around the circle. I stand up, straining to see and feel, the observing crowd leaning in on me uncomfortably. Annoyed, I turn to exclaim, "Hey, we can all see. Stop pushing." But I immediately realize almost all the non-Yewe spectators present at the edge of the circle are hiding their heads and crouching in fear, *not* wanting to see. I appear to be one of the few non-Yewe spectators standing tall, my focus directed at the material forms of the deities. The deities literally dance, proudly held high in the hands of those in trance. At one point each deity is thrown high in the sky, revolving in circles before being deftly caught in outreached hands as it descends.

This afternoon is a piece of danced theatre that is one of the most visually kinesthetic and embodied, stunning spectacles I have seen in my cumulative years of fieldwork. Even Johnson could not stop talking about this event for weeks. It is the first time I feel the current of ethnographic-inspired research as an art-making possibility. How can this deeply sensorial research moment and the stories embedded in its making be realized in a contemporary performative event, grounded in ethnographic research?

The concept of art-as-ethnography did not stop there. In Cuba, elders' oral histories and storytelling begin to stand equally beside West African experiences, layering themselves upon each other as entwined and dialogical data. What finally tips the scales is when I ask to present my years of research as a lecture at La Habana's Fundación Ludwig, a contemporary art gallery. Such a space will require a unique and creative presentation, the executive directors tell me, not a lecture. Facing this boundary, a world of possibility suddenly opens wide. We create an art installation based on the years of fieldwork to provide an alternative representation of data beyond the standard text or oral scholarly presentation, and to provide different ways of knowing and experiencing history and life-worlds.

Data to Installation: Animating Fieldwork

Part 1 narrates the elder stories through the lens of historical analysis. Part 2 narrates the process of creating the installation that preceded this book through the lens of creative art-making. While part 1 is oriented toward readers who might be ethnographers, historians, and documentarians, part 2 aims at the same audience that also plays at the edges of scholarship and art-making. In particular, it aims at art-makers who conduct historical and ethnographic research and transform that research into artistic presentations and performances.

Collectively, the artistic team takes art-as-ethnography as a blurring of boundaries that produces "productive tensions" (Elliott and Culhane 2017, ix), agitating rather than defending disciplinary borders, and as research inspired by art and ethnography that play with each other in conversation (Elliott and Culhane 2017, ix; Culhane 2017, 3; Brodine 2011, 79–80).[1] The etymology of ethnography stems from *ethnos,* a particular group of people, and from *graphein,* to write. We expand the concept of writing to include forms such as art-making, gesture, dance, and other aesthetic expressions.

For us, art-making acts as a valid mode of inquiry equal to the rigor of ethnographic and scholarly research methods. We understand, in line with the work of Culhane (2017), that artistic and ethnographic modes of inquiry "inform and transform each other" (17). Such artistic forms can transport one to "other times and places" through diverse renderings (Culhane 2017, 13; see also Leavy 2013). One of the benefits of disseminating research findings in the form of an art installation is that we reach differing audiences through fluid forms that evoke an embodied response. Art, as opposed to the prescriptive discourse of scientific rhetoric, leaves space for interpretation and engagement. The approach of art-as-ethnography creates the space for an installation that welcomes wider and more diverse audiences that would not otherwise read academic discourse, and also crosses language barriers.

Building an Installation

In order to build the installation, I enlisted a collaborative group of artists/scholars. The goal: create a multi-modal art installation embracing diverse art-making forms that could evoke the multiple modes of material culture, sensory information, and embodied sensorial expression inherent in the fieldwork. The collaborators included visual artist Susan Matthews, dancer and photographer Brian Jeffery, performance artist Marianne M. Kim, and creative non-fiction writer JT Torres. Each of us brought our own depths of historical, religious, and scholarly/artistic knowledge and training to the project, as well as previous experience working as presenting artists and researchers overseas.

Importantly, each brought skills I deeply respected as art-makers. Their chosen mediums of artistic expression were not the deciding factors in why I chose them. Instead, what was relevant was their respect for carefully grounded inquiry and exploration as artists and as scholars, their ability to respond ethically to inquiry through their individual chosen mediums, and their ability to work as a collaborative team. Added to the artistic team were Cuban research assistants Melba Núñez Isalbe and Roberto Pedroso García, and West African research assistants Johnson Kemeh and Bernard "Solar" Kwashie for Ghana and Togo respectively. Núñez Isalbe, Pedroso García, and Kwashie also participated as contributors/performers when the installation premiered in Cuba and opened in Ghana respectively.

While members of the team other than me spent varying lengths of time in the field in West Africa and Cuba, except for Kim, their primary purpose was to conduct artistic research investigating the source material for creative invention. Kim spent significant time with the data on her own, but always in conversation with me and Jeffery. Each of our approaches to art-making offered unique insights into shared themes: images of ritual objects and similarities between deities, shared structural patterns in dance movements, in storytelling, and in ritual process. Simultaneously, however, we also paid attention to each location's uniqueness. Importantly, while some aspects of the eventual installation were artistic creations, they were never drawn out of thin air. They were drawn from specific ethnographic research events and data.

The diversity of the team was key in facilitating the transdisciplinary theoretical threads inherent in the politics of creating a contemporary art installation based on research into traditional practices. For instance, of critical importance was how we addressed cultural appropriation. Sensitive to the need to remain reflexive, the team invited critiques and feedback from Núñez Isalbe, Pedroso García, Kemeh, and Kwashie, as well as from our interlocutors at all fieldsites. Additionally, the politics of presenting work from a ritual process inside a closed art gallery space was not lost on us. We understood the complications of moving knowledge "across various boundaries: between West Africa and Cuba, between religion and art, between shrine and gallery, between ethnographic and artistic representation" (Meyer 2015, 113).

Our artistic threads came together in stages. It began with my own contribution of performance-based videos that are heavily dance-influenced, and with Matthews's artwork. Matthews was with me for a large portion of the Cuban elder oral history interviews. Given Fundación Ludwig's mandate, we began generating ideas and started by focusing on shared dance gestures across Ghana and Togo. But even though gesture, one of several shared core movement themes in Ewe and Arará dance, became a critical element of one of my eventual videos, I knew that treating gesture as data placed a heavier focus on a structural analysis, rather than on the embodied process of storytelling and the "coming to be" of ritual practice.

In the meantime, Matthews devised the idea of illuminated manuscripts to evoke the depth of elders' oral histories. Because we knew that she and I would place our art-making in shared gallery spaces, we carefully con-

sidered the repetition of imagery as she illustrated her manuscripts, and as I filmed in the field. I already knew that I would blend ethnographic and contemporary footage, asking what images were key in each site, were shared across waters, and were critical components of elder stories.

Jeffery, whose primary experiences were in Ghana and Togo (with some also in Cuba), began to consider his own photographic contribution in conversation with my videos and Matthews's work. His strategy of layering sixty different photocopy images hidden and sealed behind the top image of each of his creations honored the tome of Cuban elder oral history interviews that were recorded and then transcribed and translated by Núñez Isalbe. His images became a mechanism of trust with the Dzodze and Adjodogou interlocutors, as he always brought back, or sent back through me, multiple copies of his photographs for distribution within each fieldsite. He also helped film during ritual ceremony in Ghana, and he was deeply trusted because of his demonstrated respect for the Dzodze community.

Kim's work operated as an artistic meta-analysis. While she was never in the field, she spent significant time witnessing the fieldwork primarily through my own films and photographs as well as through Jeffery's. Her idea of peeling off "secrets" from "under the skin" came in response to the installation's title, inspired by a Cuban interlocutor's story describing how the first enslaved West African arrivals brought their religious practices and objects with them as "secrets under the skin" (Mario José Abreu Díaz, interview, December 31, 2007).

My own video contributions integrated raw fieldwork footage, including that from ritual, conceptual footage, and footage from an original choreographic dance performance I created in Alaska. As I choreographed this dance, I took ideas from what I had witnessed in the field, including patterns from dances performed during ceremony. Rather than replicate movements, I used their structures as ideas for completely new movement invention. On a more conceptual level, for example, I had dancers enter quietly on stage and begin to tell their own stories while standing on squares of white cloth that replicated an image from Justo Zulueta's story when he was consecrated at the España lagoon. Sections of this filmed work were then selected and reedited into four performance-based videos that included fieldwork footage and conceptual footage that both Jeffery and I had shot in Ghana.

Throughout this process, artists retained the freedom to create their

work. Despite our artistic diversity and the fact that we lived at a distance from each other, rather than creating independently, we engaged in careful conversations with each other and with each other's mediums to explore each of our visions. We all respected the ethnographic data and each other's work, finding similarities, discussing divergences and our artistic interpretations of the data. Artistic freedom carried with it a certain responsibility. We knew our interlocutors would witness our installation.

Efficacy of our Interlocutors: Making Public Their Voices

Critically important to this project was to engage our interlocutors as much as possible. First and foremost, I spent significant time at every fieldsite before filming ritual ceremony. I began with limited filming of arranged events and took still photos at ceremony only after I had established a presence and asked permission. Sometimes, permission had to be granted by each shrine deity. Interlocutors expected me to bring back copies of photographs and videos to share. I always did.

Scholars have frequently asked how I was able to film possession, and questioned its inclusion in my performance-based videos. Once I was accepted in Dzodze (and later in Adjodogou, Perico, and Agramonte), the camera was ignored as the everyday process of ceremony carried on. After all, possession is part and parcel of ceremony. In Dzodze, as Dashi became a key interlocutor, I mainly filmed ceremonies at her shrine compound. Once, I chose not to film, and her brother Johnson commented that everyone was expecting me to do so. So I went and got my camera. The women at Dashi's shrine loved to see themselves in trance on video, marveling at their bodies inhabited by the deities. The same was true of Mario José in Agramonte. I am often asked whether I believe in spirit possession. I reply that I absolutely believe in the belief system of those I am beside in the field. They do not experience their life-worlds as unreal. In writing about her ethnographic research into spirit possession among the Anlo-Ewe in Ghana, Venkatachalam (2015) cites several other ethnographers, such as West (2008) and Friedson (2009), who caution against dismissing spirit agency and belief systems or categorizing them as primitive (23n11).

Because the perspectives of our interlocutor communities were important to the process, the methodology of initiating a conversation across the Atlantic by carrying photographs and videos back and forth for reflec-

tion and comment not only became central to knowledge production, but was also central as we developed the installation. For example, the filmed responses of Dashi and Sikasi to questions from Cuban practitioners were eventually edited together and became an important installation feature. I also showed a video of my choreography of the University of Alaska dancers to Dashi and the women at her shrine for feedback and critical response before I began editing them into my performance-based videos. Dashi and the other women were pleased to see the young Alaska dancers use elements from their own dances, even as they recognized the differences. They also recognized bits of melody from their ritual songs that I had incorporated into one of the original soundscapes.[2]

In Cuba, I took it a step further. I asked some of the Perico musicians if they would be willing to film conceptual-based footage for inclusion in the performance-based videos. I asked the same of Mario José. They all happily and willingly complied, pleased to be included. They even helped direct ideas for the footage. Matthews herself was able to get direct feedback on her own initial manuscripts and paintings when she returned with me to Cuba several times before the final installation.

As the installation developed further, interlocutors reviewed works in progress prior to the installation's openings, while those in Ghana and Togo also witnessed completed works in between its Cuban premiere and its Ghanaian opening two and a half years later. Works were carried to the fieldsites via Ghanaian and Togolese public transportation, or rental car in Cuba. Video work was shown on a laptop computer in compounds, living rooms, and in the street. In both Dzodze and Adjodogou, I arranged benches in the religious compounds where I could lay down copies of Matthews's prints. Dashi invited key shrine members to attend, as did the lead priest in Adjodogou. In addition to setting up my laptop on a chair for group viewing, I showed enlarged pictures of religious objects from Cuba, narrated the process to date, and told some of the Cuban elder stories to those in Dzodze and Adjodogou. Their comments and feedback added new dialogue as we prepared new ideas for the full installation's arrival in Ghana. More critical dialogue ensued, as we also learned how to carry and present the artwork in diverse and sometimes challenging locations.

We premiered in La Habana at Fundación Ludwig in December 2010, and then took a portion of the installation to Perico a few days later. The show traveled to Accra and Cape Coast, Ghana, in July 2013. At each lo-

cation, we were able to bring many of our interlocutors to the openings in their respective countries. The Cubans and Ghanaians saw our artistic responses to their lived experiences, as well as our artistic responses to their suggestions prior to the installation's openings. They also viewed edited fieldwork footage from both sides of the Atlantic, strategically located within the installation so that it was placed in conversation with the artwork. This strategy of bringing our interlocutors to witness the installation stimulated further comment, inquiry, and debate, giving the installation its own performative voice. From this process, new work was created for each subsequent installation, which included a final premiere in San Francisco.[3]

The Installation Spaces

Parallel voices and dialogues structured the installation's staging. While the space is infused with contemporary art, performance media, and soundscapes, it is also infused with documentary-style fieldwork videos and photographs. A text-based catalogue accompanies the installation artwork, "allowing for the performative cross-indexing of words and works" (Campbell 2011, 55). Repeating images as art and as data are layered in an interplay of ethnographic information. This dialogue of subjective and objective layers invites multiple points of view and engagement (Campbell 2011, 55). The installation does not replicate ethnographic knowledge/history, but neither does it invent ethnographic knowledge/history. It does, however, offer a creative space for understanding non-Western ritual traditions as well considering the blurred genres of art and ethnography.

As artists who spent time at ritual ceremony and listened to elders' oral histories, we were sensitive to how we staged each gallery space. We considered how attendees could move through the space in a way that would suggest different layers of encountering ritual: how they might walk through the gallery, where we needed them to stop and take more time. We considered where we needed images to be in dialogue with each other, such as my videos with Matthews's large-scale paintings. Torres, after he joined the team as the creative writer, read some of his own stories at a partial installation at an academic conference in Vancouver, B.C.

The constraints of each space created new and different opportunities at each installation. For example, in Cape Coast, our installation space was a large, open-air lobby on the third floor of a University of Cape Coast cam-

pus building. All walls were concrete; we had to hang paintings from rusty pipes, lay others out on tables we moved from classrooms, and hook up and run electrical wires from the few working wall outlets to run the videos. At the last minute, the campus staff was able to ensure that all overhead lighting actually had working bulbs.

Generally, we interspersed videos of field work interviews, or of ritual ceremony from field work, with illustrated manuscripts that told the various stories. Sometimes Matthews's illustrated manuscripts were all hung together, sometimes they were spread around the space in clusters, while her life-size paintings were always spread out along most of the wall space. Jeffery's layered photographs were always hung together, strategically placed in conversation with particular paintings of Matthews's, or they inhabited their own wall—or, when there were multiple rooms, they had their own room. My performance-based videos were either on four monitors in each corner of the room, or, when lack of equipment prevented that, they were

Figure 13.1. *Secrets Under the Skin* installation at the Mission Cultural Center for Latino Arts, San Francisco California, May 2014. Marianne M. Kim's performance space is identified by the white cloth draped on the mat on the left side of the photograph. Photo by Brian Jeffery.

shown on a single monitor/computer. In multi-roomed installation spaces, they could be spread out across the rooms, and some were projected on a wall when equipment was available. Two bound copies of all the interviews were usually placed in dialogue with the catalogue and toward the entrance of the installation. Kim, present for the La Habana premiere, both premieres in Ghana, and at the San Francisco premiere, was strategically placed in a visible but unobtrusive location, and her performance slowly unfolded over the course of each opening-night event. Attendees were free to walk around her, observe or ignore, watch for a while, walk away, and return as they pleased.

The reflexive, dialogic, and fluid nature of this installation became a site for unique generation of knowledge and art-making (Basu and MacDonald as cited in Brodine 2011, 84) and, in a sense, created its own unique archive. Meyer (2015) describes the installation as "the recognition of a shared core in Ewe and Arará dance [that] involves opening up another kind of 'living' archive with its own modes of storage and transmission: sacred sites and artefacts, human bodies, rhythms and steps" (113).

Installation Openings

At the installation's opening in La Habana, and subsequently in Perico, the religious elders, musicians, and dancers in attendance from Perico and Agramonte were particularly fascinated to hear the interviews from West Africa, view images of West African ceremonies embedded in the videos, and visually encounter selected film sections of trance from both sides of the Atlantic—including those involving themselves or their own elders.

When the show opened at the Nubuke Foundation in Accra, Ghana, in July 2013, members of Dashi's shrine arrived in rented tro-tros. Each tro-tro had a flag attached to the front, like a ship's figurehead, and each flag displayed Dashi's shrine colors (unfortunately, members from Togo could not travel due to complications with transportation and border crossing). They entered the compound singing and drumming, resplendent in their matching cloth. They carried history, faith, memory, and stories as they crossed the threshold, realizing all in embodied performance. Later, they carefully moved through the gallery space while Johnson and I narrated the installation for them, stopping attentively at each painting, image, and video (pausing in particular to watch themselves in performance and in trance

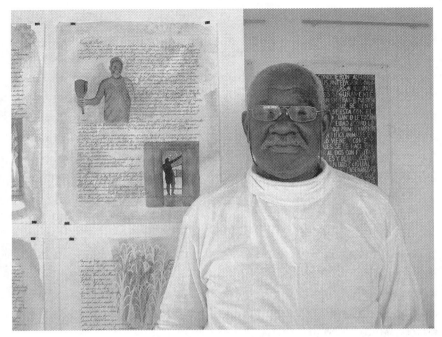

Figure 13.2. Prieto Angarica of Perico stands in front of Susan Matthews's manuscript at Fundación Ludwig narrating his story in 2010. Photo by Susan Matthews.

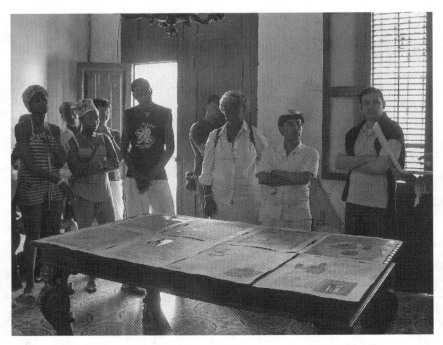

Figure 13.3. Members of the Perico community at the *Secrets* installation at Museo Municipal de Perico Constantino Barredo Guerra, December 2010. Photo by Susan Matthews.

Figure 13.4. Members of Dashi's shrine arrive at the Nubuke Foundation in 2013. Dashi is in the lead. Photo by Brian Jeffery.

on film). To close the afternoon, they danced and sang in performance for all in attendance. It was moving to have helped create the conditions in which their voices could become public in Accra (as was also true for Perico and Agramonte voices in La Habana). Critical feedback offered that day to Matthews by Kemeh led to continued changes for the next installation in San Francisco in May 2014 (https://www.uaa.alaska.edu/academics/college-of-arts-and-sciences/departments/theatre-and-dance/secrets-under-the-skin/ or contact the Cuban Heritage Collection University of Miami libraries at chc@miami.edu for an archived version of this site).

Conclusion

Clearly, *Secrets Under the Skin* is a complex project. It consists of layers of dialogue and collaboration that are built upon layers of performance, embodiment, lived experience, and fieldwork. The stories, primarily from Cuba, shared throughout the project's multiple iterations, evoke the depth

Figure 13.5. Members of Dashi's shrine at the Nubuke Foundation observing the *Secrets* Installation, 2013, in particular, an edited DVD of actual fieldwork footage shot during ceremony in Dzodze. Photo by Brian Jeffery.

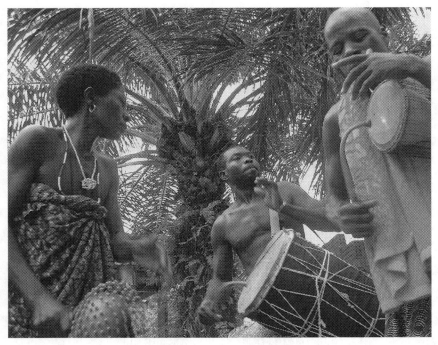

Figure 13.6. Members of Dashi's shrine perform at the Nubuke Foundation, 2013. Photo by Brian Jeffery.

of elder oral histories that this research team was not only privileged to hear but also *entrusted* with hearing.

I started this research expecting defined boundaries, clear categories, easily apprehended stories and histories, and solid dance structures. Instead, I came away with a deep respect for entanglements regarding both African and "Afro-Cuban" religious scholarship, and also regarding disciplinary boundaries, especially concerning performance theory. The "data" presented itself to us as living, breathing, smelling, tasting, touching, and moving—embodied sensuous forms and performances entangled in the memories and imaginations of the Cuban and Ghanaian performers/audience. *Secrets Under the Skin*—art-as-ethnography—embraced the sensorial challenge of bringing those sensuous forms and performances alive.

Notes

1. While we began to experiment with the idea of emergent ethnography in 2008, we eventually found resonance inside the research collective *Centre for Imaginative Ethnography* (https://imaginative-ethnography.com), and we were further inspired by the *Ethnographic Terminalia* project (http://ethnographicterminalia.org).

2. Original music was created with help from ethnomusicologist Paul Schauert, who remixed some of his own Ghanaian field recordings from Ghana with his contemporary compositions for the performance-based videos titled *Water* and *Fire*. Anchorage-based musician Nick Petumenos laid down guitar tracks to evoke ideas for Earth. I created a sung soundscape for Air.

3. The installation at Fundación Ludwig was presented from December 22–23, 2010, while the Museo Municipal Constantino Barredo Guerra in Perico hosted a partial installation on December 26, 2010. The University of Alaska Anchorage's Kimura Gallery hosted the installation from January 16–21, 2011. The Bunnell Street Arts Center in Homer, Alaska, presented the installation from April 29–May 4, 2011. Partial presentations were staged at the Bonnafont Gallery from May 19–26, 2012, and at the San Francisco Public Library from September 22–December 6, 2012. In Ghana, the installation was at the Nubuke Foundation in Accra on July 6 and 7, and at the University of Cape Coast from July 20–21, 2013. From May 14 through June 27, 2014, the show was presented at the Mission Cultural Center for Latino Arts in San Francisco. A partial presentation of the show was installed April 1, 2016, in Vancouver, British Columbia, Canada, at the Society for Applied Anthropology annual conference, at the Joyce Gordon Gallery in Oakland, CA, in 2016, and at the conference "Africa en Nosotros Ayer y Hoy" in Pedro Betancourt, Cuba, from May 26–27, 2017.

14

The Artist's Accidental Proof

The Palm Frond and the Wood Block

SUSAN MATTHEWS

I came to *Secrets Under the Skin* as a painter and a student of "Afro-Cuban" percussion. I was interested in conducting further artistic research into "Afro-Cuban" folklore and its West African origins when Jill Flanders Crosby invited me to join her collaborative research project.

Artists may not be trained ethnographers, but they gather information, documenting cultural facts that support research. In some instances, my paintings and manuscripts clarified ethnographic details not necessarily addressed in photographs or interviews from the Cuban or West African fieldwork data. For example, Flanders Crosby noticed a strong connection between sculptures of Eleggua at her Cuban fieldsites and similar sculptures at her West African fieldsites. In order to reveal their presence, we wanted to include the Cuban sculptures in a painting entitled *Cabildo de Ma Gose,* which depicted the interior of an Agramontean casa-templo. In order to fit them into my painting, however, I had to shift their actual position to a new one in relation to other objects as they appeared in photos taken inside the *cabildo.* I only allowed myself to make this minor change once it was accepted by Flanders Crosby, because she understood the meaning of the sculptures and their proper location in the room.

In total, I have created eleven life-sized paintings of people and sacred spaces in Cuba, Ghana, and Togo, and twenty gilded watercolor illustrations with handwritten texts taken from Flanders Crosby's oral history interviews conducted in Cuba. These works on paper were intended to parallel the illuminated manuscripts of medieval times, which circulated

prayers, secular tales, poems, songs, and illustrations among peoples not always literate in the original languages of the texts. My manuscripts included Spanish, Ewe, and English, and, while few people could read all three of those languages, the illustrations provided immediate entry into the subject matter.

As illustrated above, I used photography as a tool to collect data, and rendered ethnographic material as accurately as possible. At times, in order to emphasize critical elements, aspects of the source material had to be rearranged and colors or scale adjusted. I wanted my work to push the image beyond literal documentation and into the sensorial realm. Attending ceremonies in sacred spaces, wearing traditional cloth, feeling the powdery earth underfoot, sharing food and drink, breathing the sticky, humid air, listening to the drums and voices—all of these memories were built into the structure and content of the works. The life-sized scale of many of my works invited the viewer to enter into a corporeal encounter with the image.

After my 2013 trip to Ghana, I created a life-sized painting entitled *Dashi in Her Togbui Shrine*. Before I was permitted to paint Dashi inside her shrine, we needed to obtain permission to photograph her with Togbui Anyigbato from Togbui Anyigbato himself, imbued in an embellished clay and cement mound. Four times Dashi threw the divining cowries, and each time Togbui Anyigbato refused, demanding additional offerings of money and *akpeteshie,* a local spirit. Finally, after our fourth set of offerings, Togbui Anyigbato agreed to allow Brian Jeffery to photograph Dashi standing next to Togbui Anyigbato. I faithfully rendered the ritual objects inside Dashi's shrine, but when faced with painting her portrait, I could not express her charismatic power until I changed the color of her skin to dark blue. This instantly captured the shift from the mortal to the spiritual plane that I was trying to convey. I also decided to include an inscription on the wall inside the shrine, when it was actually etched into a cement block just outside the door. In doing this I was able to locate Dashi in her time and place, compressing information from inside and outside the shrine simultaneously. One photograph alone could not do this.

In spite of my commitment to rendering ethnographic material accurately, on one occasion, I omitted two seemingly incidental details. They were not, however, incidental to Johnson Kemeh, Flanders Crosby's Ghanaian research assistant. These very omissions inadvertently corroborated scholarship connecting attributes of the practice of specific rituals in Agra-

Figure 14.1. *Dashi in her Togbui Shrine* (2014). Acrylic on canvas, 72" x 54". By permission of Susan Matthews.

monte, Cuba, with those of the Ewe in Ghana/Togo. For my painting *Cabildo de Ma Gose*, a dried palm frond was partially cut off in my reference photo, and I couldn't see how it was attached to a window frame, so I left it out. I also omitted a small wood block sitting on the head of an old ritual drum because I thought I had not left enough room to include it among my depiction of the carved sticks that are used to play the drum. Time

Figure 14.2. *El Cabildo de Ma Gose* (2013). Acrylic on canvas, 67" x 54". By permission of Susan Matthews.

was short, and the painting needed to dry before I could roll it up and take it to Ghana. During our opening reception in Accra, Johnson, himself a master drummer, stood before the painting and stated matter-of-factly, "There needs to be a palm frond in the room to show it is a sacred space." He added, "And there would be a wood block on that drum." We could not have devised a more elegant test of a Ghanaian drummer's intimate knowl-

edge of a Cuban shrine than to show him a representation of it with two objects missing, and have him cite their absence from over five thousand miles away.

A year and a half later, we sat inside Ma Gose's old casa-templo. Ma Gose's great-great grandson asked us about an image of the casa-templo he suspected I might have painted. I was afraid he was going to accuse me of stealing imagery from inside the shrine, but instead, he pulled up my painting on his phone. After I admitted painting it, he insisted that we print a copy for him to display. Two weeks later a friend of ours brought him a print. By then, thanks to Johnson in Accra, I had added the palm frond and the wood block.

Receiving Secrets Under the Skin

Museo Municipal Constantino Barredo Guerra in Perico hosted our second exhibit. I dreaded the opening reception because one of my manuscripts quoted a potentially sensitive interview with Reinaldo Robinson. I knew he would be present, and I was afraid I had betrayed his trust. In the manuscript, Reinaldo stated that he had stopped attending ceremonies because he was tired of hearing all the gossip. He also noted that people were becoming lazy and were no longer performing rituals properly. Reinaldo's portrait in my manuscript looked exactly like him, so there was no mistaking his identity. I was relieved to see him nodding in approval as he stood before the manuscript, reading his own words. Our exhibit sparked conversation within the community, as we had hoped, and some of the young people told us they had been unaware of the genealogies and stories that comprised part of their heritage.

When we had exhibited the full installation at Fundación Ludwig in La Habana just a few days earlier, our Perico interlocutors had made the trip of several hours in an open truck to play their drums and sing at the reception. Lazarita, the raucous young lead singer, bounded into the gallery and screamed with delight, "Look what they did with us!" I turned the tables in my mind and imagined what it would be like if a group of Cubans had done an artistic interpretation of my friends and me. Seeing myself in their art would have been like seeing myself for the first time. This is when I began to appreciate my role as an outsider.

When we exhibited in Accra, our Dzodze interlocutors traveled 163 km

to attend the opening. They entered the Nubuke Foundation courtyard in full traditional dress, playing percussion instruments and singing. Once inside the gallery, they were fascinated at seeing their own images in videos, photographs, and paintings. Many people thought *Cabildo de Ma Gose* was a depiction of an African shrine, again illuminating connections between the Ewe of West Africa and the Arará of Cuba.

The focus of our project had not been on the transatlantic slave trade itself, but on Cuban rituals embedded in social memory dating from that era. Nonetheless, at our artists' talk at the University of Cape Coast, we found ourselves fielding questions about enslavement. As we tried to steer the conversation back to the project, one of the chiefs sternly warned young students in attendance not to turn their backs on their traditional villages. To this urban audience, the Cuban aspect of the project was of less interest than the prospect of losing their own connection to village life, where traditions and rituals were preserved and practiced.

As we were striking our Accra exhibit, a woman named Florence Benson told me she had known of a lot of people who had brands on their backs. "But they didn't show them because they didn't want to be considered as slaves. People in Ghana do not want to talk. This is opening up a story entirely," she said.

The Mission Cultural Center for Latino Arts (MCCLA) in San Francisco gave us a show in their immense gallery during Carnaval. The San Francisco Bay Area has a large community of Lucumí practitioners, and most of the people who visited the gallery could read the manuscripts in Spanish. Knowing this, we installed them at eye level, and in order, since some of the narratives spanned more than one manuscript. By contrast, in Homer, Alaska, where Spanish was not widely spoken by gallery visitors, we displayed them floor to ceiling like a patchwork quilt, distributing colors and images to create one balanced, unified work of art. The ample space at MCCLA also allowed us to juxtapose objects of one particular theme expressed in several different media. For example, Reinaldo Robinson appeared in video, painting, and photography. The various works seen in close proximity reinforced each other, contrasting the unique ways in which each medium interpreted and expressed the subject.

We found that the *Secrets Under the Skin* installation was received differently by each audience, depending on the viewers' collective cultural orientation and relationship to the transatlantic slave trade. An African-

American gallery in Oakland, ethnographers in Vancouver, high school students and their regional chiefs in Cape Coast, the academic community at the University of Alaska Anchorage, a Latino cultural center in San Francisco—all brought their life experiences and understandings of history, adding unique colors to their readings of the installation. Its impact on viewers in rural towns and big cities from Cuba to West Africa, Alaska to California and beyond depended on the stories of their own lives and histories.

15

Photographic Insights

Ceremonial Ritual in Ghana and Togo

BRIAN JEFFERY

My relationship to *Secrets Under the Skin* evolved through a thirty-year history of ongoing artistic creations and performance collaborations with Jill Flanders Crosby. Initially our mutual desire to use the arts as a vehicle to build bridges between diverse communities was realized through extensive arts outreach activities and large performance productions specifically created to involve local participants throughout Alaska. Over the years these projects consistently became larger and more relevant to the communities with which we were interacting, while also reaching a wider demographic.

It seemed a natural evolution to our professional collaborations when in 1999 I first began accompanying Flanders Crosby on numerous research trips to Cuba, and to Ghana and Togo, West Africa. It had been Flanders Crosby's consistent and persistent commitment to stay involved with these communities, returning time and again, engaging with families, elders, chiefs, priests and priestesses. Building upon these friendships while earning a deeper level of trust, the goal was to be welcomed and embraced as part of their community. Our involvement with these communities brought opportunities to participate in numerous aspects of sacred ceremonies and rituals.

How do I document, or perhaps more appropriately, how do I represent, through my experience, through my lens, that which is happening to the individual practitioners as part of these rich and long-standing rituals and spiritual practices? What is my role as invited witness, researcher, and visual documentarian? When photographing events in the field, one of my goals

is to strive continually for an impartial representation of the people, culture, and events that I have witnessed and with which I have interacted. In other words, I seek a neutral rendering of the subject rather than a sensationalized depiction. The images I have captured in ceremonies reveal moments of excitement and elation, of vulnerability and exposure. At times, these encounters have been immensely personal; at other times they were outwardly bold. Each photograph reverberated with the actions of drumming, singing, and dancing bodies remembering and celebrating the rhythms and dances of their ancestors.

Visual Truth

Some believe that photographs are mechanical representations of facts. The moment that the shutter on a camera clicks open and closed, I have stopped time, arrested my subject in action. I have frozen this moment in a tangible documentation of the subject. But I also know that photographs can lie. This misinformation might come from the perspective in the way the shot is framed to include or exclude peripheral information. Typically, a photographer is aesthetically and subjectively deciding in the moment what to leave in or leave out of the frame. So I believe that most photographs only show half-truths. Mine included. When my photographic "half-truths" are joined together with the many layers of my colleagues' narratives, visual representations and interpretations, we create a reservoir of several perspectives, many simultaneous small truths. When these are referenced or experienced together as part of the installation, the interplay of research, social memory, oral histories, and art-making becomes manifest as a greater whole.

Some of my photography consists of colorful and vibrant scenes during ceremony. Practitioners drum and sing to accompany bodies in motion, often falling into trance. I have also been given access to photograph ritual objects and sacred spaces. The sharing of these images that document activities and details in the field have proven immensely valuable to our research team, particularly in the cross-referencing of data among fieldsites. For the installation itself, I was most intrigued to capture present-day practitioners at our African fieldsites through portraiture. Since much of Flanders Crosby's research focuses on elders' oral histories, referencing ritual practices spanning decades over several generations, portraiture became

Figure 15.1. Brian Jeffery's work at Fundación Ludwig. Photo by Brian Jeffery.

a method by which to align a community of living faces, possibly family descendants, with these centuries-old stories in the installation space.

There is an old adage that says, "The eyes are the window to the soul." This thought transcends words and movement; it transcends our histories and our truths. Among photographers it is often thought that the purest

form of revealing your subject is the close-up shot. This type of traditionally framed image, straight on and flat to the front, best represents the individuals within the communities I frequented. They would present themselves to me without affectation—often looking directly into the lens, as if stating, "I am as you see me."

As part of the installation, I contributed 20 portraits. There is a saying in Ghana that in ceremony, when you stand in front of your priest to take libations, all of your ancestors are there, standing behind you. I ran with this concept in the creation of my photographic assemblages. Behind the visible topmost image, approximately 60 other different images lay hidden and sealed, perhaps suggesting a family history or lineage, whether remembered, lost, or forgotten. Perhaps it suggests memories untold, or secrets unspoken. But those possibilities are for the witness to ponder when viewing the artwork. Additionally, I also conceptually manipulated the images by reducing the quality of the photos, distressing the paper, and with the top overlay I am intentionally blurring the clarity of the image.

With *Secrets Under the Skin,* the witness who comes to the gallery to see our work, or goes to the project's website, has multiple points of entry. For those from the Cuban fieldsites who witnessed the installation in person, they could finally see the African faces that we consistently referenced. Those from Dzodze stood carefully in front of the images of themselves, pleased to see their likenesses on a gallery wall in Accra. For others, it is my hope that they leave intrigued and enriched by the many simultaneous small truths that are layered together and shaped by our diverse forms of artistic inquiry and research.

16

in listening/in response

MARIANNE M. KIM

Time: The Present
Location: Here and Now
Duration: As long as it takes

the body is the memory
only in this space
what we hope and what we have
be still and know
the body does not know boundaries
the secret is in the body
only in the time it takes
i change because you are here

"in listening/in response" was a performance event that engaged my artistic practice as an interdisciplinary artist with the years of Jill Flanders Crosby's fieldwork from Cuba and Ghana. The work examined the acute attention given to internal and external inspiration during improvisational performance. I applied "imaginative practices" (Elliot and Culhane 2017), and played within the space of art and research to create my work for *Secrets Under the Skin*.

The Creative Process

I did not accompany Flanders Crosby into the field, nor did I conduct research into the ritual dances and ceremonies of Cuba and Ghana. Instead,

in order to create my work for the installation, I researched by viewing years of Flanders Crosby's documentation via photographs and videos. I listened carefully to the stories recorded by Flanders Crosby and fellow collaborator Brian Jeffery. I absorbed details about how ritual ceremonies unfolded, and especially noted how participants waited for events to begin and build slowly. And I learned through their personal stories how Flanders Crosby and Jeffery had to pay detailed and immediate attention through careful listening, witnessing, and responding to each ritual event in order to store it in memory until they could write about it later. My interest was not to mimic specific rituals, but to explore more formalistic performance strategies inspired by their fieldwork.

The performance was an improvisational score created through observation and curiosity. As a performer, the goal was to be in the gallery spaces, both witnessing and responding to the art and audience around me in the manner of Flanders Crosby and Jeffery. The black-and-white photographic portraits by Jeffery reminded me of the impact of the simple gesture of meeting a focused gaze. Watching audience members meditate on Susan Matthews's canvases was a wonderfully layered journey into iterations of someone looking at someone looking at someone looking at someone. In the midst of all these ruminations I made a formalistic performance strategy and gave myself work to do—two deliberate tasks through which to move in and out of the space. These also functioned as a concrete time-keeper. When the performative tasks were done, it was time to leave the gallery space. This strict structure to limit the time of observation and activity gave the performance a clear beginning, middle, and end.

The creative process included developing prompts to remind me to maintain the position of active observer, and to create actions and gestures that were continually folding and unfolding. It was important to stay in a space of curiosity and *wonder*—wonder about the body, about ritual, and about the viewers, who were really the core of the performance event. Movement was generated and guided by noticing faces, sounds, shapes, and energies in each gallery space where *Secrets Under the Skin* exhibited. My hope was to create a performative situation that would inspire a mutually introspective, experiential event between performer and audience. While that mutual experiential event could be different for each viewer based on their backgrounds, images included ideas often repeated in the elder oral histories: loss of identity; loss of home; reflecting on the past;

wondering about the future of the community as elders passed away and knowledge was lost.

The overall tempo of the performance was slow and meditative as I moved from one location to the next. Hyperconsciousness of the immediate present demanded that I take my time.

Figure 16.1. Marianne M. Kim in performance at University of Cape Coast, Cape Coast, Ghana. Photo by Brian Jeffery.

Another component of the performance were the performative tasks mentioned earlier. They were more straightforward. I used stage makeup consisting of polyvinyl and glycerin to make fleshy patches that looked like my own skin, and applied these patches all over my body. On the underside of the patches were written expressions that I could slowly peel off my body, revealing the performance's "secrets." On these pieces were printed phrases such as, "I am here because of you," and "The landscape is here and now," which were translated into Spanish for the La Habana premiere. The task of peeling fifteen to twenty "secrets" off my body invited unexpected shapes and gestural pathways, including twists, spirals, asymmetrical contrapposto, unfoldings and enfoldings. As I removed the "skins," they became secret messages—a linked chain of memory left behind, much like the elder oral histories were still linked to their individual communities. One of the extended activities, or tasks, in the durational performance was literally to "link" these written "secrets" by stitching them together with needle and thread, and then to allowing them to encircle me and finally spill into a pail. The body was literally putting together this "linked chain of memory," these "secrets under the skin." The past was being linked to the present through a performative act, a ritual of remembering, reimagining, and reification.

Conclusion

The differing artistic responses to *Secrets Under the Skin* all provided different points of entry for the diversity of audience members in attendance at each site. In La Habana and in West Africa, clearly the local artistic and academic crowd found an easier entry into my contribution than those who had traveled from the rural fieldsites. In Cuba, those in attendance from Perico and Agramonte were at first perplexed, but when my artistic premise was explained by Melba, they watched with curiosity and respect. In Cape Coast, regional chiefs and high school students present at the opening were the most curious, spending significant time observing. However inscrutable the "meaning" of my performative gestures may have been, the contribution of a live performance is a reminder that history is experienced through the body as well as on paper. The ultimate objective of the performance was not to center my experience, but to center the space of mutual curiosity between me and the audience. In that spirit, I will end

with a description of my performance by our faculty host at the University of Ghana Cape Coast, Dr. Kwadwo Opoku-Agyemang, who is a scholar and poet:

Facing the direction of the sea, she placed her mat on the floor. Then she stepped about, inviting the distant roar of the sea. The soft part of her bare feet on the floor matched the gentle rhythm of the sea, like coupled notes on a piano. I have no idea how Ms. Kim managed the paradox, but in her dance presentation in the severely restricted space, her body at one and the same time achieved the fluency of water and ignited the consuming debate of fire. She slowed movement into a motion beyond time, and in that timeless space, in an abstract time, she commanded her body to canalize an unknown and silent eloquence that somehow in that bordered present articulated our ancient and future hopes and yearnings. In return we made her tensility our own. That was the true test of her art: the exchange of strengths among friends, across geography, among blood, and among ancestors. The crowd of schoolchildren in their starched uniforms who milled at the mat's edge, and the elders and chiefs in colorful robes who eagerly formed around them,

Without knowing her name they named her by their deep knowing.

And they recognized her weight in how she lifted and placed her foot; in how she tilted her neck just so; and in how she gazed into their eyes, seeing them for who they are, and thereby measuring the heights and depths of their humanhood. (Personal communication, July 2013)

17

Witnessing and Sensing Stories

MELBA NÚÑEZ ISALBE

To witness an event means to have a personal or direct cognizance of it (the happening) or to take note of it. My personal-direct knowledge or experience of religion, or *espiritismo,* goes back to the time when I lived with my grandmother. Long ago, she taught me how to say the Lord's Prayer and the Hail Mary. My name and my grandmother's somehow fused; my mother had bribed my grandmother to raise me by naming me after her. She (my grandmother) had already struggled raising my brother, who caused nothing but trouble, and she did not want to raise a second child.

My grandmother was what we call here on this island a medium, or someone who has *mediumnidad.* Early in her youth, in her beloved Santiago de Cuba, she delved into Rosicrucianism, a movement that began in the seventeenth and eighteenth centuries, affirming esoteric and occult wisdom while emphasizing mysticism and spiritual enlightenment. I inherited much of her spiritualism, especially an idea of wholeness regarding the spiritual world and religion. They complemented each other and simultaneously were one and the same. These were strange and difficult concepts for me. At the time, religion was not openly practiced in Cuba. I did not know much about religious concepts and I certainly had not been baptized. At a young age, I had no idea how deeply ingrained her teachings were becoming.

My grandmother had subtly shaped and conformed my religious views and ideas. She had somehow molded me into an educated and respectful religious performer who possessed hidden tools. She taught me how to witness, react, and recognize the signs and signals that would later in my life begin to wash over me regularly like seasonal rain.

I have to acknowledge that my grandmother's teachings lay dormant somehow in my inner consciousness. I had taken a theology course and had read extensively only for the sake of acquiring and organizing religious ideas and concepts. They were not related to my academic formation in English language and literature.

In 1999 Jill Flanders Crosby, whom I had met two years earlier in a ritual dance workshop in La Habana, asked me to accompany her to Jovellanos to attend a ritual ceremony and serve as translator. Though I agreed, I had reservations, despite my grandmother's influence on me as a child. I had no way of anticipating what it would be like actually to witness a ritual ceremony, and to embody a different reality.

Once we arrived in Jovellanos and the ceremony began, I was uncomfortable. I was not sure I could continue to accompany Flanders Crosby, and told her so. Six more years would pass before I fell in love with this project and let my inner roots grow and bear the fruits that would sustain much of my adult life.

Flanders Crosby and I kept communicating, and every time she came to La Habana we spoke about her project. Finally, in December 2006, she brought me two tapes containing an interview with Hilda Zulueta. She urgently needed me to transcribe and translate them because she had plans to return to Perico with follow-up questions based on the interview. This I could agree to do.

Listening to Hilda's voice was magic. Her stories, many of them contradictory, raised more questions than answers. Her way with words and her singing made me thirst for Arará history. I gave Flanders Crosby my finished translation and told her I would accompany her to Perico.

Hilda's knowledge, her kindness, her manner of explaining things, her voice singing chants, her love for religion, her respect for her Arará elders and heritage, her stories filled with curious shades of meaning and reality—these features of her character left me speechless. I realized that what I had been referring to as my reality, my world, my space differed greatly from what Hilda called reality. Which one was correct?

I felt a connection and wanted to know who or what struck that chord inside of me. If during my return trip from Jovellanos I felt confused, now I felt a pressing desire to know. It is true that conversing with Hilda and being part of a ceremony were two completely different encounters. Perhaps that first time, the shifting of reality happened too quickly, and I reacted

by trying to hold tightly onto my fixed reality. This second time I *believed* Hilda's stories; they somehow paved the way for me to see or sense the shifting. I began to witness that "new" space, paying attention to every detail. I could feel my spirit stretch.

Growing

In the years since I became a member of this research team, I have read as deeply as one can on Arará, which is not a very extensive field of scholarship (Andreu Alonso 1997; Brice Sogbossi 1998; Martínez Furé 1997; Ortiz 1993; Vinueza 1988 [1986]). During my time in Perico, and later on in Agramonte, I paid special attention to the spaces shared in everyday life, ceremonies, and stories. I observed each detail and wrote copious notes related to the movement of hands during dances, gestures during ceremonies, and particular positions of the body. Flanders Crosby was entirely aware of these details, and many times she would point out something I did not realize. A dancer, Flanders Crosby understands the world through body movements and gestures, a language she taught me to interpret.

Emotional changes, especially those related to possession and feeding ceremonies, were the most interesting, and often difficult to perceive and decipher. Practitioners or followers of religion have totally incorporated them as part of their daily lives. Many of our conversations were interrupted because certain ceremonies had to be done at midday, so interlocutors left living rooms for backyards to raise their arms toward the sun, close their eyes and say a prayer to their deities. Then they would resume conversation as if nothing different or out of the ordinary had happened. Yes, the coming in and going out was part of their routine, of their lives, but it had become my role to question, to ask, *Why those particular gestures? Why the prayer?* Despite this new role, I still wondered why there had to be an explanation.

I always thought Flanders Crosby's witnessing was more insightful than mine, even though I was far more fluent in Spanish. Language, I had begun to learn, is also a shifting space. Being a dancer helped Flanders Crosby perceive those subtle physical and emotional changes, beyond the more noticeable changes in speech or text, that took place. I remember vividly two instances in Agramonte. The first happened at Nemesio Lázaro "Madan" Baró's, who celebrates for San Lázaro every December 17.

Madan's San Lázaro ceremony on December 17 always packs his house. We had just arrived when several possessions began to occur. I remember asking Roberto Pedroso García about the use of a white sheet. Roberto told me the aim of the ceremony was to call more deities down to earth. He said it was a tricky ceremony because once you were underneath the sheet there was no escaping; you would surely get mounted. I sensed a strong energy coming our way that took hold of many in the front row, making them fall into trance. Roberto stepped back. I remember looking at him and not noticing any change in his body or his eyes. Ten minutes later, Flanders Crosby cried my name, ordering me to take Roberto outside, for he was falling into trance. He was stepping into that new reality, an embodiment of the shifting. How was she able to perceive it? She told me his eyes were becoming glassy and lost and she had seen these symptoms before. She had become fluent in her interpretation.

The second instance I remember took place during the day at the house of Mario José. We had just arrived. Roberto entered first to greet the family and introduce us. He did not use the front door, but the side hall that takes one directly to Mario José's religious *casitas*. When Roberto came back, I noticed something odd about his face. I said nothing. The two of us, Flanders Crosby and I, followed him.

We entered Mario José's Palo shrine. Various godchildren of Mario José's were sitting in a circle. Kneeling in the middle was the physical presence of Mario José, who had already shifted into that of his *muerto*, Juan Felipe. This time, I immediately realized the change and laughed to myself. Flanders Crosby looked at me and said something, but I gestured for her to remain silent. In that instant, Mario José turned his head and looked at her. Flanders Crosby looked at me and opened her eyes widely.

"He is in trance!" she said, surprised.

I pressed my index finger to my lips for her to keep quiet.

As time went by, I learned to see and detect such changes; my witnessing grew, became more fine-tuned. While I have never been able to embody it the way Flanders Crosby has, I continue to learn to enjoy the beats of the drums, the voices of the chorus, the dances of those bodies as they call me into new spaces and new perceptions. Importantly, the stories of elders led me there.

Much of the information we came across in our conversations contained traces of real people and events. Trying to pin down these stories is no easy

task. I remember that first time meeting Hilda. I realized her stories had an elusive realness; they were true because of her performance and her enunciation. That is why the meanings have been so hard to grasp.

My idea was never to discredit the stories or think of them as something invented and therefore not valid or important. On the contrary, the more I read Andreu Alonso (1997), the more impressive these re-created stories seemed to me. The equivocal nature of historical facts I found in Andreu Alonso (1997) was particularly interesting. Of course, the stories contained certain elements of truth together with fabricated elements that most likely changed with the passing of time, as the oral tradition was passed down from mouth to mouth. For instance, Andreu Alonso (1997) only casually mentions Justo Zulueta. But in Hilda Zulueta's stories, her grandfather Justo transforms into a mighty human being with powers of protection and healing. This was fascinating—how the same story can have different meanings and alterations depending on the narration. My witnessing let me see the trees within the forest, while all along the roots grew within.

When the *Secrets Under the Skin* installation opened in Perico, I read stories from both Hilda's and Reinaldo Robinson's interviews. This became an important performative event that helped animate the space with the voices of Perico elders in their own community. Importantly, I knew I was honoring the trust they gave all of us to hear and then (re)tell their stories.

Conclusion

Participating in Metaculture

From a methodological standpoint, one of the most critical points raised throughout this book is the entanglement of art with performance theory, and social research. This book has complicated understandings of oral history as something that emerges not just through spoken narratives, but also through gesture, song, and dance. We extend ideas of culture to include "the body" as a performance of memory (Jones 2002). By widening the scope of possible relationships between art and research, this book explores the various constructions of meaning constituted by the intersections of discourses that include the scholar's, the artist's, and the practitioner's. We hope that such a framework opens up the ways in which these intersecting discourses contribute to new meanings of culture and praxis, vis-à-vis the cultural bridge-building between Cuba and West Africa described throughout this book.

Continuing Metaculture

On January 3, 2018, I (Flanders Crosby) found myself standing on the shore of sugarcane fields in Perico. A gentle breeze stirred them, making it seem as if they were a rising tide. Melba, Miguel, and I had been directed here by Marcos Hernández Borrego, who was in our company, in order to park away from prying eyes so we could "clean" our car.

At the ceremony for María Vence Guerra at Justo's just two days earlier, the *muerto* Coballende (the Palo equivalent of San Lázaro who had come down to possess an attendee) instructed us that we must clean our car to avoid any serious problems when driving back to La Habana. While the muerto Coballende did not clarify the immediate issue, we of course had to comply. The spirits saw no difference between participant and observer.

Our presence as scholars was little different from being present as guests, as community members, as spiritual hopefuls, as humans. The emic-etic binary was a non-starter. As I had realized long ago, and as we wish to illustrate with this concluding story, we became directly involved in the socially constructed meanings we intended to study. And so we called on Marcos to help us, for he not only had an Oggún, which the muerto had said was required, but he also knew how to conduct such a cleansing.

There we stood, at the entrance to an unmaintained dirt road that led deep into the cane fields. The edges of the fields embraced us, like a gate closing around us—whether for protection or to keep us from leaving I could not say. It was not lost on me that those cane fields had once belonged to the former central España, where Ma Florentina, María Virginia, and others had toiled under the weight of enslavement. As the wind continued to rustle the sugarcane, España's towers (*torres del central*) hovered in the distance. I could imagine and sense the presence of those elders, particularly Ma Florentina. I could see her back bent over in work, with her skirts being rustled by the same wind, her face feeling the same breeze and humid air as I was, hearing the rustle of the cane and smelling the dirt. I could imagine her longing for the day when she might finally have a sense of a life returned to her.

Marcos chanted as he first brushed a handful of herbs and plants over every part of the car. Then he did the same with a *gallo* (rooster). As Marcos began offering the gallo's blood to his Oggún, a strong gust of wind whipped the sugarcanes, erupting in a howl that underscored Marcos's chant asking for a blessing: "Ñaqui, ñañaqui na fuloro."

It was this moment, nearing the book's completion, that I reflected deeply on my role as researcher. My passage into and out of this world, gated by fields of sugarcane, was only possible with permission from worlds I had never known. I understood that the knowledge generated and shared not only in this book but also in the preceding art installations was only possible via the engagement of a metacultural practice that includes and reshapes languages of scholarship, of practice, of aesthetic, and of belief. It became clear to all of us, as it did for Wirtz (2007) with her research into Santería (Lucumí), that "it is in the bright light of metacultural attention that [Afro-Cuban religion] emerges as a coherent community of practice," a process emerging from "intrinsic interpretive frames of ritual and explicit discourses of reflection and evaluation" (202). While rituals, such as

the car cleansing, tend to produce intense sensorial experiences, it is their intersection with reflective discourses from practitioners as well as scholars that constitutes a frame of meaning for such experiences. Any insistence that scholars are merely recording and not taking part in the shaping of experience irresponsibly ignores this discursive relationship (see Tierney 1995; Vidali 2016). This book, along with the installation before it, attempts to clarify this metacultural approach by bringing together the diverse perspectives of artists who engage multiple artforms and media, piecing together a bricolage of experience as opposed to a singular determination of what Arará might mean. Even within the book, we have combined literary prose with academic analysis, constantly developing multiple layers to the conversations about Arará.

"Do Something with It"

The idea that metacultural discourses shape cultural knowledge is certainly not a new one. In fact, this is the central thesis of Wirtz's (2007) text, *Ritual, Discourse, and Community in Cuban Santería*. While Wirtz primarily examines the roles played by practitioners and insiders who reflect on and evaluate ritual experiences, our particular extension is this: researchers also play a pivotal role in the constitution of metaculture. Since Clifford and Marcus (1986), the discussion is no longer about whether researchers shape the cultural narratives they study; now, the question points to *how* researchers shape the epistemological process. What seemed to be a scientific problem of researcher involvement became an artistic opportunity. Instead of worrying about subjectivity, we drew upon it, using crafts typically reserved for the illustration of subjective experiences. The result is our continued contribution to, in particular, an Arará metaculture that bridges not only the scholarly community but also the communities in Dzodze and Adjodogou. While the narratives there appear more stable than those of Perico and Agramonte, there is still the complexity of Anlo-Ewe ritual traditions and the multiple interpretations of the various deities to confront and wrestle into discourse. This book, after all, exists primarily as the result of multiple layers of performance, one of those layers being the discursive retelling of stories from their enactment in West Africa to their Arará narration in Cuba.

The oral history narratives interlocutors carry with them are constructed by complex networks of individual and social memory. Venkatachalam

(2015) has studied in depth the relationship between semantic memory (generalized knowledge about the past) and autobiographical memory (individual knowledge of life episodes) in Fofie culture (9). Often, memories from these different facets will contradict each other, as we experienced in our research. When interlocutors face such contradictions, they tend to negotiate them through a reflective discourse that includes commentary on the differences or explanations of how the differences coexist. The present culture, shaped by its current ideologies, reflects on history and thus becomes a metaculture of the past (Wirtz 2007, 11). Scholars then act as mediators of the present metaculture when they translate for other audiences their access to a culture's history. As the number of people engaging in reflection and interpretation grows and becomes more diverse, so do the possible meanings of metaculture (Deleuze and Guattari 1988). And this change is anything but linear—as the narratives about a culture's social memory change, so does the social memory of individual members; as individual social memory changes, oral history narratives then begin to "suit the ideological needs of the present" (Venkatachalam 2015, 13).

While it is important for anthropologists to consider how the cultural phenomenon of interest comes alive through social and individual reflective discourses that circulate beyond the lived moment (Wirtz 2007, 83), it is also crucial to consider how the cultural phenomenon continues to be shaped by scholars' evaluative discourses that circulate beyond local collective reflections. As we have shown in our own book, the storytellers and their stories shape the meaning of the performance being storied equally. This book is a performed retelling, and it is the hope of our interlocutors, as well as ours as artists and scholars, that our readers will find meaning in their own retellings.

Perhaps the "it" in Hilda Zulueta's wish that we "do something with *it*" refers to both Arará history *and* its metaculture. "Keep the conversation going," Hilda could have meant. "Invite others into the conversation. See what they think." For the most part, this is what Flanders Crosby accomplished among the fieldsites in Cuba and West Africa in placing them in direct conversation with each other. While perhaps not a unique methodology, it is one that is not necessarily common across the breadth of Afro-Cuban scholarship.

In the back-and-forth between West Africa and Cuba, one curious phenomenon occurred that implicates Palmié's "ethnographic interface" (2013,

262). Mario José in Agramonte was exceptionally eager to hear and talk about Flanders Crosby's research in West Africa almost every time she showed up at his door, even after an absence of a year or more. He poured over pictures that she showed him, particularly those of the physical representations of Sakpata and Togbui Anyigbato in Adjodogou and Dzodze respectively, and always asked for copies of the pictures and DVDs. On one of Flanders Crosby's return trips to Agramonte, Mario José proudly showed her a new *fundamento* he had fashioned for San Lázaro. It was modeled after the form of Adjodogou's Sakpata, based on the photograph that she had given him. On top of that form, he had placed a *dzosasa* (protective amulet) that Dashi had made and blessed for Flanders Crosby to take back to those in Cuba who might need protection. Beside it, Mario José had also placed a bracelet of West African beads, a gift from Flanders Crosby. In May 2018, she showed Mario José the image on her computer of Dashi's 2013 Togbui Anyigbato representation. He snapped its picture with his phone and then announced that the next time she returned to Agramonte, he would have a San Lázaro fundamento that would look exactly like Dashi's Togbui Anyigbato. We can just imagine a future scholar interested in West African roots entangled in Afro-Cuban ritual traditions. We can imagine this future scholar, coming to Cuba to conduct research, happening upon Mario José's fundamentos and echoing with excitement, "You see, there it is."

That said, the moments of gleeful recognition we encountered, along with physical acknowledgments (such as nods of "Yes!"), suggest the Pericans' and Agramonteans' emphasis of their West African roots. There were the times when they crowded around the monitors at both installations in Cuba (La Habana and Perico) wanting the volume turned up on the Ghanaian and Togolese interviews so they could hear the language. A poignant instance occurred in Perico when Flanders Crosby shared a picture of Dashi's ritual necklaces. "Los collares son los mismos!" they exclaimed ("The necklaces are the same!"; Prieto Angarica Diago, Kikito Morales Iglesias, Jesusito Morales Varona, Hilda Zulueta, Lazarita Angarica Santuiste, and Víctor Angarica Galarraga, interview, January 26, 2006).

Metacultural Tracks for Future Research

The oral history narratives we have shared throughout this book have important implications for different audiences. Our fieldwork, including our

interviews, which will be archived in the Cuban Heritage Collection at the University of Miami Libraries, Coral Gables, Florida, and in Cuba's Fundación Fernando Ortiz in La Habana, can be read as tracks left for other scholars and artists. Our merging of performance theory with rigorous fieldwork may inform methodologists in different contexts. Researchers might consider how art might intersect with their processes to open up new possibilities and allow for new knowledges. To those working specifically in Afro-Cuban scholarship, Hilda's wish that we "do something with it" is now passed on.

Our conclusion is a challenge to continue the responsible practice of research that also authors a layer of culture about the culture being studied. Like Marcos, who suggested that all things religious belong together, all things knowable must come together. Sometimes knowledge must come from the quantitative categories, from the rigorous design of some lab-tested methodology. Other times, knowledge must come from the artist, the poet, the opening of the night sky after hours at a ceremony, the stars rattled by the drummers' beat. At such times, to use a metaphor appropriate to this book's beginnings, knowledge must dance.

Afterword

JILL FLANDERS CROSBY

As a dancer, I am trained to actively encounter the sensorial realm. Without a doubt, the sensorial realm flooded over me during fieldwork. Reading multiple accounts and memoirs from anthropologists early on as I began the sensorial intensity, "the lived experience of fieldwork" (Ventakachalam 2015, 19) seemed a norm rather than the exception. Several accounts, such as those of Stoller and Olkes (1987) and van de Port (2011), elevated their own sensorial experiences to the status of active dialogical partners with their research data. They demonstrated how sensational moments of field-work themselves participate in the knowledge being researched. This book is a testimony to this iterative relationship: that data is inseparable from the sensorial experiences that give rise to the data. The relationship among data, knowledge, and sensorial experience is cyclical, iterative, and discur-sive. Therefore, it is only appropriate to close this book with those seminal senses that fomented the entire project from start to finish.

During the first year of my Cuban fieldwork, I lived in La Habana for almost six months and fell in love with the city. It was there that I stud-ied Arará dances as taught to me by professional teachers and performers trained in performing folkloric traditions. Many of the Afro-Cuban reli-gious dances, along with social dances, became standardized and profes-sionalized for the performance stage following the revolution. The staged Arará dances differed from those danced in Perico and Agramonte. Re-gardless, they were important to my overall picture of Arará dance.

I came to know the city at all hours of the day and night—from 6 a.m. until midnight or later—from the seat of my Flying Pigeon bicycle. It was

my main means of transportation from Centro Habana out to Siboney and Ciudad Deportiva (all neighborhoods of La Habana). I knew where almost every *ponchera* (tire repair shop) was located along my habitual routes, for flat tires were the norm of the day. To go more than two days without a flat tire was a relief.

My favorite times on my Flying Pigeon were when I was coming home late at night from the Habana Vieja neighborhood to Centro and I snuck onto the closed-to-cars Malecón due to a *frente frío* (cold front). During a frente frío along the Straits of Florida, waves would swallow the seawall and flood the Malecón street. I called this sensuous commute "bicycle surfing." One of the few people on El Malecón, I pedaled through the water, avoiding the majestic waves when they splashed over the sea wall. I could not help giggling.

I came to know Perico and Agramonte by sitting on the porches and in the rooms of elders. They readily shared fantastical stories from those "Africans" before them who were removed from their home countries as a result of the transatlantic slave trade and forced to construct a new life. I also came to know Perico and Agramonte through the many ceremonies I attended. Dancing and singing beside those who offered their history not only through story but through embodied practice became a pathway to knowledge. I came to know Dzodze, Ghana, and Adjodogou, Togo, as well as other areas of West Africa, by bumping along rough roads in a tro-tro, or on the back of a local taxi motorbike. And, of course, I learned through hours and hours of witnessing and dancing at ceremony, visiting shrines, and experiencing the eternal activity of fieldwork: waiting.

My memories of Ghana from my last trip in July 2013 are of traveling from Accra in a passenger car to Dzodze, where I grew up as a researcher. Four of the research team crammed into the back seat with Marianne Kim and me, squirming for a comfortable space. Johnson enjoyed the privilege of the front seat. The night after we arrived in Dzodze, practitioners wanted to pay their respects to me for having arranged travel for Dashi's key shrine members. The previous weekend, I had coordinated their attendance at the Nubuke Foundation for the *Secrets Under the Skin* installation in Accra. Now, one week later, Dashi's Togbui Anyigbato's shrine doors opened to play music and to dance, as a special privilege for the research team. Although this ceremony sought to honor us, we compensated the shrine, continuing a cycle of gift-giving.

About seven possessions came down rapidly that night in Dzodze. The lead chanter kept order inside the dancing circle by assisting those who got possessed. With each possession, she looked at me with what seemed to be the same curious expression I must have had on my face at the number and speed of the possessions. Against the darkening skies, other women watching the ceremony carefully tended to our bare shoulders to shoo away mosquitos. Because we were in front of a shrine, Susan, Marianne, and I were required to keep our shoulders bare by wrapping a long piece of cloth around our chests. As required for men, Brian had his cloth wrapped around his waist and wore no shirt. We left before the music-making finished. The dark closed in and I walked away, leaving behind years and years of memories, embodied moments, smells, tastes, sensations—all held emergent in the dance circle in front of Dashi's shrine. It was part of the continuum of the exchange of information and a reminder of the point of it all: to bring data alive, to *be* alive in the sensorial moment, in all its performative manifestations, and to keep conversations going.

Afterword 1. Members of Dashi's shrine dance in front of Togbui Anyigbato's open shrine door on the day set aside to honor the research team. Photo by Brian Jeffery.

Appendix A. Cast of Characters and Family Trees

Below are names, followed by brief descriptions, of those not identified in the following family trees, or who were not featured or discussed in individual chapters. They are nevertheless important to the historiography of Perico and Agramonte

A

Alberto Enrique "Kikito" Morales Iglesias—Perico

Important drummer of Perico, father to Jesús Alberto Morales Varona (Jesusito).

E

Ernestina Zulueta—Perico

Possessed the Arará *fundamento* for Oyá. According to Andreu Alonso (1997, 44) Ernestina Zulueta received the fundamento Tocoyó Yonó (one of the names for the Arará Eleggua) after Ma Florentina passed away. This fundamento would remain under the watchful care of Clara Angarica until her death in 1989.

F

Fabiana Zulueta—Perico

Possessed the fundamento Hevioso and was sister to Fidela Zulueta. She was great-aunt to Hilda Zulueta. Her Hevioso is in possession of Teresa Onelia Vidal Diago.

Felipa Zulueta—Perico

Possessed the fundamento Tocuo Yeyino Babajureco—Afrá in Arará and Eleggua-Echu in Lucumí—and Afrá's wife (Sowebi). She was sister to Justo

Zulueta and great-aunt to Iraida "Guyito" Zulueta Zulueta and Hilda "Macusa" Zulueta Dueñas.

H

Hilario "Melao" Fernández Sosa—Agramonte

Important elder, now deceased, and cousin to Mario José.

M

Marcos Hernández Borrego—Perico

Close friend of Armando Zulueta, good friend and keeper of the *awán* together with María Eugenia Suset Zulueta of Perico.

V

Valentín Santos Carrera—Perico

Born in 1945, friend and godson of Armando Zulueta, important elder and *santero* who passed away on February 24, 2008.

MA FLORENTINA
FAMILY TREE
PERICO

Ma Florentina = Ta Facundo

Aurelio Angarica = Victoria Basilisia Zulueta
(Macho Prieto) (Goddaughter of Ma Florentina)

Aurelio Felipe Angarica Zulueta

Arístides Angarica Zulueta (Cuito) = Oria Diago Miñoso

Aurelio = Hilda Zulueta Zulueta
Angarica
Zulueta

Fausta Robinson Zulueta (Cuito's 2nd wife)

Juan Fidel Angarica Robinson

Victoria Angarica Robinson (Toya)

María de Jesús Montalvo (Arístides' 1st wife)

Onier Angarica Montalvo

Arístides Angarica Diago (Ñuco)

Victor Angarica Diago (Prieto) = Estela Galarraga

Aurelio = Aquilina Suset
Angarica Zulueta
Zulueta

Auelio Angarica Suset

Estela de los Ángeles Santuiste (Arístides' 2nd wife)

Javier Angarica (El Nene)

Mairelis Angarica (La China)

Lázara Angarica (Lazarita)

Midialis Angarica Galarraga

Victor, Damián Angarica Galarraga

// El Chino

// Marioivis Chona

= married to
+ unmarried partner
? unknown

Figure A.1. Ma Florentina's family tree. Illustration by Susan Matthews.

JUSTO ZULUETA FAMILY TREE PERICO

Dionisio Zulueta = Dolores Campos (Justo's Parents)

Note: It is not known if Justo was Dionisio's biological or adopted son.

María Robinson + Justo Zulueta Campos = María Salomé + Fidela Zulueta
 (Brother to Felipa) Zulueta Zulueta (Fidela had Malé and was sister to Fabiana)

Reinaldo Robinson

Fausta Robinson

Secundino Zulueta = María Luisa = Nemesio Dueñas Nicomedes (f) Zulueta Zulueta
(1st husband) Zulueta Zulueta Dueñas (2nd husband)

Iraida Zulueta Zulueta (Gugito)

Hilda Zulueta Dueñas (Macusa)

Felipa had an Arará Eleggua that is still cared for by Macusa.

Hilda Zulueta

Fabiana had Hevioso. Hevioso is still cared for by Teresa Onelia Vidal Diago

(f) = female

Figure A.2. Justo Zulueta's family tree. Illustration by Susan Matthews.

ARMANDO ZULUETA
FAMILY TREE
PERICO

Unknown = Teresa de Laí Unknown Pedroso (Parents of Armando Zulueta)

Armando Zulueta

Justo Zulueta

Pedro Feliciano Zulueta

Dionisia Zulueta

Domingo = Francisca Suset Zulueta Armenteros

Aurora Suset Zulueta

Teresita Suset Zulueta

Miguel Suset Zulueta

Antonio Suset Zulueta (Nico)

Omaida Unzueta Suset

Janerquis Santana Unzueta (Jeny)

María Eugenia Suset Zulueta "

Aquilina Suset Zulueta

Reinaldo Hernández

Freddy Hernández Suset

Fermín Iznaga

María Eugenia Iznaga Suset

Figure A.3. Armando Zulueta's family tree. Illustration by Susan Matthews.

Figure A.4. Ma Gose's and Ta Andrés's family trees. Illustration by Susan Matthews.

Appendix B. Maps and Legends for Perico and Agramonte

Legend for Perico

(1) Oyá house:

Deity: Allegue (according to Midialis), Dañé (according to
Guillermo Andreu Alonso, 1997), Cosá (according to Orlando
Francisco Quijano).

Associated names: Ernestina Zulueta, Clara Leal Angarica, Orlando
Francisco Quijano Tortoló.

Celebration: October 15.

(2) Sociedad Africana:

Deities: Alúa (San Lázaro), Hevioso (Changó), Afrá (Eleggua),
Chacho Cuacutorio or Ocutorio (Ochosi and Aggidai).

Associated names: Ma Florentina, Victoria Zulueta, Víctor "Prieto"
Angarica Diago, Arístides Angarica Diago (Ñuco), Midialis
Angarica Galarraga, Lázara "Lazarita" Angarica Santuiste.

Celebration: December 4.

(3) San Lázaro house (Octavia):

Deities: San Lázaro, Afrá, and Aggidai.

Associated names: Octavia Zulueta (Jundesi), Juana "Marule" Ester
Zulueta Cárdenas, Pedro Pablo "Pelli" Diviñó Zulueta, el Zurdo.

Celebration: December 16.

(4) Eleggua house:

Deities: Afrá, Cuvijergán (Cuvi), Tocuo Yayino Babajureco, and
Sowebi (Sowe).

Associated names: Felipa Zulueta, María Luisa Zulueta Zulueta,
Hilda "Macusa" Zulueta Dueñas.

Celebration: June 29.

(5) Armando Zulueta house:
 Deities: San Lázaro (Afimaye Camaye), Afrá, Cuvi, Malé, Juerdase,
 Ibeyis, and drum for Hevioso.
 Associated names: Teresa de Laí, Armando Zulueta, Aquilina Suset
 Zulueta, María Eugenia Suset Zulueta, Janerquis "Jeny" Santana
 Unzueta.
 Celebration: December 17 (batá), 18 (Arará *awán*).

(6) Valentín Santos Carrera:
 Armando Zulueta's godson.

(7) Museo Constantino Barredo Guerra (Rosario Pino Domínguez,
 director).

(8) Ramona Casanova Elizalde:
 Deity: Afrequete/Frequete.
 Associated name: Catalina Frequete.

(9) Lazarita Angarica Santuiste.
 Current *gallo* of the Arará tambor.

(10) Justo Zulueta house:
 Deities: Oddu Aremu, Somaddonu, Hevioso/Santa Bárbara, Ochún,
 María Vence Guerra, Mayimbe Cunga.
 Associated names: Justo Zulueta, Reinaldo Robinson, Vladimir
 Osvaldo Fernández Tabío.
 Celebration: September 24 (Oddu Aremu), 25 (Hevioso/Santa
 Bárbara) and January 1 (María Vence Guerra and Mayimbe Cunga).

(11) Graciella Tabío Robinson (Tita, mother to Vladimir).

(12) María Eugenia Suset Zulueta:
 Niece to Armando Zulueta, currently in charge of the awán.

(13) Miriam Bravo:
 Former dancer with Grupo de Artistas Aficionados (Group of
 Amateur Artists). She and Victoria Zulueta formed Perico's
 Dahomey Arará Folkloric Group in 1978.

(14) Teresa Onelia Vidal Diago:
 Deity: Hevioso.
 Associated names: Fabiana Zulueta, Teresa Zulueta (niece to Fabiana),
 Pedralina Noelia Diago (mother to Teresa Onelia Vidal Diago).

(15) Jesús "Jesusito" Alberto Morales Varona:
Important drummer of Perico.

(16) Fidela "Chichí" Zulueta (Male's house):
Deities: Malé, Juerdase, San Lázaro, and Afrá.
Associated name: Adelina "Melo" Ferrín.
Celebration: January 1.

(17) Orlando Francisco Quijano and wife Clarisa Emilia García. Orlando
once lived in Ernestina Zulueta's Oya house.

Figure B.1. Perico map. Illustration by Susan Matthews.

Figure B.2. Agramonte map. Illustration by Susan Matthews.

Legend for Agramonte

(1) Fermina "Minita" Baró Quevedo:
Associated names: Ta Andrés "Coso Coso" Fernández, Desiderio Fernández, José Baró Fernández.

(2) Mario José Abreu Díaz:
Associated names: Federico y Laureano Fernández (uncles to Mario Jose's mother).

(3) Hilario "Melao" Fernández Sosa:
Important deceased elder of Agramonte.

(4) Templo de San Manuel:
Associated names: Manuela Fernández (Ma Gose), Sisto Fernández, Atilano Fernández, Georgina Margarita Fernández Campos, Onelia Fernández Campos, Israel Baró Oruña, Miguel Ángel Baró Fernández, Alicer Baró Fernández.
Deities: San Manuel (Danagosi), Afrá, San Lázaro (Asumayayá and Nanú), and Naná Burukú.

(5) Lázaro Madan:
Associated names: Florentino Madan (Papa Tusa).
Deities: Asojano (Creowecuto, Dojuno Ladeno).

Appendix C. Select Arará Chants/Cantos
as Currently Sung by Lazarita Angarica Santuiste in Perico, Cuba

Los muertos (The Dead)

Chants to call and receive them / Cantos para llamarlos y recibirlos

1. (gallo) icua marilleno, icua, carasuadoae
 (coro) marilleno icua carasuadoae
 Note: This chant doesn't have a special meaning. It's for calling all the dead. / No tiene significado especial. Es para llamar a todos los muertos.

2. (gallo) selina gollo gollo, selina gollo gollo enai
 serdi, nai ser die, sana legua
 (coro) selina gollo gollo, selina gollo gollo enai
 serdi, nai ser die, sana legua
 Note: This chant doesn't have a special meaning. It's for calling and saying goodbye to all the dead. / No tiene significado especial. Es para llamar y despedir a todos los muertos.

CHANT TO BID FAREWELL/ CANTO PARA DESPEDIR

1. (gallo) un guade dolo oh oh . . .
 (coro) oh, oh unveia
 Note: No special meaning. Hands go up and down because when someone dies this is the chant used to lift the coffin. / No tiene significado especial. Manos arriba y abajo porque cuando alguien muere éste es el canto que se canta para levantar el ataúd.

SANTOS

I- ELEGGUA

1. (gallo) cufi geganza abo gegan
 (coro) afara geganza gegan
 Note: Hands tangle and disentangle. / Manos que enrredan y
 desenrredan.

2. (gallo) otocororo leguamire erosolla jundeme anitererere erocararabo
 cabolegua e otocororo leguamire erosolla jundeme anitererere
 bambalo cararabo cabo megua e
 (coro) otocororo leguamire erosoya jundeme anitererere erocararabo
 cabo legua e otocororo leguamire erosolla jundeme anitererere
 bambalo cararabo cabo megua e
 Note: Each rooster sings in his own henhouse. / Cada gallo canta en su
 gallinero.

II- OGGÚN

(gallo) adufuelletosisocaboiaragüe, adufue eleguasito cabo llaragüe
(coro) adufue lletosisocabollaragüe adufue
Note: Hands up and down. / Manos arriba y abajo.

III- NANÁ BURUKÚ

(gallo) olla misagui
(coro) nana coche milodo, nana
(gallo) colore mio
(coro) aguacolore iqui agua

IV- OYÁ

(gallo) ero julla, ero julla, ero julla numite
(coro) eh, Oya numi, ollancara Oya numi
Note: No exact meaning. Oyá just wants to sing and dance with her
iruke. / No tiene un significado exacto, Oyá solo quiere bailar con
su iruke.

V- ANANÚ/ YEMAYÁ

(gallo) ero fodule, ero meguanomi cacara güeto eleselena, ero
meguanumi medeguago

(coro) ero fodule, ero meguano mi cacara güeto eleselena, ero
meguanumi medeguago

Note: Nanú is bathing in the river or in the sea. She likes to cleanse
people of evil spirits. / Nanú se baña en el río o en la mar. Le gusta
librar a las personas de los malos espíritus.

VI- OBATALÁ

1. (gallo) sagüe, sagüe donu
 (coro) efe y a efe
 Note: This chant is meant to protect your body. You have to place
 your hands on your shoulders, hips, waist, etc. while singing it. /
 Este canto es para proteger el cuerpo. Se ponen las manos en los
 hombros, caderas, cintura, etc. mientras se canta.

2. (gallo) ero pipi yagui yagui yagui, llama malodde, Oddu Aremú ero
 llamagüea
 (coro) llama malodde
 Note: To call all deities. Changó sees a ball of fire that's coming down,
 he runs and all santos run behind him. They all decide to come
 down. / Para llamar a todos los santos. Changó ve una bola de
 fuego que viene, corre y todos los santos corren detrás de él.

VII- CHANGÓ

1. (gallo) bosobo jarafidde mana guado, llimado madocueriodde, sobo
 jarafidde mana guado llimado madocueriodde
 (coro) bosobo jarafidde mana guado, llimado madocueriodde, sobo
 jarafidde mana guado llimado madocueriodde
 Note: When people sing this chant, they are saying Changó is the
 man wearing a red *guayabera*. / Este canto dice que Changó es un
 hombre que viste una guayabera roja.

2. (gallo) mosolliso manatía, ero tagüena lleddoddo
 (coro) llama ladía, llama cebora

(gallo) abocue ñañaroque

(coro) ñañaroque

Note: Changó loves to dance with this chant. He takes his axe and
dances. Hands up as if calling him. / A Changó le gusta bailar
con este canto. Levanta su hacha y baila. Las manos arriba como
llamándolo.

VIII- OCHÚN/ JUERDASE

(gallo) abobobo aguerese illara boguae, abobobo aguerese illara
boguae, illara boguae, illara yagüe, illara boguae, illara yagüe
aquerese, aquerese iyara yagüe

(coro) abobobo aguerese illara boguae, abobobo aguerese illara
boguae, illara boguae, illara yagüe, illara boguae, illara yagüe
aquerese, aquerese iyara yagüe

Note: Ochún is dancing with a plate full of honey. / Ochún está
bailando con un plato lleno de miel.

IX- SAN LÁZARO

He is the most sacred. Children must not be present when people sing
for him. / Es el santo más sagrado, los niños no deben estar cuando
se canta para él.

(gallo) ero jue nada guiriri bosicomamana cocodojun ofodula
naicabomana ofodula naicedona, ofodula naicabomana ofodula
naicedona ero jue e enaddo jue baba foddu

(coro) ero jue nada guiriri bosico mamana cocodojun ofodula
naicabomana ofodula naicedona, ofodula naicabomana ofodula
naicedona ero jue e enaddo jue baba foddu

Note: People are summoning him so that he will know what's
happening here on earth. / Las personas lo llaman para que sepa lo
que pasa en la tierra.

X- MALÉ

(gallo) dale macuto un de dale masoidea, dale macuto un de dale
masoidea, dale macuto un de magua, magua magua

(gallo) dale macuto un de dale masoidea, dale macuto un de dale masoidea dale macuto un de magua, saracoco, dale macuto un de dale masoidea, dale macuto un de dale masoidea, dale macuto un de magua, magua

XI- AGGIDAI

(gallo) Aggidainasaoro efe enado do mido efe enado mido nasaco do mi do e

(coro) Aggidainasaoro efe ena domido

Note: This chant announces the tambor is about to close, it's to give thanks. / Este canto anuncia el cierre del tambor, es para agradecer.

XII- OSAIN

(gallo) conu conu mana lloré

(coro) Osaín seboa

Note: People know they have to bring a bucket of water. / Las personas saben que ya hay que traer el cubo de agua.

TO CLOSE

(gallo) unvia güegüeroe, via güegüeru ade, via güegüeroe, via güegüeru ade matacachoco aladdo weto taché taladde, un via güegüeroe, via güegüeru ade

(coro) un via güegüeroe, via güegüeru ade, via güegüeroe, via güegüeru ade matacachoco aladdo weto taché taladde, un via güegüeroe, via güegüeru ade

Note: Everybody must be crouched down. / Todo el mundo está agachado.

References

Adjei, Sela Kodjo. 2019. "Philosophy of Art in Ewe Vodu Religion." PhD diss., University of Ghana.

Ágara Sánchez, Caridad. 2017. "El Ferrocarril Toca a Perico." *Muestra del Mes*. Monthly exhibit (publication pamphlet) at Museo Municipal Constantino Barredo Guerra, Perico, Cuba, April 26, 2017.

Akyeampong, Emmanuel, K. 2001. *Between the Sea and the Lagoon: An Eco-social History of the Anlo of Southeastern Ghana c. 1850 to Recent Times*. Oxford: James Currey.

Andreu Alonso, Guillermo. 1997. *The Arará in Cuba: Florentina, a Princess from Dahomey*. Translated by Carmen González. La Habana: Instituto Cubano del Libro.

Amenumey, D.E.K. 1986. *The Ewe in Pre-Colonial Times: A Political History with Special Emphasis on the Anlo, Ge, and Krepi*. Accra, Ghana: Sedco Pub. Limited.

Assmann, Jan, and John Czaplicka. 1995. "Collective Memory and Cultural Identity." *New German Critique* 65: 125–133.

Basso Ortiz, Alessandra. 2001. "Los Gangá Longobá: El Nacimiento de los Dioses." *Boletín Antropológico* 52: 195–208.

Bay, Edna G. 1998. *Wives of the Leopard: Gender, Politics, and Culture in the Kingdom of Dahomey*. Charlottesville, VA: University of Virginia Press.

Becker, Judith. 2004. *Deep Listeners: Music, Emotion, and Trancing*. Indianapolis: Indiana University Press.

Behar, Ruth. 1996. *The Vulnerable Observer: Anthropology that Breaks Your Heart*. Boston: Beacon Press.

Bolívar Aróstegui, Natalia. 1994. *Los Orishas en Cuba*. La Habana: PM Ediciones.

———. 2000. *Lydia Cabrera en Su Laguna Sagrada*. Santiago de Cuba: Editorial Oriente.

Bourdieu, Pierre. 1990. *The Logic of Practice*. Translated by Richard Nice. Stanford: Stanford University Press.

Brandon, George. 1997 [1993]. *Santeria from Africa to the New World: The Dead Sell Memories*. Bloomington and Indianapolis: Indiana University Press.

Brice Sogbossi, Hippolyte. 1998. *La Tradición Ewe-Fon en Cuba: Contribución al Estudio de la Tradición Ewe-Fon (Arará) en los Pueblos de Jovellanos, Perico y Agramonte, Cuba*. La Habana: Fundación Fernando Ortiz.

Brodine, Maria T. 2011. "Struggling to Recover New Orleans: Creativity in the Gaps and Margins." *Visual Anthropology Review* 27(1): 78–93.

Brown, David H. 2003. *Santería Enthroned*. London and Chicago: University of Chicago Press.

Brown, Karen McCarthy. 2001. *Mama Lola: A Vodou Priestess in Brooklyn*. Updated and expanded. Vol. 4. Berkeley: University of California Press.

Butler, Judith. 1988. "Performative Acts and Gender Constitution: An Essay in Phenomenology and Feminist Theory." In *Performing Feminisms: Feminist Critical Theory and Theatre,* edited by Sue-Ellen Case, 519–531. Baltimore: Johns Hopkins University Press.

———. 1997. *Excitable Speech: A Politics of the Performative.* New York: Routledge.

Cabrera, Lydia. 1993 [1973]. *La Laguna Sagrada de San Joaquín.* Miami: Ediciones Universal.

Campbell, Craig. 2011. "Terminus: Ethnographic Terminalia." *Visual Anthropology Review* 27(1): 52–56.

Carpentier, Alejo. 2001. *Music in Cuba,* 5th ed. Minneapolis: University of Minnesota Press.

Chernoff, John Miller. 1979. *African Rhythm African Sensibility: Aesthetics and Social Action in African Musical Idioms.* Chicago: University of Chicago Press.

Clifford, James, and George E. Marcus. 1986. *Writing Culture: The Poetics and Politics of Ethnography.* Berkeley: University of California Press.

Culhane, Dara. 2017. "Imagining: An Introduction." In *A Different Kind of Ethnography: Imaginative Practices and Creative Methodologies,* edited by Denielle Elliott and Dara Culhane, 1–21. Toronto: University of Toronto Press.

Deleuze, Gilles, and Félix Guattari. 1988. *A Thousand Plateaus: Capitalism and Schizophrenia.* New York: Continuum.

Dodson, Jualynne E. 2004. "Review of *Santería Enthroned: Art, Innovation, and Ritual in an Afro-Cuban Religion* by David H. Brown and *AfroCuban Religions* by Miguel Barnet." *The North Star* 8(1 Fall). Last accessed September 30, 2017. https://www.princeton.edu/~jweisenf/northstar/volume8/brown_barnet.html.

Domínguez, Lourdes S. 2016. *Necklaces in Cuban Santería.* La Habana: Editorial José Martí.

Drewal, Henry John. 2008. "Mami Wata: Arts for Water Spirit in Africa and Its Diasporas." *African Arts* 41(2): 60–83.

Elliott, Denielle. 2017. "Writing." In *A Different Kind of Ethnography: Imaginative Practices and Creative Methodologies,* edited by Denielle Elliot and Dara Culhane, 23–44. Toronto: University of Toronto Press.

Elliott, Denielle, and Dara Culhane. 2017. "Preface." In *A Different Kind of Ethnography: Imaginative Practices and Creative Methodologies,* edited by Denielle Elliott and Dara Culhane, ix. Toronto: University of Toronto Press.

Fabian, Johannes. 1990. *Power and Performance: Ethnographic Explorations through Proverbial Wisdom and Theater in Shaba, Zaire.* Madison: University of Wisconsin Press.

Feld, Steven. 1982. *Sound and Sentiment: Birds, Weeping, Poetics, and Song in Kaluli Expression.* Philadelphia: University of Pennsylvania Press.

Fernández Martínez, Mirta. 2005. *Oralidad y Africania en Cuba.* La Habana: Instituto Cubano del Libro.

Friedson, Steven. 2009. *Remans of Ritual: Northern Gods in a Southern Land.* Chicago: University of Chicago Press.

Gee, James Paul. 1992. *The Social Mind: Language, Ideology, and Social Practice.* New York: Bergin & Garvey.

Geertz, Clifford. 1973. *The Interpretation of Cultures: Selected Essays.* New York: Basic Books.

———. 1988. *Works and Lives: The Anthropologist as Author.* Palo Alto: Stanford University Press.

Gilbert, Michelle V. 1982. "Mystical Protection Among the Anlo-Ewe." *African Arts* 15(4): 60–66.

Greene, Sandra E. 2002. "Notsie Narratives: History, Memory and Meaning in West Africa." *South Atlantic Quarterly* 101(4): 1015–1041.

Grossi, Angelantonio. 2020. "Religion on Lockdown: On the Articulation of Vodu, Media and Science." *Religious Matters in an Entangled World*. Last updated April 15, 2020. Accessed April 18, 2020. https://religiousmatters.nl/religion-on-lockdown-on-the-articulation-of-vodu-media-and-science/.

Guanche, Jesús. 1996. *Componentes Étnicos de la Nación Cubana*. La Habana: Ediciones Union.

———. 2005. "Identificación de los Componentes Étnicos Africanos en Cuba: Contribución a su Estudio en los Siglos XX y XXI." *Revista del Cesla* 7: 237–251.

Gutiérrez Machín, Luisa, and Marcela Calderín Kindelán. n.d. "Cronología Histórica del Municipio de Perico." *Joven Club*. Last accessed May 18, 2018. mtz.jovenclub.cu/historia/dload/Cronologia%20de%20Perico.exe.

Halbwachs, Maurice. 1980. *The Collective Memory*. New York: Harper & Row.

Hall, Stuart. 1990. "Cultural Identity and Diaspora." In *Identity: Community, Culture, Difference,* edited by Jonathan Rutherford, 222–237. London: Lawrence & Wishart.

Jones, Joni L. 2002. "Performance Ethnography: The Role of Embodiment in Cultural Authenticity." *Theatre Topics* 12(1): 1–15.

Journet, Debra, Beth A. Boehm, and Cynthia E. Britt, eds. 2012. *Introduction to Narrative Acts: Rhetoric, Race and Identity, Knowledge*. New York: Hampton Press.

Kirk, Alan, and Tom Thatcher. 2005. *Memory, Tradition, and Text: Uses of the Past in Early Christianity*. Vol no. 52. Atlanta, GA: Society of Biblical Literature.

Laumann, Dennis. 2005. "The History of the Ewe of Togo and Benin from Pre-Colonial to Post-Colonial Times." In *The Ewe of Togo and Benin,* edited by Benjamin N. Lawrance, 14–28. Accra: Woeli Publishing Services.

Leavy, Patricia. 2013. *Fiction as Social Research*. Walnut Creek, CA: Left Coast Press.

Martínez Furé, Rogelio. 1997 [1979]. *Diálogos Imaginarios*. Havana: Instituto Cubano del Libro.

Mason, John. 2016. *Òrìsà: New World Black Gods*. New York: Yoruba Theological Archministry.

Mason, Michael Atwood. (2011a, June 10). "Güeró, Oshumaré the Rainbow in Arará" [blog post]. Retrieved from: http://baba-who-babalu-santeria.blogspot.com.

———. (2011b, September 16). "Reflections on Water and the Different Stages of Nana Burukú" [blog post]. Retrieved from: http://baba-who-babalu-santeria.blogspot.com.

———. (2011c, October 7). "Babalú-Ayé in Perico: The Arará-Dajomé" [blog post]. Retrieved from: http://baba-who-babalu-santeria.blogspot.com.

———. (2013, June 13). "The Many Roads of Babalú-Aye" [blog post]. Retrieved from http://baba-who-babalu-santeria.blogspot.com.

———. (2017, December 29). "Babalú-Ayé and a Theory of Multiplicity" [blog post]. Retrieved from: http://baba-who-babalu-santeria.blogspot.com.

Meyer, Birgit. 2008. "Powerful Pictures: Popular Protestant Aesthetics in Southern Ghana." *Journal of the American Academy of Religion* 76(1): 82–110.

———. 2010a. "Aesthetics of Persuasion: Global Christianity and Pentecostalism's Sensational Forms." *South Atlantic Quarterly* 109(4): 741–763.

————. 2010b. "'There is a Spirit in That Image': Mass Produced Jesus Pictures and Protestant Pentecostal Animation in Ghana." *Comparative Studies in Society and History* 52(1): 100–130.

————. 2011. "Mediation and Immediacy: Sensational Forms, Semiotic Ideologies and the Question of the Medium." *Social Anthropology* 19(1): 213–239.

————. 2015. "Art, Anthropology, and Religion." *Material Religion* 11(1): 113–115.

Moore, Robin, and Elizabeth Sayre. 2006. "An Afro-Cuban Batá Piece for Obatalá: King if the White Cloth." In *Analytical Studies in World Music,* edited by Michael Tenzer, 120–160. New York: Oxford University Press.

Morales Rodríguez, Gisselle. 2015. "The Magic Realism of Natalia Bolivar." *Havana Times.* Last accessed September 30, 2017. https://havanatimes.org/interviews/the-magic-realism-of-natalia-bolivar/.

Mullen, Carol. 1994. "A Narrative Exploration of the Self I Dream." *Journal of Curriculum Studies* 26(3): 253–263.

Ness, Sally Ann. 1992. *Body Movement and Culture: Kinesthetic and Visual Symbolism in a Philippine Community.* Philadelphia: University of Pennsylvania Press.

Nodal, Roberto. 1983. "The Social Evolution of the Afro-Cuban Drum." *The Black Perspective in Music:* 157–177.

Novack, Cynthia. 1990. *Sharing the Dance: Contact Improvisation and American Culture.* Madison: University of Wisconsin Press.

Nugent, Paul. 2005. "A Regional Melting Pot." In *The Ewe of Togo and Benin,* edited by Benjamin Lawrance, 29–43. Accra: Woeli Publishing.

Nukunya, Godwin K. 1969. "The Yewe Cult among Southern Ewe-Speaking People of Ghana." *Ghana Journal of Sociology* 5(1): 1–7.

Nyamuame, Samuel Kwame Elikem. 2013. "History, Religion and Performing Yeve: Ewe Dance-Drumming, Songs and Rituals at Ave-Dakpa, Ghana." PhD diss., University of Florida.

Olick, Jeffery K., and Joyce Robbins. 1998. "Social Memory Studies: From 'Collective Memory' to the Historical Sociology of Mnemonic Practices." *Annual Review of Sociology* 24: 105–140. Accessed March 27, 2020. https://www.annualreviews.org/doi/full/10.1146/annurev.soc.24.1.105.

Ortiz, Fernando. 1984 [1921]. "Los Cabildos Afrocubanos." In *Ensayos Etnográficos: Fernando Ortiz,* edited by Miguel Barnet and Ángel L. Fernández, 11–40. La Habana: Editorial de Ciencias Socialez.

————. 1987 [1916]. *Los Negros Esclavos.* Havana: Editorial de Ciéncias Sociales.

————. 1993. *Etnia y Sociedad.* La Habana: Editorial de Ciencias Sociales.

Palmié, Stephan. 2005. "Santería Grand Slam: Afro-Cuban Religious Studies and the Study of Afro-Cuban Religion." *New West Indian Guide/Nieuwe West-Indische Gids* 79(3/4): 281–300.

————. 2013. *The Cooking of History: How Not to Study Afro-Cuban Religion.* Chicago: University of Chicago Press.

————. 2018. "When is a Thing? Transduction and Immediacy in Afro-Cuban Ritual; or, ANT in Matanzas, Cuba, Summer of 1948." *Comparative Studies in Society and History* 60(4): 786–809.

Perret Ballester, Alberto. 2008 [2007]. *El Azúcar en Matanzas y Sus Dueños en La Habana.* Havana: Editorial de Ciéncias Sociales.

Phelan, Peggy. 1993. *Unmarked: The Politics of Performance.* New York: Routledge.

Porcello, Thomas, Louise Meintjes, Ana Maria Ochoa, and David. W. Samuels. 2010. "The Reorganization of the Sensory World." *Annual Review of Anthropology* 39: 51–66.

Propp, Vladimir. 1968. *Morphology of the Folktale,* 2nd ed. Austin: University of Texas Press.

Reyes Herrera, Ileana, and Andrés Rodríguez Reyes. 1993. "Los Santos Parados o Santos de Manigua." *Del Caribe* 21: 28–34.

Richardson, Laurel. 1990. "Narrative and Sociology." *Journal of Contemporary Ethnography* 19(1): 116–135.

———. 1993. "Poetics, Dramatics, and Transgressive Validity: The Case of the Skipped Line." *The Sociological Quarterly* 34(4): 695–710.

Ricoeur, Paul. 2007. *From Text to Action: Essais d'Herméneutique II.* Translated by Kathleen Blamey and John B. Thompson. Evanston, IL: Northwestern University Press.

Rivero Glean, Manuel. 2011. *Deidades Cubanas de Origen Africano.* La Habana: Casa Editora Abril.

Rosenthal, Judy. 2005. "Religious Traditions of the Togo and Benin Ewe." In *The Ewe of Togo and Benin,* edited by Benjamin Lawrance, 183–196. Accra: Woeli Publishing.

Salm, Steven J., and Toyin Falola. 2002. *Culture and Customs of Ghana.* Westport, CT: Greenwood.

Schechner, Richard. 2011. *Between Theater and Anthropology.* Philadelphia: University of Pennsylvania Press.

Scott, Rebecca J. 2001. *La Emancipación de los Esclavos en Cuba. La Transición al Trabajo Libre 1860–1899.* La Habana: Editorial Caminos.

Sklar, Deidre. 1991. "On Dance Ethnography." *Dance Research Journal* 23(1): 6–10.

———. 1994. "Can Bodylore be Brought to its Senses?" *The Journal of American Folklore* 107(423): 9–22.

Soumonni, Elisée. 2012. "Disease, Religion and Medicine: Smallpox in Nineteenth-Century Benin." *História, Ciências, Saúde—Manguinhos* 19: 35–45. Accessed March 31, 2020 http://www.scielo.br/pdf/hcsm/v19s1/03.pdf.

Stoller, Paul. 1997. *Sensuous Scholarship.* Philadelphia: University of Pennsylvania Press.

———. 2018. Storytelling and the Construction of Realities. *Etnofoor* 30(2), 107–112.

Stoller, Paul, and Cheryl Olkes. 1987. *In Sorcery's Shadow: A Memoir of Apprenticeship among the Songhay of Niger.* Chicago: University of Chicago Press.

Tierney, William G. 1995. "(Re)Presentation and Voice." *Qualitative Inquiry* 1(4): 379–390.

Thompson, Robert Farris. 1993. *Face of the Gods: Arts and Altars of Africa and the African Americas.* Munich: Prestel.

Torres, Jonathan. 2016. "Discourse as Ritual: Reflecting on the Multi-Literacies of Religious Practice in Cuba." *Creative Approaches to Research* 9(1): 111–124.

University of Chicago. 2013. "Wednesday Lunch at the Divinity School with Stephan Palmié." YouTube video, 51:56. https://www.youtube.com/watch?v=uMJ9EgbKqys.

Urban, Greg. 2001. *Metaculture: How Culture Moves through the World.* Minneapolis: University of Minnesota Press.

Van de Port, Mattijs. 2011. *Ecstatic Encounters: Bahian Candomblé and the Quest for the Really Real.* Amsterdam: Amsterdam University Press.

Van Dyke, Ruth M. 2009. "Chaco Reloaded: Discursive Social Memory on the Post-Chacoan Landscape." *Journal of Social Archaeology* 9(2): 220–248.

Venkatachalam, Meera. 2015. *Slavery, Memory, and Religion in Southeastern Ghana, c. 1850–Present.* Cambridge, UK: Cambridge University Press.

Vidali, Debra Spitulnik. 2016. "Multisensorial Anthropology: A Retrofit Cracking Open of the Field." *American Anthropologist* 118(2): 395–400.

Vinueza, María Elena. 1988 [1986]. *Presencia Arara en la Musica Folclorica de Matanzas*. La Habana, Cuba: Casa de las Américas.

Vygotsky, Lev Semenovich. 1980. *Mind in Society: The Development of Higher Psychological Processes*. Cambridge: Harvard University Press.

West, Harry G. 2008. *Ethnographic Sorcery*. Chicago: University of Chicago Press.

Wirtz, Kristina. 2007. *Ritual, Discourse, and Community in Cuban Santería: Speaking a Sacred World*. Gainesville: University Press of Florida.

Interviews (in Chronological Order)

Yohansi González Smith, Juan Emerio Corbea Rodríguez, William Sanabria, Carmen Inocencia Zulueta Gonzueta, Asela Andrea González Barquilloso, and María Eugenia Suset Zulueta, interview with Jill Flanders Crosby and Roberto Pedroso García, December 18, 2005, Perico, Cuba.

Hilda Victoria Zulueta Zulueta, interview with Jill Flanders Crosby, Roberto Pedroso García, and Lourdes Tamayo, January 8, 2006, Perico, Cuba.

Alfredo Rodríguez González, interview with Jill Flanders Crosby and Roberto Pedroso García, December 18, 2005, Perico, Cuba.

Lazarita Angarica Santuiste, interview with Jill Flanders Crosby, Roberto Pedroso García, and Lourdes Tamayo, January 15, 2006, Perico, Cuba.

Reinaldo Robinson, interview with Jill Flanders Crosby, Roberto Pedroso García, and Lourdes Tamayo, January 15, 2006, Perico, Cuba.

Hilda Victoria Zulueta Zulueta, interview with Jill Flanders Crosby, Melba Núñez Isalbe, and Roberto Pedroso García, January 21, 2006, Perico, Cuba.

Víctor (Prieto) Angarica Diago, Alberto (Kikito) Enríquez Morales Iglesias, Jesús (Jesusito) Alberto Morales Varona, Hilda Victoria Zulueta Zulueta, Lazarita Angarica Santuiste, and Víctor Angarica Galarraga, interview with Jill Flanders Crosby, Melba Núñez Isalbe, and Roberto Pedroso García, January 26, 2006, Perico, Cuba.

Adela de las Mercedes (Mamaita) Corbea, interview with Jill Flanders Crosby, Melba Núñez Isalbe, and Roberto Pedroso García, January 21, 2006, Perico, Cuba.

Reinaldo Robinson, interview with Jill Flanders Crosby, Melba Núñez Isalbe, and Roberto Pedroso García, January 21, 2006, Perico, Cuba.

Reinaldo Robinson, interview with Jill Flanders Crosby, Melba Núñez Isalbe, Roberto Pedroso García, and Susan Matthews, December 16, 2006, Perico, Cuba.

Hilda Victoria Zulueta Zulueta, interview with Jill Flanders Crosby, Melba Núñez Isalbe, Roberto Pedroso García, and Susan Matthews, December 18, 2006, Perico, Cuba.

Mario José Abreu Díaz, interview with Jill Flanders Crosby, Melba Núñez Isalbe, and Roberto Pedroso García, December 17, 2007, Agramonte, Cuba.

Hilda (Macusa) Victoria Zulueta Dueñas, interview with Jill Flanders Crosby, Melba Núñez Isalbe, and Roberto Pedroso García, December 18, 2007, Perico, Cuba.

Valentín Santos Carrera, interview with Jill Flanders Crosby, Melba Núñez Isalbe, and Roberto Pedroso García, December 18, 2007, Perico, Cuba.

María Eugenia Suset Zulueta, Antonio Suset Zulueta, and Janqueris Santana Unzueta, interview with Jill Flanders Crosby, Melba Núñez Isalbe, and Roberto Pedroso García, December 19, 2007, Perico, Cuba.

Alberto (Kikito) Enríquez Morales Iglesias and Adela de las Mercedes (Mamaita) Corbea, interview with Jill Flanders Crosby, Melba Núñez Isalbe, and Roberto Pedroso García, December 20, 2007, Perico, Cuba.

Hilda Victoria Zulueta Zulueta, interview with Jill Flanders Crosby, Melba Núñez Isalbe, and Roberto Pedroso García, December 20, 2007, Perico, Cuba.

Iraida (Guyito) Zulueta Zulueta, interview with Jill Flanders Crosby, Melba Núñez Isalbe, and Roberto Pedroso García, December 20, 2007, Perico, Cuba.

Ramona Casanova and Hilda Victoria Zulueta Zulueta, interview with Jill Flanders Crosby, Melba Núñez Isalbe, and Roberto Pedroso García, December 21, 2007, Perico, Cuba.

Orlando Francisco Quijano Tortoló, interview with Jill Flanders Crosby, Melba Núñez Isalbe, and Roberto Pedroso García, December 26, 2007, Perico, Cuba.

Víctor (Prieto) Angarica Diago and Alberto (Kikito) Enríquez Morales Iglesias, interview with Jill Flanders Crosby, Melba Núñez Isalbe, and Roberto Pedroso García, December 28, 2007, Perico, Cuba.

Fermina Baró Quevedo, interview with Jill Flanders Crosby, Melba Núñez Isalbe, and Roberto Pedroso García, December 31, 2007, Agramonte, Cuba.

Onelia Fernández Campos, Israel Baró Oruña, and Mario José Abreu Díaz, interview with Jill Flanders Crosby, Melba Núñez Isalbe, Roberto Pedroso García, and Susan Matthews, December 31, 2007, Agramonte, Cuba.

Hilario (Melao) Fernández Sosa, interview with Jill Flanders Crosby, Melba Núñez Isalbe, Roberto Pedroso García, and Susan Matthews, December 31, 2007, Agramonte, Cuba.

Valentín Santos Carrera, interview with Jill Flanders Crosby, Melba Núñez Isalbe, Roberto Pedroso García, and Susan Matthews, December 31, 2007, Agramonte, Cuba.

Reinaldo Robinson, interview with Jill Flanders Crosby, Melba Núñez Isalbe, Roberto Pedroso García, and Susan Matthews, January 2, 2008, Perico, Cuba.

Fermina (Minita) Baró Quevedo, interview with Melba Núñez Isalbe and Roberto Pedroso García, April 9, 2008, Perico, Cuba.

Hilario (Melao) Fernández Sosa and Mario José Abreu Díaz, interview with Melba Núñez Isalbe and Roberto Pedroso García, April 9, 2008, Agramonte, Cuba.

Lázara Graciela, interview with Melba Núñez Isalbe and Roberto Pedroso García, April 9, 2008, Agramonte, Cuba.

Melkíades Leopoldo Fernández, interview with Melba Núñez Isalbe and Roberto Pedroso García, April 9, 2008, Agramonte, Cuba.

Arístides (Ñuco) Angarica Diago, interview with Melba Núñez Isalbe and Roberto Pedroso García, April 9, 2008, Agramonte, Cuba.

Georgina Margarita Fernández Campos and Onelia Fernández Campos, interview with Melba Núñez Isalbe and Roberto Pedroso García, April 11, 2008, Agramonte, Cuba.

Reinaldo Robinson, interview with Melba Núñez Isalbe and Roberto Pedroso García, April 11, 2008, Perico, Cuba.

Fermina (Minita) Baró Quevedo, interview with Jill Flanders Crosby, Melba Núñez Isalbe, and Roberto Pedroso García, December 15, 2008, Agramonte, Cuba.

Mercedes Zulueta, interview with Jill Flanders Crosby, Melba Núñez Isalbe, and Roberto Pedroso García, December 16, 2008, Perico, Cuba.

Reinaldo Robinson, interview with Jill Flanders Crosby, Melba Núñez Isalbe, and Roberto Pedroso García, December 16, 2008, Perico, Cuba.

Georgina Margarita Fernández Campos, interview with Jill Flanders Crosby, Melba Núñez Isalbe, and Roberto Pedroso García, December 17, 2008, Agramonte, Cuba.

Mario José Abreu Díaz, interview with Jill Flanders Crosby, Melba Núñez Isalbe, and Roberto Pedroso García, December 17, 2008, Agramonte, Cuba.

Iraida (Guyito) Zulueta Zulueta, interview with Jill Flanders Crosby, Melba Núñez Isalbe, and Roberto Pedroso García, December 18, 2008, Perico, Cuba.

Marcos Hernández Borrego, interview with Jill Flanders Crosby, Melba Núñez Isalbe, and Roberto Pedroso García, December 18, 2008, Perico, Cuba.

Mario José Abreu Díaz, interview with Jill Flanders Crosby, Melba Núñez Isalbe, and Roberto Pedroso García, December 17, 2009, Agramonte, Cuba.

Reinaldo Robinson, interview with Jill Flanders Crosby, Melba Núñez Isalbe, and Roberto Pedroso García, December 17, 2009, Perico, Cuba.

Iraida (Guyito) Zulueta Zulueta and Hilda (Macusa) Victoria Zulueta Dueñas, interview with Jill Flanders Crosby, Melba Núñez Isalbe, and Roberto Pedroso García, December 17, 2009, Perico, Cuba.

Reinaldo Robinson, interview with Jill Flanders Crosby, Melba Núñez Isalbe, Roberto Pedroso García, and Susan Matthews, December 26, 2010, Perico, Cuba.

Arístides (Ñuco) Angarica Diago Ángeles and Ester de los Ángeles Santuiste, interview with Jill Flanders Crosby, Melba Núñez Isalbe, Roberto García, and Susan Matthews, December 26, 2010, Perico, Cuba.

Reinaldo Robinson, interview with Jill Flanders Crosby, Melba Núñez Isalbe, Roberto Pedroso García, and Susan Matthews, December 20, 2011, Perico, Cuba.

Vladimir Osvaldo Fernández Tabío, interview with Jill Flanders Crosby, Melba Núñez Isalbe, and Roberto Pedroso García, December 18, 2015, Perico, Cuba.

Jesús (Jesusito) Alberto Morales Varona, interview with Jill Flanders Crosby, Melba Núñez Isalbe, and Roberto Pedroso García, December 28, 2015, Perico, Cuba.

Iraida (Guyito) Zulueta Zulueta and Hilda (Macusa) Victoria Zulueta Dueñas, interview with Jill Flanders Crosby, Melba Núñez Isalbe, and Roberto Pedroso García, December 28, 2015, Perico, Cuba.

Fermina (Minita) Baró Quevedo, interview with Jill Flanders Crosby, Melba Núñez Isalbe, and Roberto Pedroso García, December 28, 2015, Agramonte, Cuba.

Miguel Angel Baró Fernández, interview with Jill Flanders Crosby, Melba Núñez Isalbe, and Roberto Pedroso García, December 28, 2015, Agramonte, Cuba.

Midialis Angarica Galarraga, interview with Jill Flanders Crosby, Melba Núñez Isalbe, and Roberto Pedroso García, December 31, 2015, Perico, Cuba.

Arístides (Ñuco) Angarica Diago and Ester de los Ángeles Santuiste, interview with Jill Flanders Crosby, Melba Núñez Isalbe, and Roberto García, January 1, 2016, Perico, Cuba.

Marcos Hernández Borrego, interview with Jill Flanders Crosby, Melba Núñez Isalbe, and Roberto Pedroso García, January 2, 2016, Perico, Cuba.

Ramón Adair González Díaz and Danny Daniel Perera Gutiérrez, interview with Jill Flanders Crosby, Melba Núñez Isalbe, Roberto Pedroso García, and JT Torres, May 17, 2017, Pedro Betancourt, Cuba.

Marcos Hernández Borrego, interview with Jill Flanders Crosby, Melba Núñez Isalbe, and JT Torres, May 18, 2017, Perico, Cuba.

Pedro Pablo (Pelli) Diviñó Zulueta, interview with Jill Flanders Crosby, Melba Núñez Isalbe, and JT Torres, May 18, 2017, Perico, Cuba.

Nemesio Lázaro (Madan) Baró, interview with Jill Flanders Crosby, Melba Núñez Isalbe, and JT Torres, May 19, 2017, Agramonte, Cuba.

Jesús (Jesusito) Alberto Morales Varona, interview with Jill Flanders Crosby, Melba Núñez Isalbe, and JT Torres, May 21, 2017, Perico, Cuba.

Armando Omar Pérez Méndez and Midialis Angarica Galarraga, interview with Jill Flanders Crosby, Melba Núñez Isalbe, and JT Torres, May 21, 2017, Perico, Cuba.

Orlando Francisco Quijano Tortoló, interview with Jill Flanders Crosby, Melba Núñez Isalbe, and JT Torres, May 21, 2017, Perico, Cuba.

Michael Atwood Mason, interview with Jill Flanders Crosby and Melba Núñez Isalbe, October 13, 2017, telephone interview from Anchorage, Alaska.

Olivia King Canter, interview with Jill Flanders Crosby, November 9, 2017, telephone interview from Anchorage, Alaska.

David Brown, interview with Jill Flanders Crosby, November 10, 2017, telephone interview from Anchorage, Alaska.

Michael Atwood Mason, interview with Jill Flanders Crosby, November 11, 2017, telephone interview from Anchorage, Alaska.

Meera Ventakachalam, interview with Jill Flanders Crosby, April 21, 2018, telephone interview from Anchorage, Alaska.

Informal Conversations (in Chronological Order)

Kpetushie (Dashi) Kemeh Nkegbe, Dzodze, Ghana, April 1992.

Kpetushie (Dashi) Kemeh Nkegbe, Dzodze, Ghana, November 1998.

Kpetushie (Dashi) Kemeh Nkegbe, Dzodze, Ghana, June 2007.

Kpetushie (Dashi) Kemeh Nkegbe, Dzodze, Ghana, June 2010.

Sikasi Ede, Adjodogou, Togo, June 2010.

Bernard (Solar) Kwashie, Accra, Ghana, June 2010.

Bernard (Solar) Kwashie, Accra, Ghana, July 2011.

Jonathan Marion, Anchorage, Alaska, February 2016.

Mario José Abreu Díaz, Agramonte, Cuba, December 30, 2017.

Graciella (Tita) Tabío Robinson and Vladimir Osvaldo Fernández Tabio, Perico, Cuba, December 30, 2017.

Marcos Hernández Borrego, Perico, Cuba, December 31, 2017.

Fermina (Minita) Baró Quevedo, Agramonte, Cuba, January 1, 2018.

María Eugenia Suset Zulueta, Perico, Cuba, January 1, 2018.

Vladimir Osvaldo Fernández Tabío, Perico, Cuba, January 2, 2018.

Hilda (Macusa) Victoria Zulueta Dueñas, Perico, Cuba, January 2, 2018.

Pedro Pablo (Pelli) Diviñó Zulueta, Perico, Cuba, January 2, 2018.

Teresa Vidal Diago, Perico, Cuba, January 3, 2018.

Dalia Mariela Hernández Zulueta, Perico, Cuba, January 3, 2018.

Víctor (Prieto) Angarica Diago and Midialis Angarica Galarraga, Perico, Cuba, January 3, 2018.

Orlando Francisco Quijano Tortoló, Perico, Cuba, January 4, 2018

María del Rosario Pino Domínguez, Perico, Cuba, January 4, 2018.

Alicer Baró Fernández, Agramonte, Cuba, January 4, 2018.

Vladimir Osvaldo Fernández Tabío and Graciella (Tita) Tabío Robinson, Perico, Cuba, January 4, 2018.

Fermina (Minita) Baró Quevedo, Agramonte, Cuba, January 4, 2018.

Mario José Abreu Díaz, Agramonte, Cuba, January 4, 2018.

Michael Atwood Mason, Washington, D.C., February 5, 6, and 7, 2018.

David Brown, telephone conversation, May 16, 2018.

María Eugenia Suset Zulueta, Perico, Cuba, May 18, 2018.

Ismari Caridad Diago González, Cárdenas, Cuba, May 18, 2018.

Víctor (Prieto) Angarica Diago and Midialis Angarica Galarraga, Perico, Cuba, May 19, 2018.

Vladimir Osvaldo Fernández Tabío, Perico, Cuba, May 19, 2018.

Marcos Hernández Borrego, Perico, Cuba, May 19, 2018.

Hilda (Macusa) Victoria Zulueta Dueñas, Perico, Cuba, May 19, 2018.

Mario José Abreu Díaz, Perico, Cuba, May 19, 2018.

Pedro Pablo (Pelli) Diviñó Zulueta, Perico, Cuba, May 20, 2018.

David Brown, telephone conversation, April 25, 2020.

Contributors

JILL FLANDERS CROSBY holds an EdD from Teachers College, Columbia University. She is a professor in the Department of Theatre and Dance, University of Alaska Anchorage. She began research in Ghana in 1991, and focused on ritual dance forms in Ghana, Togo, and Cuba from 1997–2018. She spearheaded a collaborative art installation inspired by her extensive Ghanaian and Cuban fieldwork that appeared in Havana, Cuba, in December 2010, in Ghana, West Africa in 2013, and in San Francisco in 2014. She has presented her Ghanaian and Cuban research at numerous scholarly conferences, including those of the Society for Ethnomusicology, the African Studies Association, the Congress on Research in Dance, and the Society for Applied Anthropology. She has published her work on Ghana and Cuba in the edited volume *Making Caribbean Dance*, the journals *Southern Quarterly, Material Religion, Etnofoor, Revista Catauro*, and on the Centre for Imaginative Ethnography website. She has also researched the making of jazz dance and published in the edited volume *Jazz Dance: A History of the Root and Branches*. She is currently conducting oral history research in the Cook Islands of the South Pacific among dancers, choreographers, and composers.

JT TORRES holds a PhD in educational psychology from Washington State University. He researches the ways identity emerges through reflective writing and the discourse of writing assessment. He is a member of Phi Kappa Phi, the Centre for Imaginative Ethnography, and the National Council of Teachers of English. With an MFA, he is also a published writer, with stories and essays appearing in numerous literary journals, such as *Best Food Writing 2014, Alimentum, Florida Review, Fiction Writers Review, BrokenPlate*, and *A Capella Zoo*. Since first traveling to Cuba in 2014, he has written extensively about the lived experiences of those in Perico and Agra-

monte. Some of his work in this area has been published or is forthcoming in *Creative Approaches to Research, Anthropology & Humanism,* and *InTensions.* His blend of creative writing and scholarship has won him numerous awards and grants for Writing Across the Curriculum. As an educator, he has taught courses in creative writing, composition, research methodologies, and teacher education at Georgia College & State University, Johns Hopkins University, Front Range Community College, University of Alaska Anchorage, Washington State University, and Quinnipiac University.

BRIAN JEFFERY has held faculty appointments in the departments of theater and dance at University of Alaska Anchorage, Northwestern University, Columbia College Chicago, and University of Wisconsin Milwaukee. In addition to conducting extensive residencies as a guest lecturer at many universities and cultural institutions across the US and internationally, Jeffery was founding artistic director of XSIGHT! Performance Group from 1987–2002. His vision of exploring the amalgamation of theater, dance, and the visual arts has been consistently recognized by popular and critical acclaim. During numerous research trips to Cuba, Ghana, and Adjodogou (Togo) from 1999–2013, Jeffery frequently photographed and documented images of family life in small villages and rural communities. These environmental portraits, revealing moments of preparation for ceremony, ritual possession, private shrines, and hidden artifacts, would eventually serve as both reference documents and source materials for many aspects of the *Secrets Under the Skin* project.

MARIANNE M. KIM is a Korean American artist working in screendance, multimedia installation, and performance art. Her areas of research include the disorienting effects of technologized labor, cultural identity, consumerism, and, most recently, the forces within industrial food production and promotion that mediate race, gender, and bodies. She is a professor of Interdisciplinary Arts & Performance in the School of Humanities, Arts, and Cultural Studies at Arizona State University. Her work can be seen at mariannekim.com and disorientalism.net.

SUSAN MATTHEWS is a painter and percussionist living in Oakland, California. She holds a BFA from the University of California, Berkeley, and an MFA from San Francisco State University. She is adjunct professor of

Drawing and Painting at the College of San Mateo in San Mateo, California. Her artistic work has focused on Afro-Cuban folklore since 1995, when she began an intensive study of percussion in Cuba. Her long-term study and hands-on experience as a performer with Carolyn Brandy and Ojalá, Nuevo Mundo, and other folkloric and popular Cuban-based musical groups strengthened her contribution to the *Secrets Under the Skin* project. She has exhibited at the 2016 and 2018 Biennale in Dakar, Senegal, and in galleries and cultural centers in Cuba, Ghana, Alaska, Nevada, and California. Matthews's images can be seen on book covers for Lazaro Pedroso, Scholastique Mukasonga, Miguel Amedo-Gómez, and Michael Smith, and on CD covers for Linda Tillery, Jesus Diaz Y Su QBA, and others. She is the principal visual artist for Women Drummers International.

MELBA NÚÑEZ ISALBE graduated from the University of Havana with a degree in English language and literature in 1997. She was a professor of Spanish language and lexicology and stylistics at the same university. In 2000, she began work for the Cuban Institute of Art and Cinematic Industries (ICAIC), where she is a translator, interpreter, assistant director, and annotator. She also currently trains students who are going to sit for the Cambridge FCE, CAE, and CPE exam. In 1999, she began to accompany Flanders Crosby to her fieldsites in Matanzas Province. From 2006 she was a member of the *Secrets Under the Skin* project and research team. She actively participated and collaborated in all the different processes this project entailed. She transcribed, translated, and cross-referenced all the Cuban interviews that were conducted between 2005 and 2018.

Index

Printed in the United States
by Baker & Taylor Publisher Services